Learning Resource Centre

Park Road, Uxbridge, Middlesex, UB8 1NQ

Renewals: 01895 853344

Please return this item to the LRC on or before the
last date stamped below:

778
FRI

MARCUS BLEASDALE
ALEXANDRA BOULAT
RON HAVIV
ED KASHI
GARY KNIGHT
ANTONIN KRATOCHVIL
JOACHIM LADEFOGED
CHRISTOPHER MORRIS
FRANCO PAGETTI
STEPHANIE SINCLAIR
JOHN STANMEYER

QUESTIONS WITHOUT ANSWERS

THE WORLD IN PICTURES BY THE PHOTOGRAPHERS OF VII

A FIRE IN THE LENS
DAVID FRIEND

On many evenings when groups of journalists assemble, the talk inevitably turns to the conflicts they have covered. They relate their own close calls and, quite often, those of friends and colleagues in peril, on deadline, or under fire (often all three). They somehow convey the grace or ingenuity or black humour with which fellow journalists managed to escape with the pictures and the story and their lives. Or they dwell on those rare, tragic instances when the best of their breed never managed to make it back home.

On many other nights, of course, the talk centres on the sorry state of the trade itself. That is, the lack of venues for serious journalism, the dwindling pages in magazines, the contraction of newspapers, the warped priorities in television newsrooms . . . not to mention the public's attenuating attention. And usually, along with the amber glow of drink that tends to illuminate these proceedings, there is a background hum as well, a two-theme refrain that echoes in the hollows of the evening: the need to seize the opportunities (or confront the chaos) provided by the digital revolution; the need to reinvent oneself in order to survive and thrive. This sense of woe in the picture business, on a charmed night, will often give way, if the mood is right, to an underlying sense of promise in the near term, the vigour of mission, a semblance of hope. On these evenings, the aperture seems not half closed but, miraculously, half open.

And then there are those nights that are rarer still. These are the nights when someone sage takes the really *long* view. I recall one such dinner with a dozen or so cohorts from *Vanity Fair*. I happened to be sitting in proximity to the writers Christopher Hitchens and William Langewiesche, and editor Cullen Murphy. At one point Hitchens, as he often did, brought a hush to our end of the table. 'Name me a great war poem from World War II,' he demanded.

None of us could quite summon one.

'That's right,' Hitchens said, approvingly, like a teacher pleased by a few bright students.

'All right, then,' he continued. 'Name me a great war poem from Vietnam.'

Again, after praising the great James Fenton, we came up blank.

Hitchens argued that the most memorable war poetry, in large part, had been written during World War I.

And with that, he began to recite from memory 'Dulce et Decorum Est', written by Wilfred Owen in 1917:

> . . . But someone still was yelling out and stumbling,
> And flound'ring like a man in fire or lime . . .
> Dim, through the misty panes and thick green light,
> As under a green sea, I saw him drowning.
> In all my dreams, before my helpless sight,
> He plunges at me, guttering, choking, drowning.
> If in some smothering dreams you too could pace
> Behind the wagon that we flung him in,
> And watch the white eyes writhing in his face,
> His hanging face, like a devil's sick of sin;
> If you could hear, at every jolt, the blood
> Come gargling from the froth-corrupted lungs,
> Obscene as cancer, bitter as the cud
> Of vile, incurable sores on innocent tongues,
> My friend, you would not tell with such high zest
> To children ardent for some desperate glory,
> The old Lie; *Dulce et Decorum est*
> *Pro patria mori.*

We were mesmerized as we took in the impromptu performance. Surely, our friend had been required to commit the poem to memory as a child in school. Surely, we'd all been over-served that night, adding an extra lustre in our listening. But none of this accounted for his ability to render Owen with such emotion. Nor did it explain the power of the verse itself. Hitchens' audience sat stunned as much by the terse, focused force of word, metre, rhyme and admonition – 'My friend, you would not tell with such high zest/To children ardent for some desperate glory,/The old Lie; *Dulce et Decorum est/Pro patria mori*' – as by our friend's almost flawless delivery.

Hitchens was correct (as he was, maddeningly, all too often). War poetry hadn't travelled well in the years since the Great War. Cullen Murphy and I, as I recall, ran through a checklist of conflicts as we sat there. The Russian Revolution, we realized, had been best recounted by journalists such as John Reed and by biographers and historians. World War II, in truth, had been better rendered in prose and novels and photographs. Vietnam had brought us great films (*The Deer Hunter, Apocalypse Now*) and testament (*Dispatches*), and works of fiction and journalism too numerous to list. And during that war, it had been still photographs and television footage that had turned the tide of public opinion against American intervention in Southeast Asia.

Poetry, indeed, had been replaced by other (more ostensibly visual) media. And when it came to certain subjects – combat being one of them – still photography had no match in its ability to compress so much moment and meaning into so small a slice of time and space. Photography, like poetry, possessed a powerful concision. And this economy of expression, along with the medium's universality – and new technologies that let photographers rapidly capture, edit, transmit, and post or publish their pictures – had allowed the visual image to dominate how our culture had chronicled news and conflict in the late twentieth and early twenty-first centuries.

Al Qaeda's attack on New York and Washington, DC, on 11 September 2001, was the real turning point for such coverage. As the world changed, so the cliché goes, there was a corresponding change in the way we watched the world change. Advances in digital photography and digital news gathering, which came of age over the course of the 1990s, had suddenly made it possible, by 2001, for much of the world to witness the attacks in an approximation of 'real time'. Thousands of photographers and videographers that day had exposed tens of thousands of frames and hundreds of hours of tape. The internet and broadcast, cable and satellite television had sent that imagery everywhere. As a result, never before had more human beings witnessed the same news event. More than 2 billion people, in fact – roughly a third of the human race – saw a visual rendering of the attacks within those first 24 hours.

And it has been clear ever since 9/11 that modern conflict is being led by images, even in this period when photographers everywhere are struggling to make a living in their chosen field. Robert Calo, of Berkeley's Graduate School of Journalism, observed, in the aftermath of the Asian tsunami of 2004: 'If you think back, news gatherers would [traditionally] get the story and then commission a photographer to go and get the pictures.

'WE WERE INVENTING [VII] AS WE WENT ALONG . . . WE PAID THE LAWYER IN PRINTS. WE PAID THE ACCOUNTANT AND THE WEB-MASTER AND THE GUY WHO DESIGNED THE LOGO THAT WAY . . . WHAT WE WERE DOING WAS NOT A NEW IDEA BUT AN OLD ONE IN A NEW AGE.'

GARY KNIGHT

Now we have flipped it around to where reporters are chasing the pictures, trying to create some context for what viewers are observing.' Indeed, as recent unrest upended autocrats in Tunisia, then Egypt, then reverberated throughout the region, it was photos and videos on YouTube and on social networking sites such as Facebook – along with alerts on Twitter and links on Google – that served as the warning shots of revolution. The mobile phone snapshot and the video clip were casement windows onto history. Digital cameras in the hands of professional journalists and camera-equipped mobile phones, camcorders and point-and-shoots in the hands of enlightened citizens who just happen to be on history's front lines – married with the internet's facility for sharing this imagery almost instantaneously – have forever altered the way we view and react to conflict around the globe.

The modern camera, and its new promise of synchronized universal regard, have made combatants, governments and the world at large not only more accountable but accountable in the here and now. Photography, as evidence, has cast a warning shot across the bow of all would-be perpetrators of atrocity: a threat that whatever one does in public life, for good and especially for ill, may very well be witnessed and recorded for all time and for all eyes, a dossier against the culpable. In this way, the twenty-first-century camera – coincident with the end of the Cold War and of Soviet-era communism, and emerging as new mutations of democratic or dictatorial government have taken hold in many nations (the 20-year period that is documented in the pages that follow) – has engendered among viewers of documentary and news photography a sort of compact, an agreement that those who are witnesses share an ethical obligation to react and respond to injustice, inhumanity, inequity, illness, atrocity and privation, if not through action, then at least through passing along for posterity the photographs, the stories and the lessons embedded in them.

It is no surprise, then, that as the world changed and photography changed, a new collective of photojournalists, committed to covering significant change in the world, would emerge to take advantage of these shifts in technology, in photographic story-telling and in social obligation. Three days before 9/11, the photo agency VII (pronounced 'Seven') was born. That week, many of the world's top photographers and members of the professional photography community descended on Perpignan, France, for the annual Visa pour l'Image festival, the international conclave for photojournalists. Many arrived with a sense of malaise, despite the spirit of liberation that had absorbed much of the western world with the fall of the Berlin Wall in 1989, 12 years earlier.

Indeed, the late 1990s had seen unprecedented consolidation in the news-and-feature side of editorial photography, and a certain gloom had enveloped the rank and file. Photojournalism seemed to be on the wane; celebrity coverage was ascendant. Many publications seemed to be sacrificing experience for expedience. Titans such as Getty Images and Corbis continued to snap up photo archives and agencies – grandly rewarding certain photographers while marginalizing others – as they created agencies of enormous power with vast digital archives. And many attendees at Perpignan that week felt threatened, alienated from the industry to which they had devoted their careers.

Yet there was reason for hope. On Saturday, 8 September 2001, a group of seven leading photojournalists sat on stage at a rag-tag press conference. The photographers were there to announce the formation of a small, independent photo collective – part

'AT THE TURN OF THE MILLENNIUM, THE PHOTO BUSINESS, [EXPLAINS STANMEYER] HAD BECOME DEHUMANIZING. I FOUND OUT ABOUT MY AGENCY BEING SOLD FROM A FRIEND, WHO CALLED WHILE I WAS ON A MOTORBIKE IN EAST TIMOR.'

JOHN STANMEYER

traditional agency, part global network reliant on the Web – to be based not in Paris or New York, in Seattle or Silicon Valley, but at their seven separate laptops and computer desktops in their seven home offices, from Manhattan to Provence to Bali.

'We were inventing [VII] as we went along,' explains the agency's initial strategist, Gary Knight, 'everyone cleaning out their ATMs. We paid the lawyer in [photographic] prints. We paid the accountant and the Webmaster and the guy who designed the logo that way. That week [in Perpignan] was . . . the first time we had all met in the same room and had the opportunity to go through the business model together, face to face.' Those in the press-conference audience, long starved for good news and a fresh approach, seemed to warm to their concept. 'What we were doing was not a new idea,' Knight admits, 'but an old one in a new age.'

The notion behind VII was simple and counterintuitive. As picture agencies became more unwieldy and impersonal, why couldn't a septet of friends form their own cooperative – maintaining their ethical standards, photographic quality, camaraderie – and share their profits, all the while using the World Wide Web to transmit their images digitally from their own corners of the globe? (VII, as described in some of its earliest literature, was 'designed from the outset to be an efficient, technologically enabled distribution hub for some of the world's finest journalism'.) And why couldn't more subtle, nuanced pictures – images created not merely in response to the immediacy of world events but evolving out of each photographer's unique editorial and artistic perspective – make it into the journalistic pipeline? Somehow, Knight and his confrères would try to elevate socially engaged documentary photography – a silent, meditative, anachronistic medium in the light-speed era of 24/7 news.

Knight was spurred on, he says, by the legendary Magnum photographer Gilles Peress, who Knight insists had been urging him to set out on his own and create something new. Knight felt

something click one night, at 3.00 a.m. He happened to be visiting photographer John Stanmeyer on a trip to Hong Kong. 'We were down in my studio,' recalls Stanmeyer, 'standing over an old [Macintosh] G3. We were doing Web stuff, talking about how to market an archive. And Gary said, "What about doing this together?"'

In the intervening six to nine months, via late-night rap sessions and countless e-mails, they joined forces with other adventurous photographer friends – Ron Haviv, Antonin Kratochvil, Alexandra Boulat and Christopher Morris – veterans of conflicts in Bosnia, Kosovo and the West Bank. (Boulat would perish in 2007 after suffering a ruptured brain aneurysm in Gaza.) One by one, emboldened by a collegial bond, they came on board, in search of a new business paradigm and a chance for ownership and opportunity. At the turn of the millennium, the photo business, explains Stanmeyer, had become 'dehumanizing. I found out about my agency being sold [during a conversation on my mobile phone] from a friend, who called while I was on a motorbike in East Timor.' Here was a vote against the mainstream and in favour of the streamline; a vote against the corporate and in favour of esprit de corps.

And then Photographer No. 7, who had been integrally involved in the conception of the agency since its early planning stages, fully signed on: James Nachtwey, a modern-day heir to the great combat chroniclers of the past century. In early 2001 Nachtwey had left Magnum, his photographic home of 17 years. When he heard the murmurs about VII, Nachtwey felt compelled to join his like-minded comrades, 'a group of people,' he says, 'who all have worked with each other all around [the world] in adversity, in the kind of situation where strong friendships are made very quickly.' The name for the agency evolved after discarding more conventional names, such as Witness. 'Someone asked, how many of us are there?', Nachtwey recalls, prompting the name The Seven – a reference, in part, to the Seven Samurai. Then it became, simply, Seven, then VII. 'I suggested the roman numeral VII. It would be a word, a number and a visual logo, all at the same time.' Stanmeyer adds, 'Someone did a study on the number of people who can coalesce in a group and not have factions form. And it was seven.'

And so, on 8 September, VII was officially launched at the press conference in front of an appreciative, if somewhat sceptical, crowd of professional peers. Its genesis called to mind not only the creation of Magnum Photos in 1947 but also, curiously, the founding of United Artists in 1919 – when the silent screen actors Mary Pickford, Douglas Fairbanks and Charlie Chaplin defected from the studio system, plotting to return the power of film-making to a consortium of artists. (It isn't too much of a stretch to imagine Boulat as Pickford, surely, and any of the original seven as a swashbuckling Fairbanks. Of course, the role of the effervescent Chaplin would have to be played by the inimitable Antonin Kratochvil.)

The next morning, on 9 September, VII's Christopher Morris set out for home – Tampa, Florida – by way of Barcelona. A long-time White House correspondent for TIME, Morris had been among the most accomplished war photographers throughout the protracted Balkan conflict of the 1990s. On 9 September, it turned out, Morris was on a deadline. He had been assigned to shoot a story on internet gambling on the Caribbean island of Antigua – for TIME and its website, TIME.com. And he knew that after he completed that one-day shoot, he would have to quickly make his way back to Washington to cover his usual beat: dogging the trail of President George W. Bush.

Driving to Barcelona in his rental car, Morris made a pit stop at a supermarket in southern France. His wife, Vesna – born in Yugoslavia, raised in France, living in the United States – had a weakness for *beurre au sel de mer*, a special type of butter made with sea salt, which he knew he could find only in France. All week long, Morris recalls, Vesna had reminded him by phone 'every day, "Please, get that butter", with me telling her I had bought the butter, but I hadn't bought the butter'. That day, he dutifully purchased 'five or six big bars', which he placed on the back seat. He pulled out of the car park and promptly lost his way. Then he hit a traffic jam. Morris finally made it to the airport, only to watch the plane take off without him. With no place to sleep, he decided to head back – 195 kilometres (120 miles) – to Perpignan, butter in tow.

As he drove, he realized he would never be able to make it to Antigua *and* keep his Washington assignment. So, upon arriving, and finding his new VII colleagues hanging out together, Morris turned to Nachtwey and persuaded him to fill in for him on the gambling shoot. 'We buttered it up for Jim,' Morris says, 'telling him there were beautiful Chinese women who do the roulette tables.' Nachtwey, half-jokingly, saw an opportunity at hand. Realizing that this was VII's first official assignment – on wagering and games of chance, no less – he beseeched the others: 'Give me something to gamble with. [Robert] Capa used to go to the races with Magnum's money, hoping to raise some seed money.' Each pitched in his share, and soon Nachtwey had a $100 bill to wager. That night, remembers Morris, 'We all met in this apartment in Perpignan and we opened the cube. They all had to taste this butter that I missed my plane over.'

The next day, recalls Knight, 'Jim leaves Perpignan one day early [than he had planned]. He pockets the $100. He hops on a train and airplane and arrives in New York on September 10, intending to go to Antigua to spend our $100. On the morning of September 11, *Time*'s messenger arrives with 100 rolls of colour-negative film, as he's packing his bags.' Nachtwey lives downtown, near the South Street Seaport, just blocks from the Twin Towers. 'And he hears a bang,' Knight says. Nachtwey would capture some of the most harrowing frames taken of the Al Qaeda attack that would claim the lives of some 3,000 people in New York, Washington, DC and Pennsylvania.

Even today, Nachtwey says, he occasionally ponders the fate that befell those men and women standing on the other side of the tower that morning. Yet the journalist in him had to move forward. Nachtwey believed in the new agency (he actually held onto the $100 bill as a keepsake, before misplacing it; Morris saved the *beurre au sel de mer* wrapper) and both photographers committed themselves to covering the broader conflict. 'We launched on September 8, three days before the attacks', Nachtwey says of the agency's baptism by fire. 'Then the world changed. And we've been following that story ever since.'

In due course, all but one of the early VII team (soon expanded to nine members by adding Lauren Greenfield, who has since branched out on her own and, for a time, Christopher Anderson and Eugene Richards) would cover the subsequent war in Afghanistan. Seven photographers would do the same in Iraq, placing themselves directly on the conflict's front lines. VII's ranks have grown in recent years. The agency, at the time of writing, now consists of Marcus Bleasdale, Alexandra Boulat (1962–2007), Ron Haviv, Ed Kashi, Gary Knight, Antonin Kratochvil, Joachim Ladefoged, Christopher Morris, Franco Pagetti, Stephanie Sinclair and John Stanmeyer; James

'WHILE THE STARK REALITIES OF THE BATTLEFIELD LOOM LARGE, VII TURNS ITS GAZE WITH EQUAL INTENSITY ON MORE SUBTLE FORMS OF CONFLICT, DOCUMENTING THE DEEPER CHANGES AND DEVELOPMENT OF SOCIETY AND CULTURE, WORLDWIDE.'

VII

Nachtwey has since disassociated himself as a photographer from VII. In addition, the agency now represents a rich mix of photographers with an affiliated group working alongside the members but who do not share ownership, and the VII Mentor Program.

What, in hindsight, *is* the story that erupted the week VII was born, the one that its photographers have been 'following ever since'? In fact, these photojournalists as individuals – long before establishing VII – had been covering an overarching set of challenges: the ongoing struggles in the Middle East following the Islamic uprisings of 1915, the birth of modern Islamist extremism in Egypt in the ensuing decades, and the establishment of the state of Israel in the shadows of World War II; the lurching aftermath of communism's demise in the late 1980s; late twentieth-century Islamist revolt against monarchical Arab regimes and western nations, followed by a twenty-first century wave of newly empowered young citizens intent on democratic reform; a rash of genocidal conflicts that have now spanned a generation; the combined effects of globalization, global economic recession, diminishing resources and environmental devastation; the increasing disparity between the wealthy and the impoverished.

And yet, the conflict that emerged in sharp relief on 11 September 2001 was one of specific gravity and urgency. At one end of the spectrum, some have called it the initial cannonade of Armageddon, or, at least, the clash of civilizations, epochal and foreordained, between the Christian West and the Islamic East. (Middle East historian Bernard Lewis sees the clash as a showdown between 'Islamic theocracy and liberal democracy'.) At the other extreme, those sharing the sympathies of the 9/11 attackers have considered it the beginning of the end of the West's global dominance, and the emergent voice, illegitimate or not, of the underclass. Across that great divide, it has been called any number of antithetical, irreconcilable labels: the infidel's demise; 'freedom' under siege; the faith-splintered West imploding; terrorism as internet-age spectacle; the figurative defeat of materialist culture; the democratic ideal resilient, ready to rebound and stronger still.

Nedjma, the Muslim feminist author, called it a collision of 'two fundamentalisms'. Novelist Don DeLillo called it an attack on 'the white-hot future' and on 'the high gloss of our modernity . . . the thrust of our technology . . . our perceived godlessness'. Commentator Fareed Zakaria, citing Thomas Hobbes, called it a harbinger of the resurrection of the State in the name of security. Others called it Pure Evil, finally establishing its beachhead; the litmus test of democracy, unbowed, to be defended at all costs; the slow run-up to World War III; the fiery twilight of oil dependency, of the West's progress-at-all-cost ethos, of capitalism itself. Whatever its name, as these upheavals have been documented by the men and women of VII – from the waning days of the Cold War to the new salvoes of insurrection in the Arab world, from the struggles in Eastern Europe to the crises in Africa, from the confrontations in Afghanistan and Iraq to today's simmering global economic turmoil – the agency has taken its birthright seriously. Born in fire, it continues to cover places where the body politic is enflamed and to cover social issues in dire need of witness.

The VII photographers, as a rule (though they maintain no fixed rules), are professionally industrious, aesthetically focused, passionate in temperament, active and activist in their humanitarian pursuits, personally generous and engaging. By one measure, they have become, per capita, the most award-winning cadre of consistently working photojournalists over the course of the past decade.

The collective has expanded its mission so that members envision their role as being documentarians of conflicts both large and small – social, political, environmental – striving to produce what its founders call 'an unflinching record of injustices created and experienced by people caught up in the events [the photographers depict]. While the stark realities of the battlefield loom large, VII turns its gaze with equal intensity on more subtle forms of conflict, documenting the deeper changes and development of society and culture, worldwide.'

In this image-laden era, this is about as worthy an endeavour as might be embarked upon by a group of visual storytellers. And the stories that they tell, even in this global age, always reinforce the notion that the local – the individual life – is what actually matters. The men and women of VII, in short, are distinguished by their commitment and compassion, by their expressive eloquence, and by their courage to photograph the world in a manner that demands that viewers peer deeper than they might have otherwise dared: deep into the visual fabric of the image, deep into the human and social motivations outside the photographic frame, and deep inside themselves.

I. AFTER THE COLD WAR

The post-Cold War era was to usher in a sense of uncertainty and fragility in the geopolitical order. 'Globalization' began to expose citizens and their states to mutual vulnerabilities in the international system – a process at once new and centuries old. In Africa, exploitation of natural resources went hand in hand with unresolved conflict and predatory government, while Asia, economically more confident, was rocked by a financial crisis that led to the departure of the Indonesian president in 1999. South Africa appeared a notable exception: the election of anti-apartheid activist Nelson Mandela in the country's first fully representative democratic election in 1994 was a salve to past grievances. But South Africa was to be blighted by the highest rate of HIV/AIDS infection in the world. Both in Africa and in Southeast Asia, HIV/AIDS cast a long shadow as governments proved either unwilling or unable to manage the disease's spread. The low life expectancies of the already young populations were a sobering contrast with the western fixation on celebrity and with its ageing populations.

In Europe, the fall of the Berlin Wall in 1989 came to represent the moment the rules were rewritten. The Soviet behemoth that had become saturated by economic inefficiency and political repression crumbled. Communist Yugoslavia was also to fall prey to the Rubik's Cube of shifting borders. There, the rise of ethnic nationalism led to a decade of conflict that pitted former neighbours against one another in bitter warfare. The UN and the EU attempted to assuage the so-called 'ancient ethnic hatreds', but the NATO-led intervention could not prevent terrible war crimes on all sides.

While the tensions in Eastern Europe had historical precedence, no one could have predicted the significance of the coordinated bombing of two US embassies in the African capitals of Kenya and Tanzania on 7 August 1998. Killing over 200 people, the incident portended the emergence of a sustained anti-American assault led by Saudi Islamist Osama bin Laden, later to be granted global infamy as the mastermind of the 9/11 terrorist attacks on the United States. Bin Laden claimed to have been motivated by the US military operation in Somalia in 1992–1993, calling into question the United States' interventionist gamble in far-away theatres. The group widely believed to be the actual perpetrators of the crime, Egyptian Islamic Jihad, reportedly did so in response to the extradition of four of its members from Albania, locus of Europe's then-preoccupation. While much of the West returned its attention to the boiling ethnic tensions of the Balkans, Russia attempted to pacify the nationalist struggle in Chechnya at great civilian cost. Meanwhile, the phenomenon of jihadist terrorism, networked across the Middle East and North Africa, was to grow in size and influence, striking at the heart of US power on 11 September 2001.

The gruesome attacks on the American homeland led Washington to declare its War on Terror on Al Qaeda and 'every terrorist group of global reach'. Later, the administration would draw criticism for intelligence failures and its fruitless goose-chase for bin Laden, but at the time its friends and allies rallied round. Less than a month passed before US and British forces began a bombing campaign against the Taliban in Afghanistan that would keep them and other NATO allies embroiled in the country for at least the next decade.

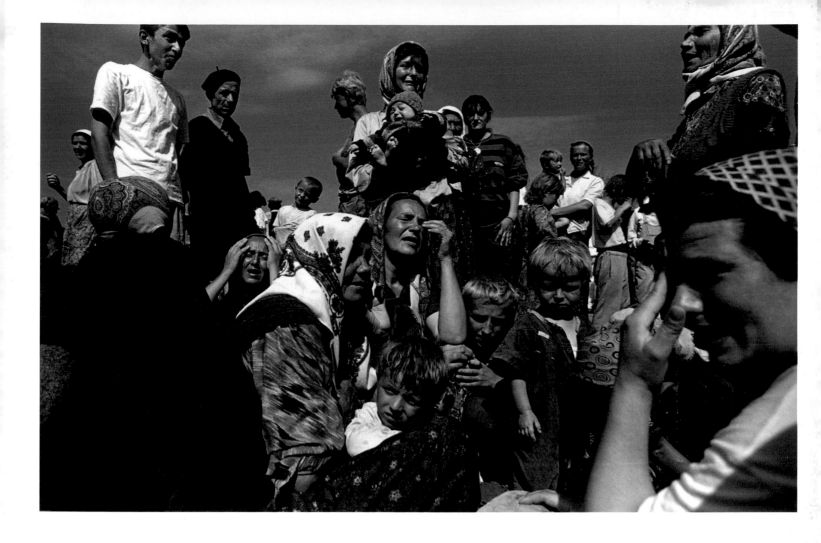

1991–1998
BLOOD AND HONEY
RON HAVIV

Blood and Honey (Kan and Bal in Turkish) explores the violent confrontations that took place during the dissolution of Yugoslavia. It was formed of six republics: Bosnia-Hercegovina, Croatia, Macedonia, Montenegro, Serbia (including the autonomous provinces of Kosovo and Vojvodina) and Slovenia. By the late 1980s, nationalisms were stirring, in particular that of the Serbian leader, Slobodan Milosevic. Slovenia, Croatia and Macedonia declared independence in 1991. War broke out in Croatia as its Serbian population tried to separate: in 1992, the same happened in Bosnia as Serbian nationalists tried to create a 'Greater Serbia' by ethnically cleansing Muslim areas. By 1993, the Bosnian Muslim government was besieged in Sarajevo. Major atrocities eventually forced NATO to intervene and impose the 1995 Dayton Agreement, which ended the war. In 1998, the issue Dayton ignored – Kosovo – flared up as the ethnic-Albanian Kosovo Liberation Army rose up against Serbian rule. NATO intervened, but its air strikes could not prevent thousands of refugees fleeing the province. Eventually, Milosevic was deposed in 2000, and in 2001 he was put on trial at The Hague for crimes against humanity and genocide.

Survivors of the Serb attack on Srebrenica, Bosnia, learn of the fall of Tuzla, a United Nations 'safe haven', 15 July 1995. More than 7,000 Bosnian Muslims were killed and tens of thousands were forced to flee during the Srebrenica massacre.

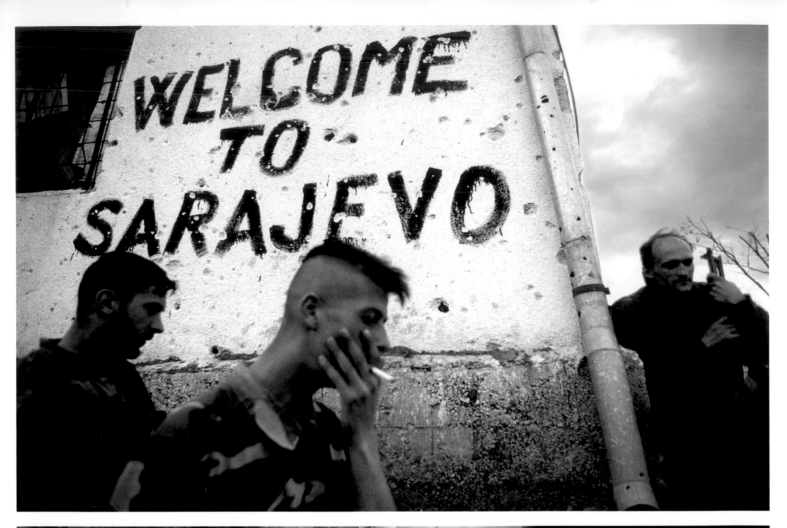

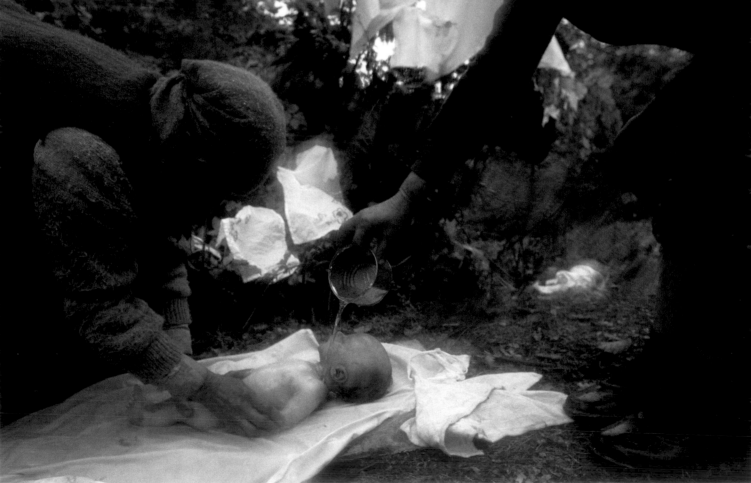

Above. Bosnian soldiers on the front line take a break beneath the 'Welcome to Sarajevo' sign, 1 September 1994. Trench warfare was fought all around Bosnia's encircled capital city during the four-year siege.

Below. Kosovar Albanians, who had fled to Drenica in Kosovo, prepare a baby for burial, autumn 1998. The five-week-old had died of exposure in the Kosovo mountains. Thousands of Kosovars were internally displaced during the early Serb offensives in the war for Kosovo's independence.

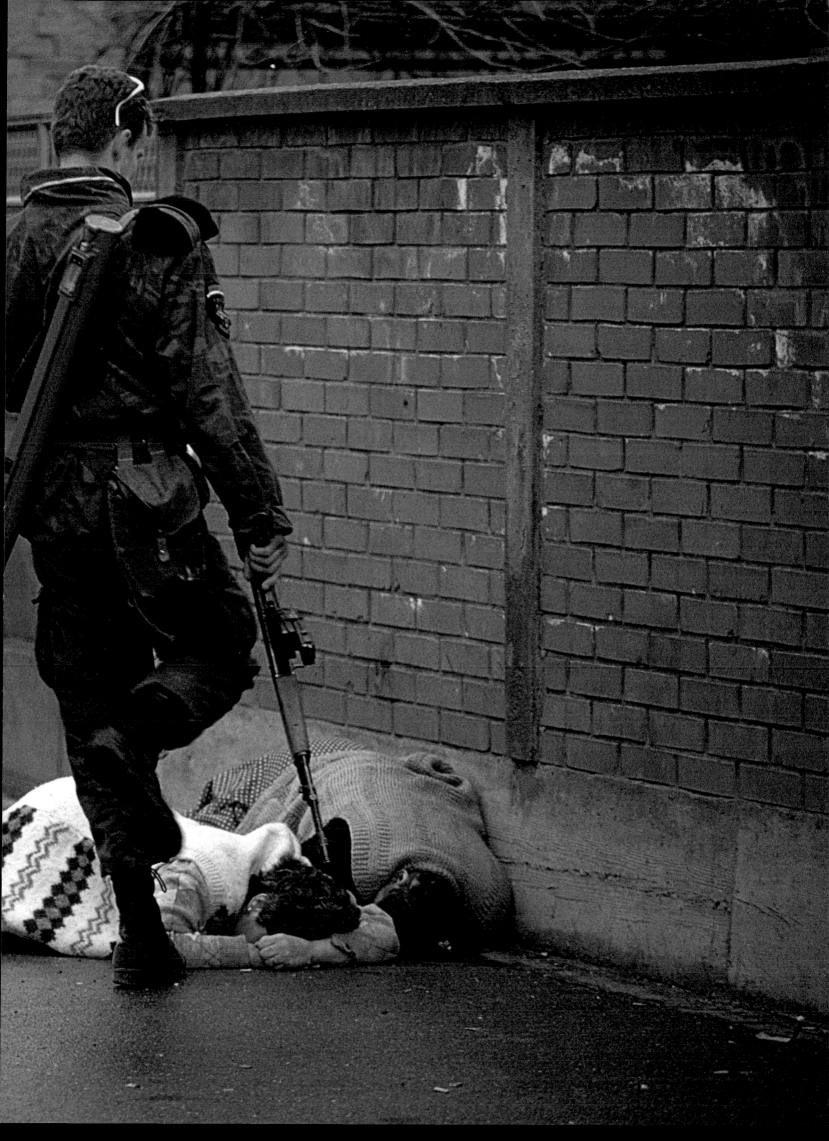

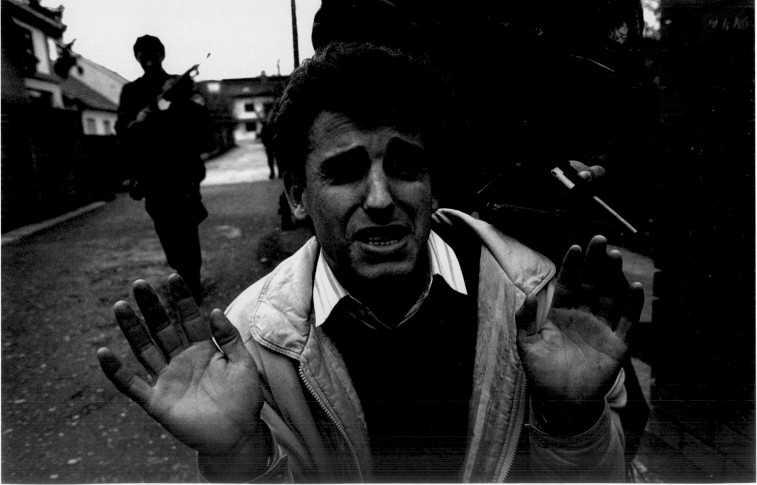

Previous page. Serbian paramilitaries walk past the dying bodies of Bosnian Muslims during the first battle of the Bosnian War in Bijeljina, 31 March 1992. **Above.** A Bosnian Muslim finds his home in ruins, 1 September 1995. He is standing on what is believed to be a mass grave, which includes members of his family.

Below. A Muslim in Bijeljina, Bosnia, begs for his life after capture by Arkan's Tigers in the spring of 1992.

Bosnian and Croatian prisoners of war at the Serb-run camp in Manjaca, Bosnia,
22 August 1992. All sides involved in the Bosnian conflict ran prison camps, where
many people were massacred, and several commanders were later indicted for
war crimes.

Ron Haviv – Blood and Honey 19

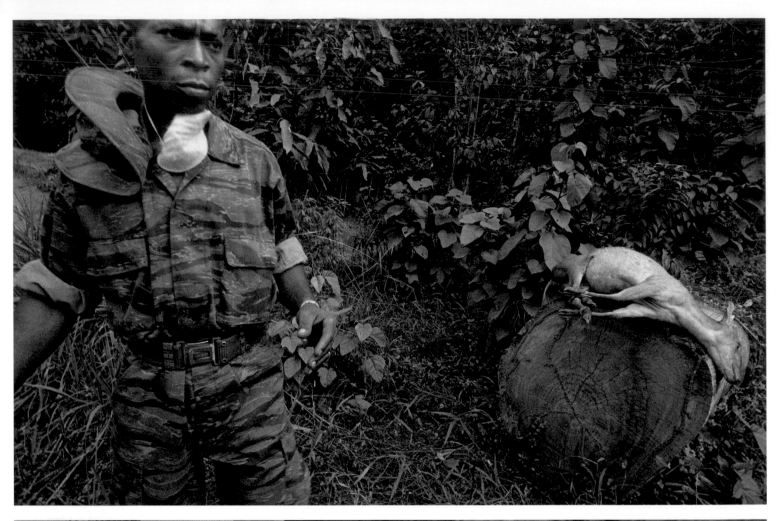

Above. An ecoguard with a poacher's catch, Ndoki, Congo, 2005. Illegal poaching in Congo produces an estimated 5 million tonnes of bushmeat per year. At this rate, the region's wildlife will be extinct within 15 years.

Below. Former government soldiers wounded by mines, Luanda, Angola, 2001. The number of land mines in Angola is estimated between 10 and 20 million, or up to two land mines per person.

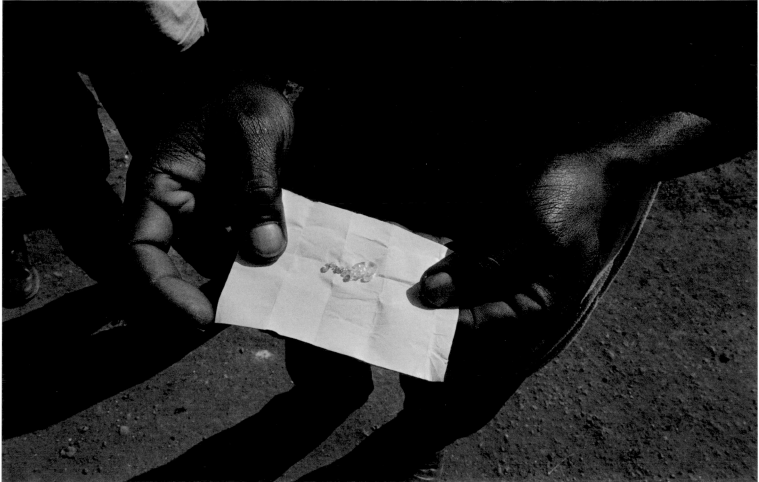

Above. Pollution in the Caspian Sea, 1998. Oil lying on the sea's surface prevents evaporation and so the sea floods the land.

Below. A diamond buyer, Unita Territory, Angola, 2001. At one time, Unita's illegal diamond trade was estimated at $1 million per day.

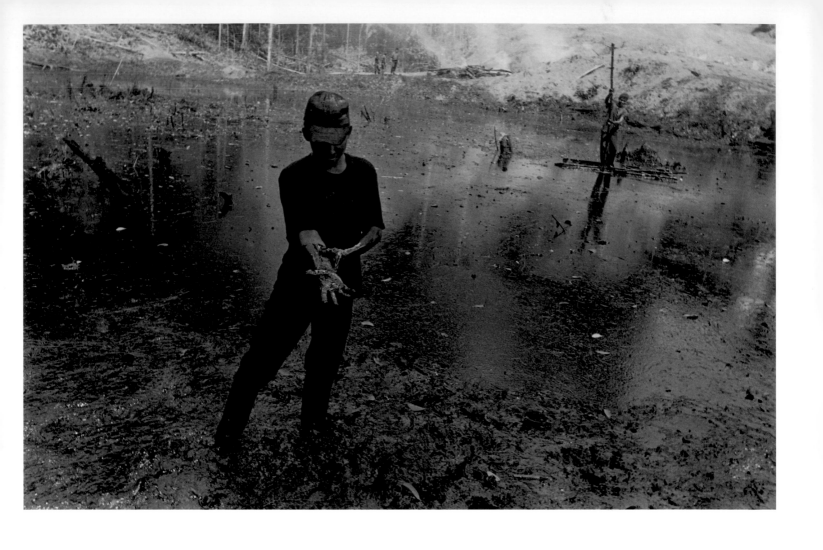

Workers clean up an oil spill in Oriente, eastern Ecuador, 1994. It is widely alleged that Chevron Texaco spilled 16.8 million gallons of oil in the area from ruptured pipelines, one and a half times that of the Exxon Valdez oil tanker disaster in 1989.

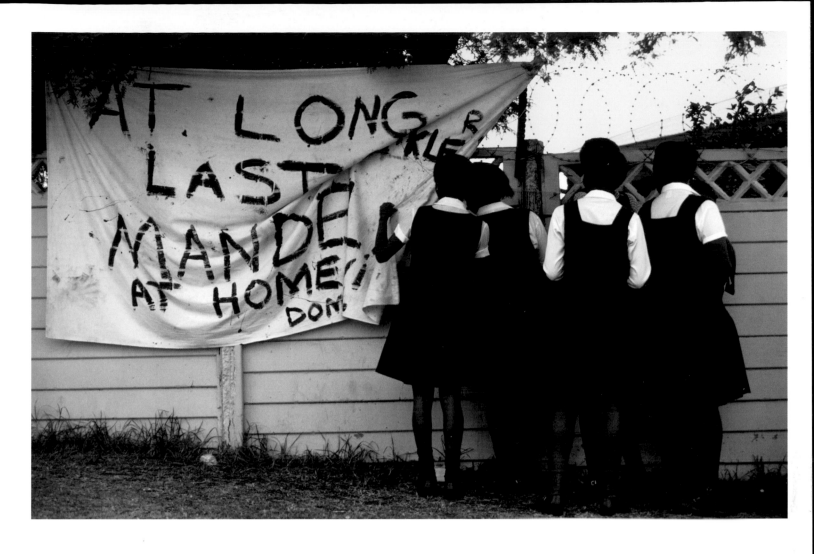

1994
THE ELECTION OF NELSON MANDELA
RON HAVIV

Nelson Mandela is undoubtedly the most famous of the activists who fought against the apartheid system of South Africa. Growing international support for his struggle led to his release in 1990, after 27 years of imprisonment. The role he played, through dialogue with the National Party leader President F. W. de Klerk, in ending racial segregation policies was recognized by the award to both of the joint Nobel Peace Prize in 1993. The following year saw South Africa's first fully democratic presidential elections in which, as leader of the African National Congress, Mandela was elected by an overwhelming majority and took up office as the first black president of South Africa. Entrusting his deputy, Thabo Mbeki, with the day-to-day running of the government, Mandela concentrated on promoting South Africa around the world, successfully persuading multinational corporations to stay and invest in the country. Having engineered the transition to an inclusive state, Mandela stepped down in 1999 to be succeeded by Mbeki.

Above. Outside Nelson Mandela's home in Soweto, shortly after his release from prison, February 1990.
Overleaf. Nelson Mandela campaigns in the black African homeland of Transkei, March 1994. Transkei was dissolved and reintegrated into South Africa in 1994.

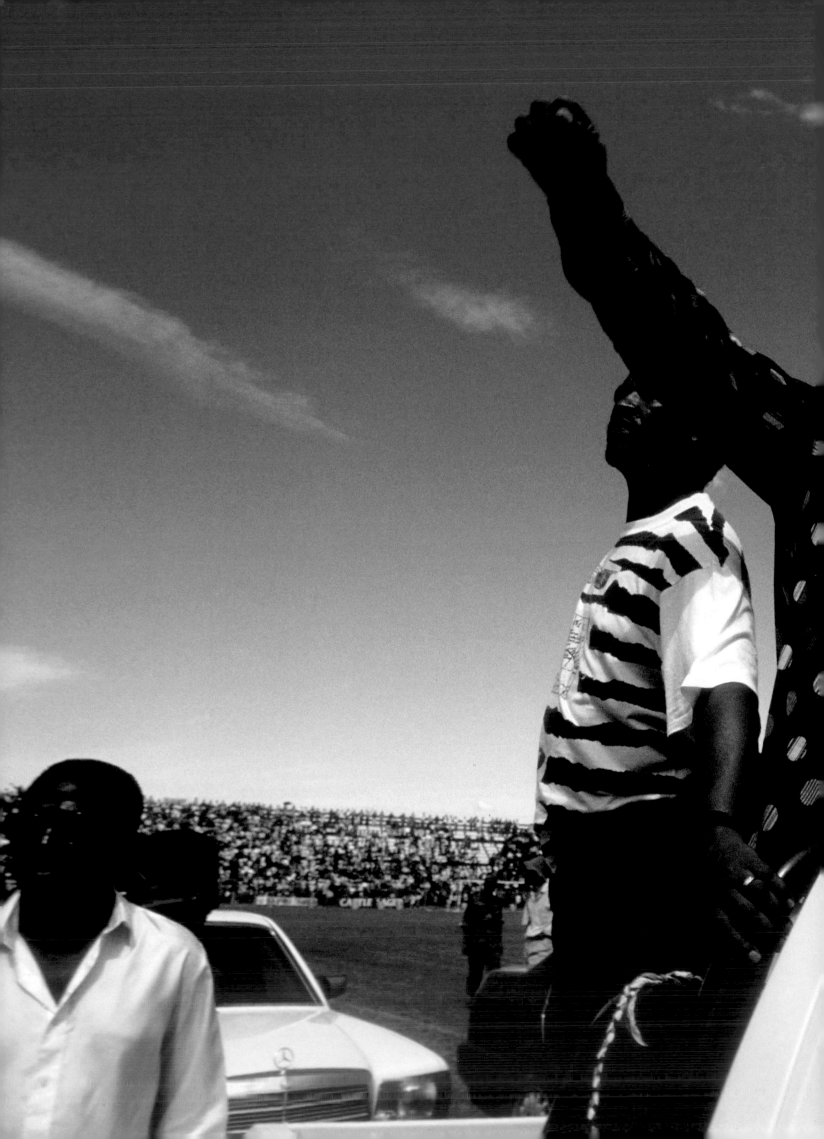

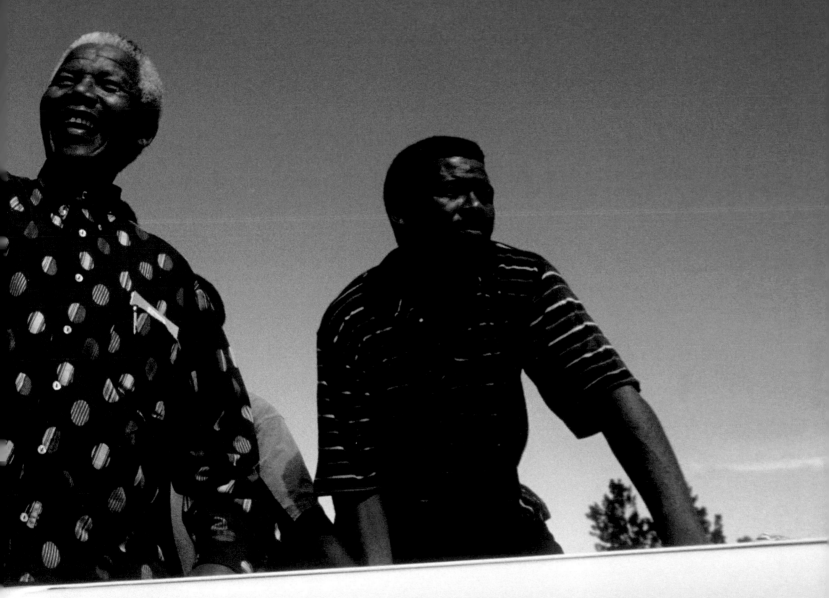

Transkei Region

ANC **MANDELA**

speaks

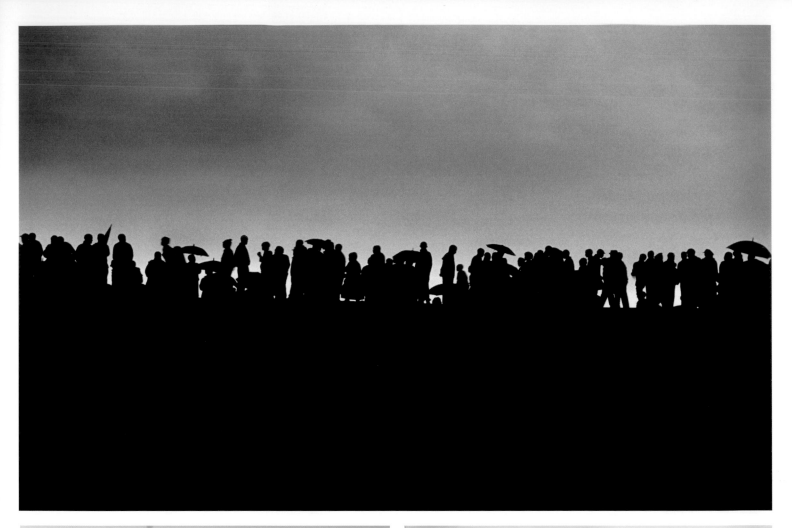

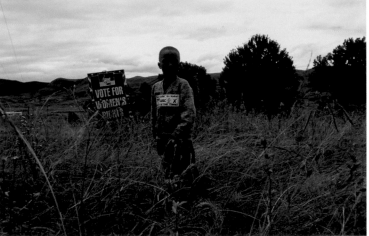

Above. African National Congress (ANC) supporters gather during their campaign to elect Nelson Mandela as president of South Africa, April 1994.

Left. ANC supporters clash with supporters of F. W. de Klerk and his National Party, February 1994.

Right. Nelson Mandela's campaign in Transkei, March 1994.

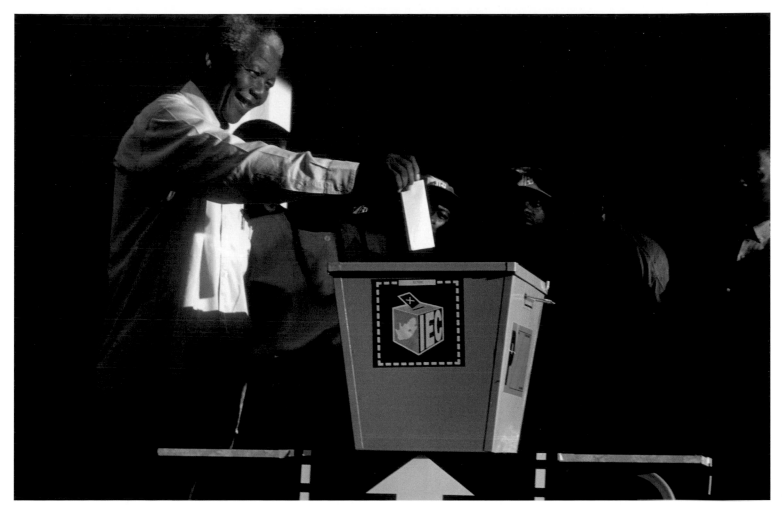

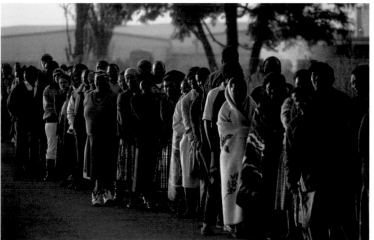

Above. Nelson Mandela casts his vote in South Africa's first multiracial election, April 1994.

Left. People in Katlehong, the second largest black township after Soweto, queue to vote in South Africa's first multiracial election, April 1994.
Right. Nelson Mandela's supporters celebrate his victory in the presidential election, April 1994.

1995–2009
IN PERSON
VII

Charles Baudelaire wrote 'A portrait! What could be more simple and more complex, more obvious and more profound.' With his portraits, Antonin Kratochvil turns his camera away from the destruction he has documented in Eastern Europe to reveal another side of modernity: the broad-reaching spectrum of the entertainment industry. Unlike the candy-coated imagery so prevalent in today's fashion and film magazines, his work underscores the physical and psychological intensity of the creative men and women who have sat before his camera, with images not designed to flatter but to seek out something, possibly hidden, below the surface. Similarly, the portraits of entertainment icons Iggy Pop and Matthew Williamson, captured by Christopher Morris and Franco Pagetti, respectively, reveal their unique personas. Likewise, Joachim Ladefoged portrays the unwavering determination of one of the world's most famous conductors, Valery Gergiev.

31. Antonin Kratochvil.
David Bowie, New York, 1997.

32. Above. Antonin Kratochvil.
Bernardo Bertolucci, New York, 1996.

32. Below. Antonin Kratochvil.
Debbie Harry, New York, 2004.

33. Above. Antonin Kratochvil.
Jean Reno, Paris, 1997.

33. Below. Antonin Kratochvil.
Willem Dafoe, New York, 1998.

34–35. Joachim Ladefoged.
Valery Gergiev, Mariinsky Theatre,
St Petersburg, 2009.

36. Antonin Kratochvil.
Liv Tyler, Tuscany, 1995.

37. Above. Christopher Morris.
Iggy Pop, Miami, 2009.

37. Below. Franco Pagetti.
Matthew Williamson, London, 2009.

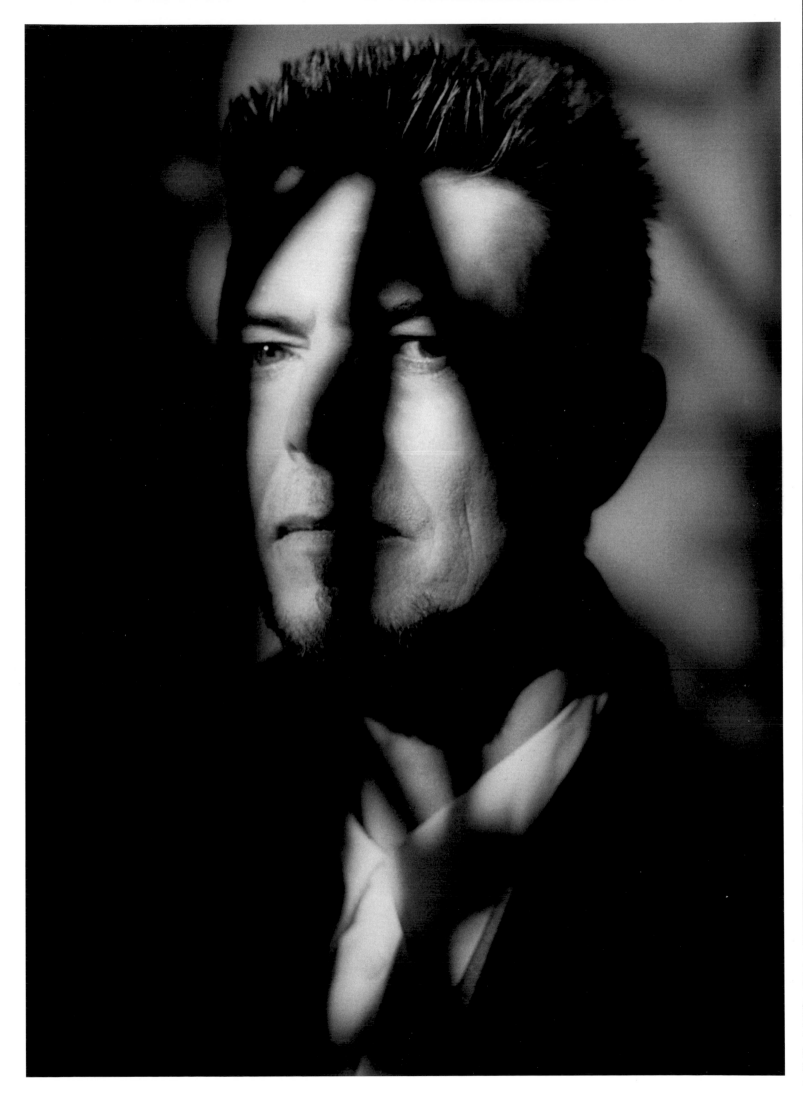

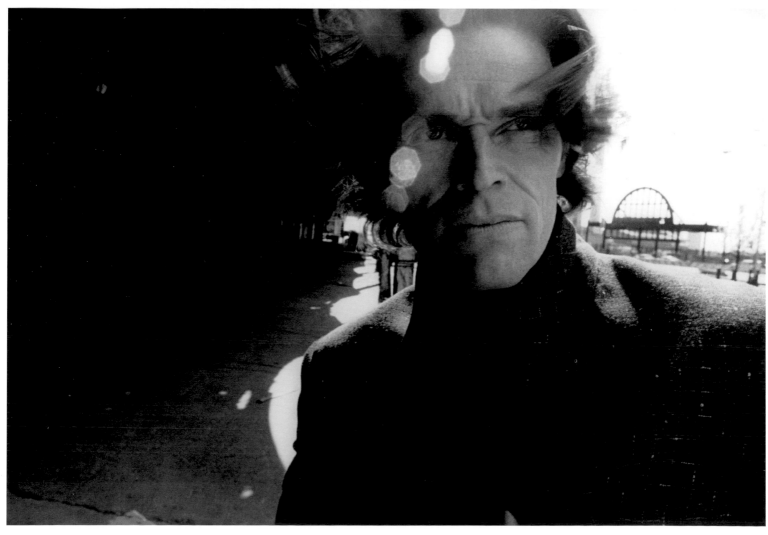

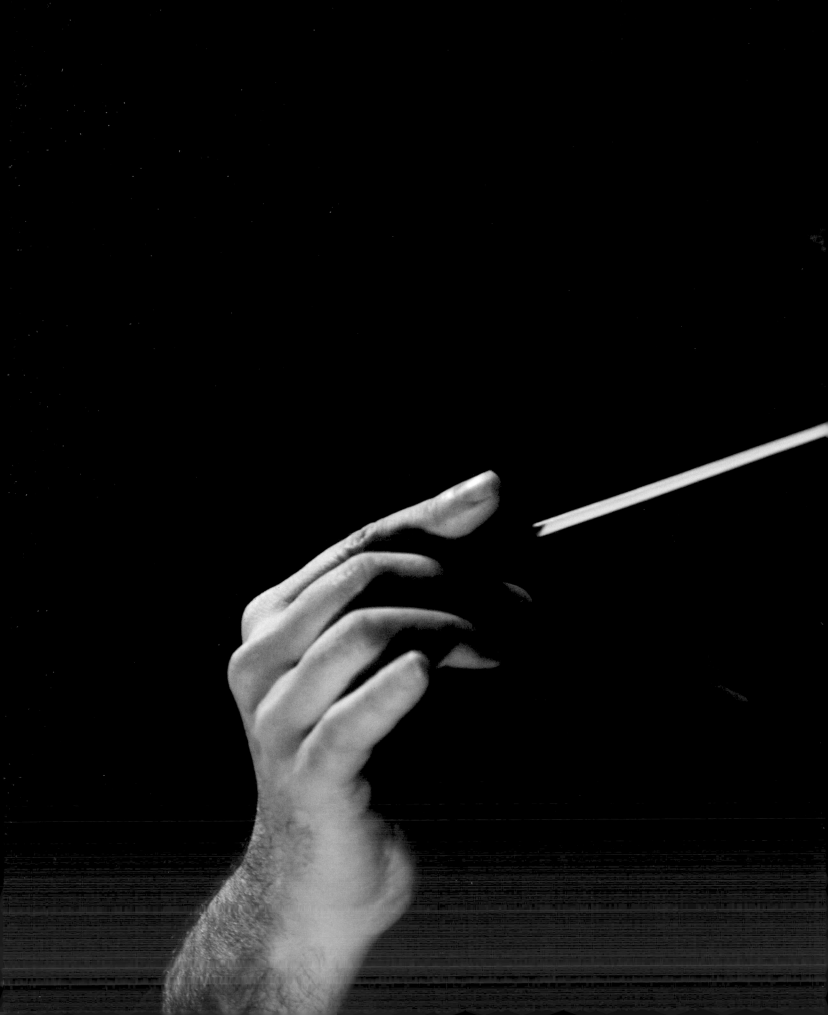

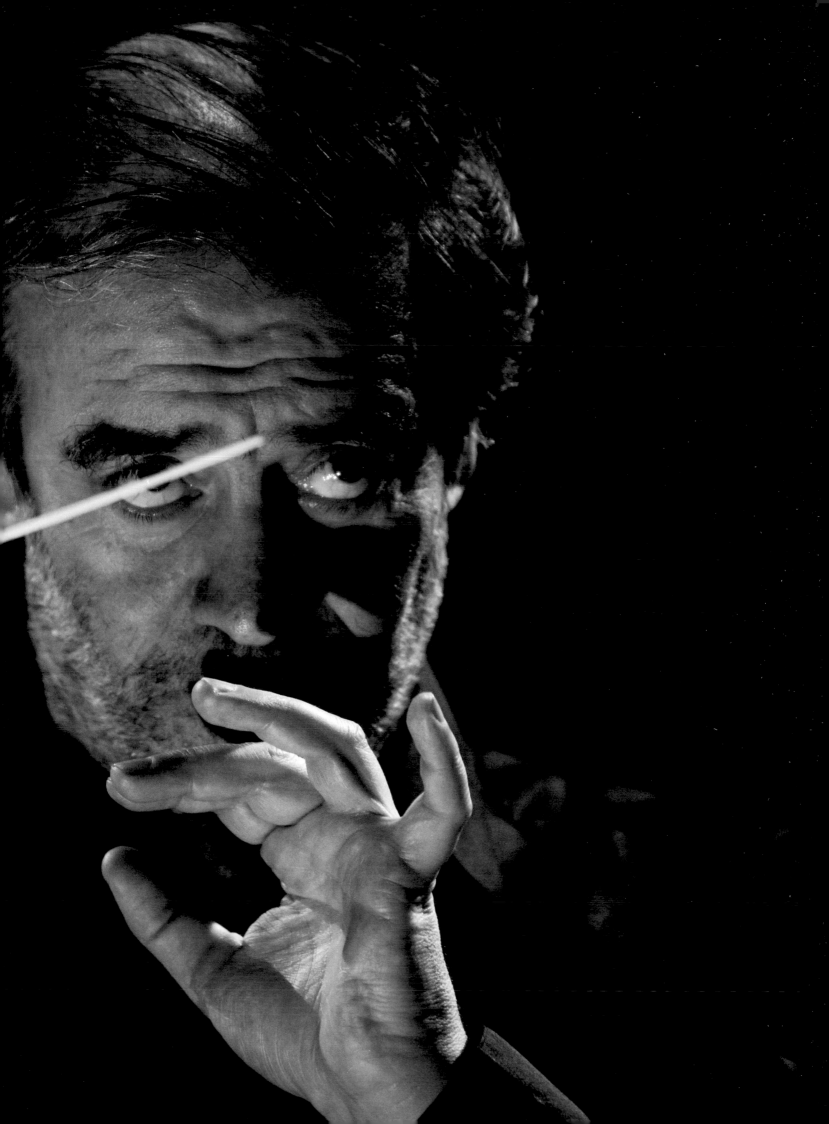

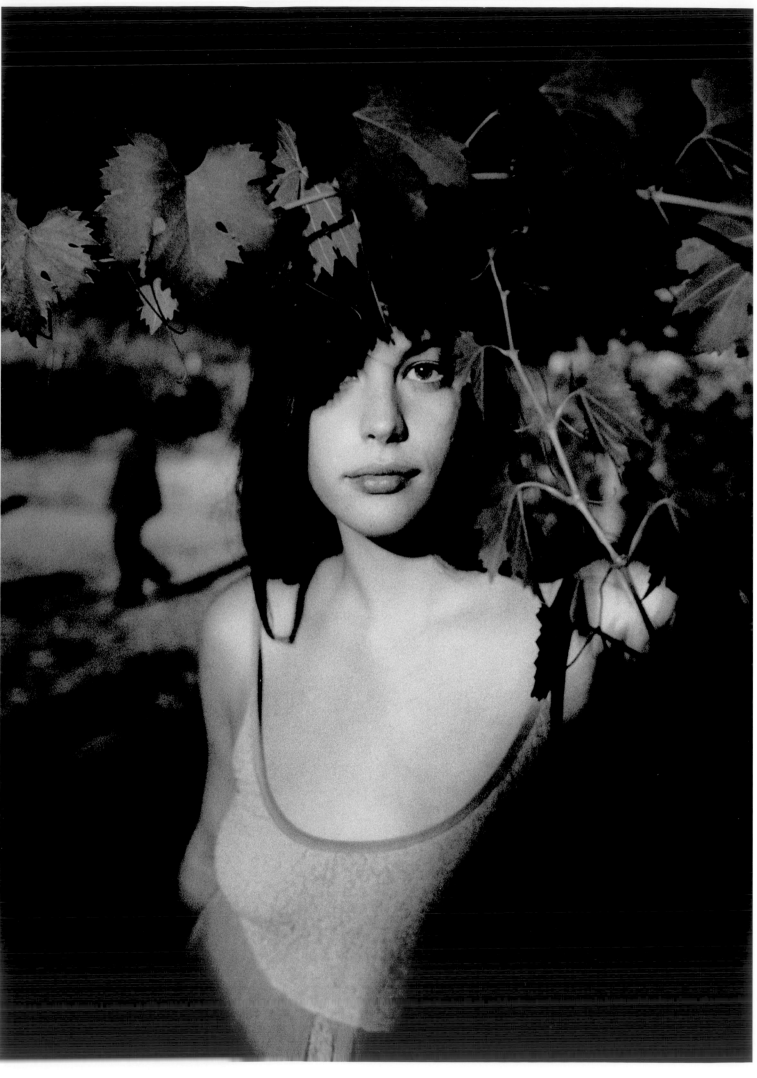

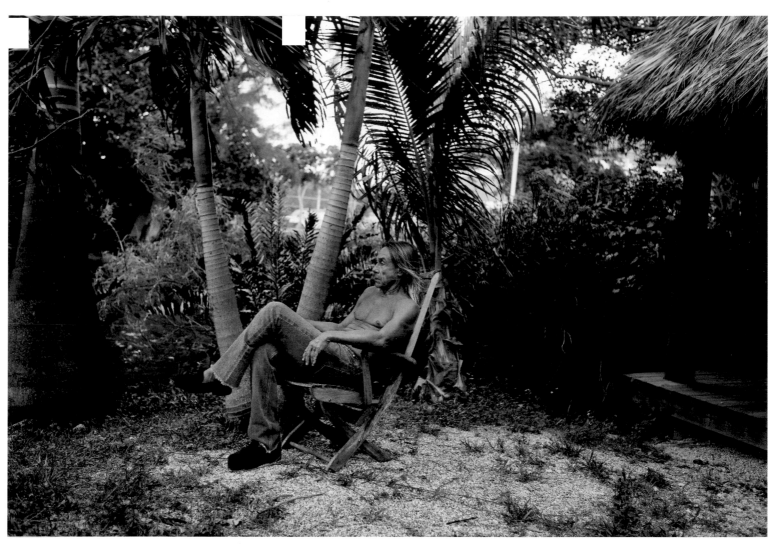

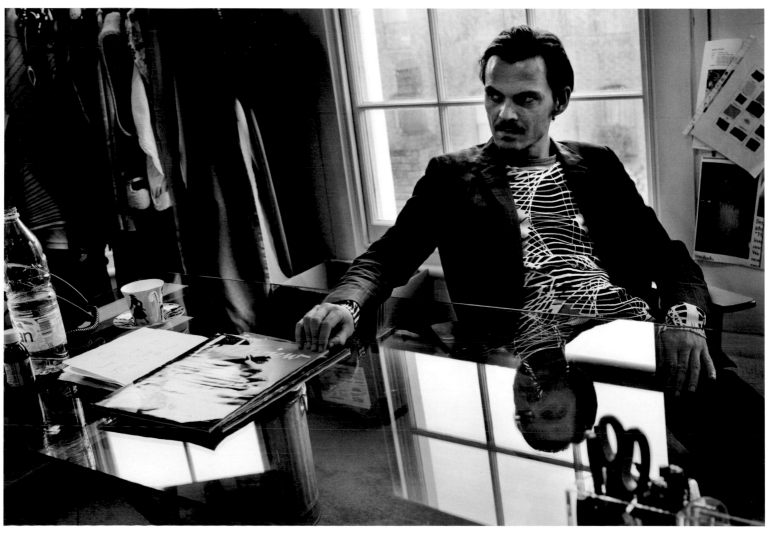

KODAK 5063 TX 13 KODAK 5063 TX 14 KODAK 5063 T
12A 8 13A 9 14A

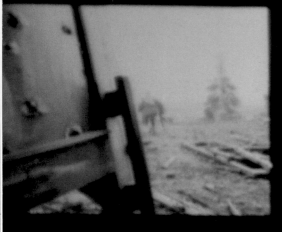

7A 8 8A 9 9A
KODAK 5063 TX 3 KODAK 5063 TX 4 KODAK 506

3 3A 4 4A
AK 5063 TX 00 KODAK 5063 TX

00

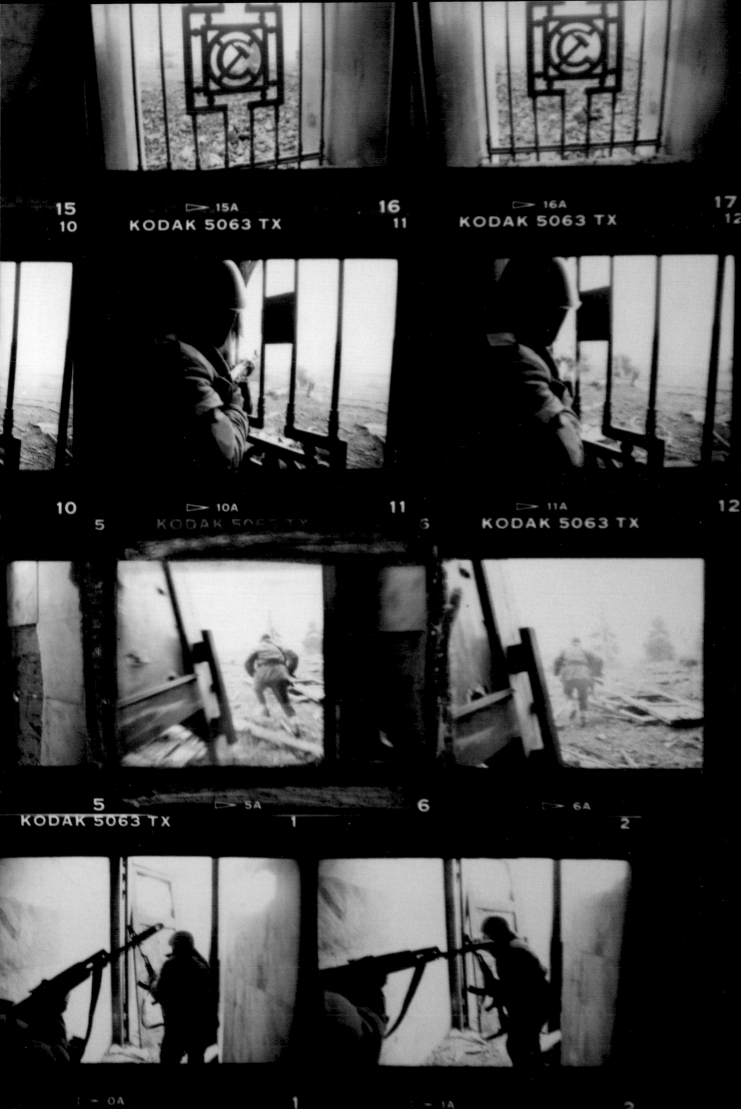

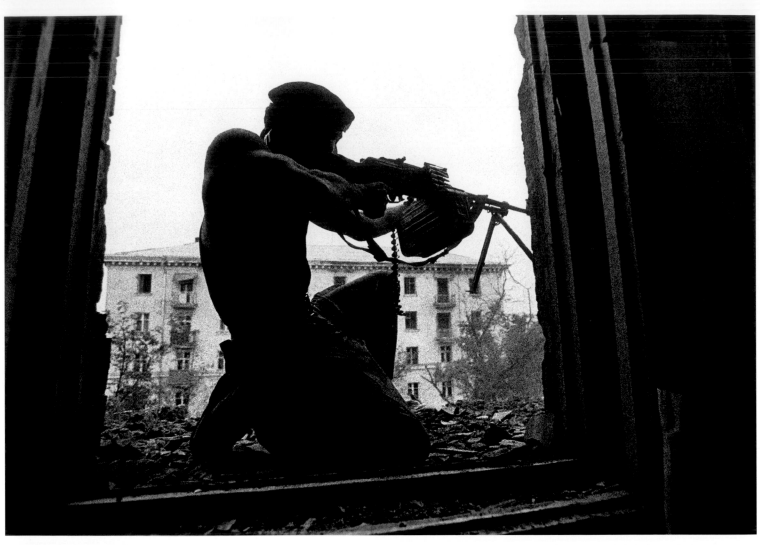

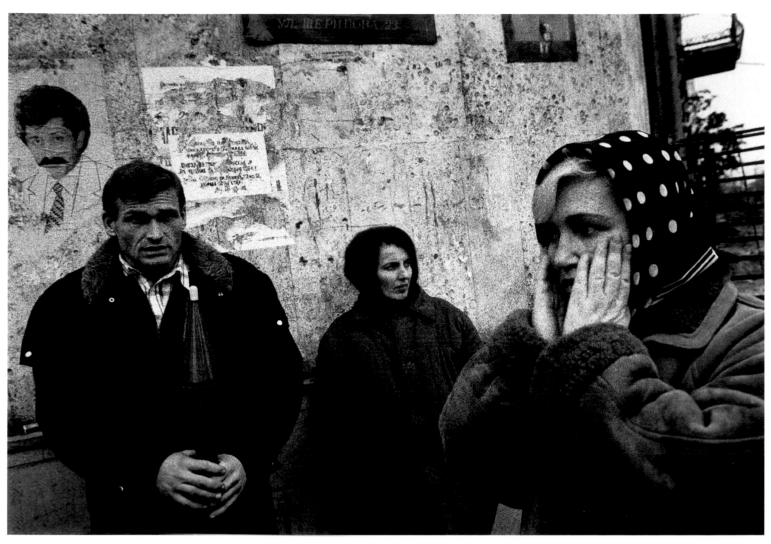

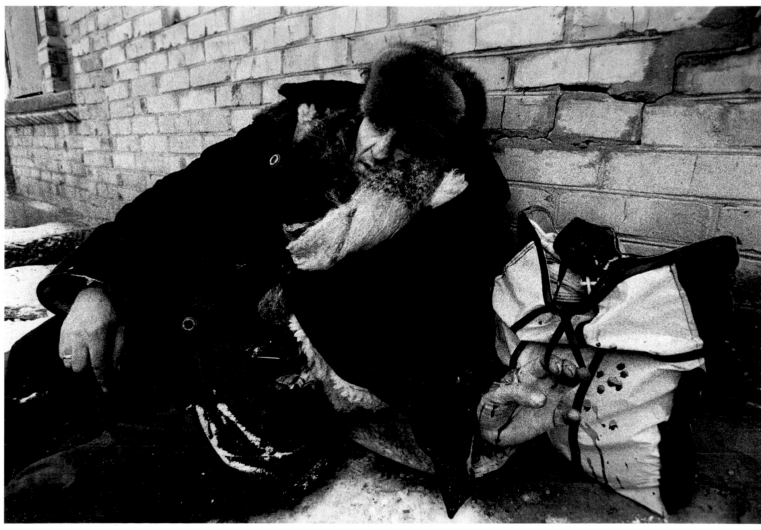

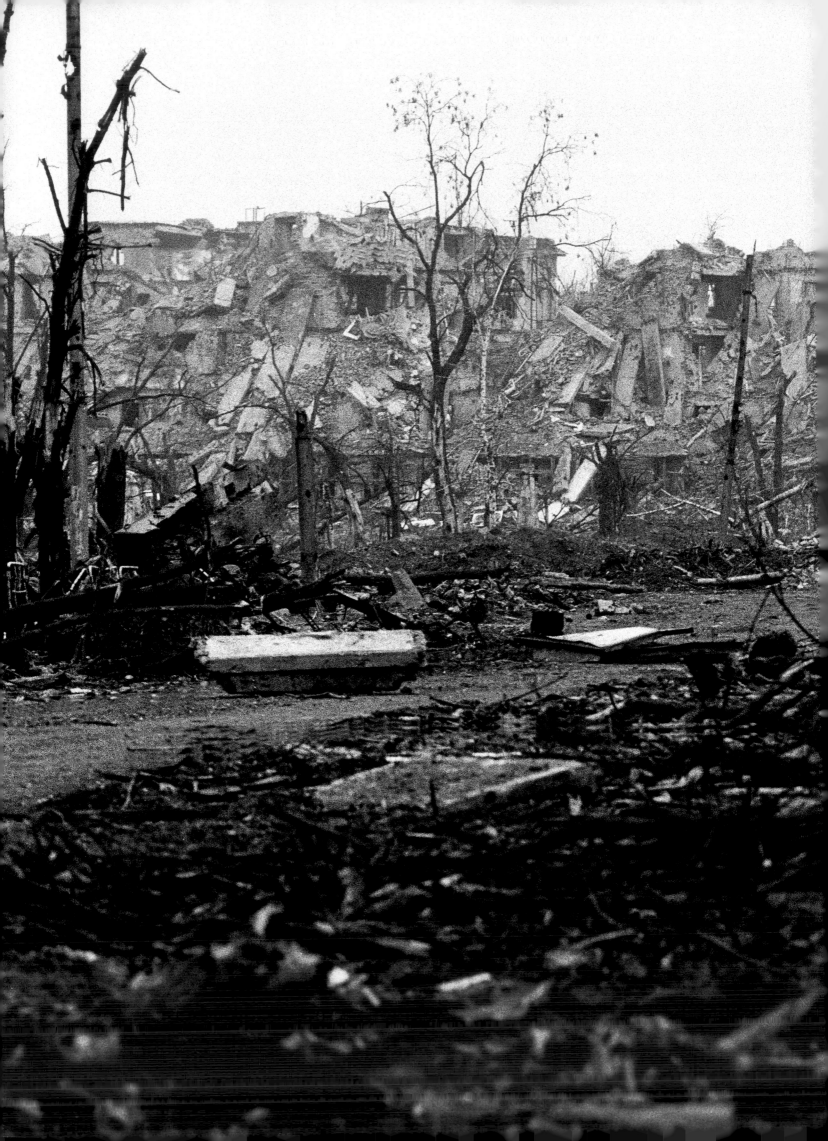

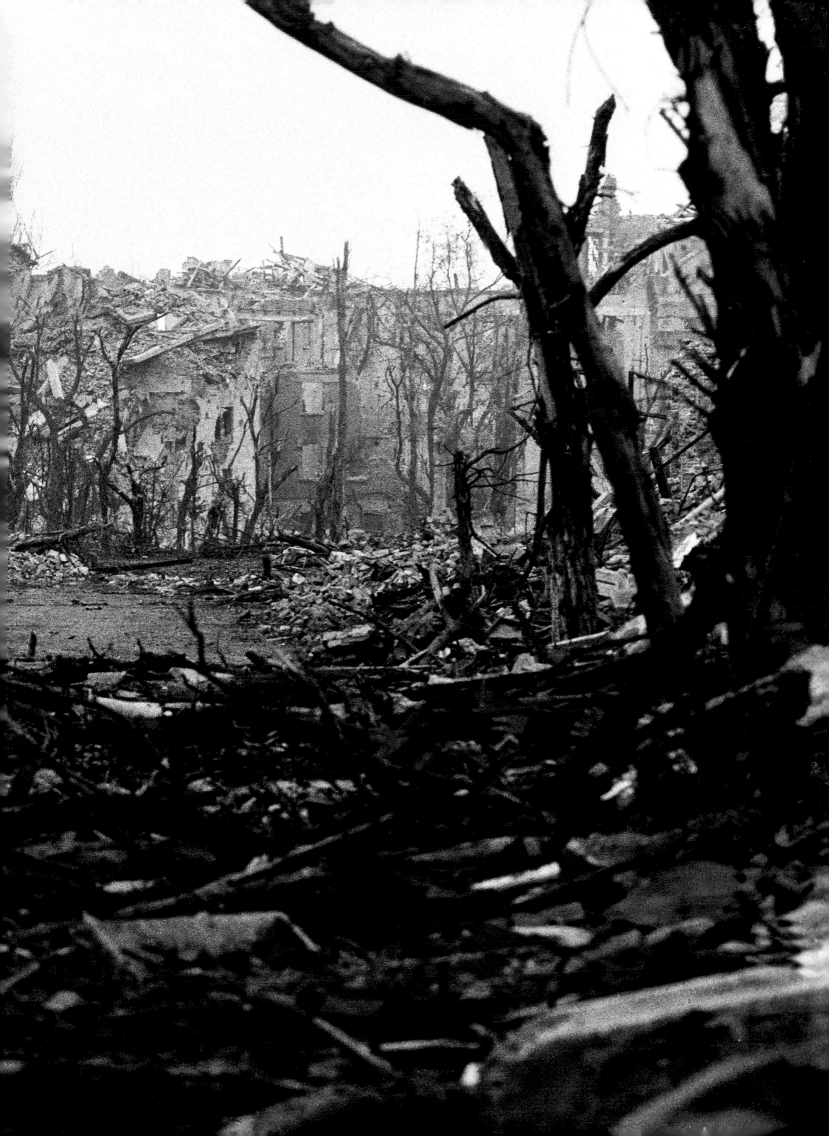

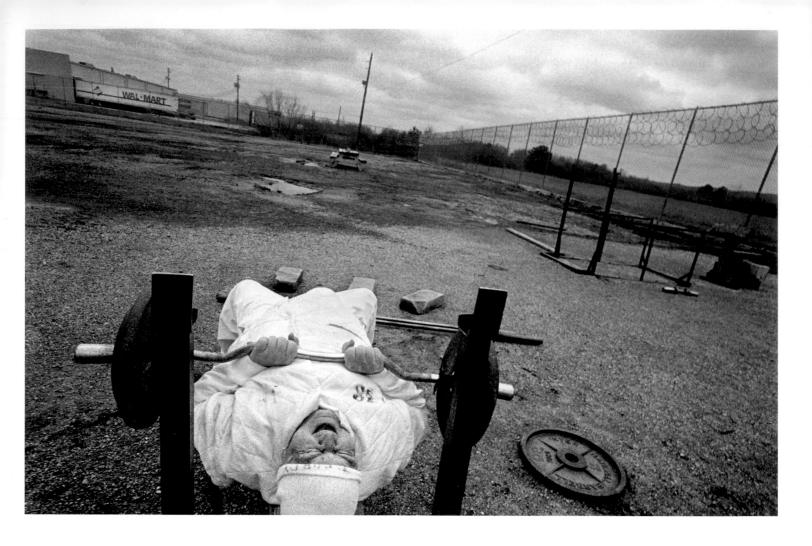

1997–2001
AGEING IN AMERICA
ED KASHI

Ranging from geriatric incarceration, to vitality in ageing, love and loss, and reinvention in retirement, these images aim to challenge the western culture of ageing. A rallying call to our elders-to-be to consider what kind of world we want to live in, there is a common responsibility among us all to remake this society in the image we desire for ourselves. Ed Kashi's sequence of photographs inspires us to learn more, prompts us to get involved and creates a chance to step back from our frenetic lives, slow down and take a moment to reflect on how we can make a difference for ourselves and our elders. Throughout several years of travel across the United States, Kashi and his wife, writer/filmmaker Julie Winokur, have collected scores of personal histories that, when seen collectively, challenge the culture of ageing in America. These images are a journey across the topography of ageing, investigating the truth of what it means to attain 'a good old age'. Negotiating the experience of our elders, from the 'wellderly' to the elderly, we are provided with a series of intimate vignettes of people who are living the new old age.

Truman Purdy, 61, lifts weights in the Hamilton Aged and Infirmed prison exercise yard in Alabama, 1997. His 25-year sentence for sexual abuse and sodomy began in 1992. Over time, older inmates become more of a medical burden than a security risk, costing the state three times more than younger inmates.

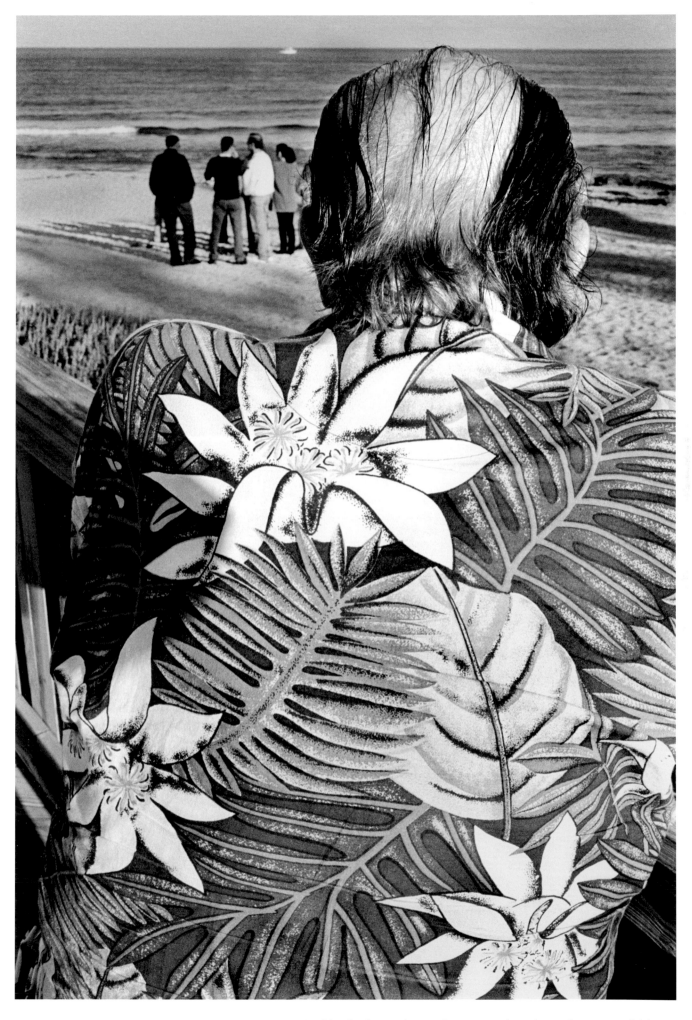

An older Floridian resident watches a group of people socializing at Deerfield Beach, Florida, 2001.

Above. Gerald Gross and Ricky Caminetti fell in love in their eighties. She refused to sleep with him before they got married, so he proposed within a week of their first date. Their wedding, in Miami, Florida, 2000, was attended by over 200 guests.

Below. A senior citizen plays the slot machines at a casino in Reno, Nevada, 2000. For the first time in history, as people grow older, they are gambling more. With free time to fill and heightened social needs, the elderly have become easy prey for the gaming industry.

Above. Thanks to daily visits from On Lok health workers, Isaac Donner, 100, lives alone in a single-room occupancy hotel, San Francisco, 1999.
Below. Virginia Magrath watches as her husband's body is taken away by funeral home staff after his passing in the On Lok hospice in San Francisco, 1999.

Overleaf. Surrounded by family, friends and hospice aides, Maxine Peters passes away at home in Gladesville, West Virginia, 2000. The Hospice Care Corporation sends health workers into rural homes to make sure that people can meet a dignified end, surrounded by their families.

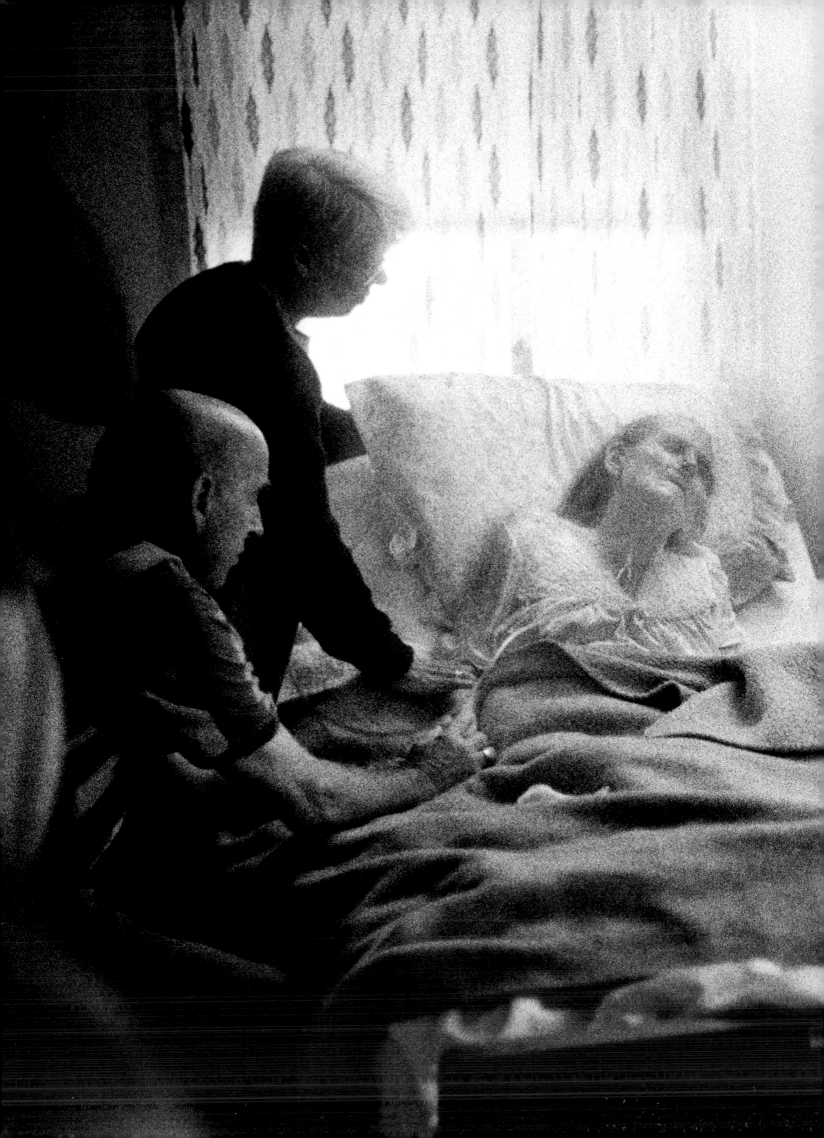

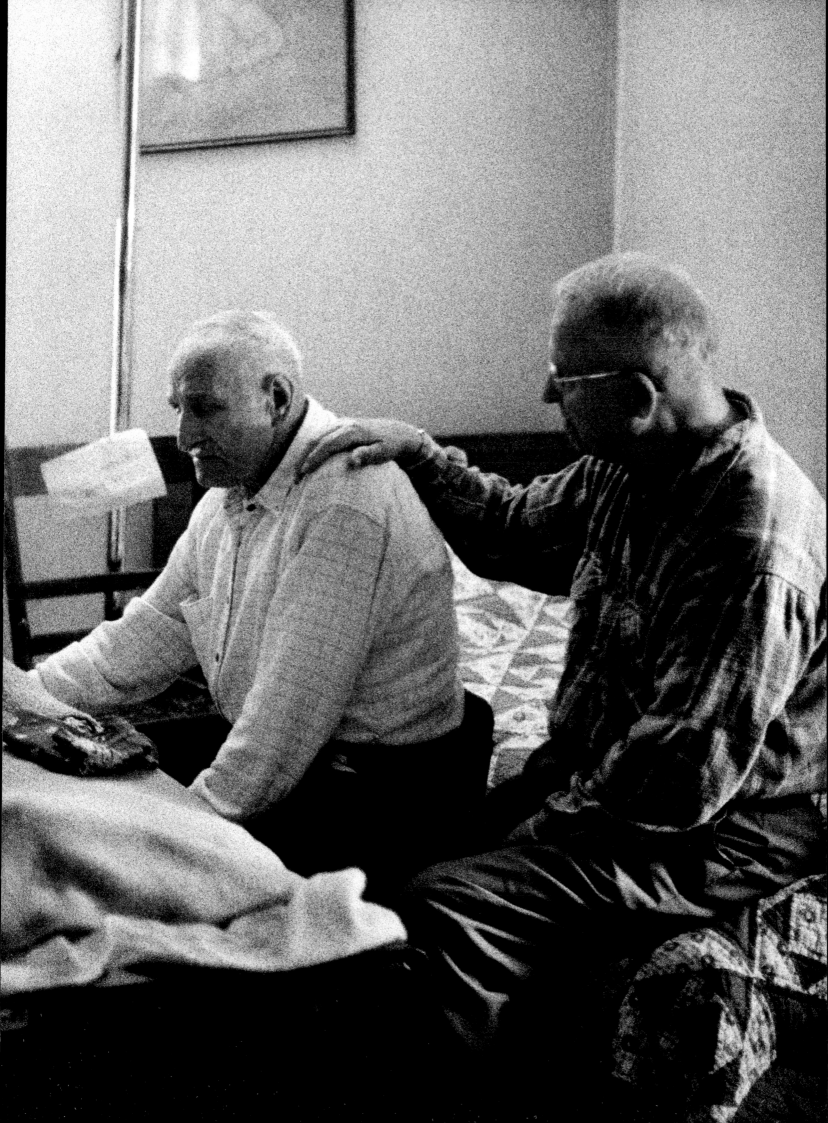

1997—2000
THE ALBANIANS
JOACHIM LADEFOGED

Joachim Ladefoged documented the history of the Albanians during
a critical period, from 1997 to 2000. The poorest country in Europe,
Albania was one of the last to emerge from communism and in only
two years made the difficult and rapid transition into a multi-party
democracy. With the collapse of the economy in January 1997,
widespread rioting and looting broke out. The military was helpless
as army supplies were plundered. Many weapons were smuggled
into neighbouring Kosovo, a majority Albanian province in southern
Serbia, to the 2 million ethnic Albanians living under the tyranny
of Slobodan Milosevic. The volatile mixture of ethnic conflict and
fresh supplies of weapons gave birth to the guerrilla army known
as the Kosovo Liberation Army. NATO's bombing of Kosovo in 1999
caused a mass exodus of around 850,000 ethnic Albanians. On
their return to Kosovo in mid-1999, many sought revenge, killing
innocent and aged Serbs who had had no connection with the war.

Albanian school children, in 2000, look out of a window in which is reflected the
Serbian part of Kosovska Mitrovica, a city in northern Kosovo badly damaged
during the 1999 Kosovo War.

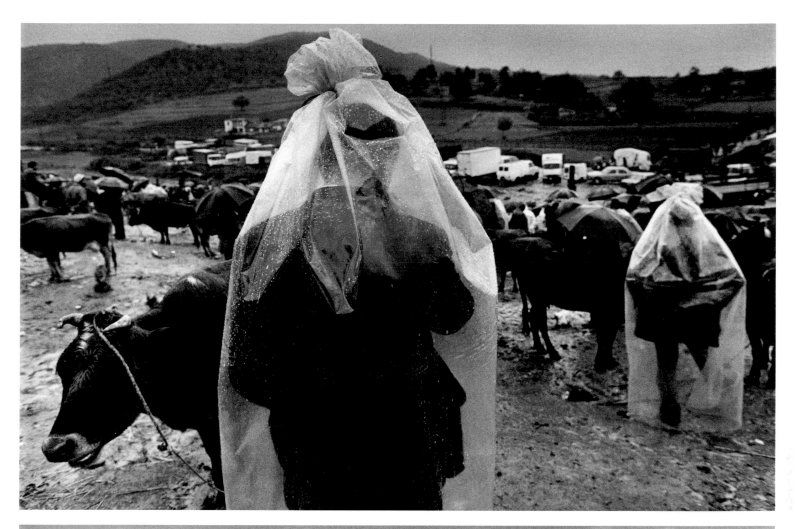

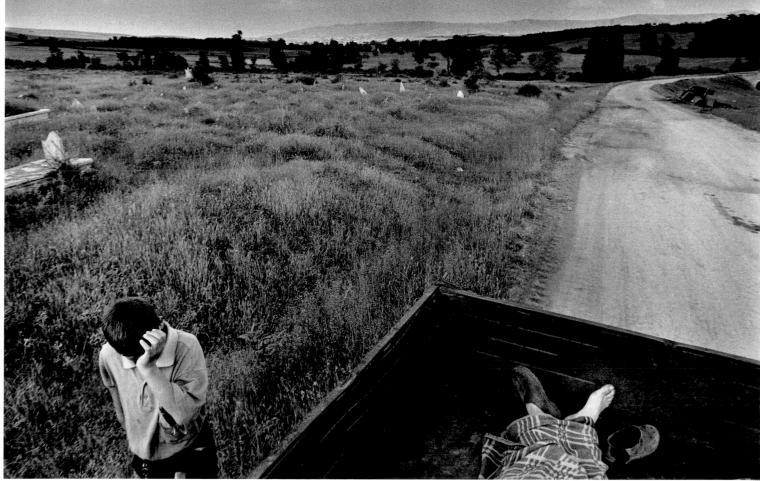

Above. Farmers examine cattle in the pouring rain at a large cattle market in a field somewhere between Lushnje and Berat, Albania, October 1997.

Below. The youngest brother of two young Albanian men cries as he accompanies the wagon that carries their bodies to their funeral, Kosovo, June 1999. The brothers were buried within four hours of their death, caused by a mine that detonated while they were herding the family's cattle.

Joachim Ladefoged – The Albanians 53

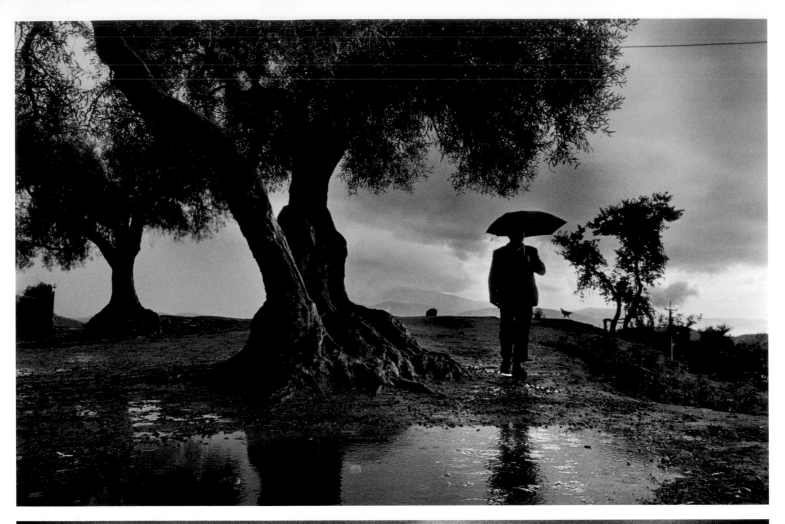

Above. A man stands with an umbrella near a tree in Albania, October 1997.

Below. A young Kosovo Albanian boy dives into an artificial lake outside Gnjilane, southeastern Kosovo, June 1999.

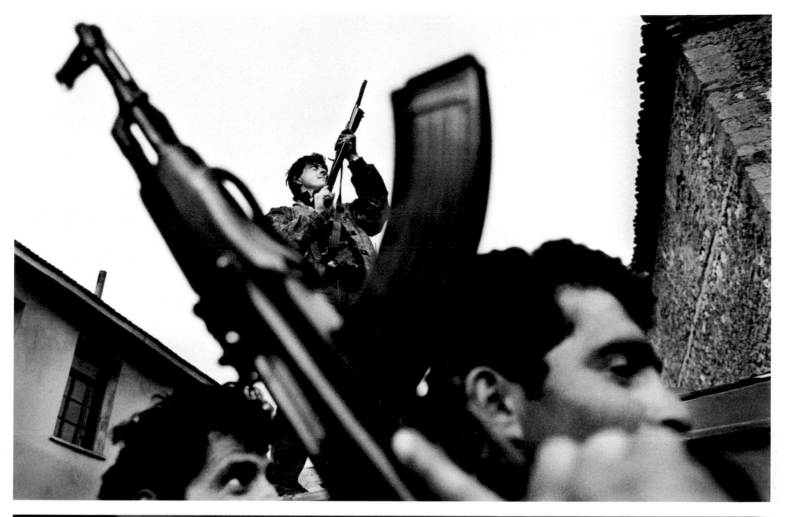

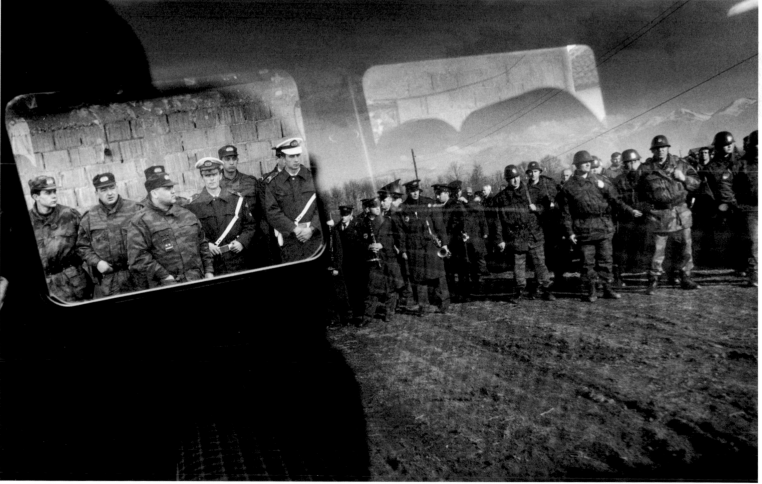

Above. In April 1997, a new, heavily armed police force patrols the streets in the regional capital of Vlore, Albania. The old police were forced out in early January. **Below.** Serb police and military attend the funeral of a fellow policeman, killed by unknown people in Djakovica, western Kosovo, in February 1999.

Overleaf. Children protect themselves from grit and dust swept off the ground by wind whipped up by French Army helicopters, in Kukes, northeast Albania, April 1999.

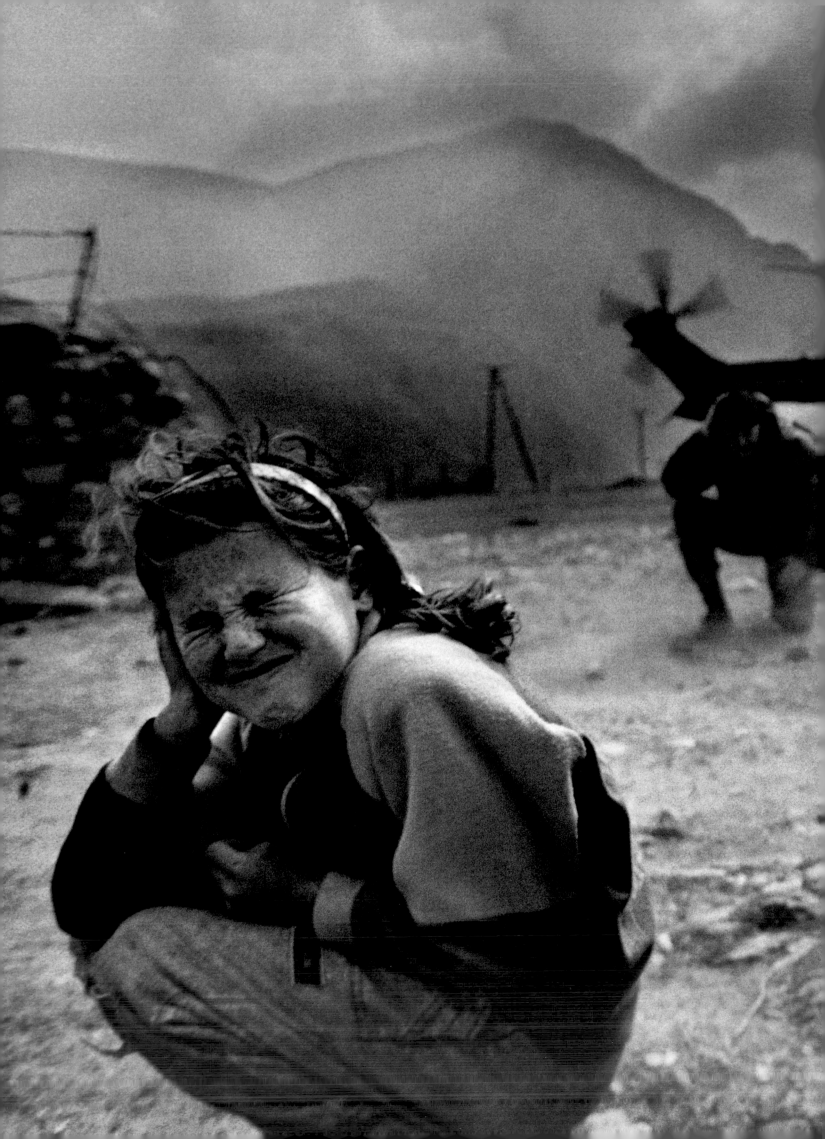

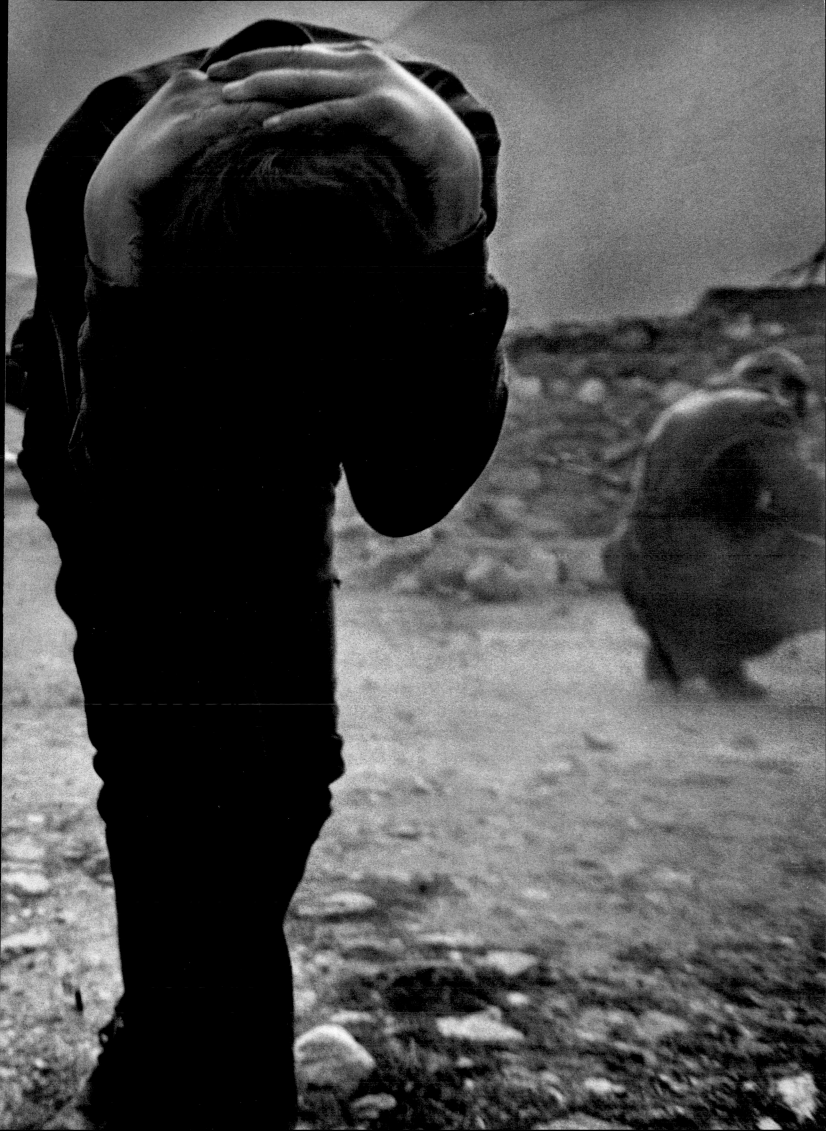

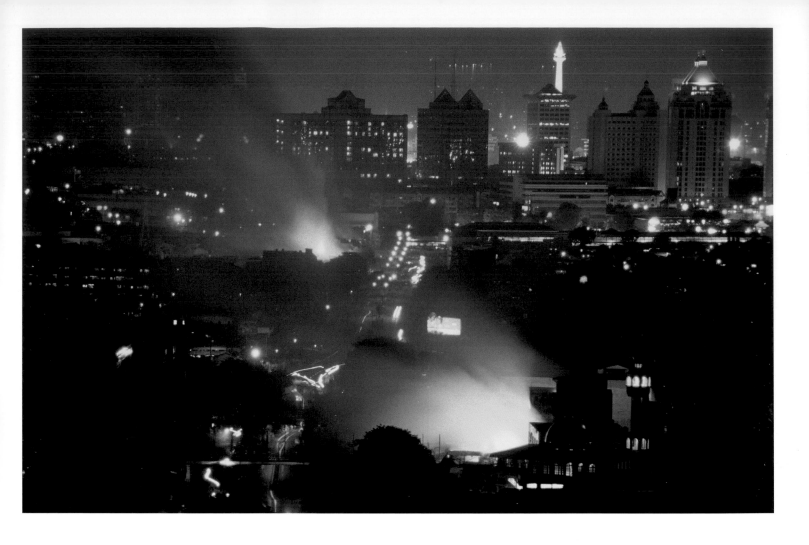

1998—1999
INDONESIA'S DEMOCRATIC TRANSITION
JOHN STANMEYER

What started in early 1998 as a simple demonstration by students on the streets of Jakarta in Indonesia, triggered by the continuing financial crisis across the region, led a year later to the fall of President Suharto, after more than 30 years of rule. Historically, Indonesia has always been an unstable nation, with ethnic tensions causing violent upheavals. Since Suharto grabbed power in 1966, a ruthless government maintained unity of the island archipelago through restricting civil liberties, engendering fear and committing human rights violations. Today, Indonesia continues to learn about democracy, correcting the mistakes of the Suharto era and – in emulation of the Four Asian Tigers of Hong Kong, Singapore, South Korea and Taiwan – hopes to regain its stature as one of Southeast Asia's Tiger Cub economies.

In May 1998, Jakarta, the capital of Indonesia, burns as the Asian financial crisis grips the country and protestors take to the streets calling for President Suharto to resign.

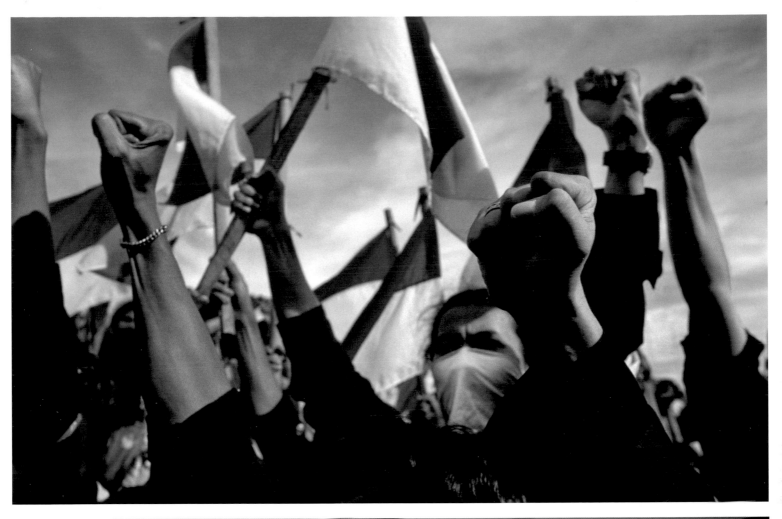

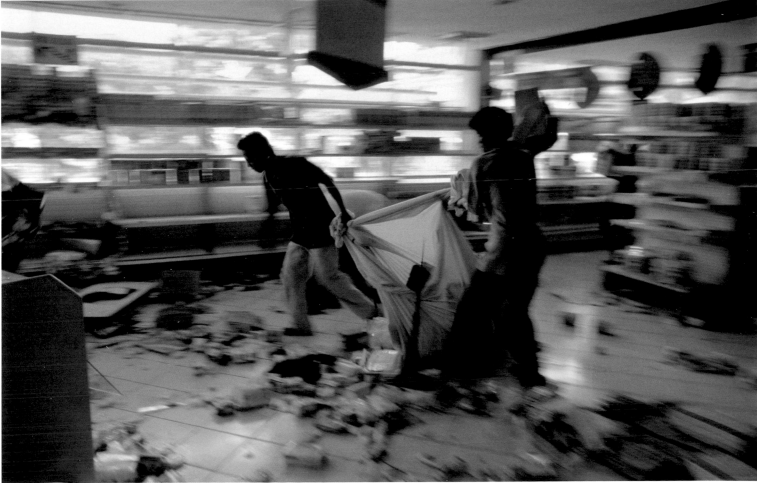

Above. In May 1998, a group of students unite in anger after taking over the parliament building just hours before President Suharto resigned.

Below. Looters ransack a supermarket during riots against President Suharto's regime in May 1998. As the Asian financial crisis grew more harsh, people were no longer able to afford food.

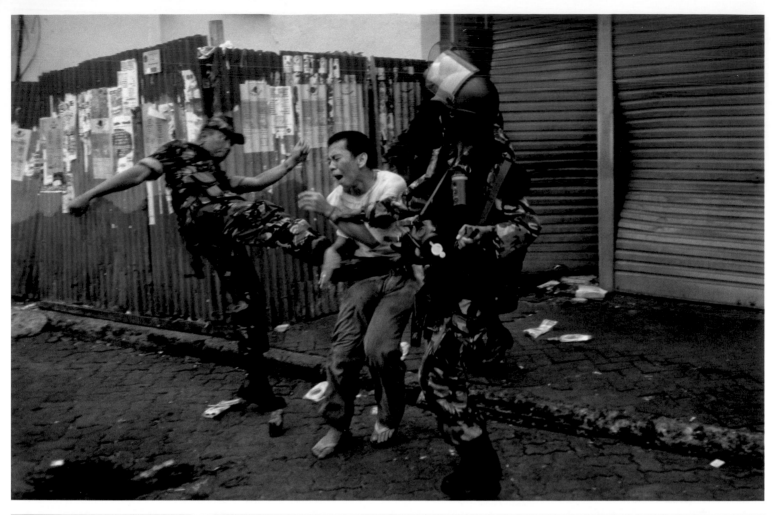

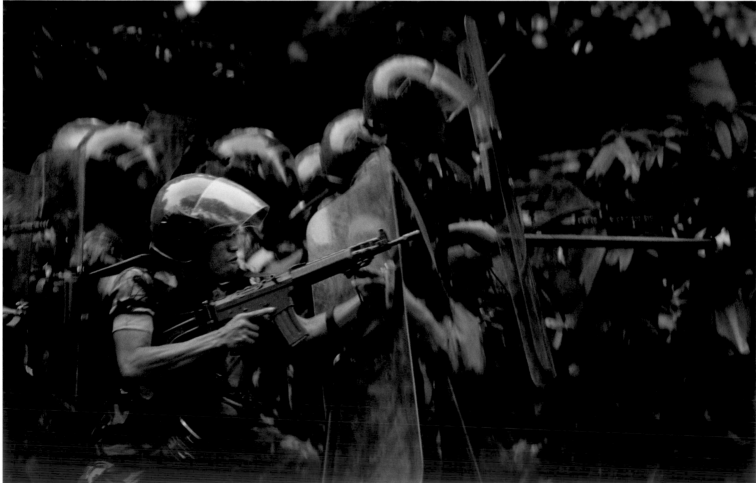

Above. As riots and looting break out across Jakarta in May 1998, following calls for President Suharto to step down, military police move in to try and restore order, using their full force to clamp down on looters and protestors.

Below. On 13 November 1998, police open fire on demonstrating students in central Jakarta, killing at least 15 and injuring hundreds. Thousands of students were calling for immediate free elections and were opposed to President B. J. Habibie, Suharto's successor, running for re-election.

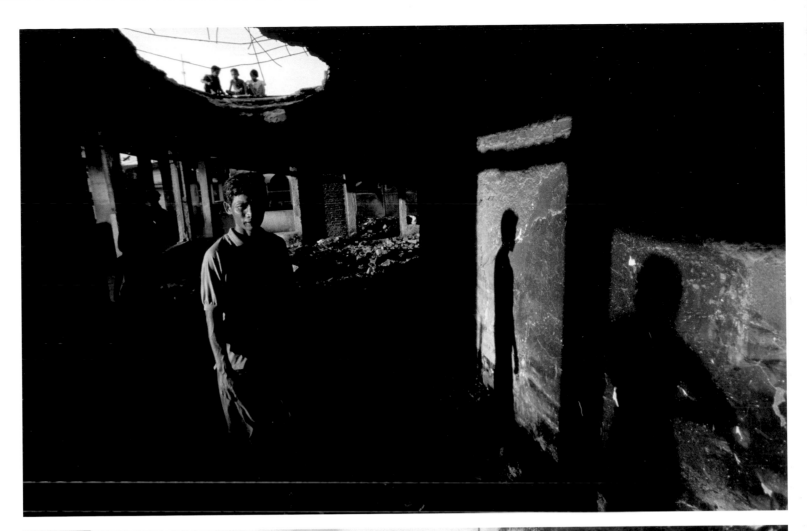

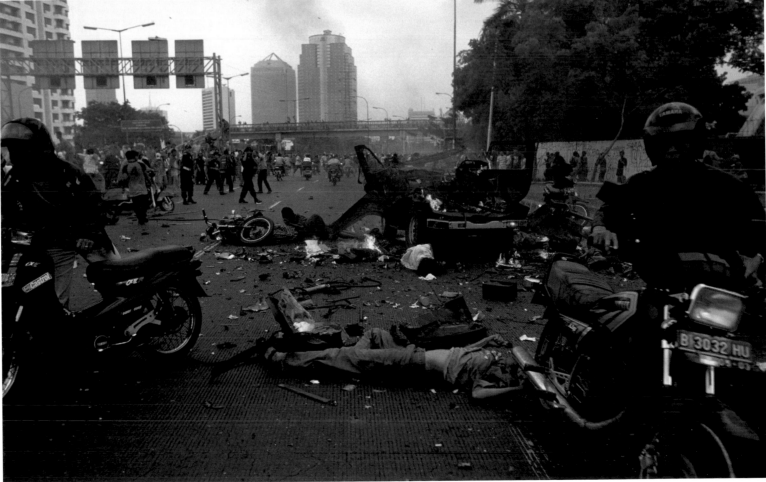

Above. In March 1998, economic hardship on the island of Sulawesi forces people to seek out shelter wherever they can. Conflicts between Muslims, Chinese Buddhists and Chinese Christians exacerbate the problem.

Below. A car bomb near Jakarta's parliament building kills supporters of Abdurrahman Wahid (Gus Dur) on the eve of his appointment as Indonesia's first elected president in October 1999.

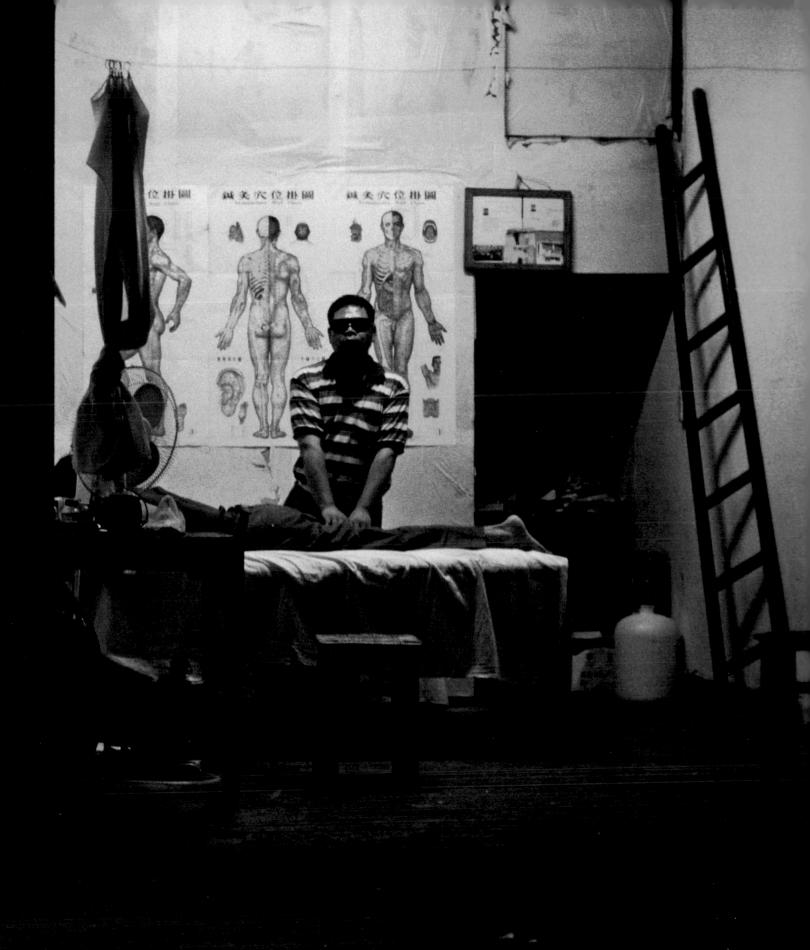

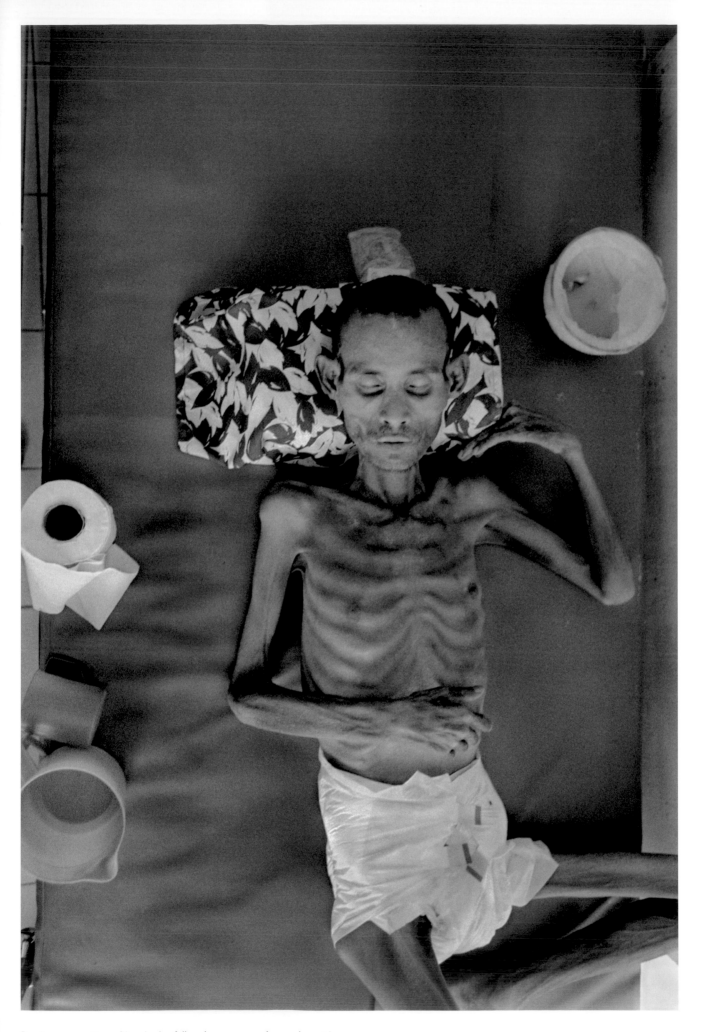

Previous page. One of hundreds of illegal massage parlours, alongside one of the last remaining blind masseurs, in Ruili, Yunnan, a town on China's border with Burma, 2000. HIV/AIDS runs rampant in this wild border town.

Above. A man dying of AIDS at a hospice in Lop Buri, Thailand, 1999.

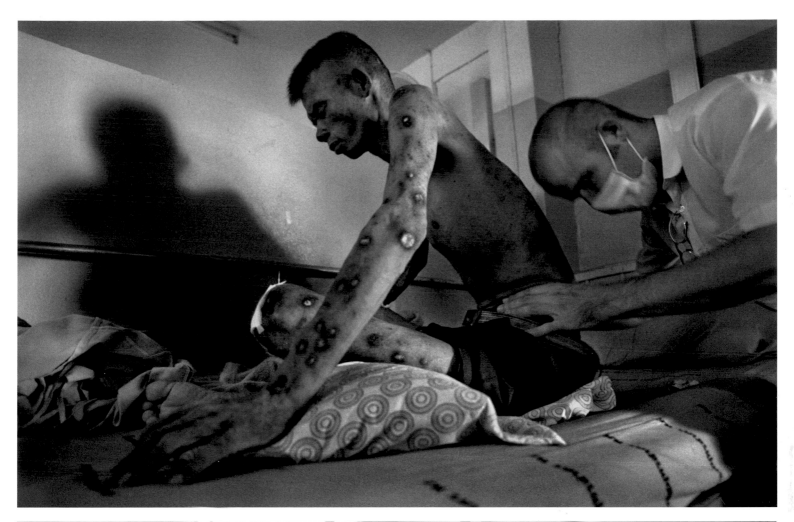

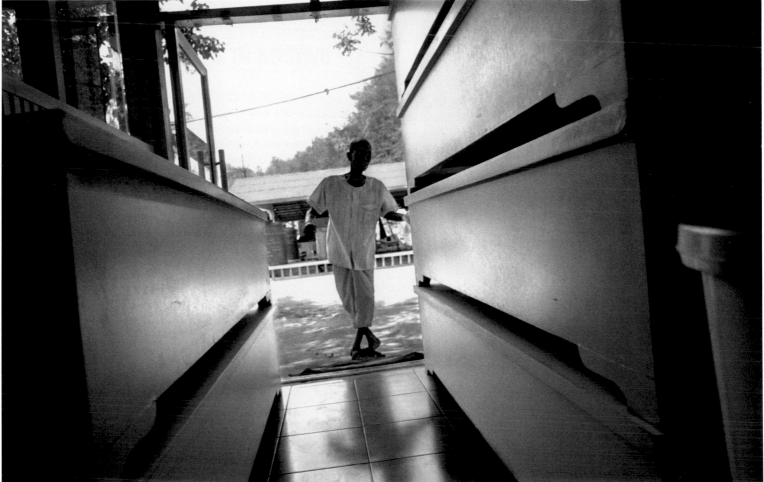

Above. A volunteer massages a man who is in the advanced stages of AIDS at a hospice in Lop Buri, Thailand, 1999. Although Thailand is one of the few developing countries with an effective public policy against the spread of HIV/AIDS, over half a million people still live with the virus.

Below. A passageway lined with coffins greets all those visiting and living in a special AIDS hospice, formerly a Buddhist temple, in Lop Buri, Thailand, 1999.

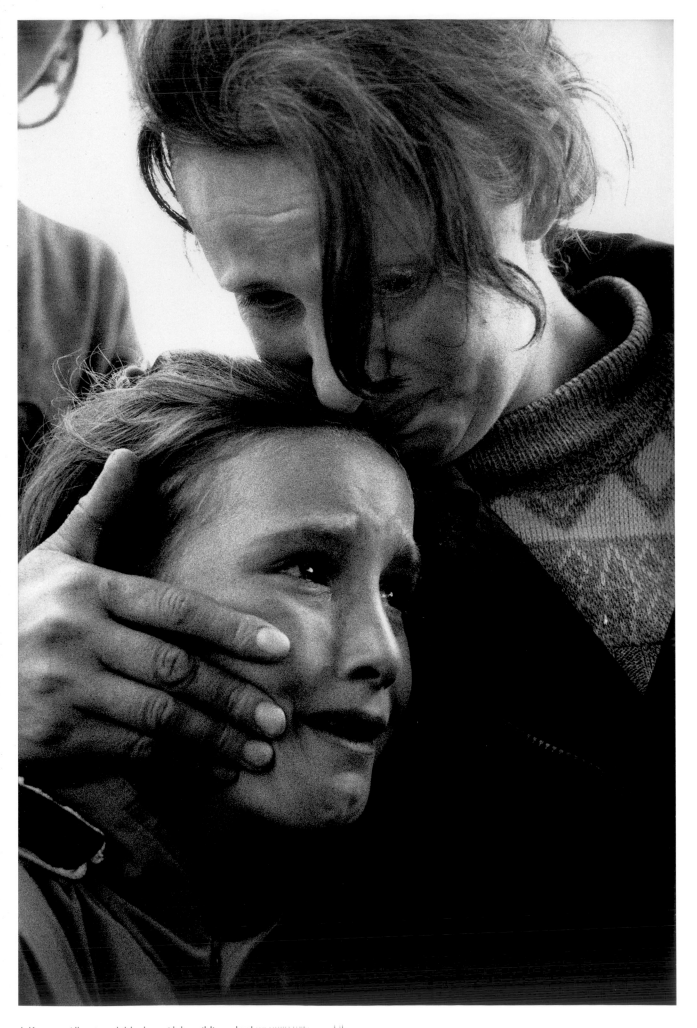

A Koșovar Albanian child who, with her siblings, had recently witnessed the execution of her father by Serb paramilitaries in the village of Meja, southwest Kosovo, near the border with Albania.

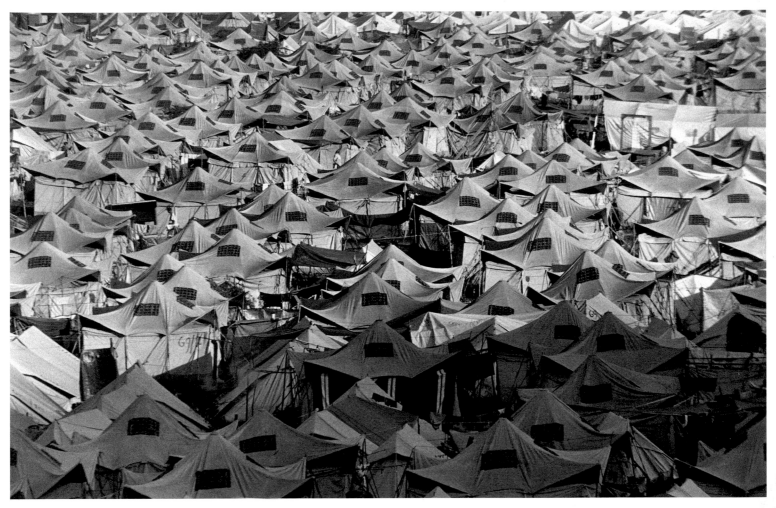

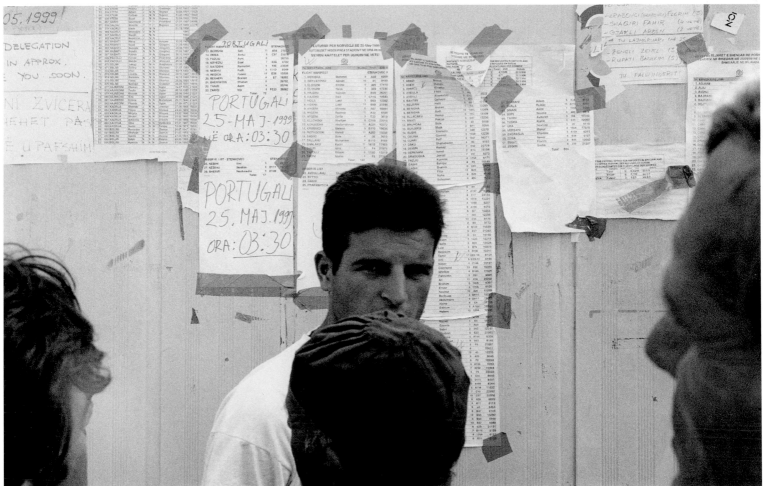

Above. The refugee camp at Cegrane, northwest Macedonia.

Below. At Cegrane refugee camp, Kosovar Albanians search for the names of families and friends on lists of refugees who have been granted asylum in other countries.

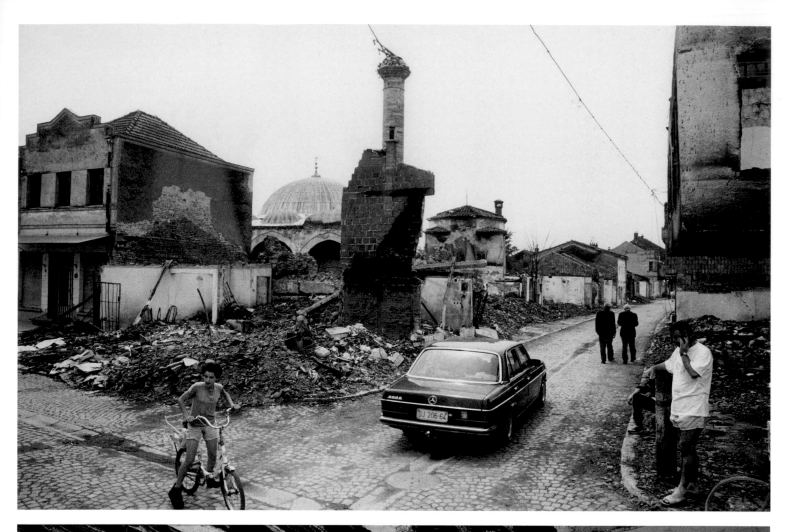

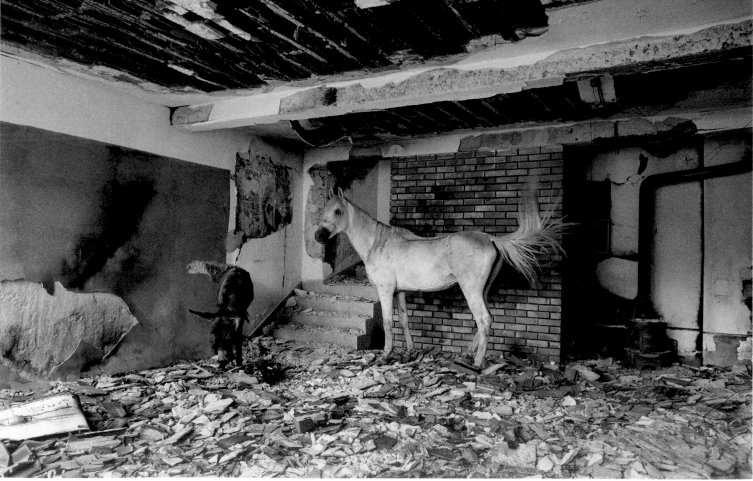

Above. The old centre of Dakovica, a city in western Kosovo, levelled by Serb forces shortly after the start of the NATO bombing campaign.

Below. A former shop in the Albanian quarter of Pec, a town in western Kosovo.

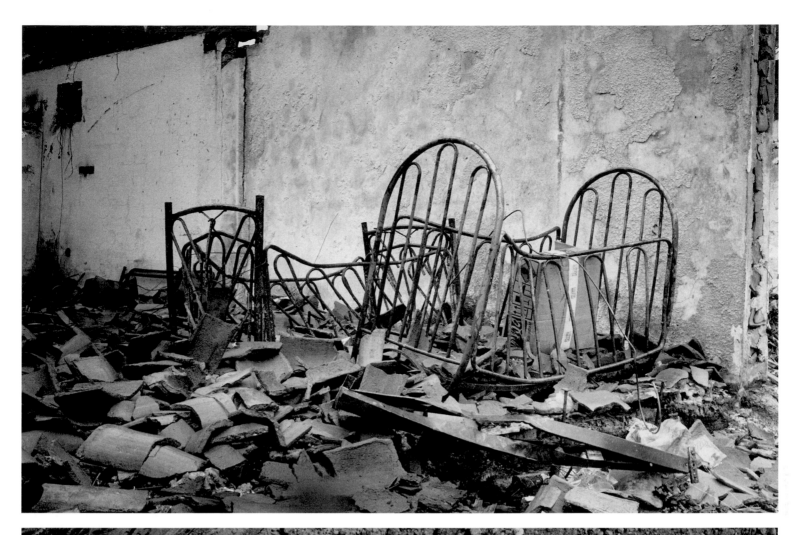

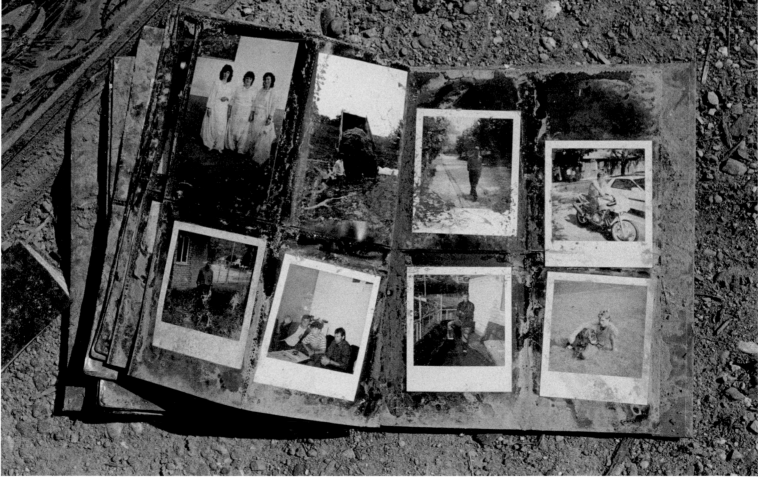

Above. The remains of a house in the old centre of Dakovica, wrecked by the Serb military.

Below. A photo album found outside a burnt house belonging to Kosovar Albanians in the village of Velika Krusa, southwest Kosovo.

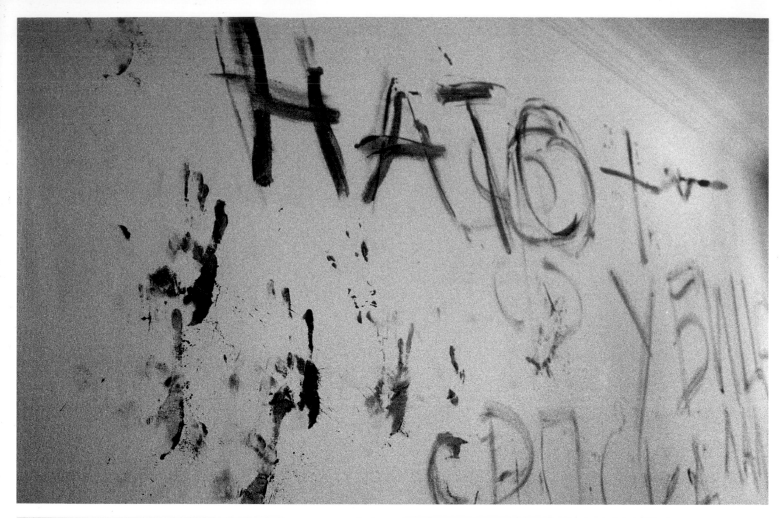

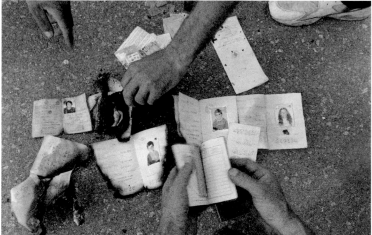

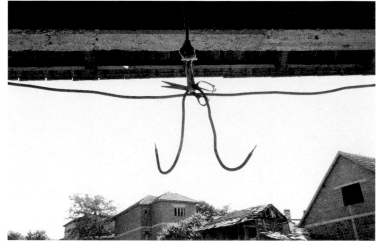

Above. A house in the Albanian district of Pec, western Kosovo. Neighbours claim that Serb paramilitaries from the 'Frankie's Boys' unit murdered several Kosovar Albanians here and daubed anti-NATO slogans on the walls with their victims' blood.

Left. ID cards and passports of Kosovar Albanians in Meja, southwest Kosovo, presumed to have been executed by Serb paramilitaries.
Right. Meat hooks hang in a farmhouse in Velika Krusa, northwest of Prizren, Kosovo. Investigators believed that the basement was used for interrogations.

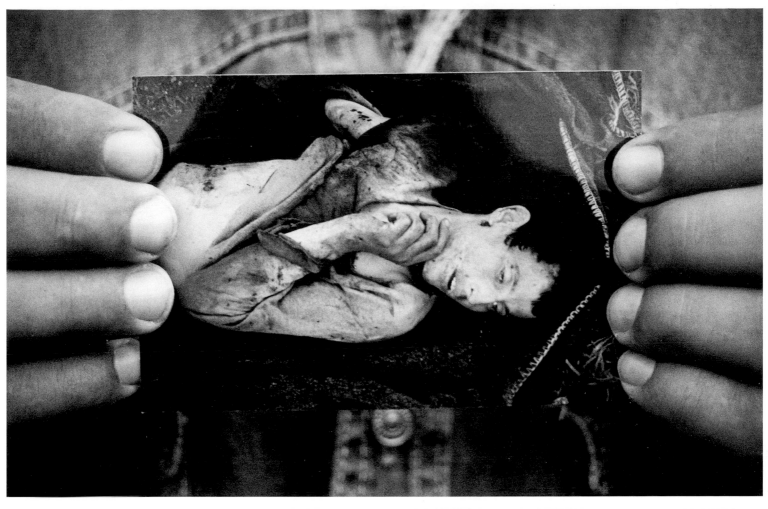

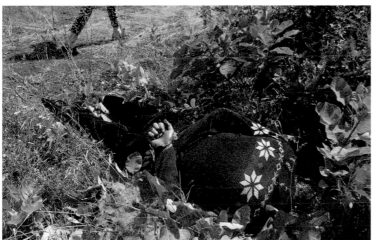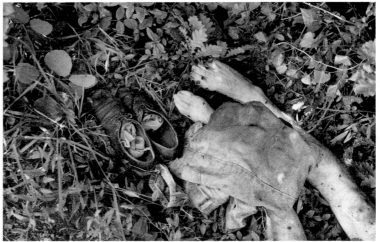

Above. Habib Zogaj, a resident of the village of Turjak in central Kosovo, holds a photograph that he took of a young Kosovar Albanian, one of many he says was executed by Serb military police in his village on 31 March and 8 April 1999.

Left and right. The bodies of two recently executed men lie by the side of a track near the village of Xrce, Kosovo. They were killed a few days after the NATO Kosovo Force (KFOR) peacekeepers arrived. Their identity and ethnicity is unknown.

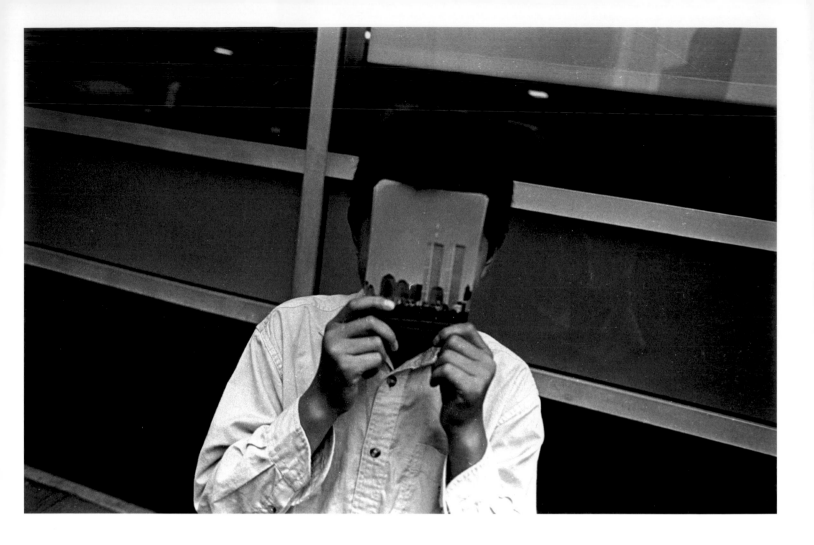

2001
9/11
ANTONIN KRATOCHVIL

On this day the world changed forever. Two hijacked aeroplanes crashed into the Twin Towers of the World Trade Center in New York on 11 September 2001, killing everyone on board the planes, thousands at work within the buildings and, subsequently, rescuers responding to the carnage. Another plane was crashed into the Pentagon in Washington, DC, and another into a field in rural Pennsylvania. Approximately 3,000 people (including 19 hijackers) died in the coordinated suicide attacks orchestrated by Al Qaeda. It was, in the words of photography commentator Peter Howe, one of those singular events when 'everyone who lived through that day remembers where they were when they heard the news. [It was] the culmination of decades of misunderstanding and resentment between different cultures and religions, and at the same time [it] marked the beginning of the response of President [George W.] Bush's administration and others in the western democracies.' During the days following the deadliest terrorist attack on US soil, Antonin Kratochvil documented the devastating aftermath.

Near the obliterated World Trade Center site that became known as Ground Zero, a Korean street vendor sells photographs of the Twin Towers, New York, 20 September 2001.

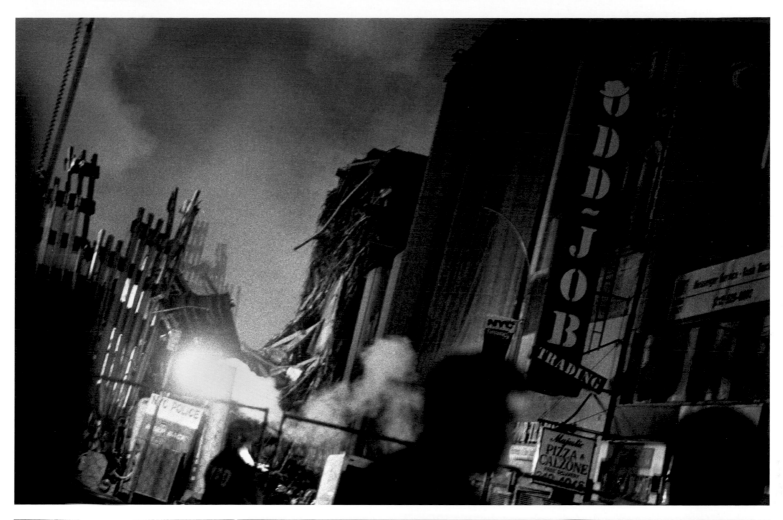

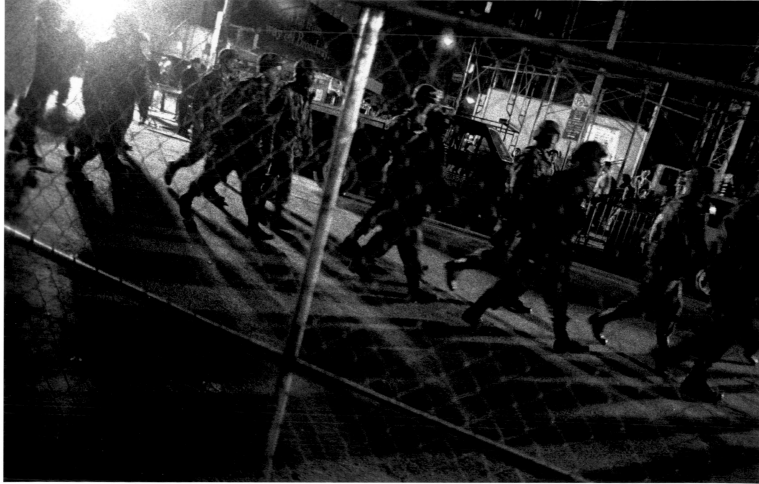

Above. A night view of the destroyed World Trade Center site, called Ground Zero after the September 11 attacks, New York, 17 September 2001.

Below. Citizen soldiers of the National Guard keep watch over Ground Zero, New York, 17 September 2001.
Overleaf. People on the Staten Island Ferry observe the much-altered skyline of Manhattan, New York, 18 September 2001.

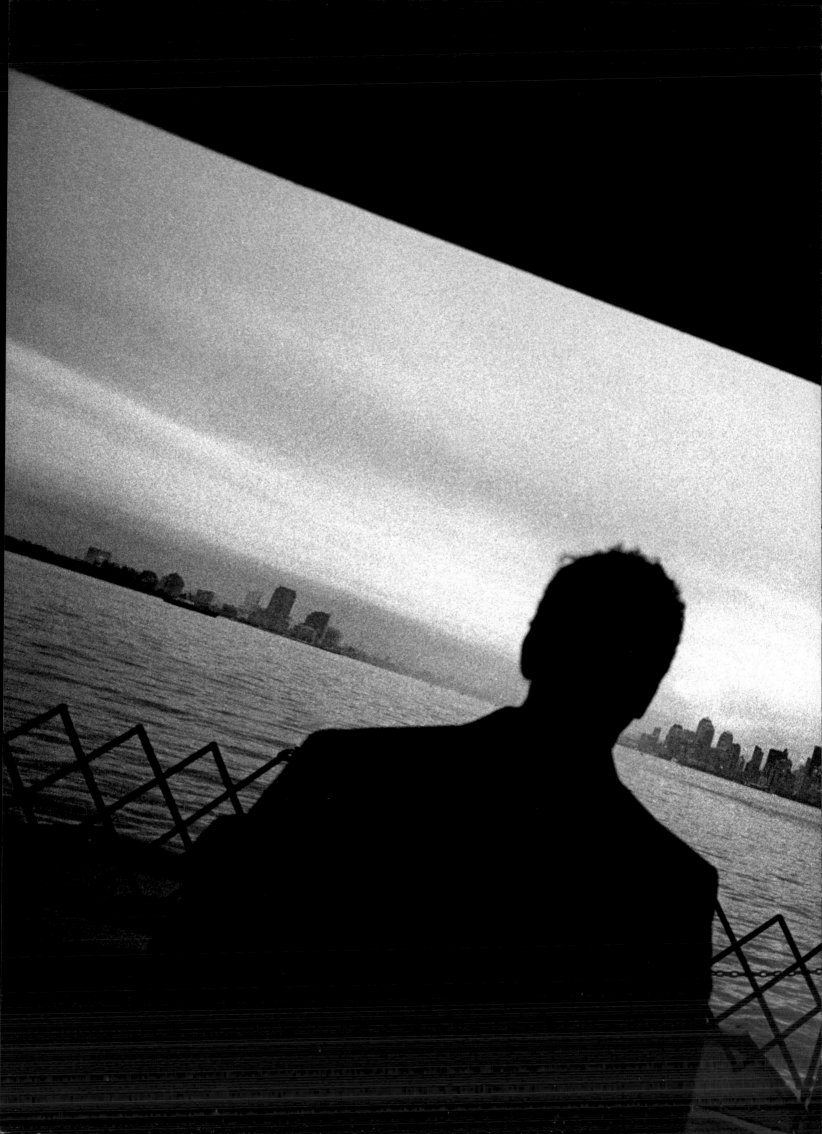

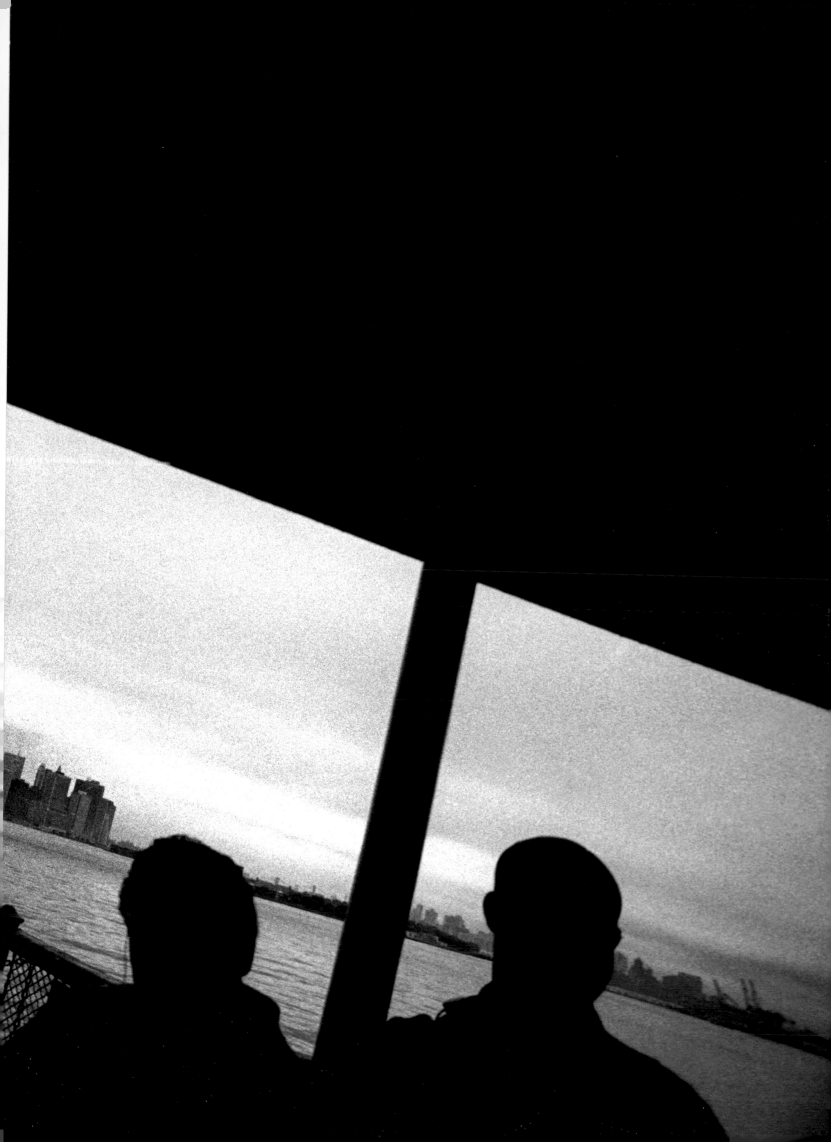

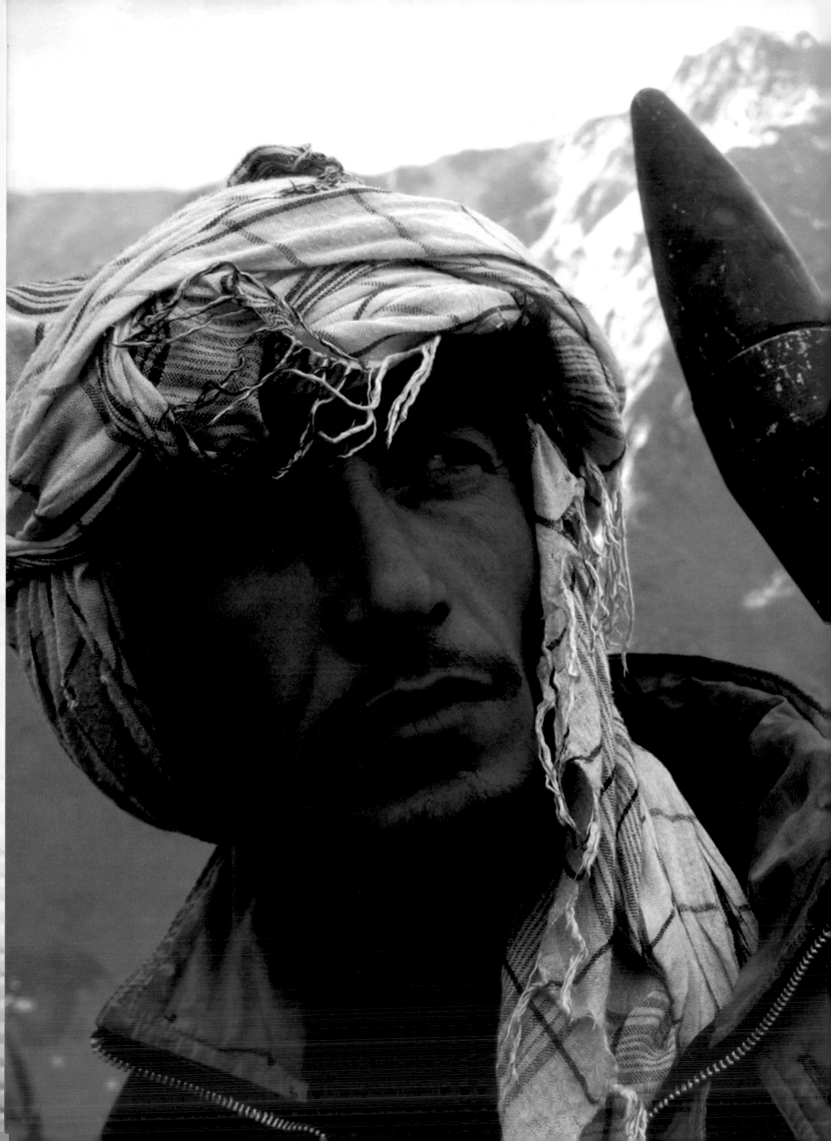

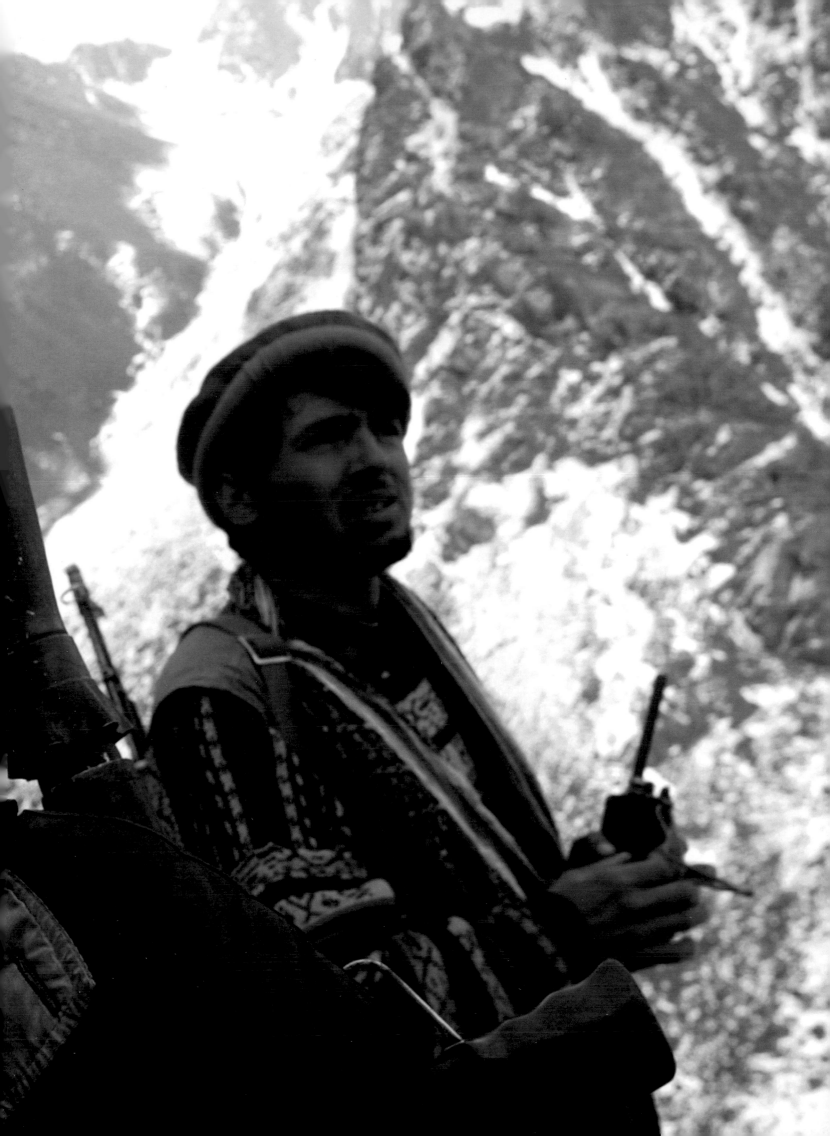

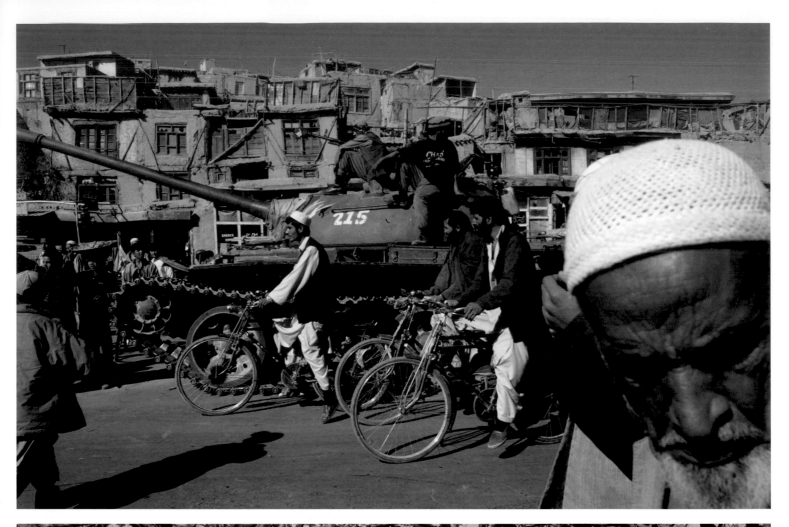

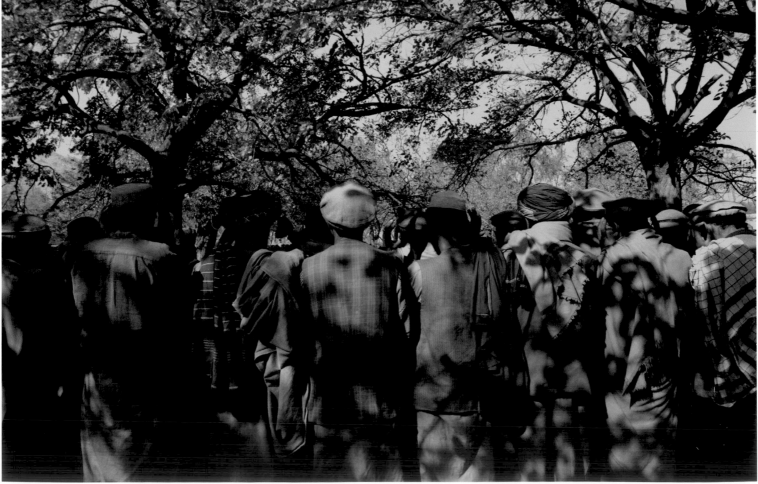

Above, A Northern Alliance tank in the centre of Kabul several days after the Taliban fled the capital, November 2001.

Below, Mourners attend the funeral of a woman killed by a US bomb that fell on a Northern Alliance village, October 2001.

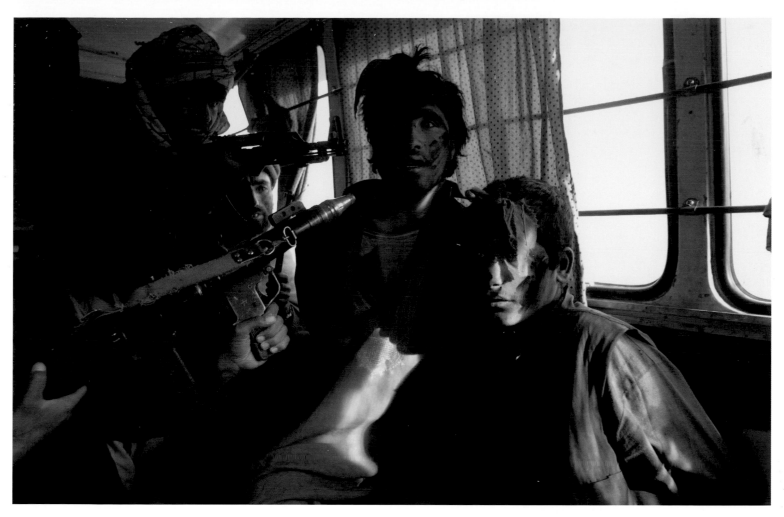

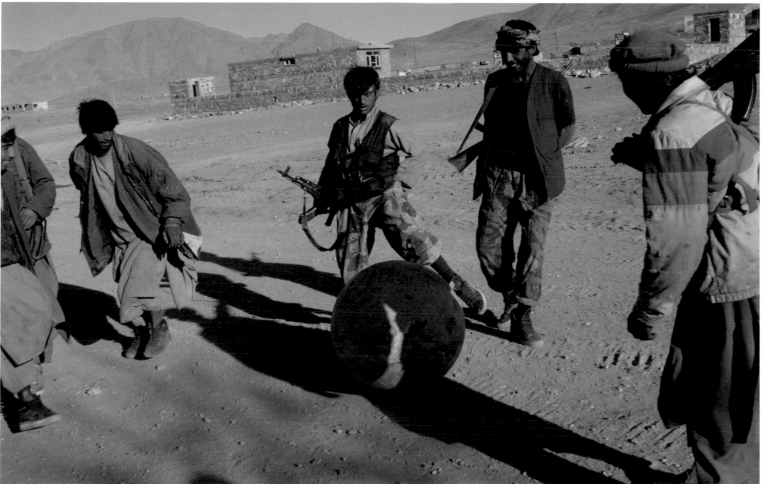

Above. Northern Alliance soldiers show off Taliban prisoners of war on the outskirts of Kabul several hours before the city fell, November 2001.

Below. Soldiers play with a globe they found in a Taliban school, November 2001.
Overleaf. Northern Alliance soldiers with their dying commander during the assault on the Taliban stronghold of Maidan Shahr, November 2001. They withdrew after being outflanked by the Taliban.

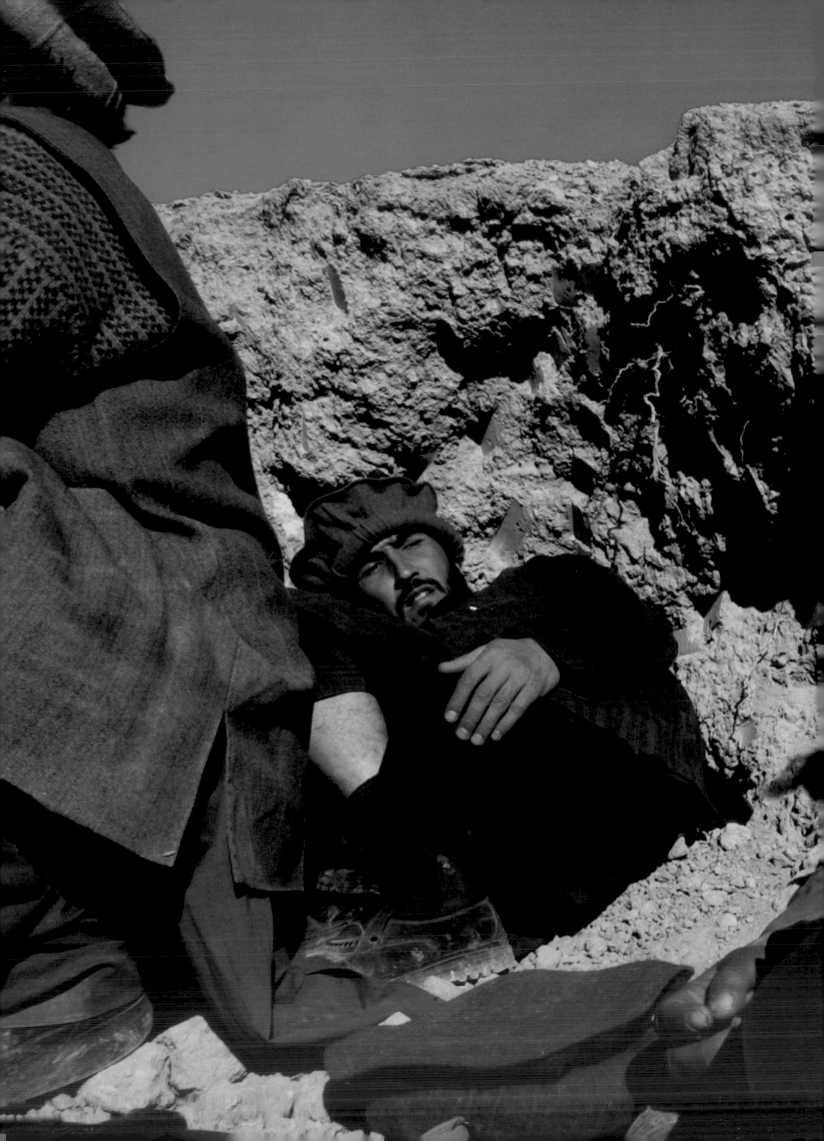

II. LIVES IN THE BALANCE

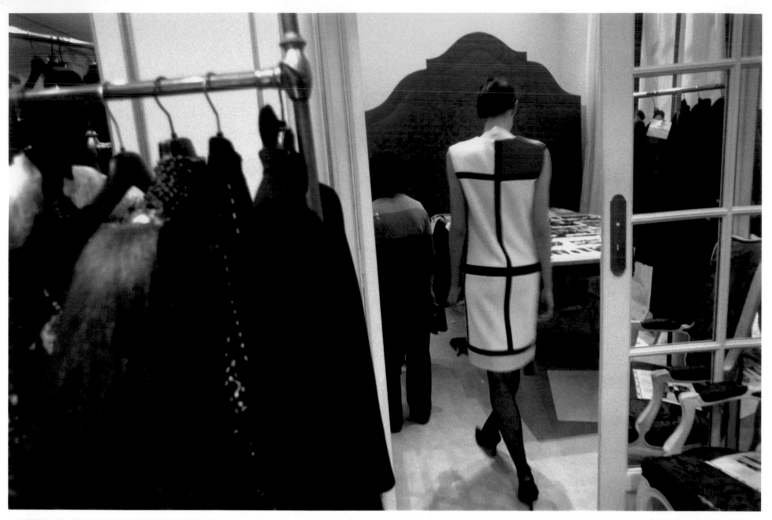

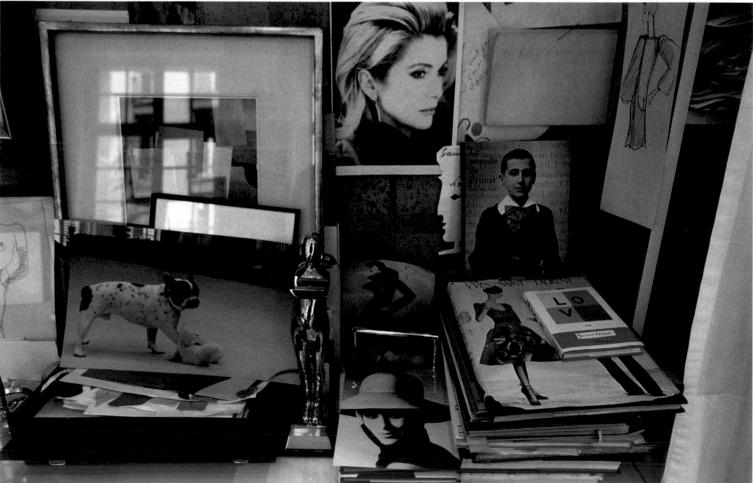

Above. A model wears Yves Saint Laurent's 'Mondrian' day dress, designed in 1965, at the couturier's Paris studio, 17 January 2002. His final show featured 200 of his best creations since the beginning of his career in 1962.

Below. Yves Saint Laurent's personal collection of images in his Paris studio includes photographs of his friend Catherine Deneuve, Proust and his bulldog Moujik. Among them is a small painting by Braque, 17 January 2002.

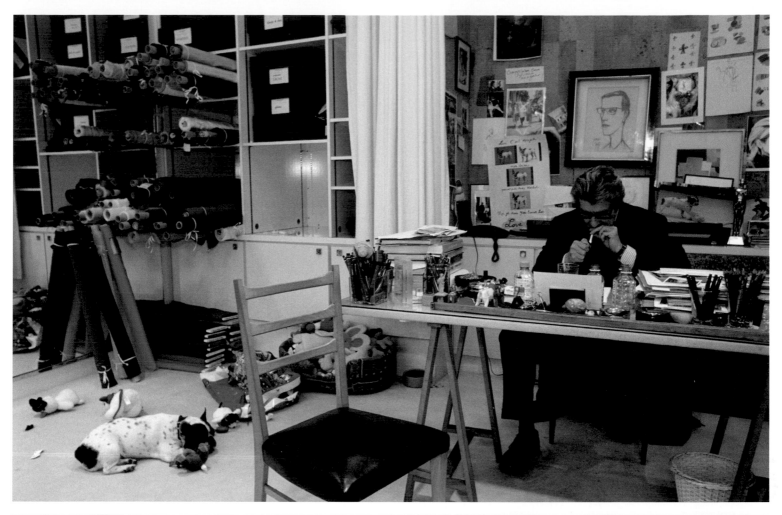

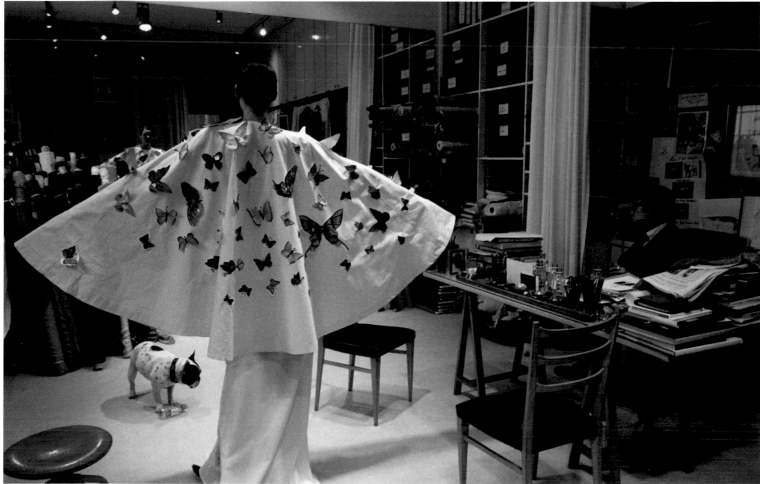

Above. Yves Saint Laurent, with his bulldog Moujik, working in his Paris studio on his final collection, 17 January 2002.

Below. Yves Saint Laurent, at his Paris studio, reviews a calico toile of a design he has created for his final collection, 17 January 2002.
Overleaf. Yves Saint Laurent having lunch at home in Paris, 21 January 2002, the day before his haute couture show at the Pompidou Centre.

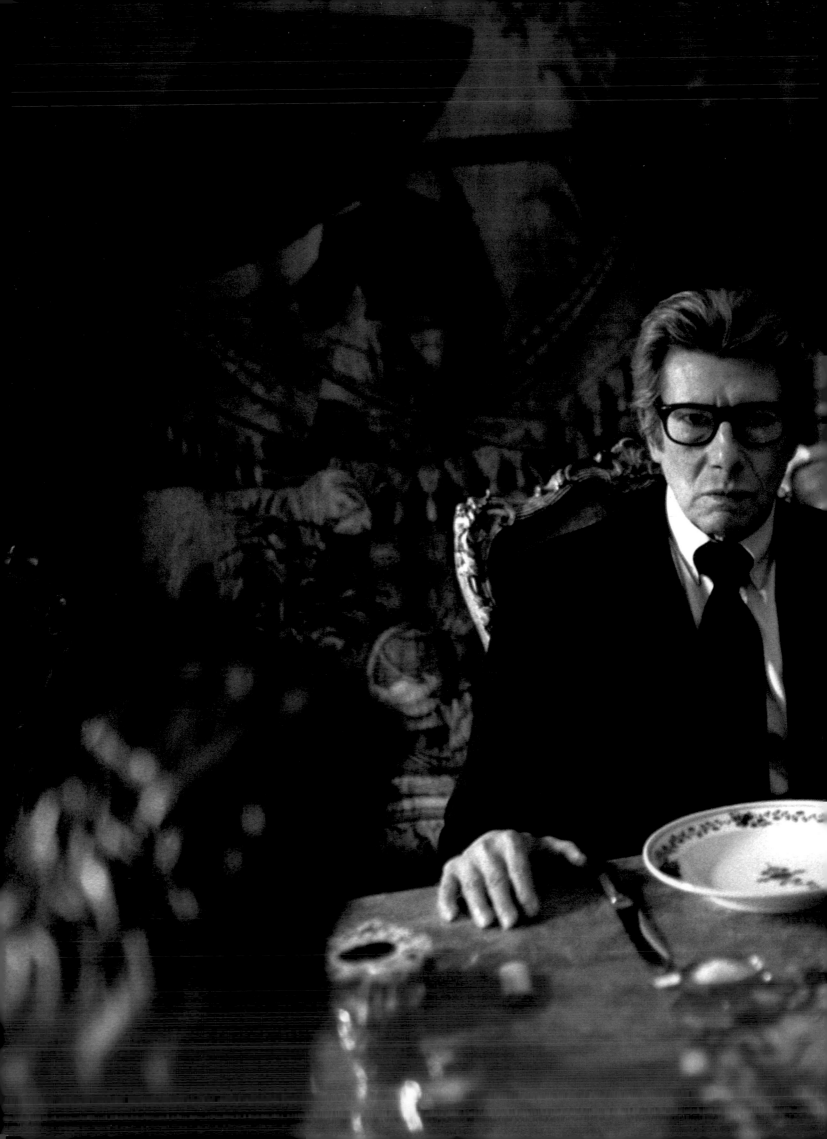

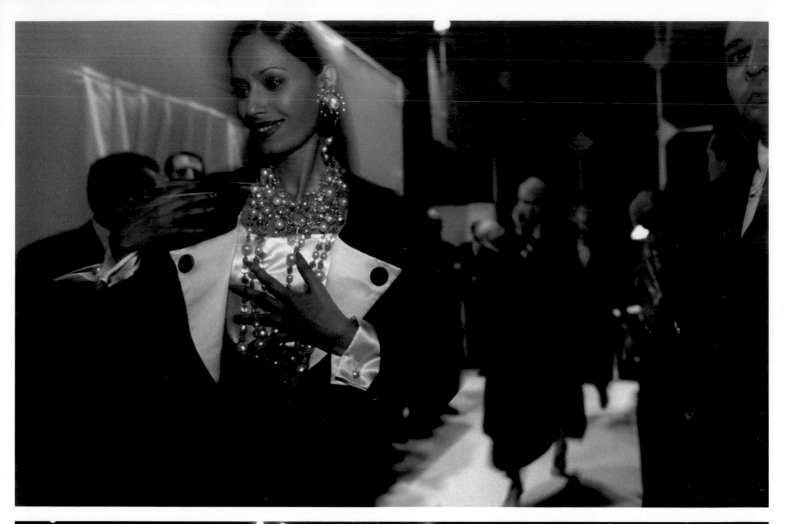

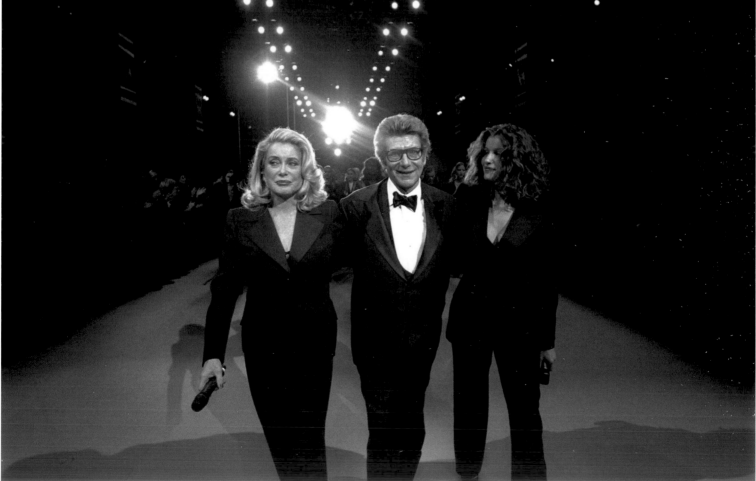

Above. A model on her way to the catwalk during the Yves Saint Laurent show at the Pompidou Centre, Paris, 22 January 2002.

Below. Yves Saint Laurent acknowledges the audience, accompanied by French actress Catherine Deneuve and top model Laetitia Casta, at the end of his final show, which was held at the Pompidou Centre, Paris, 22 January 2002.

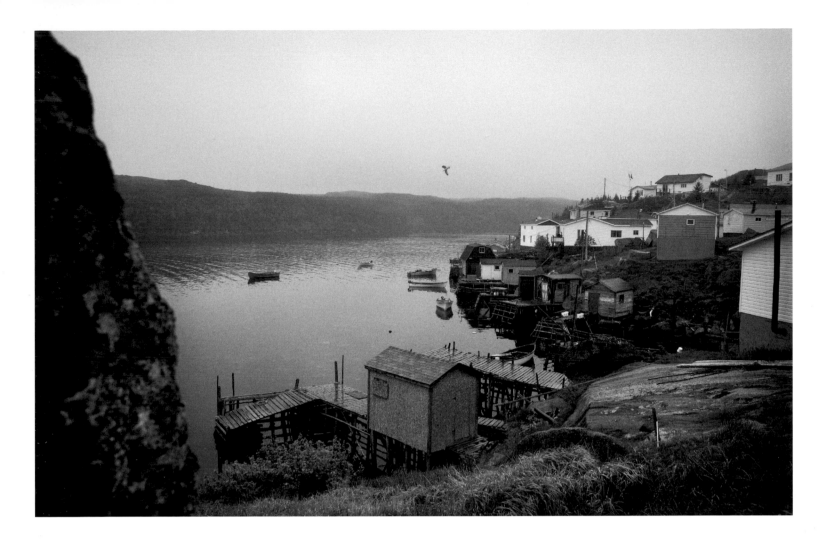

2003
A VANISHING WAY OF LIFE
JOACHIM LADEFOGED

During June 2003, Joachim Ladefoged lived with the La Poile fishing community on the island of Newfoundland, off the east coast of Canada. For generations, families in such communities have survived off the bounties of the ocean. The family trade was passed from father to son. Now it is a way of life that has all but vanished. As a result of the Canadian government's ban on northern cod fishing in the early 1990s and subsequent quota controls, now there are no jobs and only a small number of fishing communities survive.

A view of the bay at La Poile, home for 128 people, on the south coast of Newfoundland.

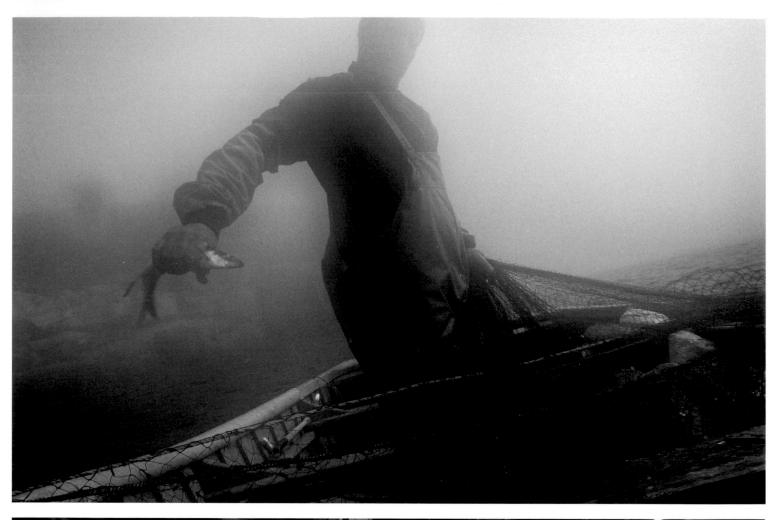

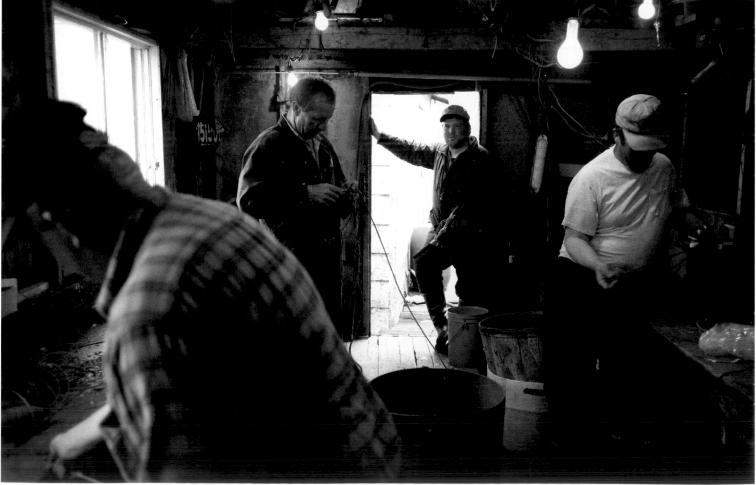

Above. The fishermen in La Poile use the traditional hook and line to catch halibut, using herring for bait.

Below. The life of a fisherman is tough and physical – few days go by without hard labour.

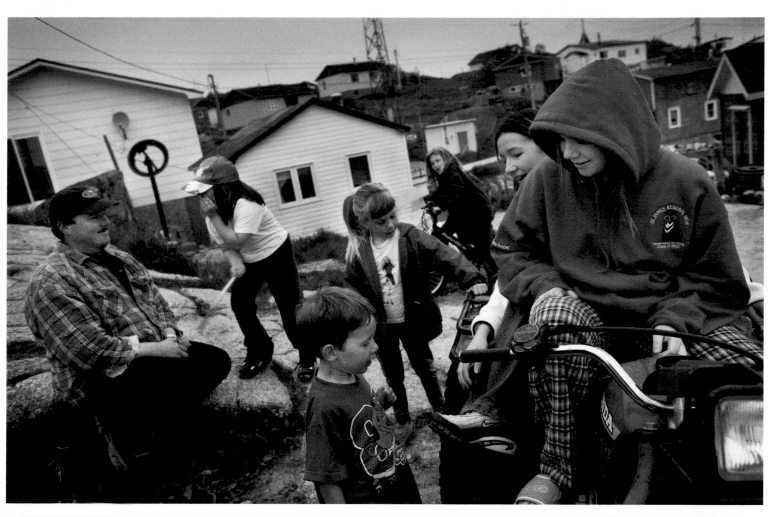

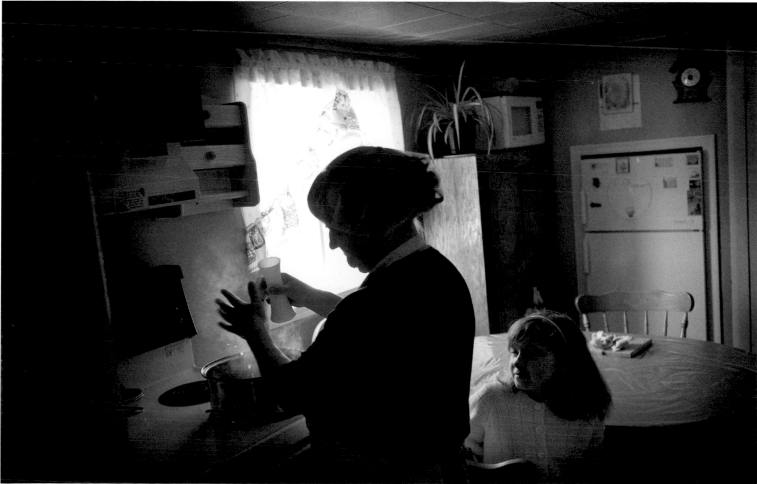

Above. Teenage girls (seen on their bikes), home for the summer holidays, are socializing in a La Poile street.

Below. A grandmother cooking in a house in La Poile.
Overleaf. A fisherman and his son head out to check their lobster pots in the bays near La Poile.

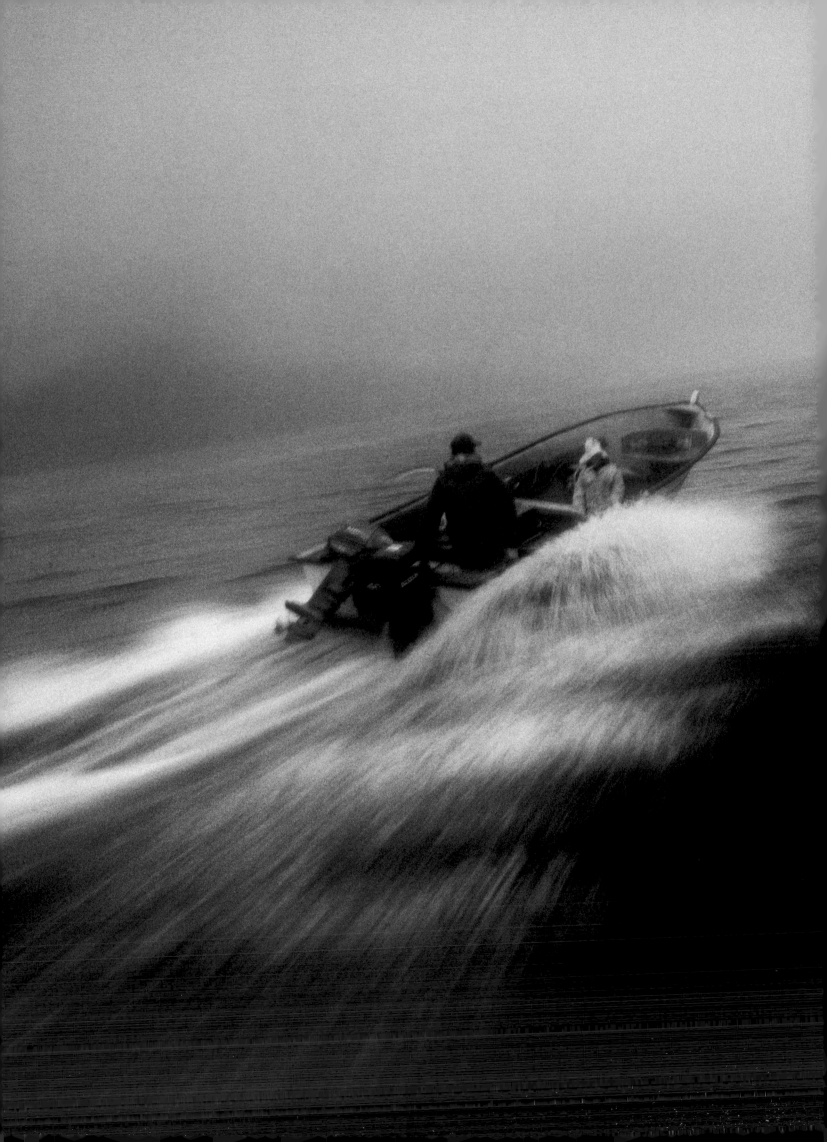

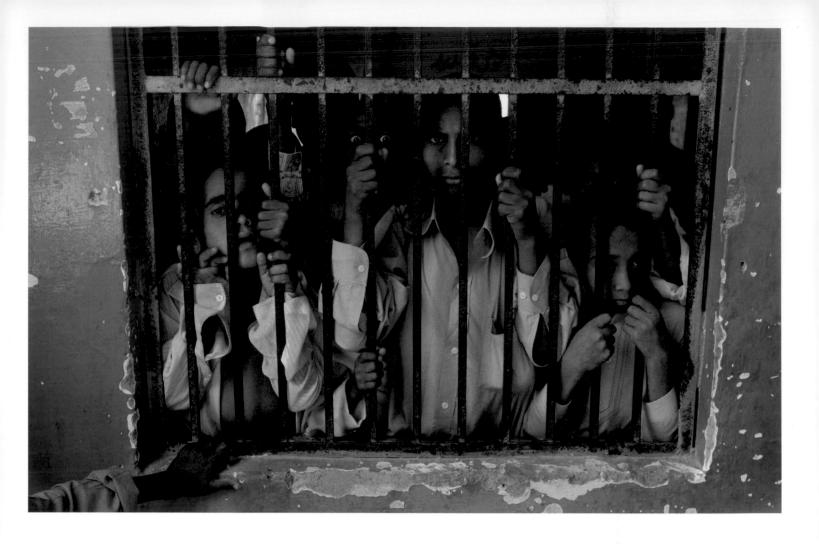

2003
LOST LIVES
JOHN STANMEYER

Although Asia's emerging economies, including China and
Indonesia, are leading the way out of recession and the political
climate in the region has generally stabilized, their governments
and international organizations have not addressed Asia's alarming
mental health crisis. Stigmatized, forgotten and often locked away,
thousands of mentally ill people are left to founder in hellish conditions,
no better than those of animals in a zoo. John Stanmeyer spent
much of 2003 documenting the treatment of mental health patients
across Asia, including China, Indonesia and Pakistan. His alarming
social commentary illustrates the dire need, long overdue, for the
authorities to provide greater funding and support action for the
proper care of its people, who still today are imprisoned, drugged,
malnourished and generally neglected.

Children or young men in languish at Edhi Village, a privately funded centre
for the mentally ill, outside Karachi, Pakistan. Over 1,000 patients live crammed
together, many locked behind bars, some of who repeatedly slam their heads
against the walls of their cells.

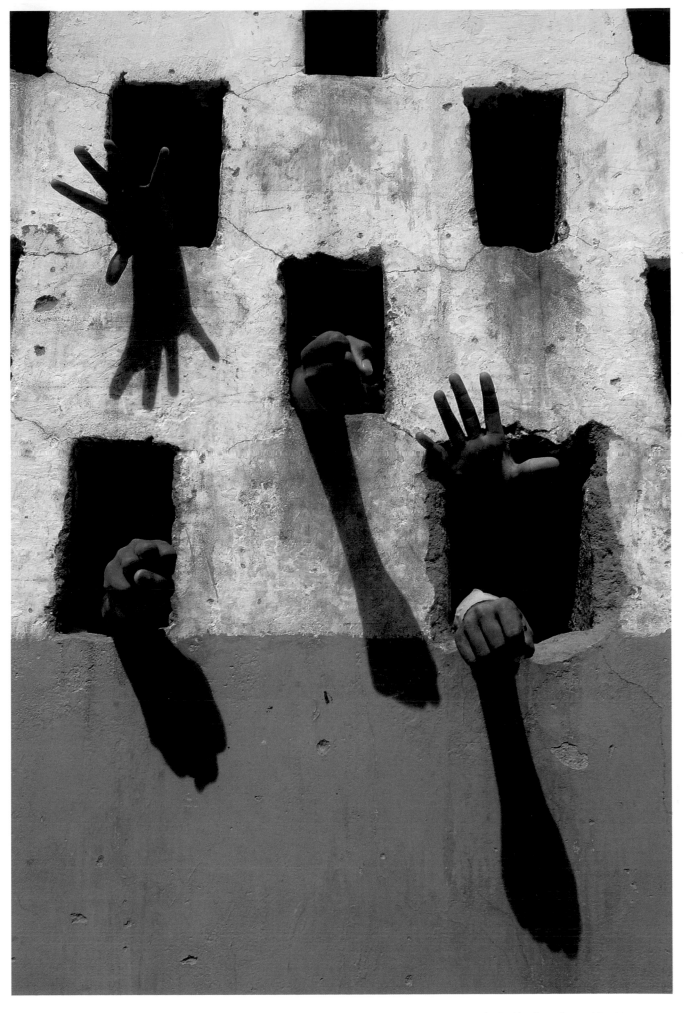

Above. Due to the Pakistani government's lack of funding of mental health care, overburdened foundations such as Edhi Village try to fill the gap in provision.
Overleaf. At Edhi Village, outside Karachi, Pakistan, children sleep on the floor and none of the boys have shoes.

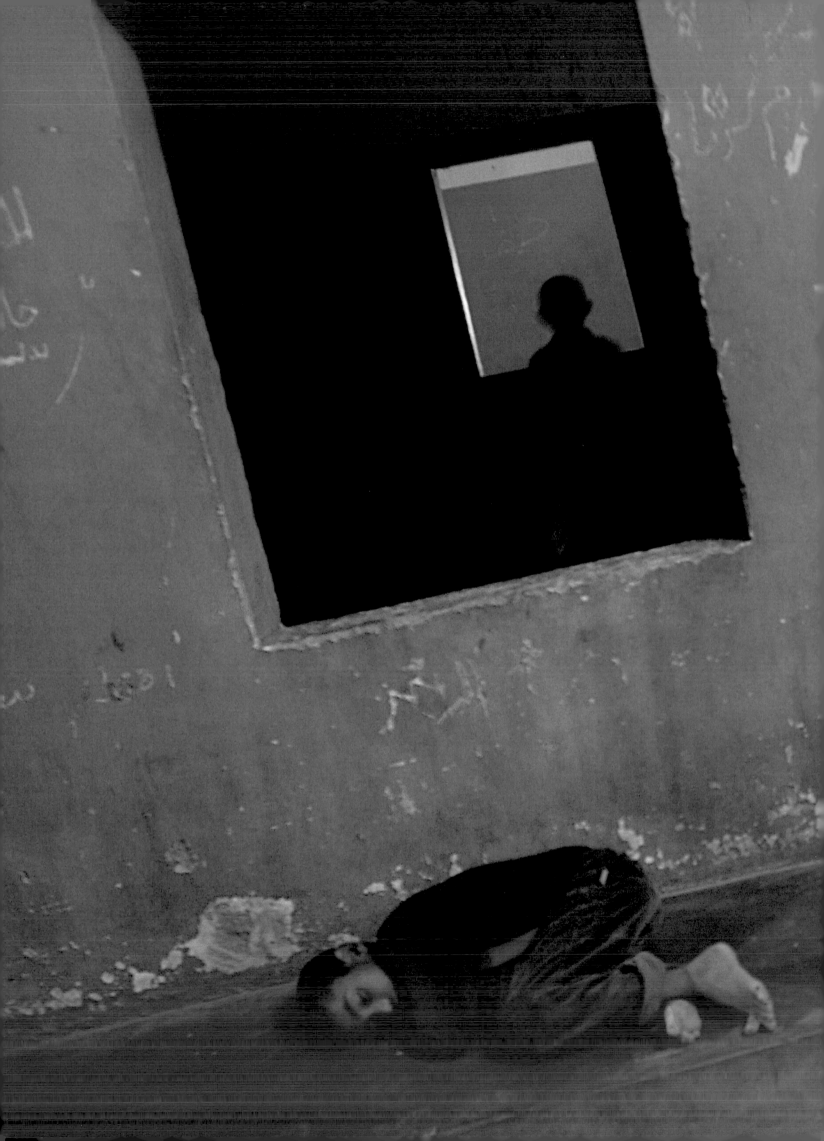

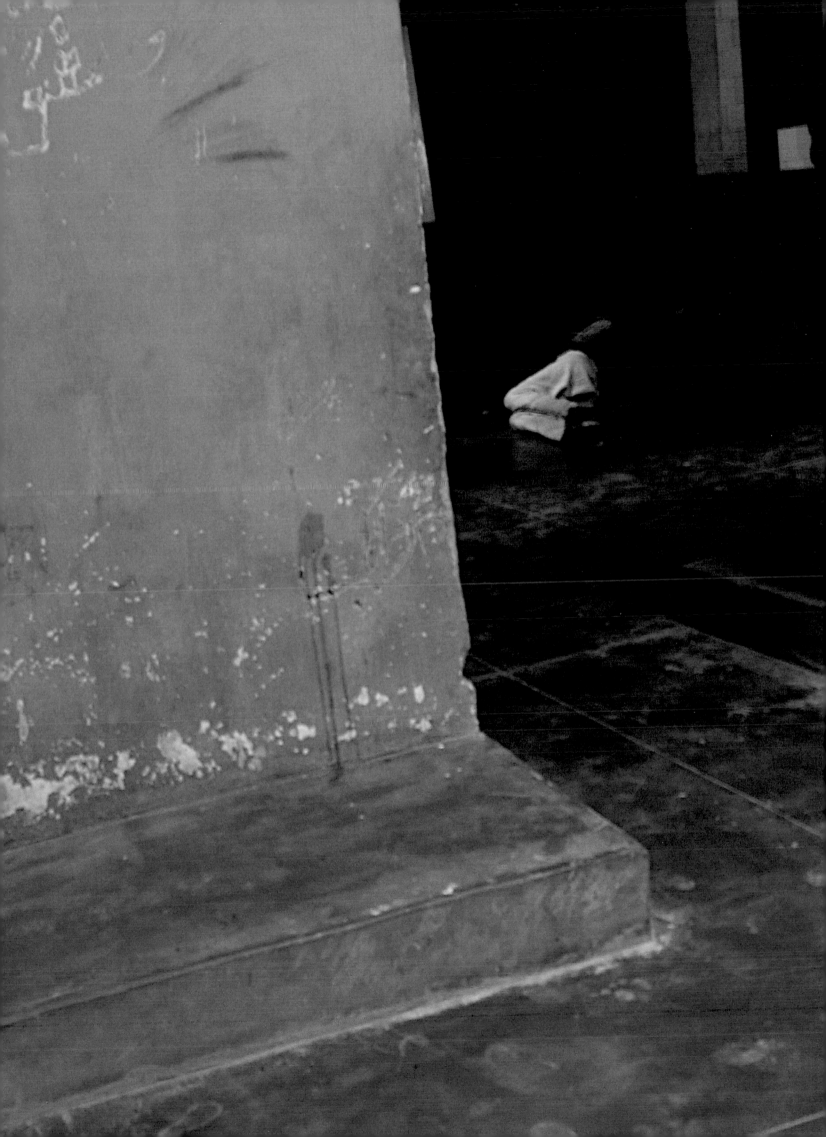

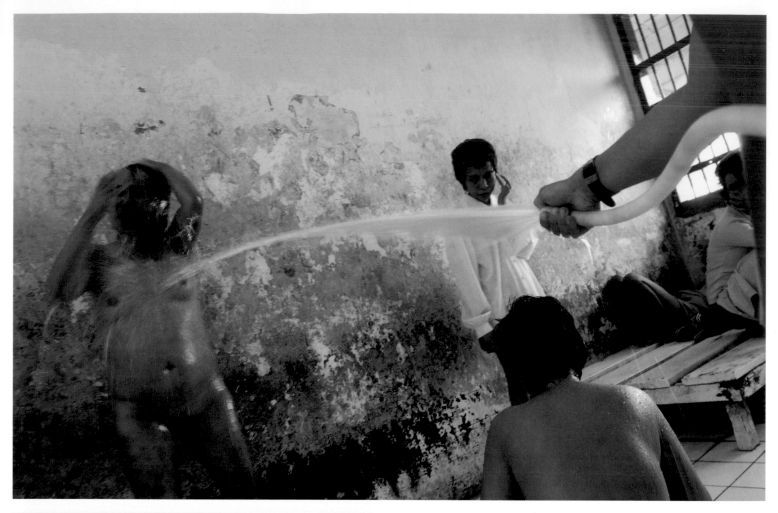

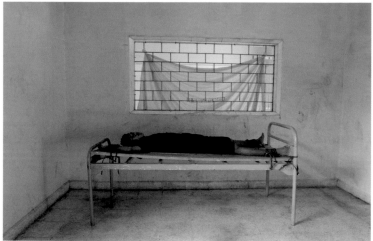

Above. Since the 1997 Asian financial crisis hit Indonesia, funding for issues such as mental health care have declined. The government-run Panti Bina Laras Cipayung Centre in east Jakarta has less than $1 per day per patient for all their medical and nutritional requirements.

Left. Monotony and desperation of daily life are the norm for the women and men who live in the Panti Bina Laras Cipayung mental health centre in Jakarta.
Right. A man is restrained to prevent him hurting himself and other patients at the desperately underfunded Dr Marzuki Mahdi Hospital in Bogor, Indonesia.

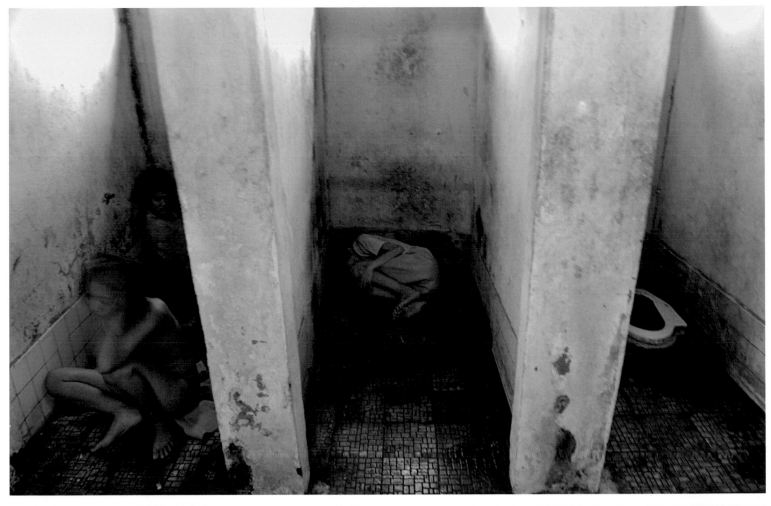

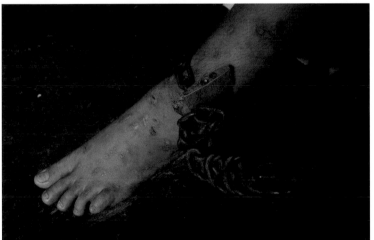

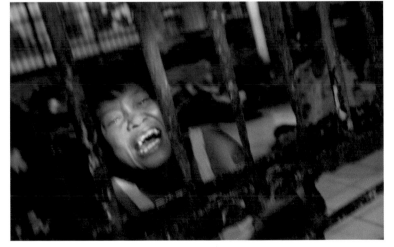

Above. At the Panti Bina Laras Cipayung Centre, Jakarta, men and women are mostly naked and given little medication. A facility for 150 people now holds twice that number. Increasing patient numbers partly stem from homelessness caused by Indonesia's economic problems.

Left. Some patients at Jakarta's Panti Bina Laras Cipayung Centre are chained to the walls. Patients live in a deplorable state due to lack of government provision. **Right.** Overcrowding at the government-funded Panti Bina Laras Cipayung Centre leads the authorities to keep the 300 men and women in prison-like conditions.

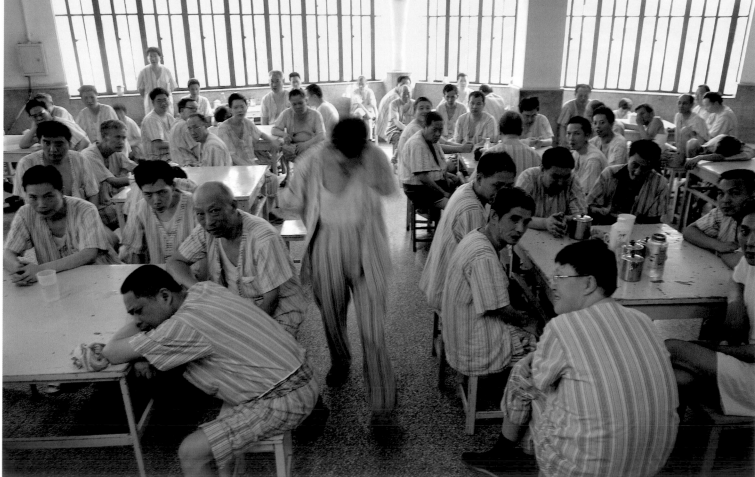

Above. A student at the Miyun School for children with learning difficulties in Shanghai, China, spends most of his day hiding behind his desk. The stigma of mental illness within Chinese society is so great that most afflicted people are kept concealed at home.

Below. At the men's ward at the Hongkou District Mental Health Centre, central Shanghai, high levels of sedation are used to control the patients so that most walk around in lifeless states.

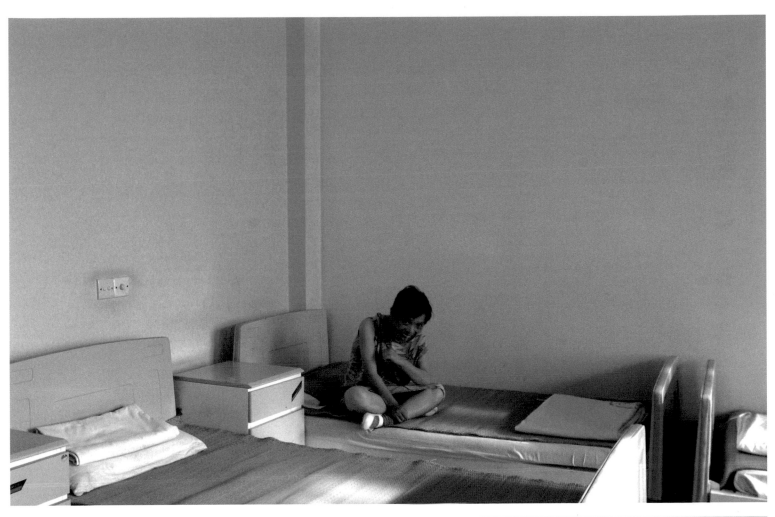

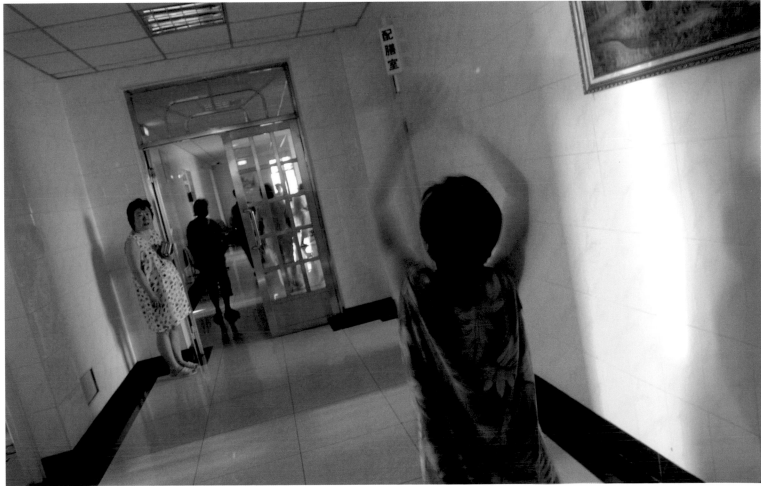

Above. A female patient lives a regimented life at the Mental Health Centre of Xuhui District, western Shanghai. China's rapid development has not fully kept up with the health needs of all its people.

Below. The female ward at Xuhui District Mental Health Centre, western Shanghai.

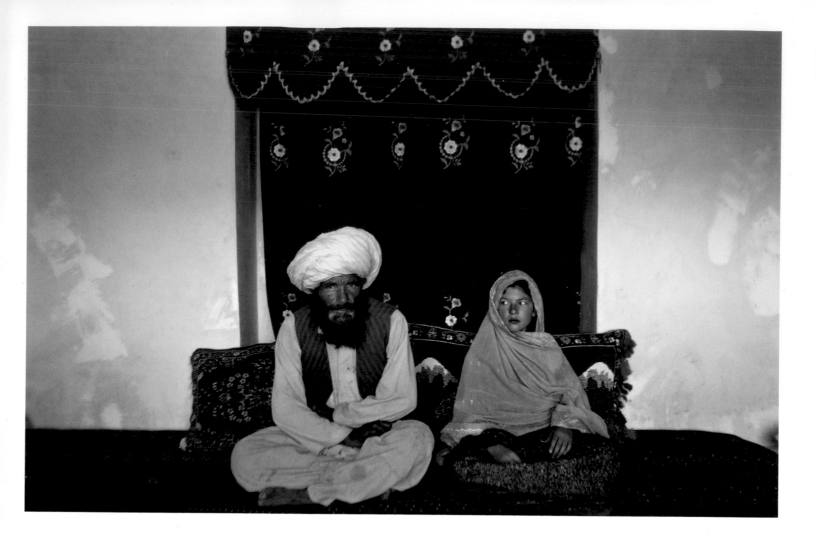

2003–2010
CHILD BRIDES
STEPHANIE SINCLAIR

Throughout the world, more than 51 million girls below the age of 18 are married, even though it is outlawed in many developing countries and international agreements forbid the practice. Child marriage spans continents, language, religion and caste. Over an eight-year period, Stephanie Sinclair investigated the phenomenon in India, Yemen, Afghanistan and Ethiopia, among other countries. Apart from India, where girls are typically matched with boys four or five years older, the husbands may be young men, middle-aged widowers or even abductors who commit rape first. Some marriages are little more than business transactions: a debt cleared in exchange for an eight-year-old bride; a tribal feud resolved by the delivery of a virginal 12-year-old daughter. Child marriage denies girls their right to education, restricts friendships with peers and perpetuates the cycle of poverty in their communities. In many cases, young married girls have little power in relation to their husbands and in-laws. They are therefore extremely vulnerable to domestic violence, which may include physical, sexual or psychological abuse.

Faiz Mohammed, 40, and Ghulam Haider, 11, at her home before their wedding in Ghor Province, Afghanistan. According to the Afghan Ministry of Women's Affairs, around 57 per cent of Afghan girls get married before the legal age of 16.

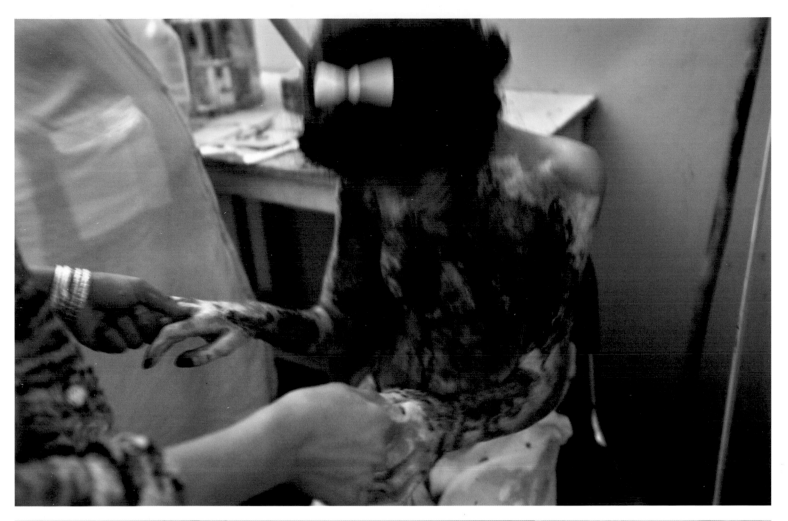

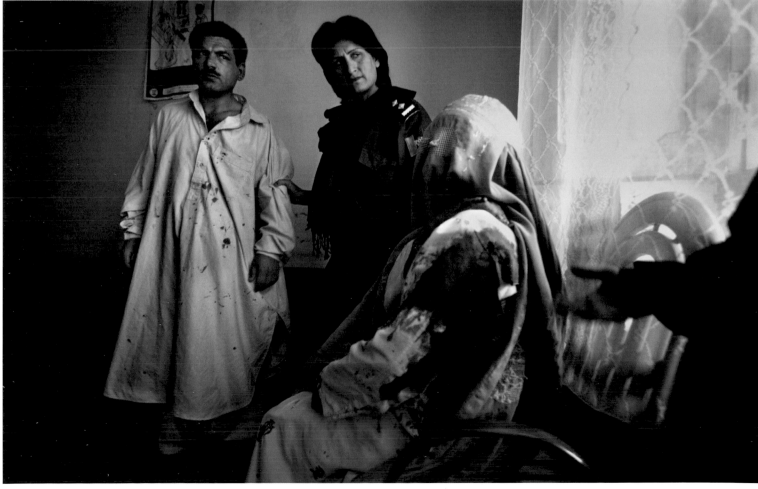

Above. Marzia Bazmohamed, 15, is treated for burns at Herat Public Hospital, Afghanistan. Marzia set herself on fire because she was afraid of her husband's reaction to her breaking the family television set. They were married when she was only nine years old.

Below. In Afghanistan, Kandahar policewoman Malalai Kakar arrests a man, 35, after he repeatedly stabbed his wife, 15, for disobeying him. Asked what would happen to the husband, Kakar said, 'Nothing. Men are kings here.' Kakar was later killed by the Taliban.

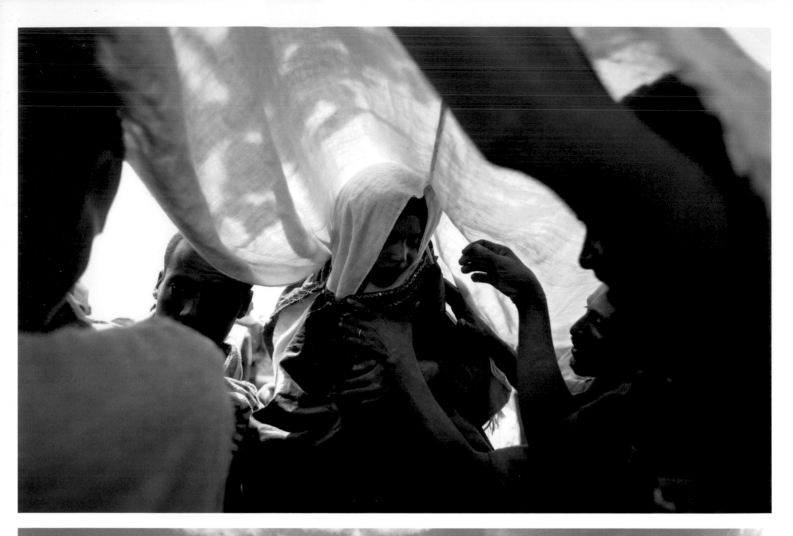

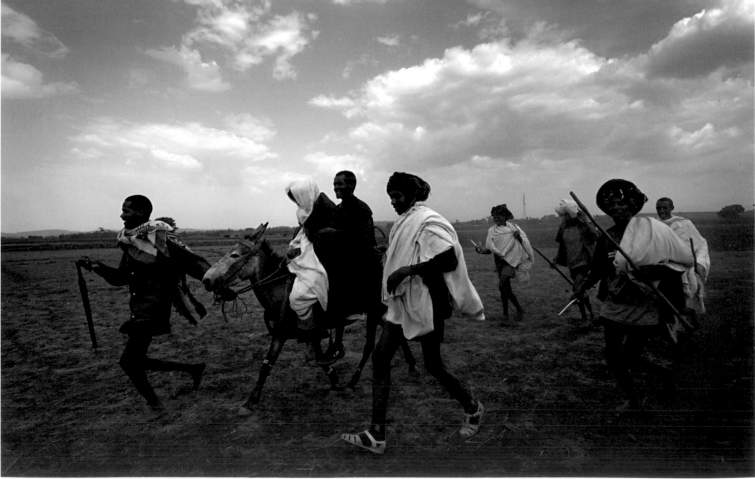

Above. Family members bind Leyualem Mucha, 14, in a white wedding cloth before she is whisked away on a mule by her new groom and groomsmen in Amhara Region, Ethiopia. Leyualem had never met her husband before.

Below. Leyualem Mucha is taken to the home of her new groom in Amhara Region, Ethiopia. The men said they covered her head for the journey so that she would not be able to find her way back home should she want to escape the marriage.

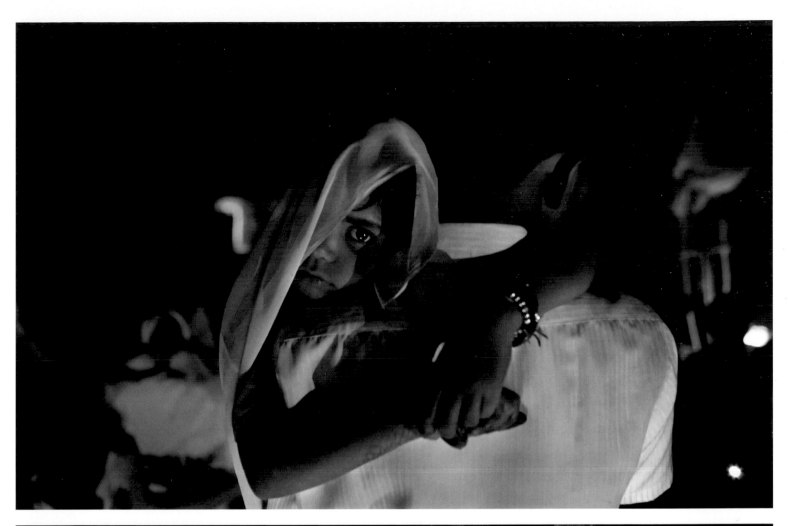

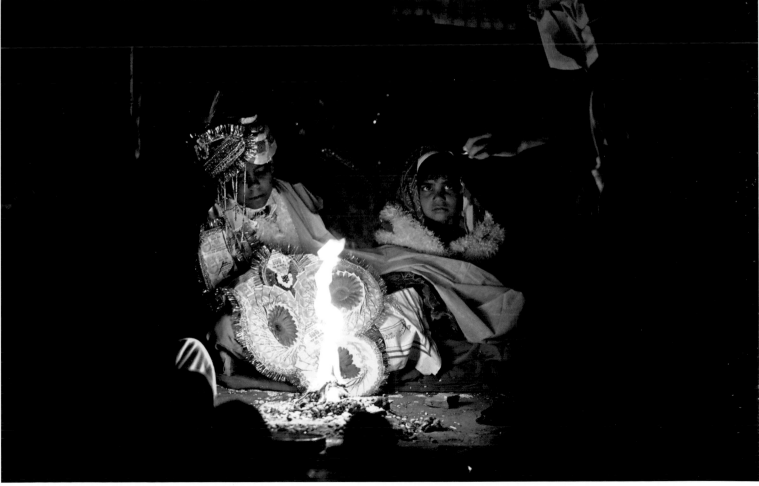

Above. Five-year-old Rajni is roused from her sleep and carried by her uncle to her wedding. Child marriage is illegal in India, so ceremonies are often held in the early hours of the morning. 'It becomes a secret,' explained a farmer. 'The village is unified. We don't let it leak out.'

Below. Rajni and her boy groom barely look at each other as they are married before a sacred fire. The young bride will live at her parents' home until puberty, when a second ceremony will signal her readiness to move in with her husband.

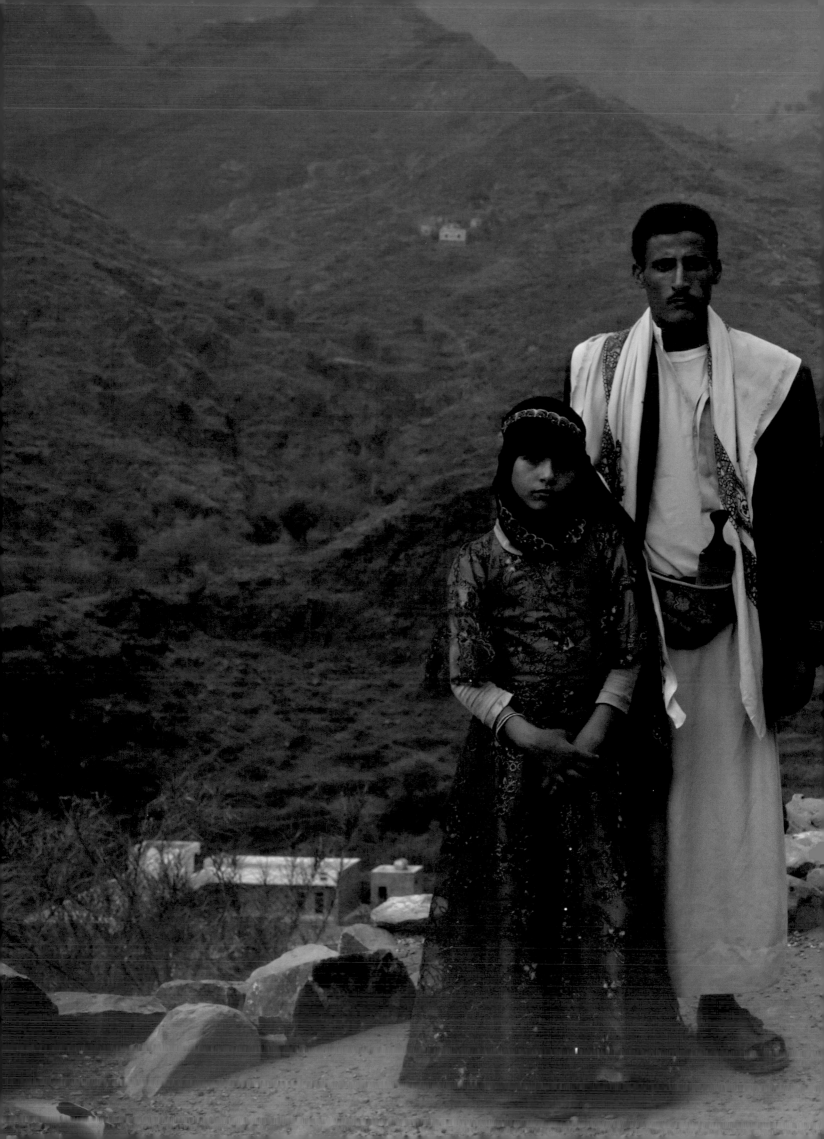

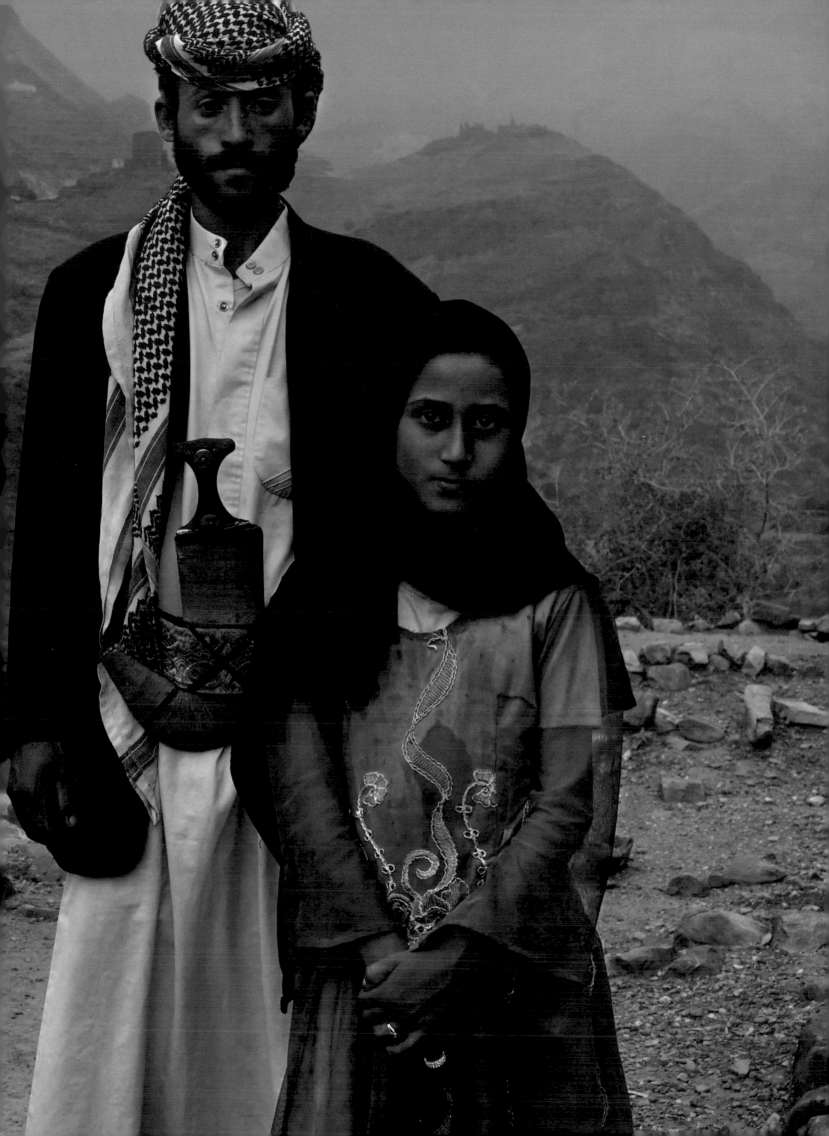

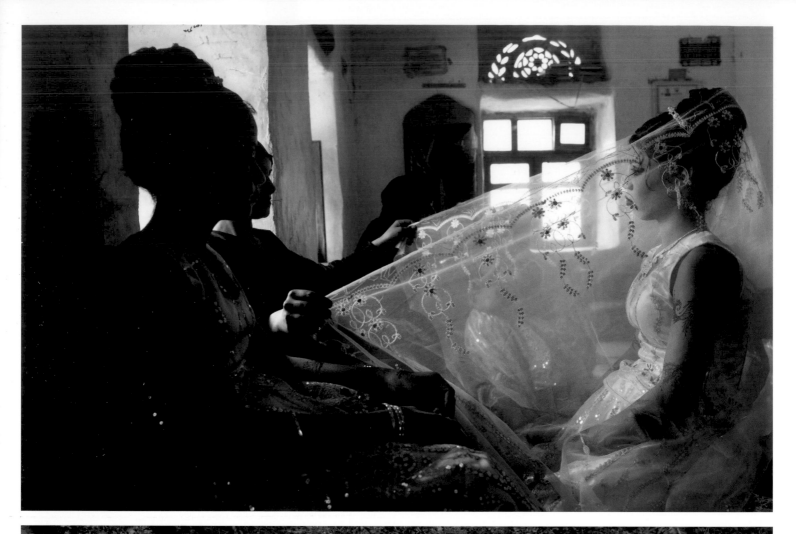

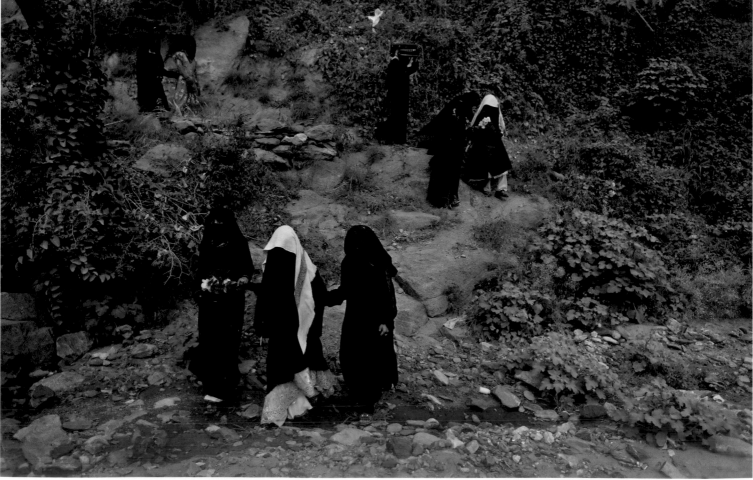

Previous page. 'I was so scared whenever I saw him I ran away,' recalls Tahani (in pink) of the early days of her marriage, when she was nine. Three years later she poses for this portrait with a former classmate, also a child bride, outside her mountain home in Hajjah, Yemen.

Above. In Yemen, marriage is often a business transaction; sisters Sidaba, 11 and Galivaah, 13, prepare to marry relatives in exchange for their cousin's marriage.
Below. After celebrating with female relatives, Yemeni brides Sidaba and Galivaah are escorted to a new life with their husbands.

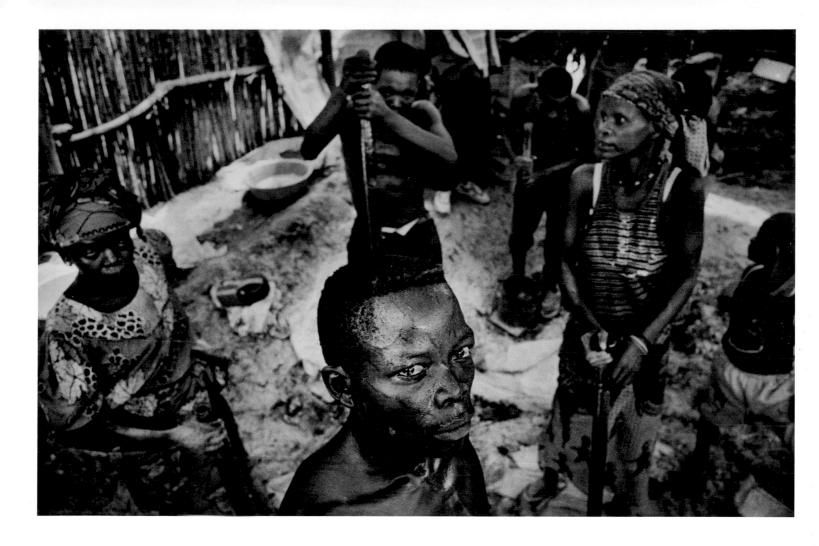

2003–2008
THE RAPE OF A NATION
MARCUS BLEASDALE

Diamonds and gold – vast natural resources that could enrich a nation – are a curse in the Democratic Republic of Congo (DRC), where over 5.4 million defenceless civilians have died during more than ten years of fighting. The conflict between warlords and armed rebels for control of the spoils have plunged the citizens into a life of poverty, violence and rape. In 2003, a dozen or more armies were fighting in eastern Congo. Armed militias consisted of ruthless, undisciplined men from the main ethnic groups, from neighbouring states, as well as from organized crime fuelled by the illegal exploitation of the diamond and gold mines. Among them are some 30,000 child soldiers. Although there were signs of change in late 2006, when 2 million of the 4 million refugees returned home and some militias had been disarmed, aid workers accessed vulnerable communities and found the mortality rate was still over 1,000 per day.

Bonded workers crush rocks in Mongbwalu, northeastern DRC, October 2004. Whole families work in slave conditions for warlords, who control huge amounts of land, where gold is extracted to finance their military campaigns. The majority of the gold mined in this region leaves the DRC illegally and is sent to Uganda.

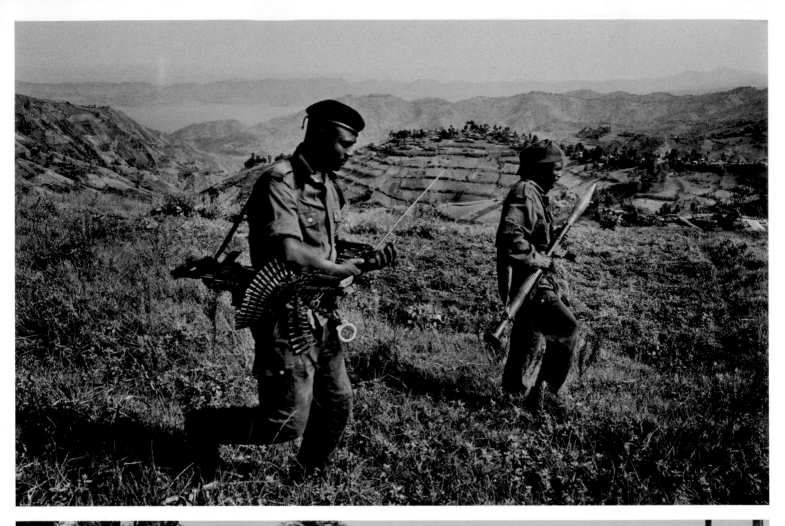

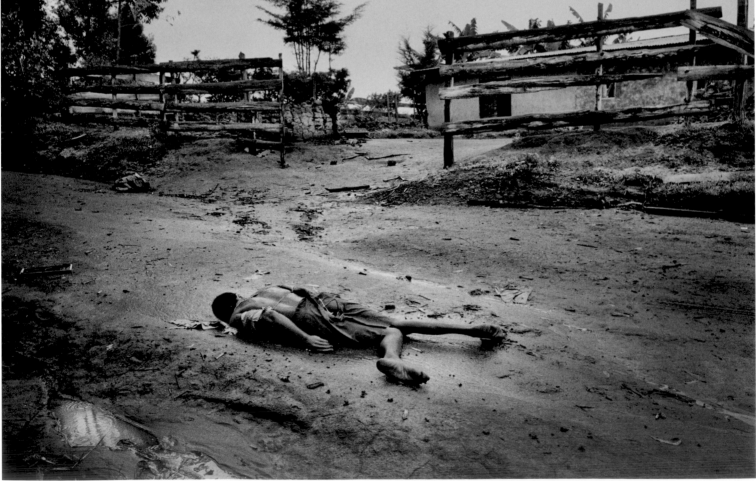

Above. Rebranded soldiers of the Armed Forces of the DRC relax after winning their first battle in months against General Laurent Nkunda in Karuba, Nord-Kivu province, January 2008. Increasing fighting continues between the government forces, Nkunda's Tutsi rebels and the Hutu Rwandan rebels in the eastern DRC.

Below. Two dead Hema men lie on a road after being executed just hours before by a Lendu militia group north of Fataki, northeastern DRC, August 2003. They were both bound and impaled before being shot and their ears had been bitten off in the ritual killing.

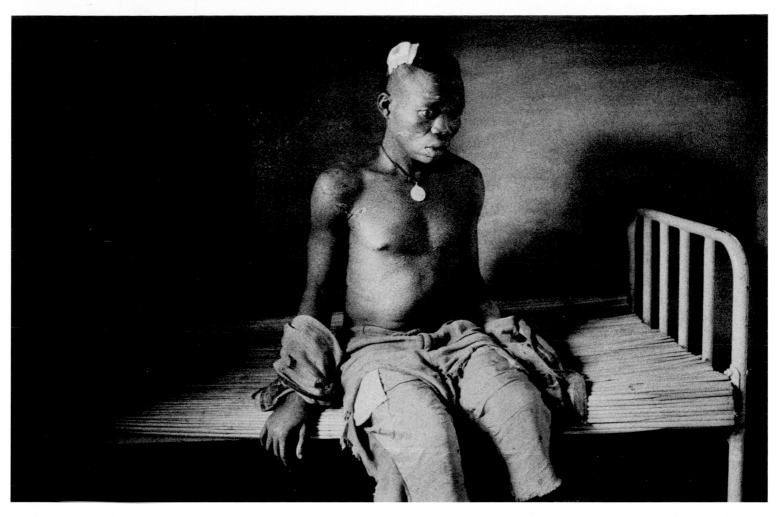

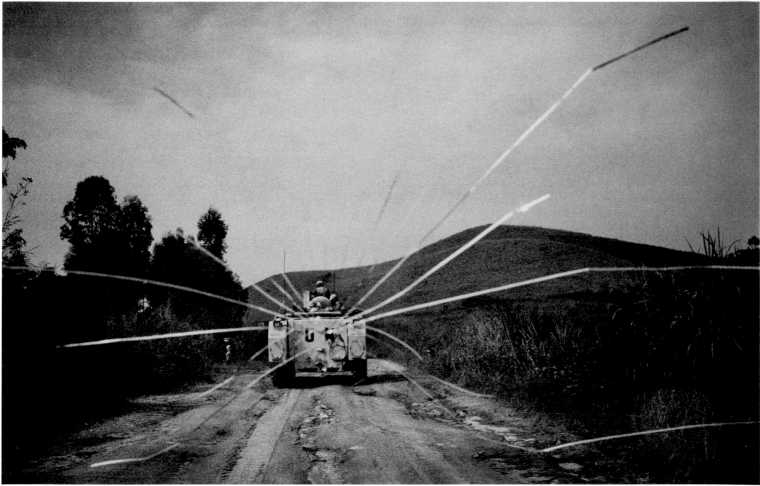

Above. A Lendu soldier sits on a bed in a makeshift hospital in Drodro, Ituri province, DRC, August 2003. Accused of cannibalism, the soldier was captured and beaten by the local Hema population. He now waits to learn of his fate.

Below. A UN vehicle drives near Gety, Ituri province, July 2006. The peacekeeping force was deployed during the DRC's first democratic elections in 46 years.
Overleaf. Artisanal gold miners work solely by hand in Watsa, DRC, October 2004. Most miners are combatants who exploit these mineral-rich areas for profit.

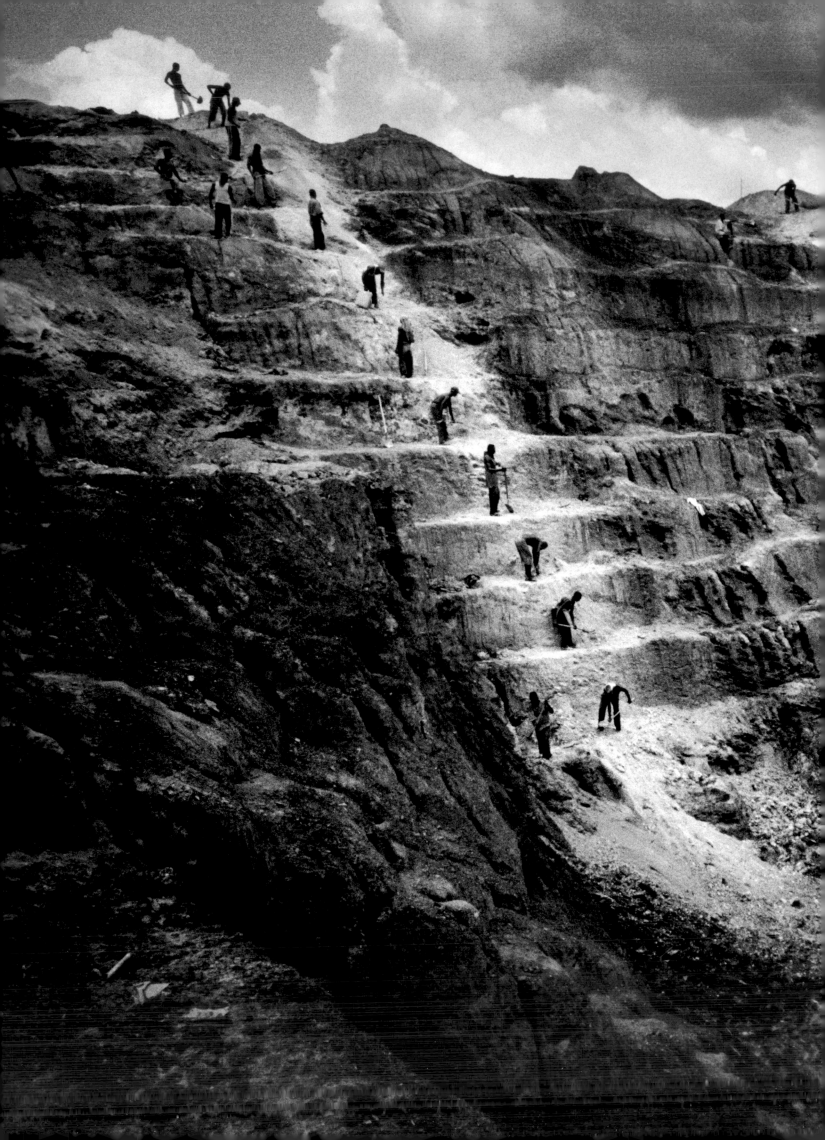

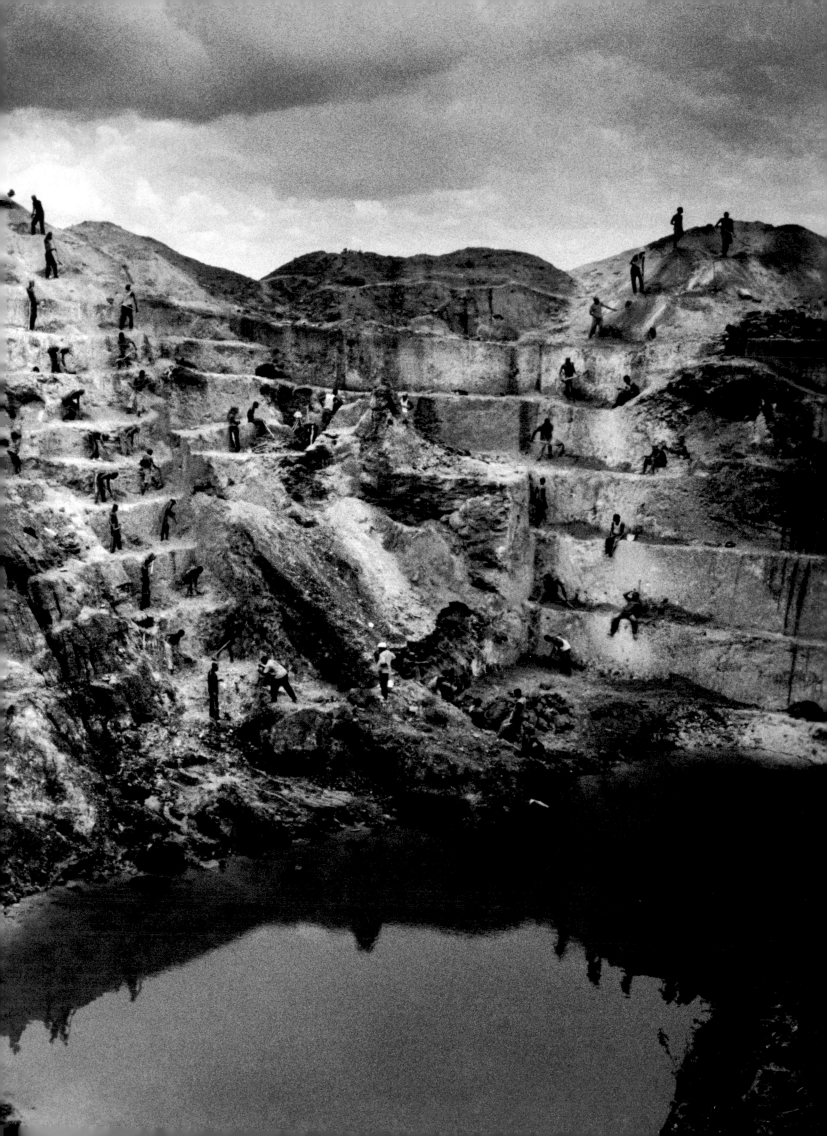

Above. Diamond dealers buy stones in Mbuji-Mayi, Kasai-Oriental province, 2005, known as DRC's diamond centre. Diamond trading has almost totally replaced agriculture. Many dealers become church pastors in order to wield their influence and convince their congregations to join the diamond industry.

Below. Men prepare for the burial of Sakura Lisi, the eight-month-old daughter of an artisan gold miner, in Mongbwalu, northeastern DRC, October 2004. The child died of anaemia brought on by malaria.

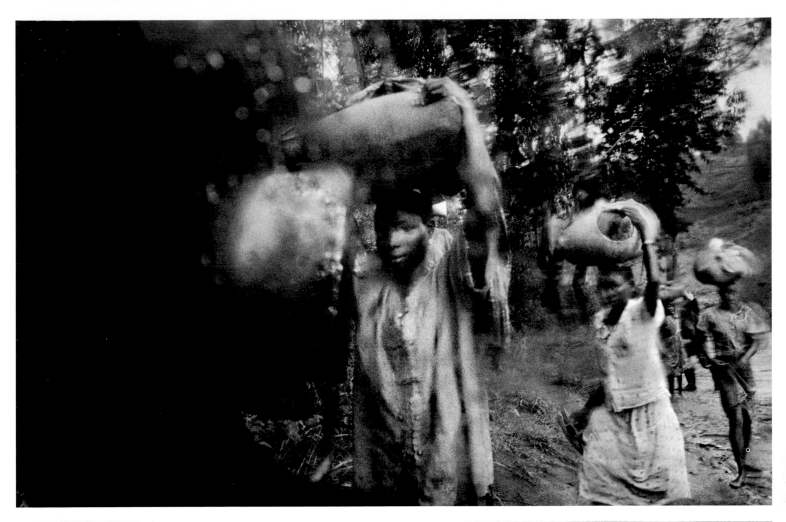

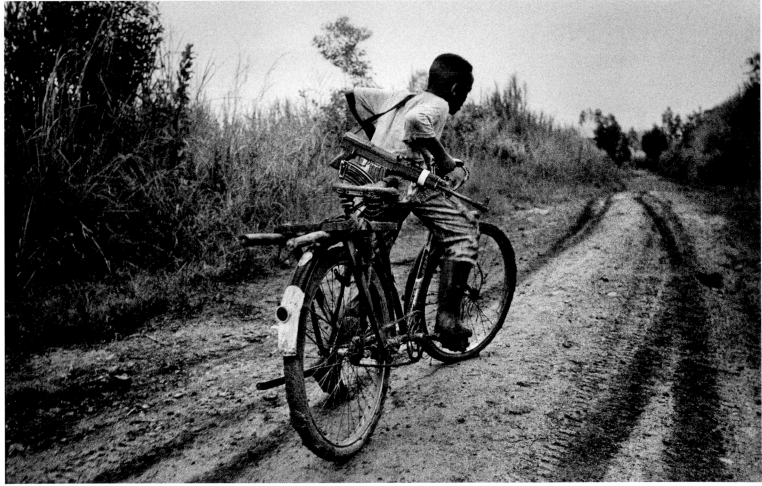

Above. Internally displaced people flee south after a rebel attack on Bule and Fataki, northeastern DRC, August 2003.

Below. A child soldier of the Union of Congolese Patriots (UPC), carrying an AK-47 rifle, rides back to his base on an adult-sized bicycle in Bule, northeastern DRC, August 2003.

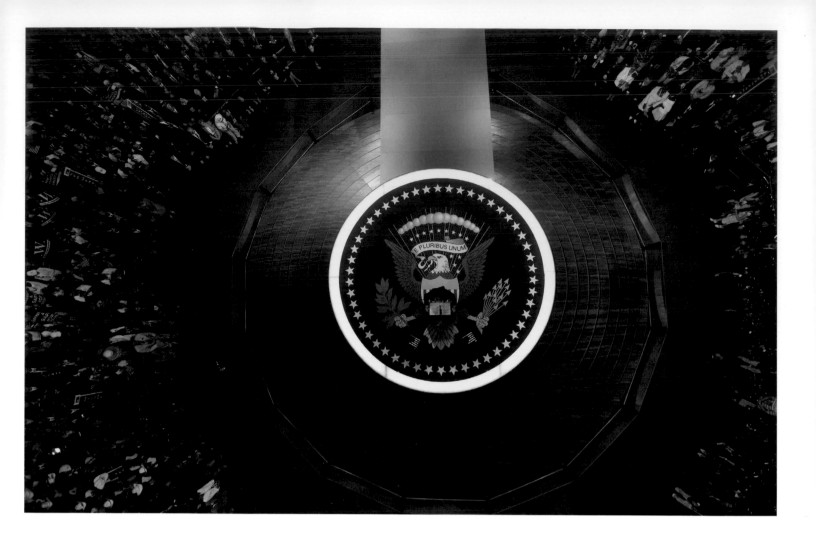

2003–2006
MY AMERICA
CHRISTOPHER MORRIS

Christopher Morris produced a series of photographs over a
period of five years called My America while on assignment to
cover the first and second administrations of US President George
W. Bush. From a privileged vantage point close to the centre of
American power, Morris documented a personal and critical vision
of Republican America, which he saw as being at the intersection
of patriotism and control, politics and devotion. His aim is that
we should 'see what I saw and feel what I felt – a nation that has
wrapped its eyes so tightly in red, white and blue that it has gone
blind. This is "My America".'

New York, New York, 2004.

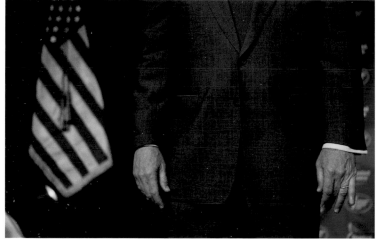

Above. Dinuba, California, 2003.

Left. Washington, DC, 2005.
Right. Harrisburg, Pennsylvania, 2004.

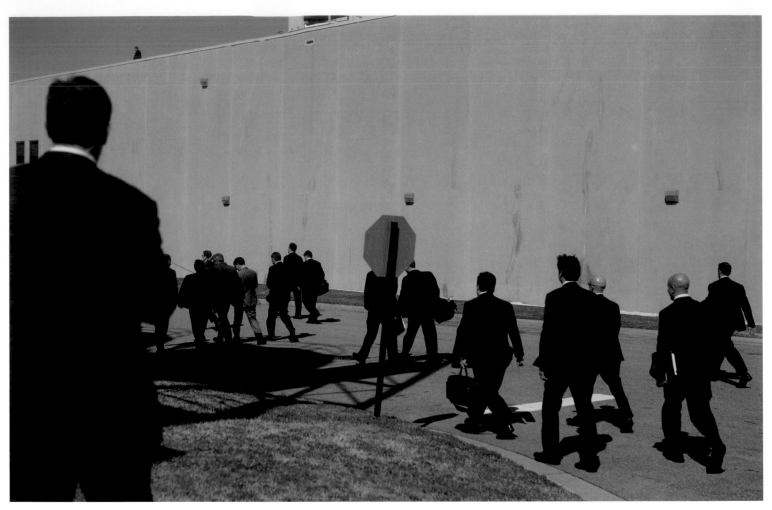

Above. Franklinton, North Carolina, 2006.

Left. Wells, Maine, 2004.
Right. Nampa, Idaho, 2005.

Above. Farmington Hills, Michigan, 2004.

Left. Washington, DC, 2005.
Right. Istanbul, Turkey, 2004.

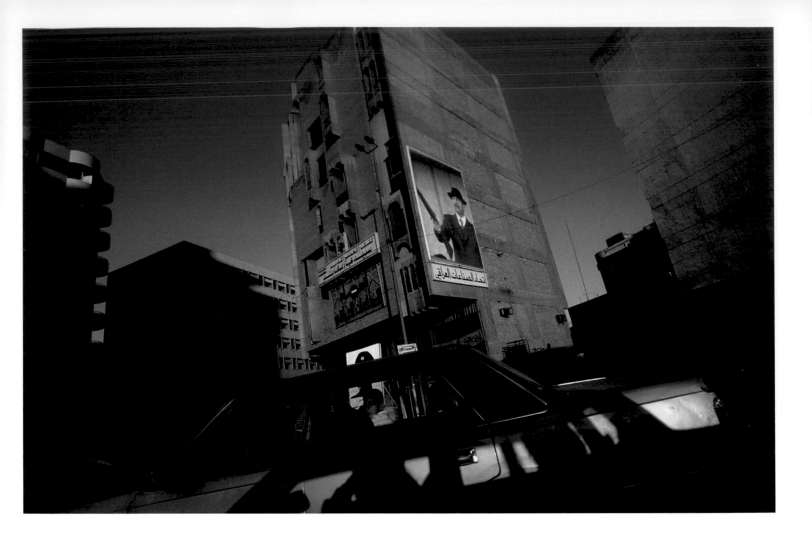

2003
IRAQ THROUGH THE FALL
ALEXANDRA BOULAT

When Alexandra Boulat arrived in Baghdad in Iraq at the end
of January 2003, she had little idea of what was about to unfold
before her very eyes. Over a period of three months she kept a
journal that began with Saddam Hussein's dictatorship and ended
with the invasion of Iraq by the US-led coalition forces. Her first
impressions were that Baghdad, far from being third world, was
full of educated and open-minded people, whose way of life was
in many ways western. She witnessed the mood of Baghdad's
5-million-strong population changing as US forces gathered. Some
people left for Syria or Jordan; a few started digging trenches.
American troops formally took control of Baghdad on 9 April
2003 after two weeks of bombing. The overriding feeling was relief
that the air strikes had stopped. By the end of April, when Boulat
returned home, Baghdadis had started hunting for relatives who
had disappeared under Saddam's regime in order to give them
proper burials.

In Baghdad, Iraq's capital, a car passes a poster of Saddam Hussein a few weeks
before the US-led invasion, February 2003.

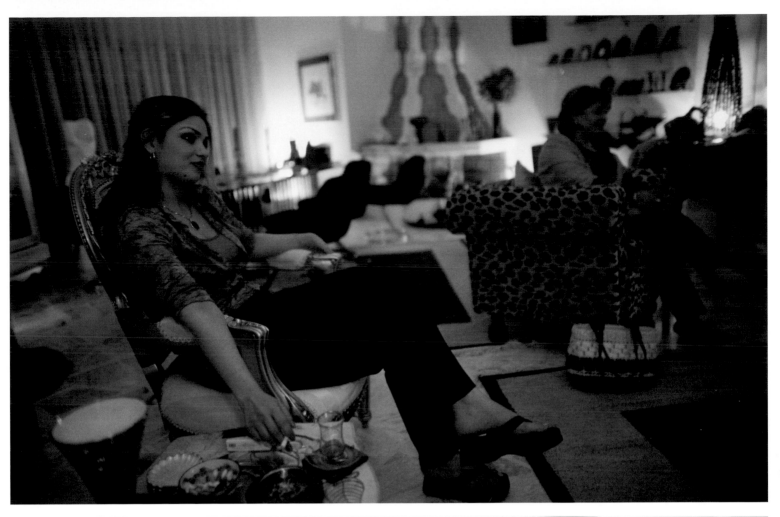

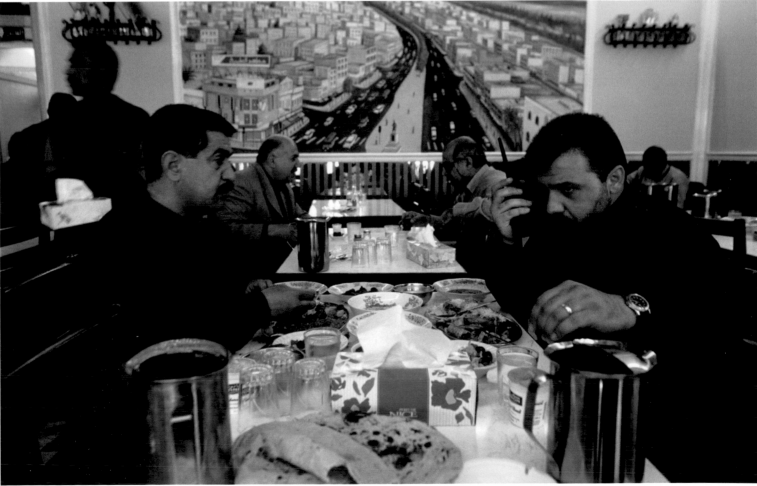

Above. At the home of art gallery owner Samira Abdulwahab (left) in a wealthy Baghdad suburb, March 2003. Despite the comfortable surroundings, the mood was tense. Samira was consumed with fear that her world was about to end.

Below. Loyalists to the regime of Saddam Hussein lunch in downtown Baghdad, March 2003, just weeks before the invasion.
Overleaf. A Baghdad rooftop surrounded by smoke from oil wells set alight by the Iraqis to hinder US fighter jets during the bombing of the city, March 2003.

Alexandra Boulat – Iraq Through the Fall 131

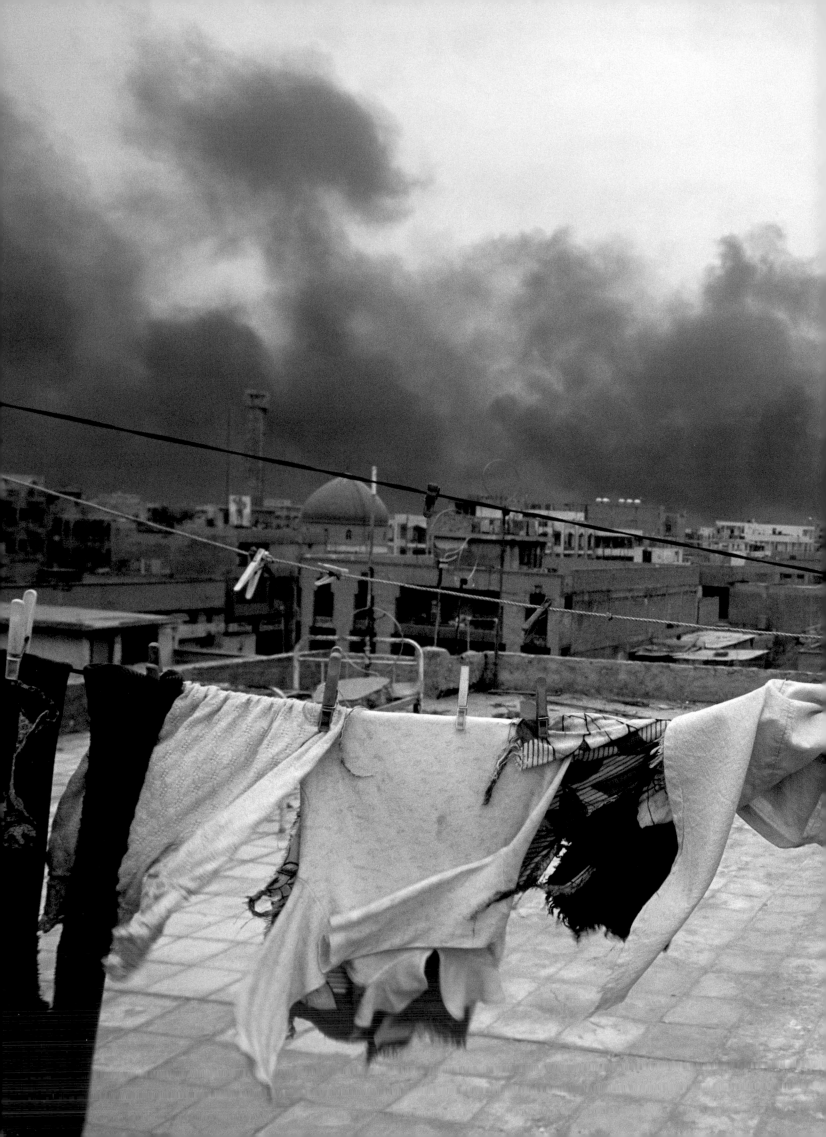

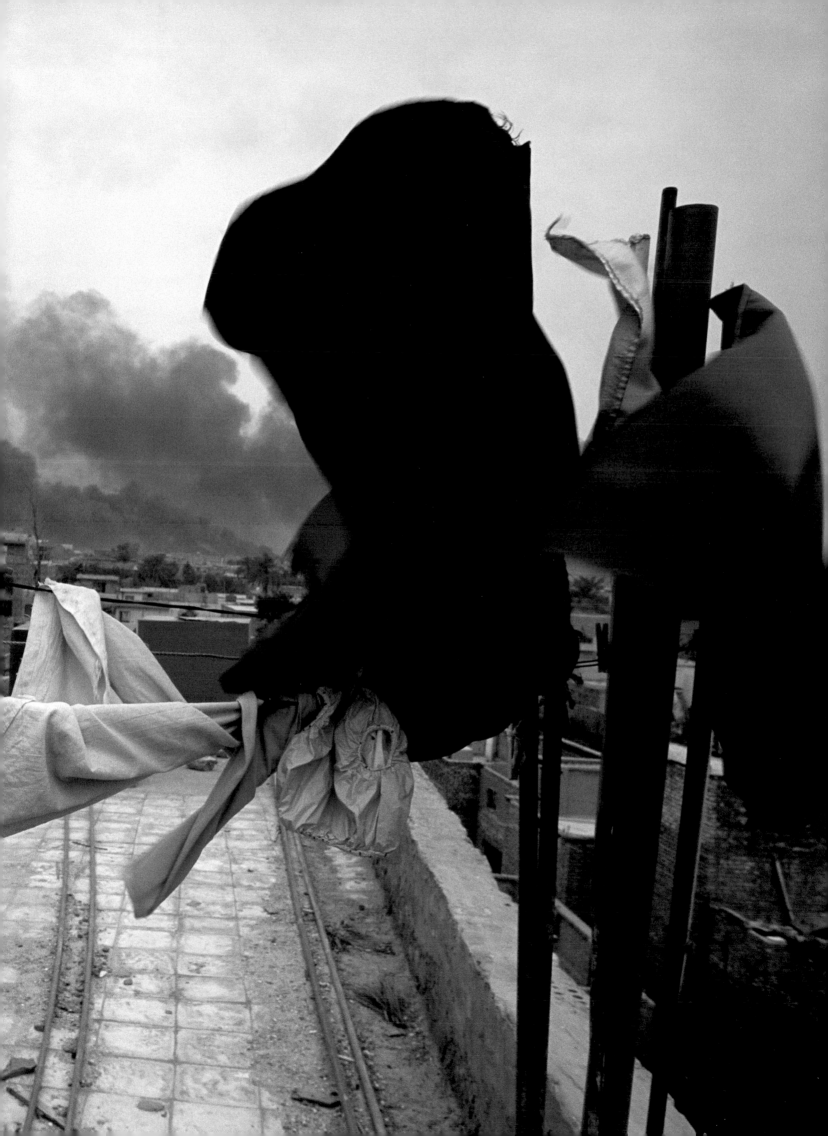

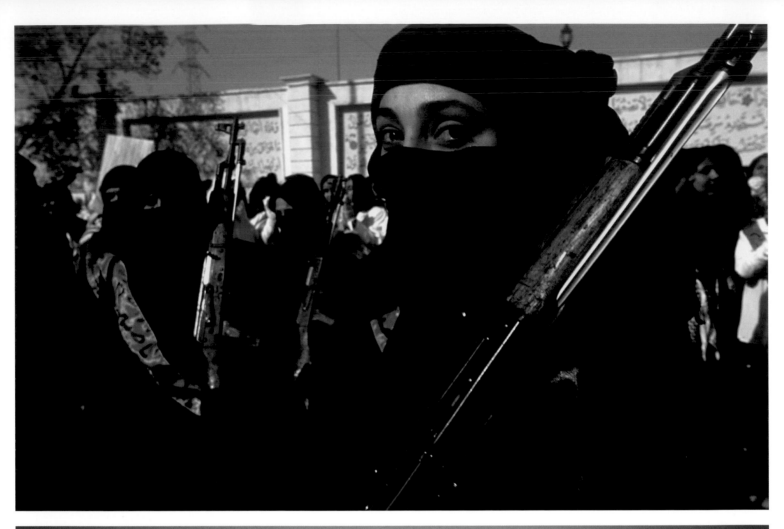

Above. A military parade in Tikrit, a town northwest of Baghdad on the Tigris River, before the invasion of Iraq, February 2003.

Below. Armed with toy Kalashnikovs, schoolboys wait beside the Tigris River in Baghdad to greet a busload of foreign peace activists, March 2003, who had come to act as human shields in anticipation of the invasion. The boys performed songs praising Saddam Hussein in a little parade.

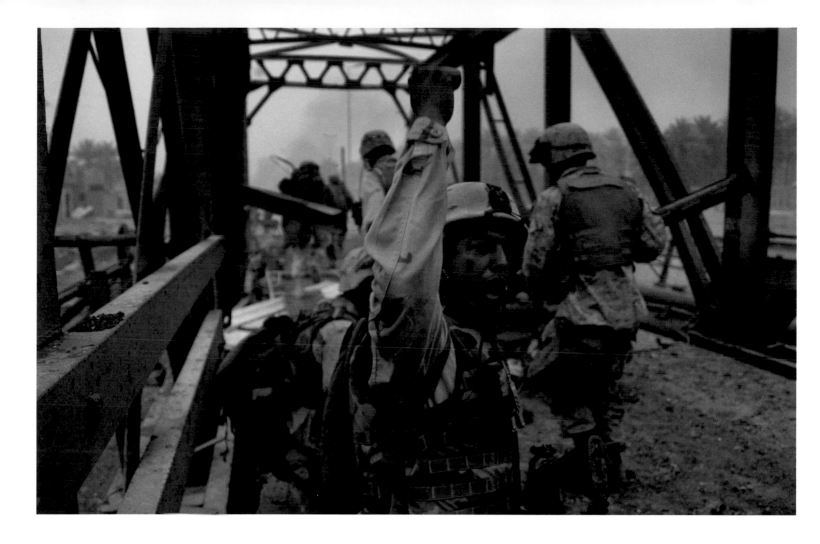

2003
THE BRIDGE
GARY KNIGHT

'Incoming rocket-propelled grenades burst in the sky above our heads and a Marine screams that they are coming from some houses 400 yards (365 metres) away. The tanks fire and .50 cal machine guns and assault rifles spit in reply, the smell of cordite drifts through the palm trees and the once silent grove is now smoking and animated...I jump out of my car with a camera and...run past the Marine command post up to Kilo and India Companies parked at a road junction firing grenades and 50 cal into houses 200 yards (185 metres) away. The Marines are advancing on foot to take Diyala Bridge.'

The battle for the Diyala Highway Bridge, about 15 kilometres (9 miles) southeast of Baghdad, was one of the first of the major assaults of the Iraq War. The 3rd Battalion 4th Marines captured the bridge on 6 April 2003, before pushing on into central Baghdad and taking part in the toppling of Saddam Hussein's statue on 9 April. Gary Knight documented the run-up to the action in his journal and photographed the combat over three days.

Above and following pages. The battle for the Diyala Highway Bridge, southeast of Baghdad, Iraq, 6 April 2003.

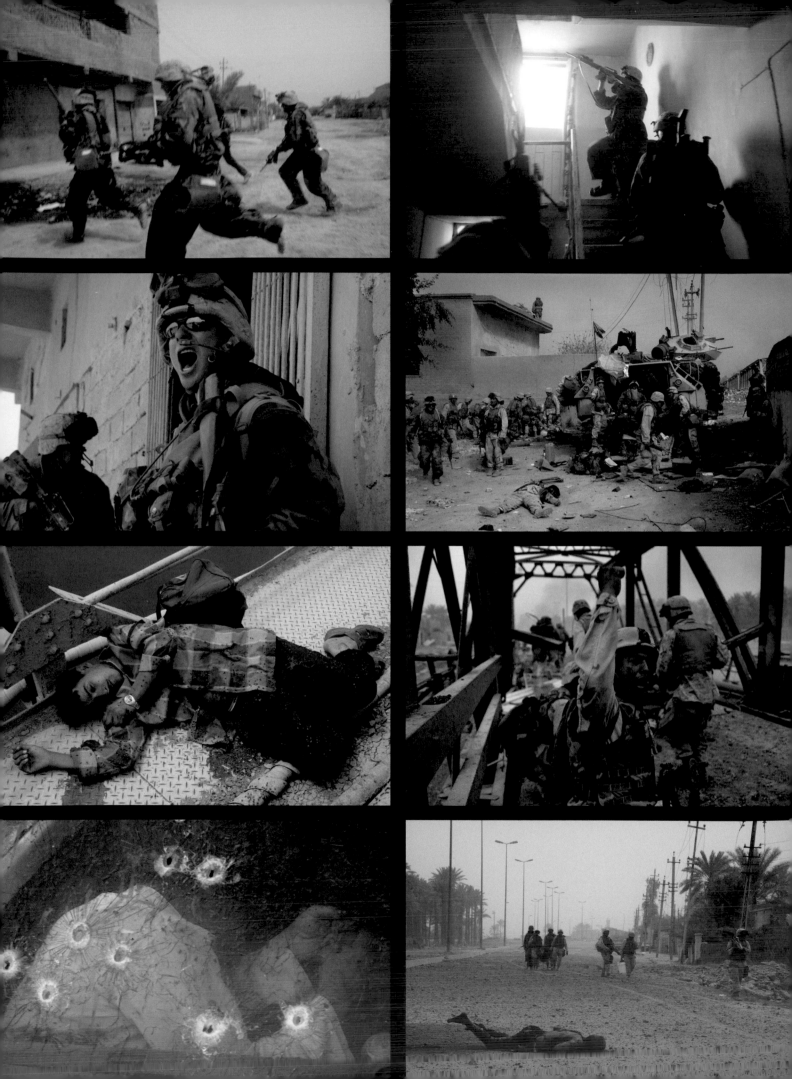

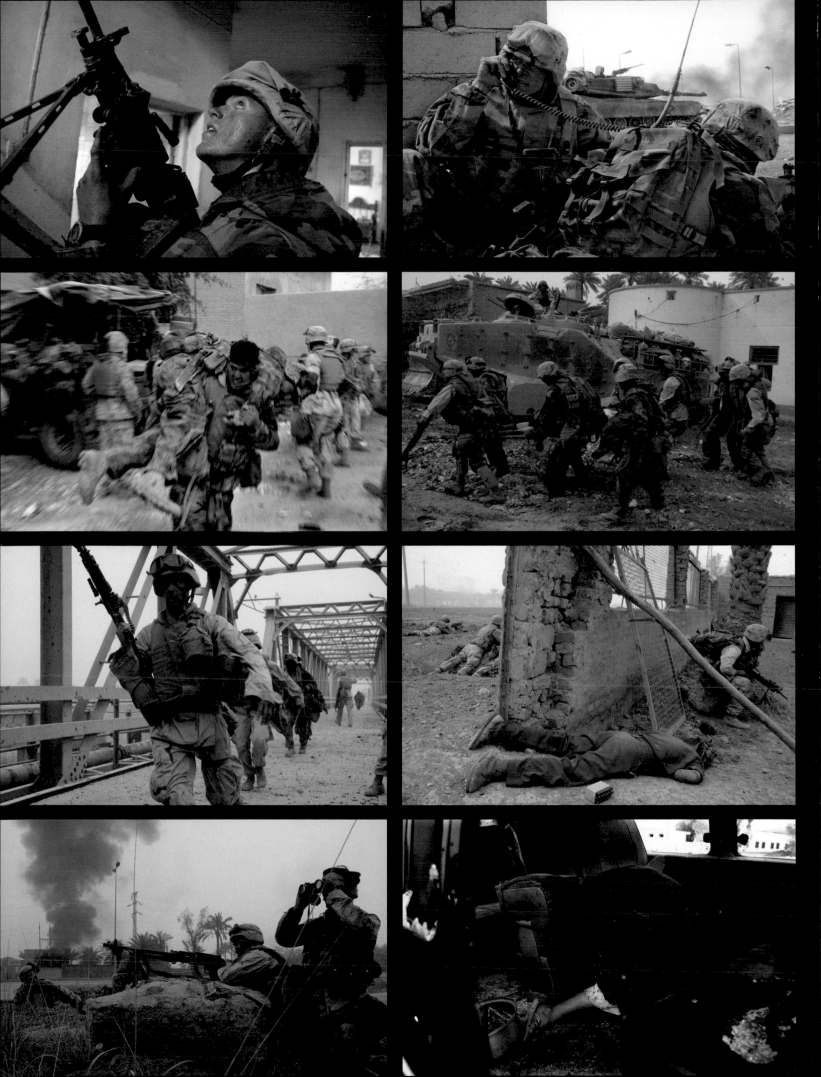

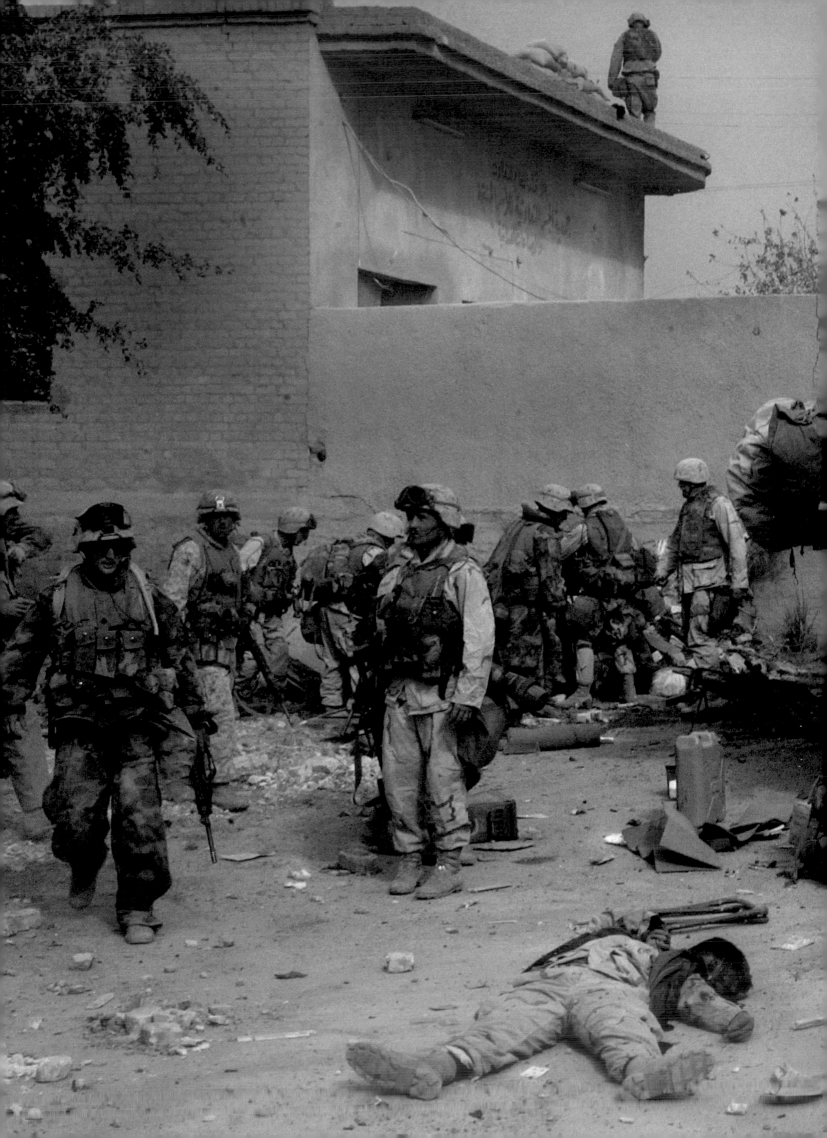

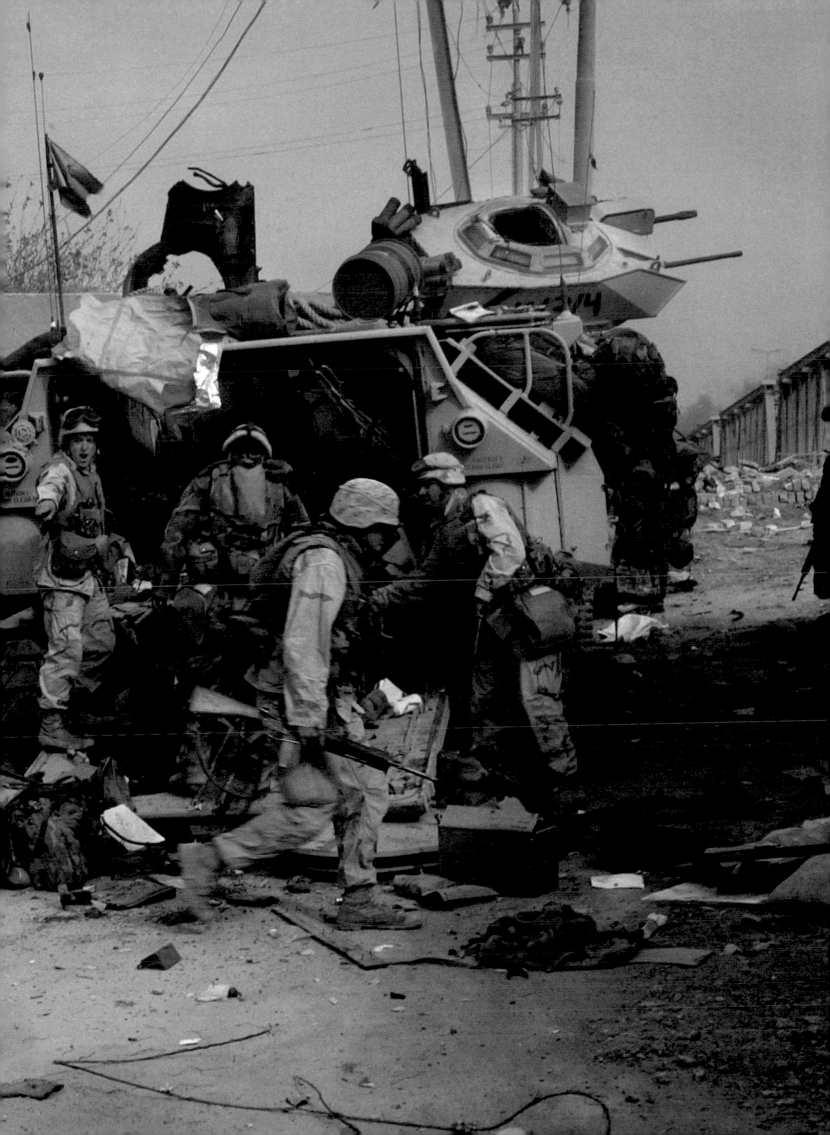

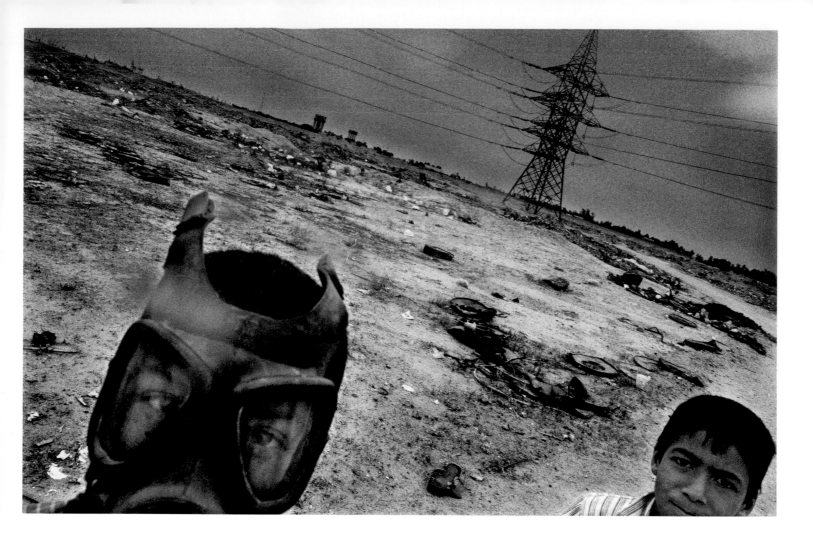

2003
LANDSCAPES OF WAR
ANTONIN KRATOCHVIL

In March and April 2003, a combined force of troops from the United States, the United Kingdom, Australia and Poland invaded Iraq to topple Saddam Hussein's government. In addition to air attacks on Baghdad, Iraq's capital, an air and amphibious assault was made on southern Iraq to secure the oil fields around Basra and the Al-Faw Peninsula on the Persian Gulf. Antonin Kratochvil's series of 'warscapes' shows the scars left by tanks and troops during their invasion of southern Iraq in April 2003.

Boys play on the wrecked streets of Umm Qasr, a port city with a canal connection to the Persian Gulf, south of Basra and close to the border with Kuwait.

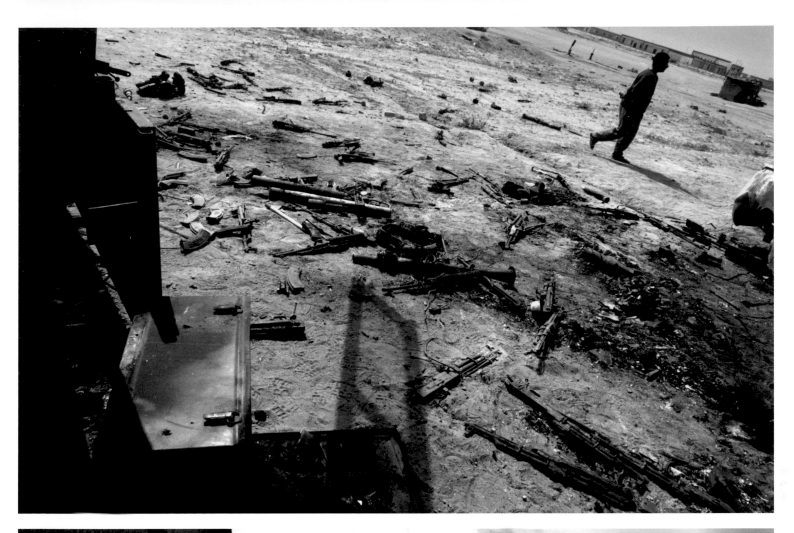

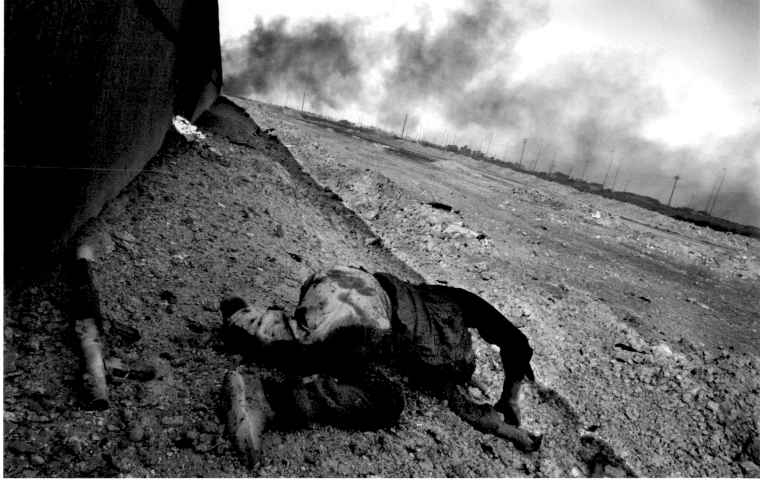

Above. Debris from a battle litters the landscape on the outskirts of Basra. British forces fought for several weeks to take control of the city, one of Iraq's largest and a centre for oil production.

Below. An Iraqi soldier lies dead on the front line near Basra. The Iraqis launched mortars and grenades at British troops from this former school compound.
Overleaf. Residents of Basra flee as their city is besieged.

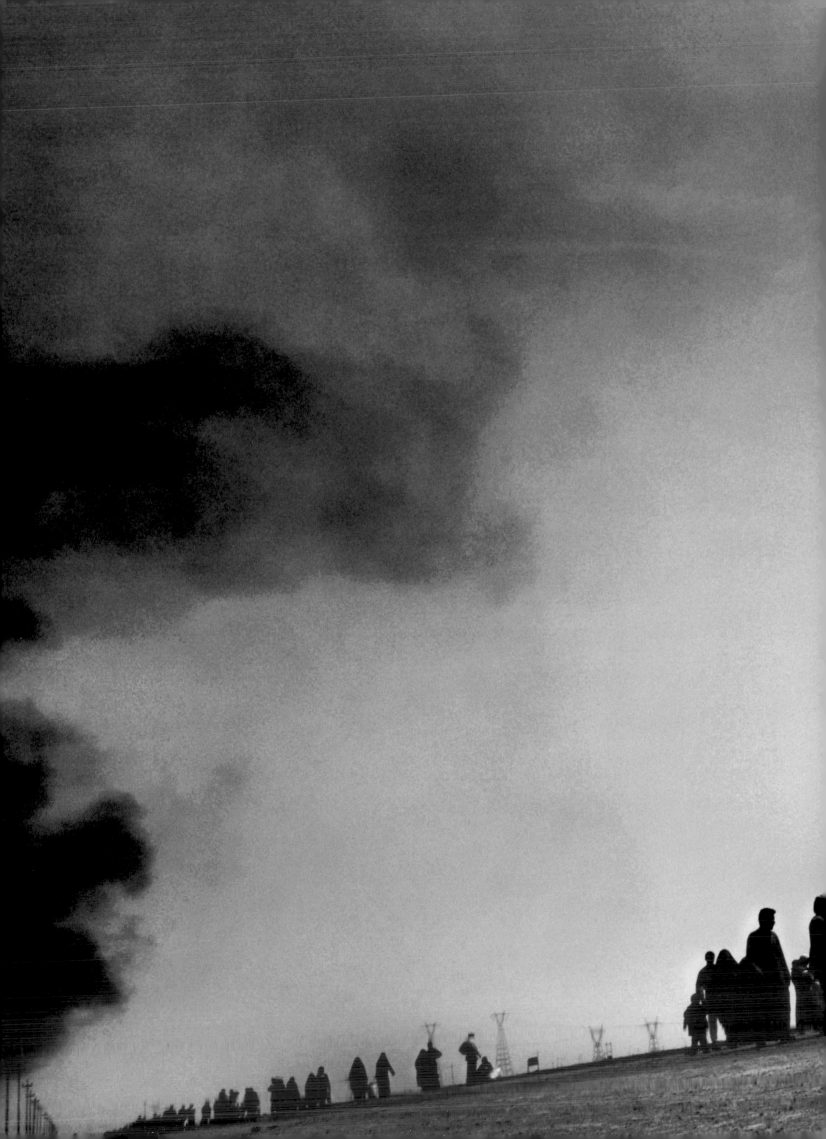

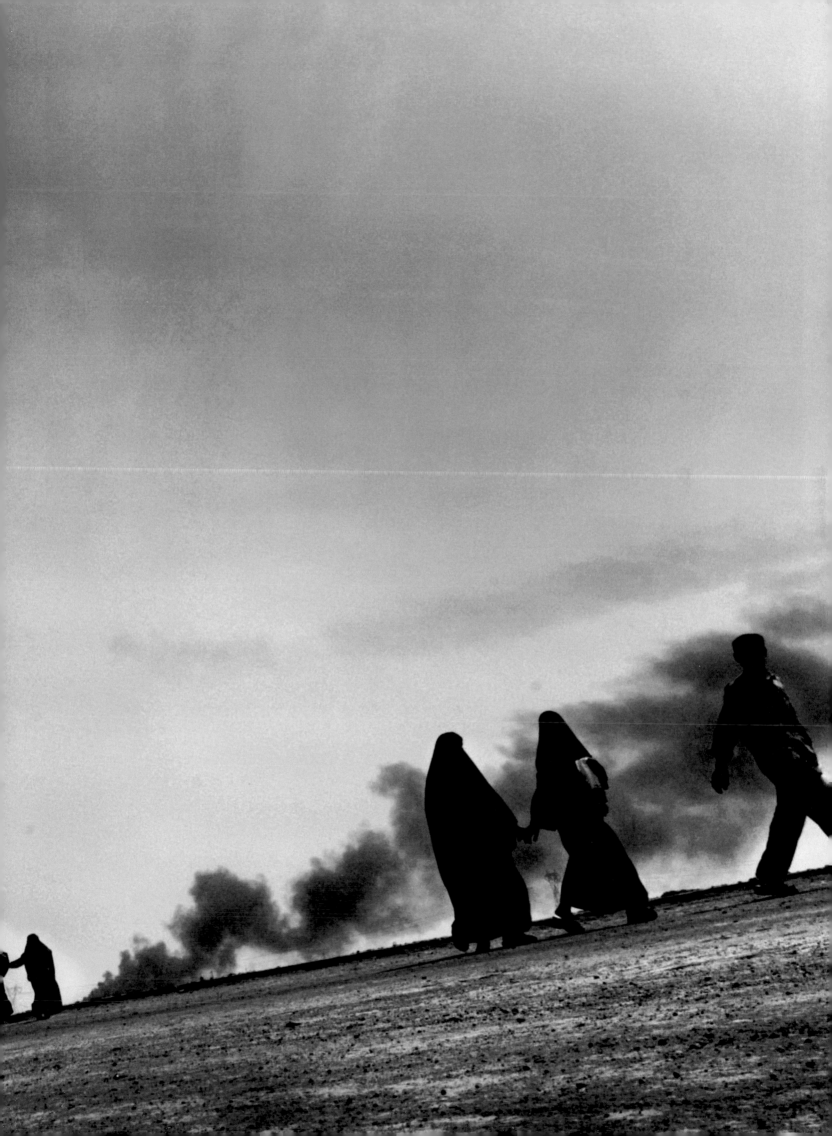

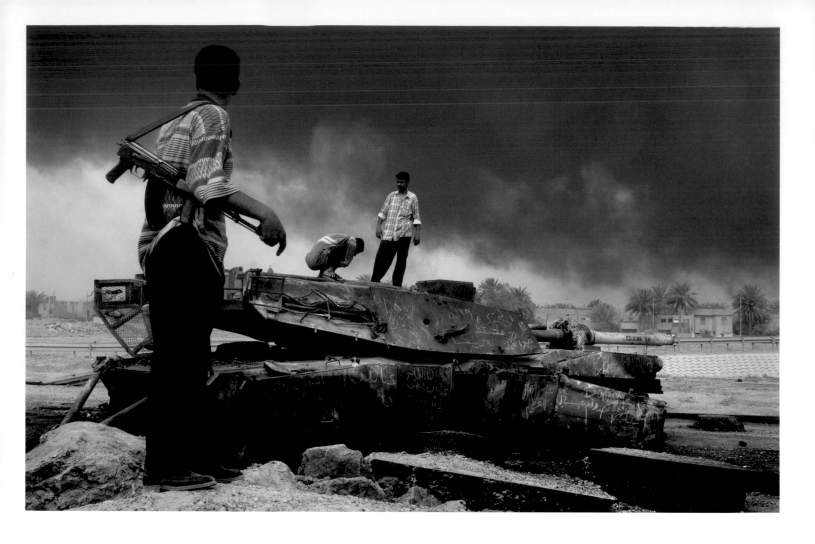

2003—2008
THE IRAQ WAR
FRANCO PAGETTI

Franco Pagetti has covered the conflict in Iraq since January 2003, just before the US-led invasion. His images document the horrors of war, the brief flowering of hope after ousting Saddam Hussein, the rise of rebel groups and the inexorable descent into sectarian civil war. The invasion (March–May 2003) saw the fall of Baghdad. On 19 March, coalition forces began 'Operation Iraqi Freedom', bombing Iraq in order to end Saddam Hussein's regime. Although coalition forces were hampered by sandstorms and smoke from burning oil wells, the Iraqi government and military collapsed within three weeks. Following the regime's collapse, Shi'a and Sunni Islam factions began fighting for dominance. By April 2004, US forces were confronted by large-scale resistance against the occupation, led by Shi'ite followers of Moqtada al-Sadr. In November, the coalition mounted 'Operation Phantom Fury' against insurgents in Al Fallujah, one of the fiercest battles yet. In 2007, amid escalating violence, thousands of additional US troops were sent to Iraq in order to strengthen security in Baghdad.

A wrecked armoured vehicle disabled by Iraqi forces in Baghdad, April 2003. Once the crew had been rescued, a US F-16 jet fighter destroyed the tank to prevent it being used by enemy forces.

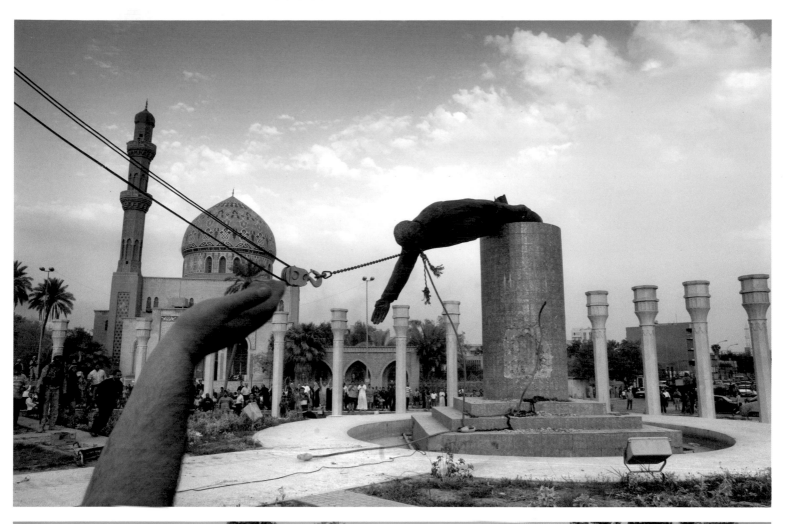

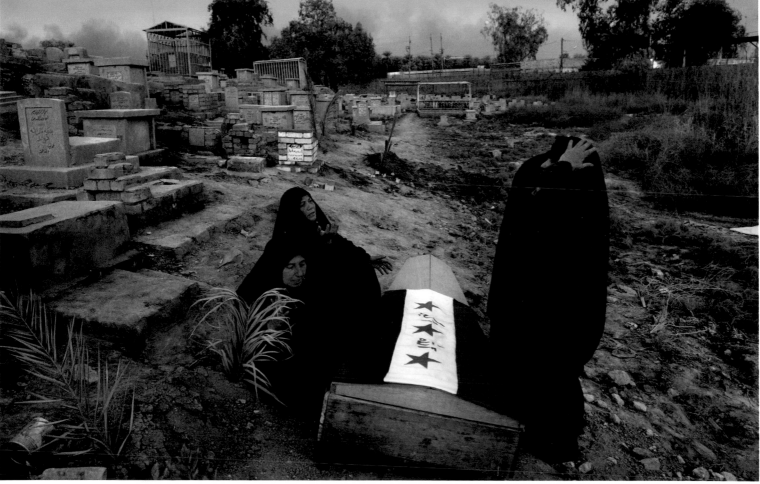

Above. On 9 April 2003, after the fall of Baghdad, Iraqis and US Marines topple the statue of Saddam Hussein in Firdos Square, Baghdad's main public space, near the Palestine Hotel, the base for international reporters. This episode, broadcast live throughout the world, was one of the prevailing images of the Iraq War.

Below. A family bury their father at Baghdad's Baratha cemetery, March 2003. During the fighting, Baghdadis were forced to bury their dead here rather than at An Najaf, one of Shi'a Islam's holiest cities.

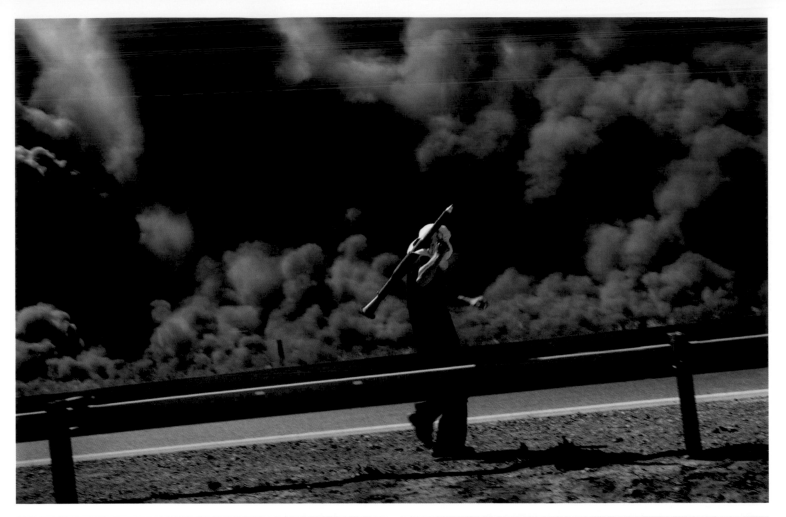

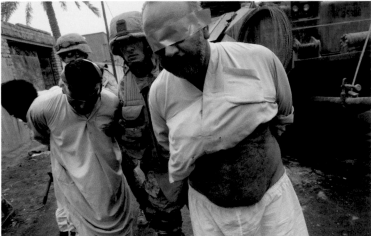

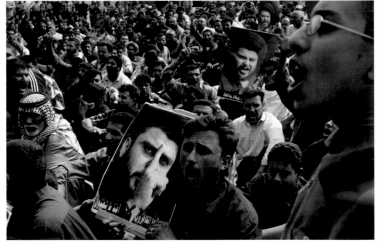

Above. Members of the resistance attack a convoy transporting oil and other materials on the Baghdad to Jordan highway, near Al Fallujah, April 2004.

Left. US Marines of the 1st Marine Expeditionary Force, Lima Company and Weapons Company arrest suspected insurgents in Al Fallujah, November 2004.
Right. Supporters of Moqtada al-Sadr stage a protest in front of the Palestine Hotel, Baghdad, after their newspaper was closed down by US forces, April 2004.

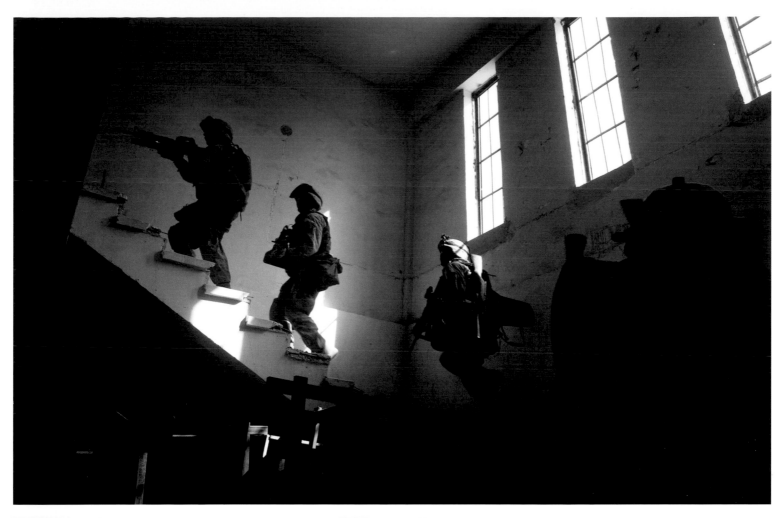

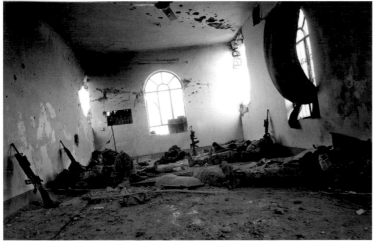

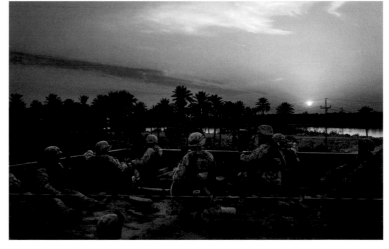

Above. US Marines search houses on an offensive against rebels in Al Fallujah, November 2004. Al Fallujah, about 50 kilometres (30 miles) west of Baghdad, had been the centre of an insurgency that dogged US and Iraqi forces for over a year, and where it was believed terrorist leader Abu Musab al-Zarqawi was based.

Left. US Marines take a break during a military offensive against Iraqi insurgents in the northeast of Al Fallujah, November 2004.
Right. During a confrontation with insurgents on the south bank of the Euphrates in Al Fallujah, US Marines surveil the area from a rooftop, November 2004.

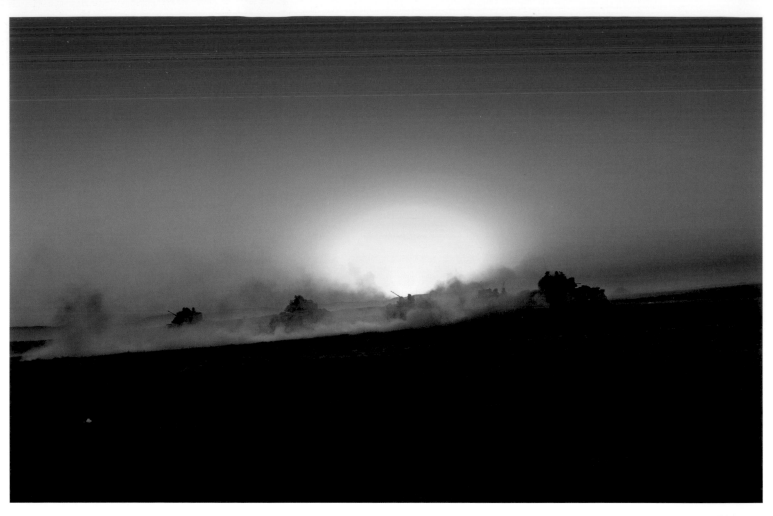

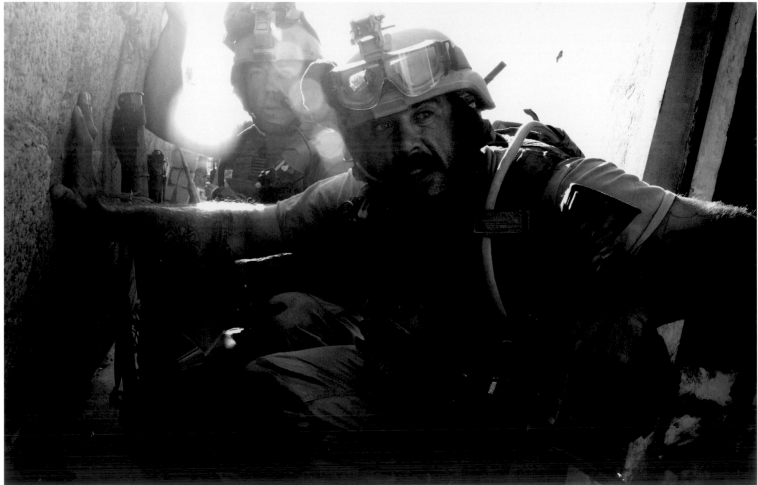

Above. The 3rd Armored Cavalry Regiment takes position in the desert outside Tall 'Afar, ready to launch a massive attack, dubbed Operation 'Restoring Rights', on the Al Qaeda refuge in September 2005. US troops pushed north through the town's ancient streets to the stronghold district of Sarai.

Below. During Operation 'Restoring Rights', US and Iraqi troops search for insurgents in Tall 'Afar, a town near the Syrian border, September 2005. Having cleared Shi'ite civilians from their homes, they advanced on the area under Al Qaeda control, battling sniper fire and grenades from insurgents in the alleyways.

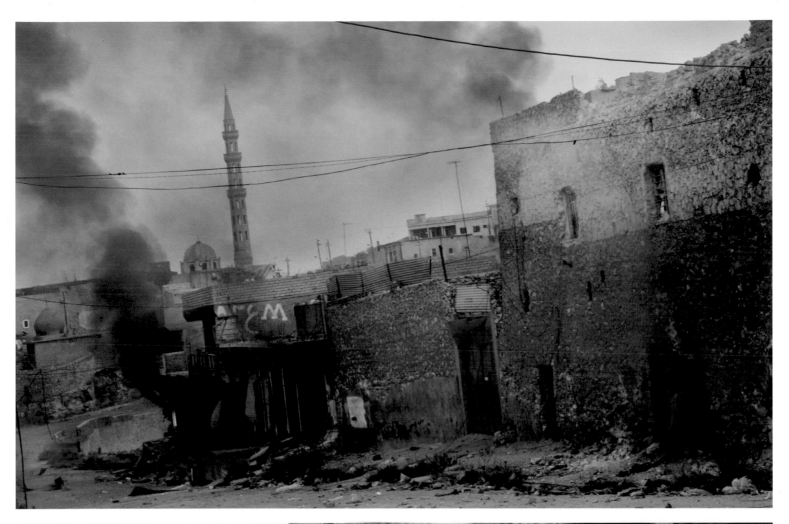

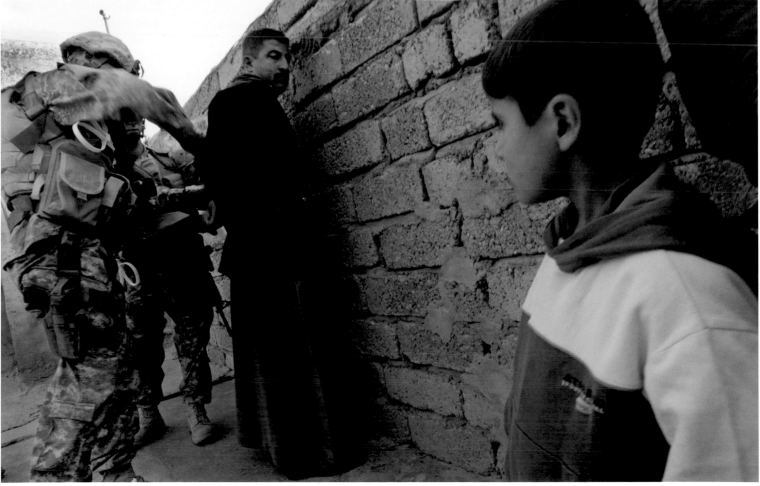

Above. Smoke fills the air on the battle-charred streets of Tall 'Afar, September 2005. In Iraq's northwest corner, close to the Syrian border, this besieged town has been ruled like a fiefdom by Al Qaeda forces for months.

Below. Members of 82nd Airborne Division, during a raid in search of insurgents around Tall 'Afar, arrest a suspected terrorist in front of his son.
Overleaf. A US Army helicopter fires flares to deter anti-aircraft missiles as it passes over the Shi'ite shrine of Imam Musa al-Kadhim, Baghdad, June 2007.

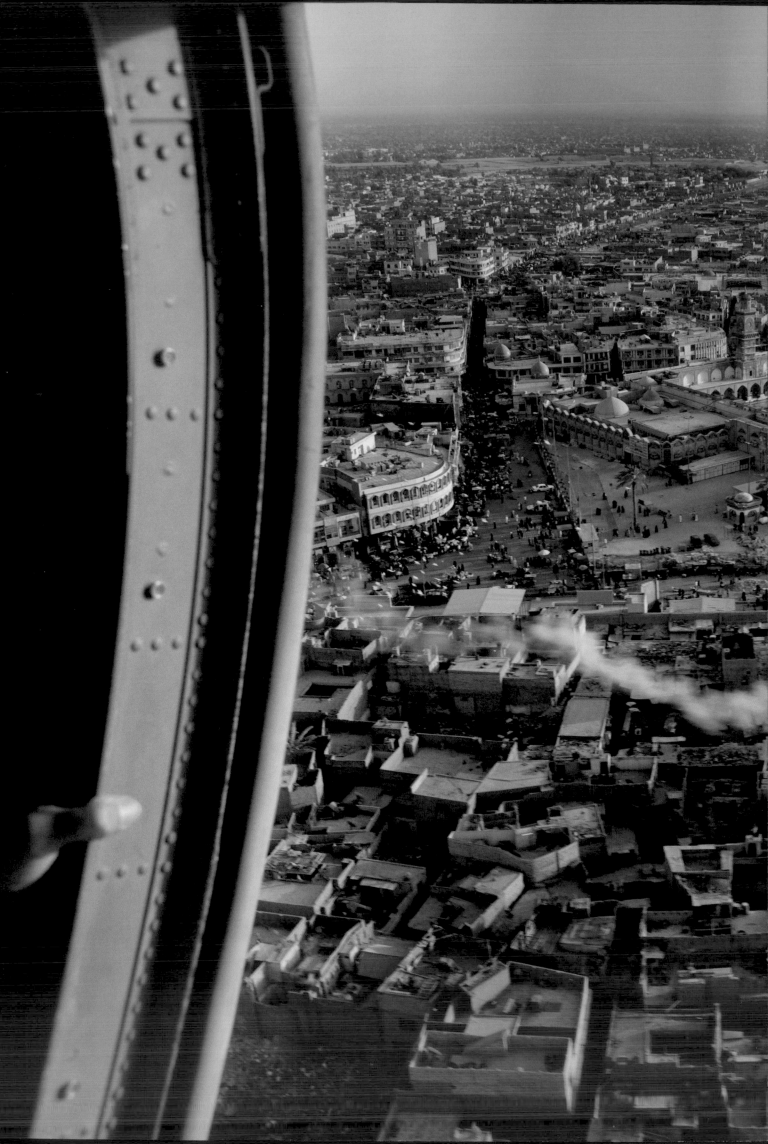

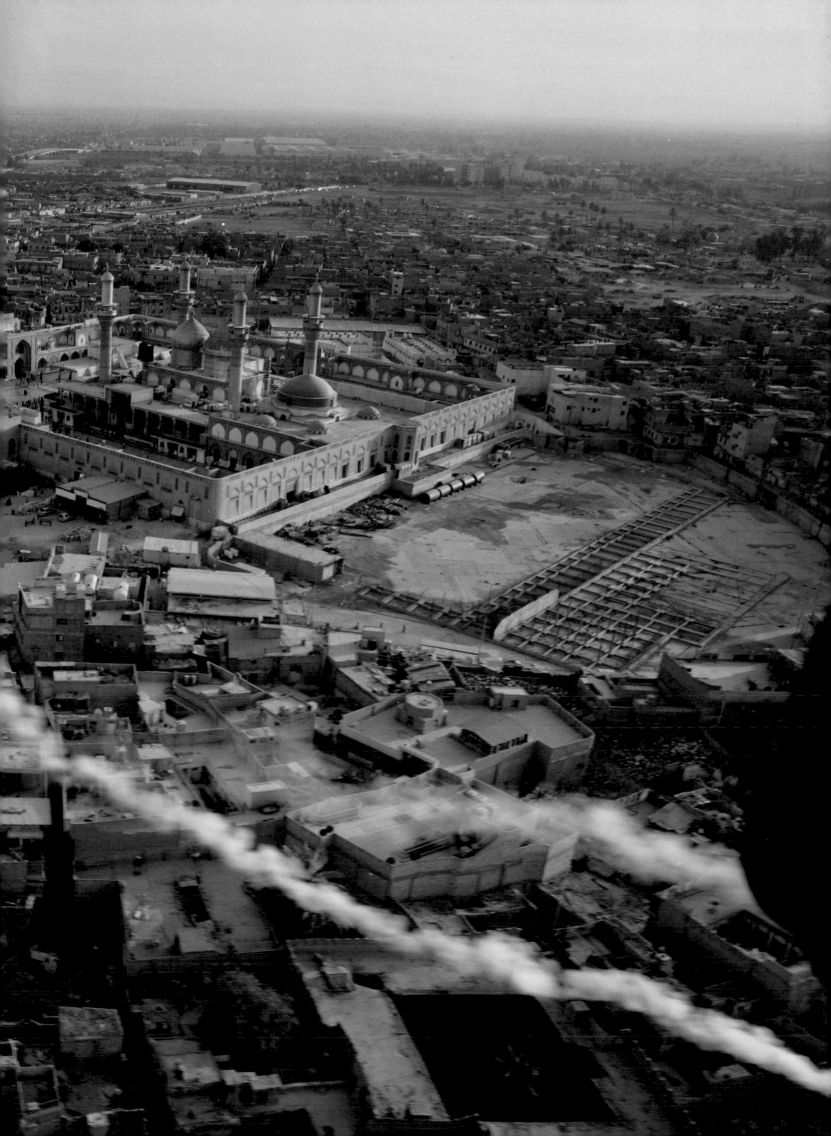

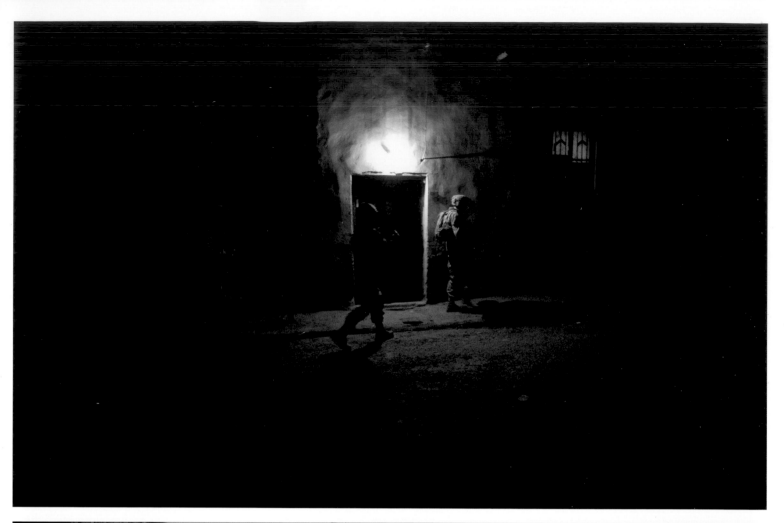

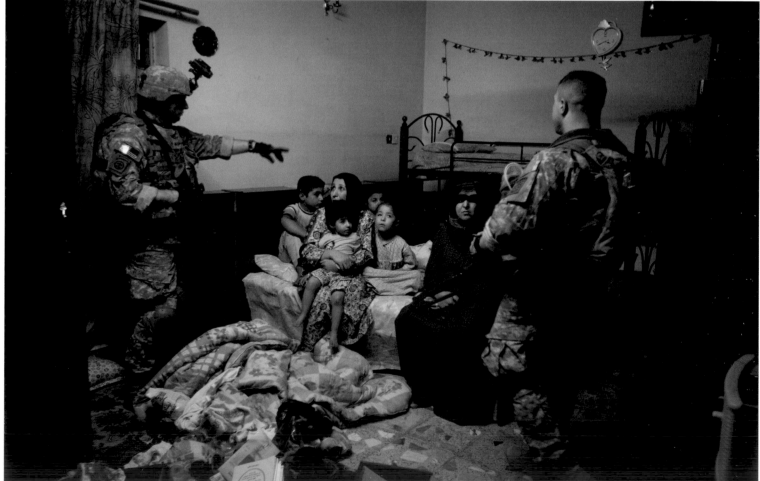

Above. Soldiers from the 'Smash Platoon' of the 82nd Airborne Division perform a target raid for the arrest of two Al Qaeda supporters in Samarra, a town 115 kilometres (70 miles) north of Baghdad, September 2007. This is the platoon's last mission before returning to the United States.

Below. Soldiers from the 'Smash Platoon' (2nd Platoon, 2nd Battalion, 505th Parachute Infantry Regiment, 3rd Brigade Combat Team, 82nd Airborne Division) guard a family during a target raid on a house in Samarra, September 2007. They arrested two men suspected of being Al Qaeda terrorists.

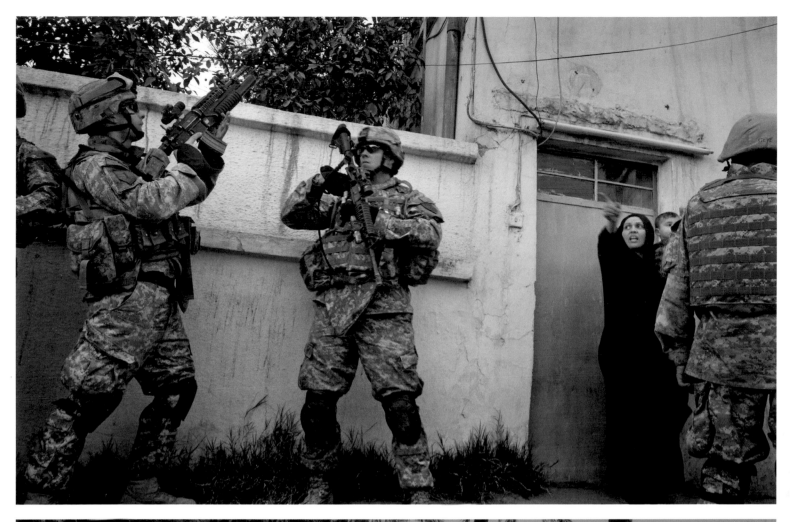

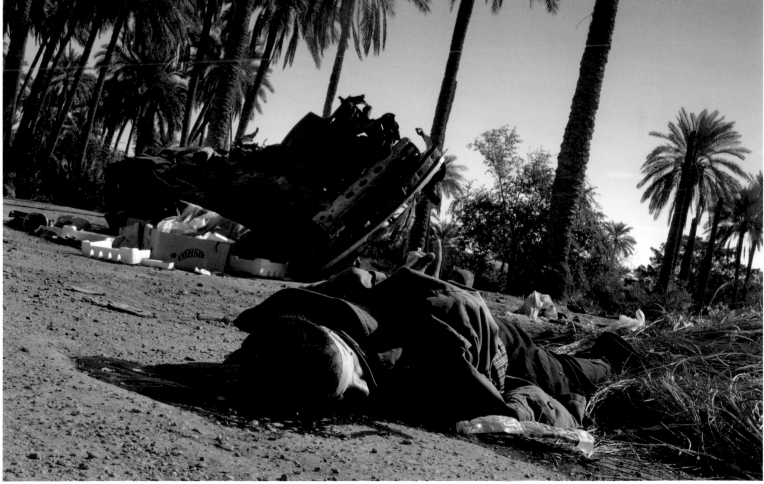

Above. Soldiers from 1st Battalion, 26th Infantry Regiment 'Blue Spaders', 2nd Brigade Combat Team, 1st Infantry Division, from Forward Operating Base Apache, elicit information regarding insurgent activity from residents in Baghdad, January 2007.

Below. A soldier takes cover behind an armoured vehicle as a man lies dead in the Adhamiyah district of Baghdad, February 2007. The execution bore the hallmarks of Shi'ite death squads: blindfolded, with hands and feet bound, a single bullet was shot into the back of the man's head.

Above. In the White House's private presidential lift, First Lady Laura Bush brushes down the President's suit as they head down to an evening function.

Left. President Bush starts his day at the Oval Office early in the morning, with his dog Barney by his side.
Right. President Bush, before an afternoon cycle ride, at a secret service training facility near Washington, DC.

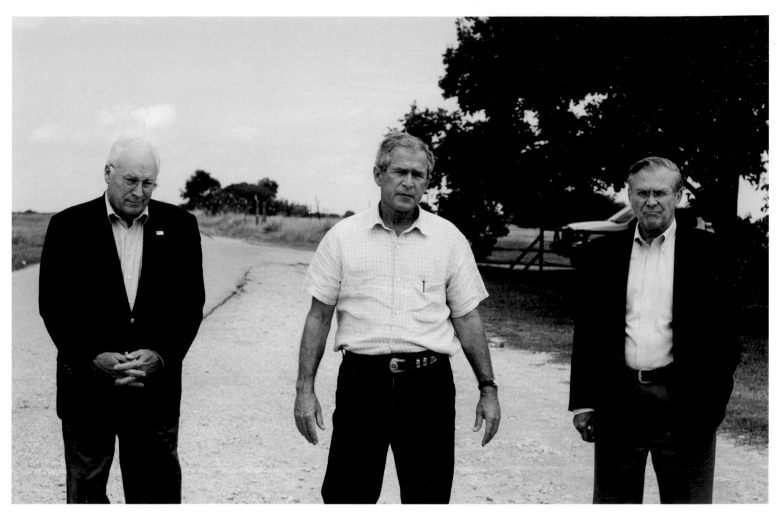

Above. Vice President Dick Cheney, President George W. Bush and Secretary of Defense Donald Rumsfeld at the President's ranch outside Crawford, Texas.

Left. President Bush during his daily morning security briefing in the Oval Office.
Right. President Bush on the steps of *Marine One*, the presidential helicopter, after landing on the South Lawn of the White House, Washington, DC.

2004
US PRISONS IN IRAQ
RON HAVIV

During Saddam Hussein's regime, Abu Ghraib – a prison about
32 kilometres (20 miles) west of Baghdad – was notorious for its
cramped and filthy conditions. After the regime's collapse in April
2003, when the complex was stripped bare by looters, the coalition
government updated the facilities and Abu Ghraib was put in the
hands of the US military. The prisoners, including women and
teenagers, ranged from common criminals to suspected insurgents.
In April 2004, the press revealed conclusions from the US Army's
Taguba Report, highlighting instances of systematic physical,
psychological and sexual abuse carried out by US military police
and intelligence officers. Although the perpetrators were reprimanded
or convicted, and the US government declared the Abu Ghraib
incident isolated, there has been evidence since then that human
rights violations were more widespread. The Abu Ghraib scandal
forced the United States to re-examine their treatment of Iraqi
detainees. Ron Haviv photographed Iraq's US-run prisons after
the new standards came into force.

Newly arrived Iraqi detainees are processed at Abu Ghraib prison, October
2004. After registering, the detainees are told the rules and held here for several
days before joining the prison's general population.

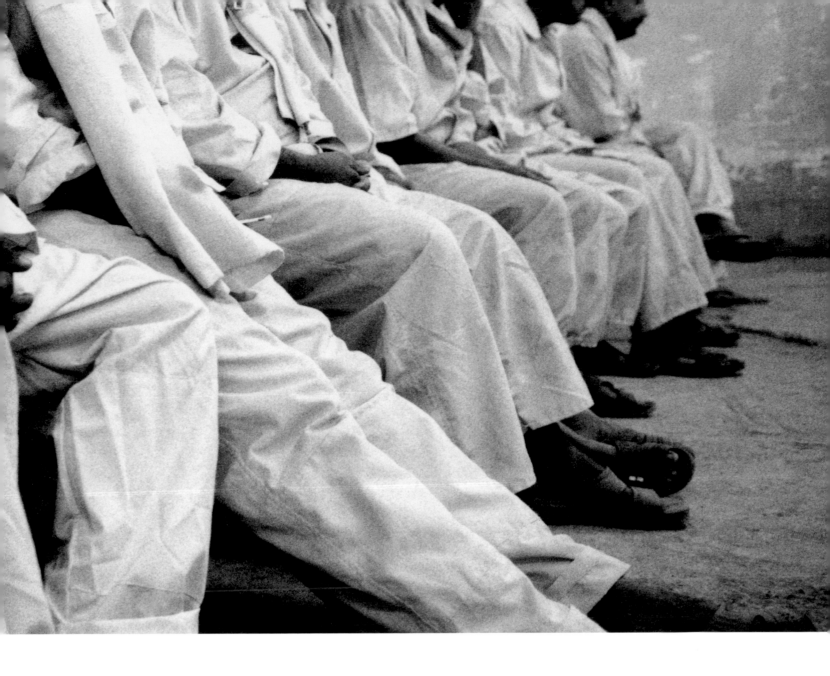

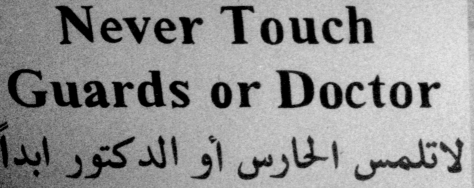

ce Never Touch
Guards or Doctor

Hea
at all time

ابتع لاتلمس الحارس أو الدكتور ابداً عندما تكون
طول الوقت

Signs outlining rules for Iraqi detainees at a prison in Baghdad, October 2004. The
prison was run by the 1st Cavalry Division, a huge combat division of the US Army.

own
out of cell
رأسك الى الأس
خارج القفص

Follow all guard orders
اتبع جميع تعليمات
الحـــارس

Iraqi detainees at Abu Ghraib prison, October 2004.

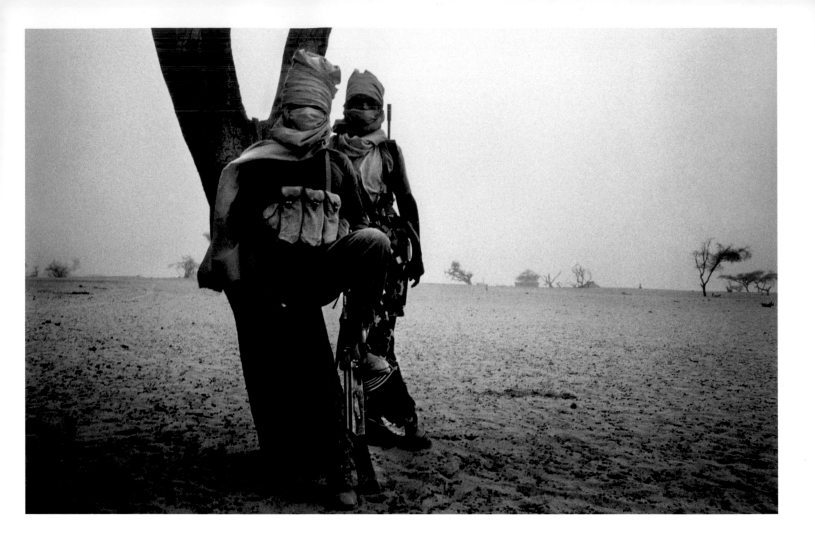

2004—2007
DARFUR
VII

Darfur was a nameless corner of Africa until conflict erupted in 2003. About the size of France and home to some 80 tribes and ethnic groups, Darfur lies in the arid western region of Sudan. Tensions over land and widespread resistance to Arab rule sparked a war that the UN estimates has claimed 300,000 lives, displaced over 2.5 million within Darfur and created more than 200,000 refugees in neighbouring Chad. Although Sudan's government blamed Darfur's rebel groups for triggering the crisis, many prominent voices in the West and elsewhere described its actions as 'genocide'. In the words of human rights activist John Prendergast, 'The Khartoum-based government has carried out systematic ethnic cleansing. Darfur's suffering people are hemmed in camps, kept alive by abused humanitarian aid. But they have also frequently taken matters into their own hands and tried to craft their own solutions. Darfurians are not helpless. They have agency and they have a voice. With a little outside help, they can bring a future for Sudan that is peaceful, democratic and just.'

Marcus Bleasdale. Rebels of the Sudan Liberation Army (SLA) in Ji Dili, North Darfur, February 2004. About 12,000 SLA and Justice and Equality Movement (JEM) rebels, who accuse Khartoum of discriminating against black Africans in favour of Arabs, have been fighting government troops and the Arab Janjaweed since 2003.

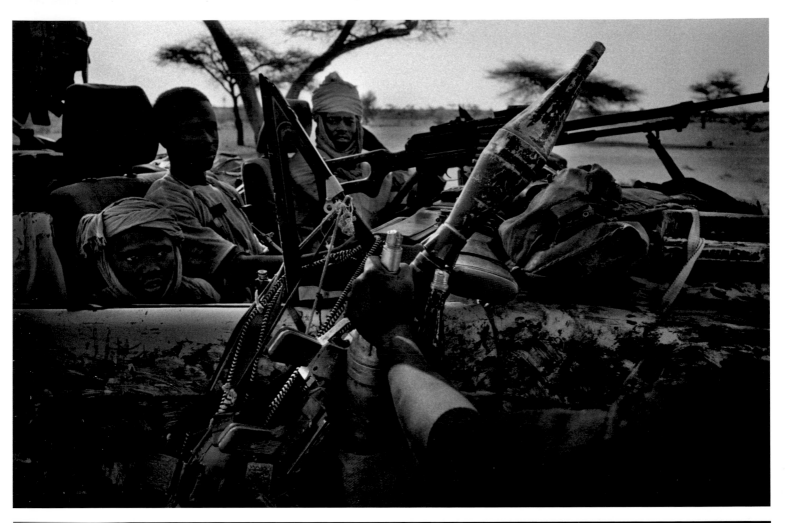

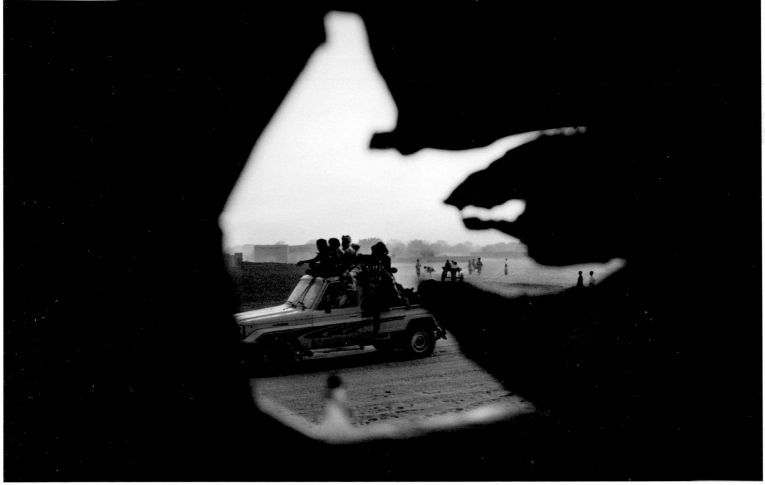

Above. Marcus Bleasdale. Sudan Liberation Army (SLA) rebels in Ji Dili, North Darfur, February 2004. Child soldiers are used by many of the rebel groups: some are actively recruited in the displacement camps and others are taken after their families are killed by government forces.

Below. Marcus Bleasdale. A multinational unit passes the Médecins Sans Frontières hospital in Adré, Chad, near the Sudanese border. The hole was created by a rocket-propelled grenade during the attack of 1 February 2007.

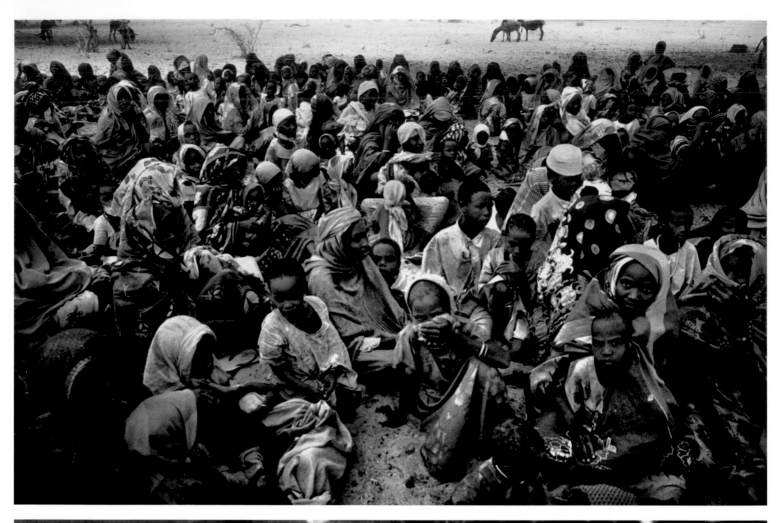

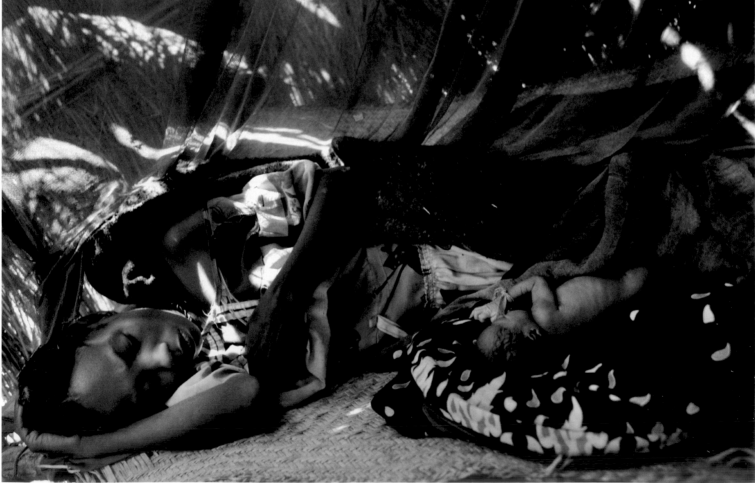

Above. Marcus Bleasdale. Displaced Sudanese take refuge under a tree in Carov, North Darfur, May 2004. There are an estimated 2 million displaced people in Darfur, surrounded by government troops to the east, west and south. To the north is desert wasteland, which claims the lives of their livestock and weaker family members.

Below. Marcus Bleasdale. Khadija Ishar and her daughter, natives of Chad, in the refugee camp in Mareina, eastern Chad, February 2007. She was pregnant with twins when an attack on her village forced her to flee. Having no food, one child was stillborn. The surviving child weighs less than 1 kilogram.

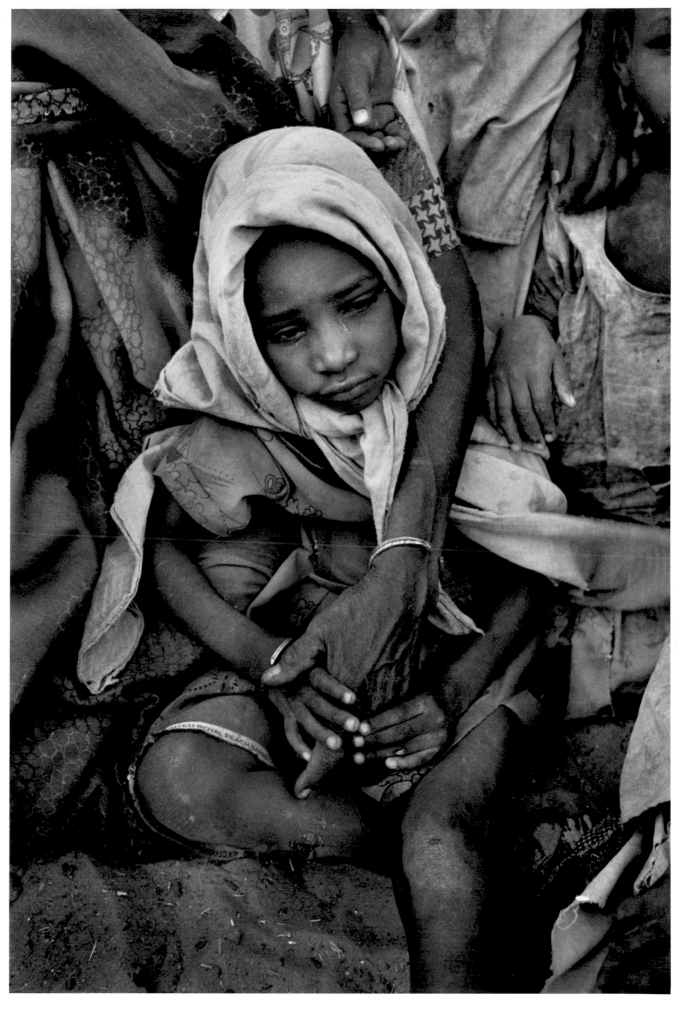

Marcus Bleasdale. A child waits with her mother in Disa, North Darfur, May 2004. Displaced from her village, which has been burnt down, her only source of food is berries from the trees.

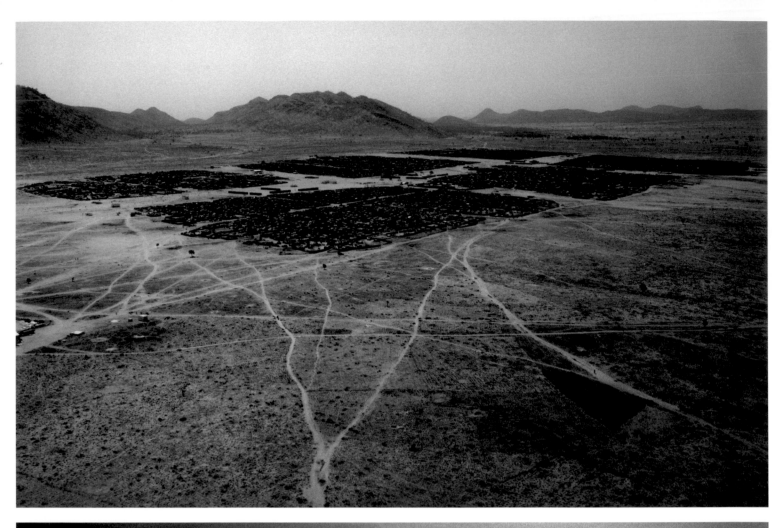

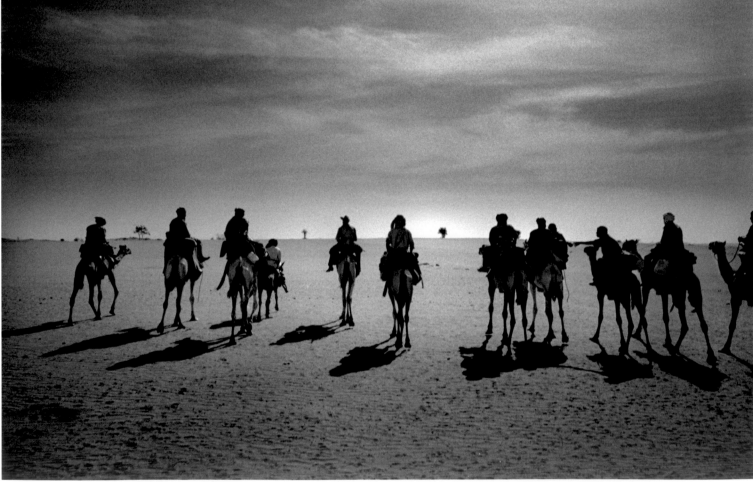

Above. Marcus Bleasdale. Djabal camp in eastern Chad, February 2007, has been home for over 20,000 Sudanese refugees during the past two years. They are neighbours to 10,000 Chadians across the valley who have been displaced by attacks from Janjaweed militia in southern Chad.

Below. Marcus Bleasdale. Rebels of the Sudan Liberation Army in Ji Dili, North Darfur, February 2004. Camels are used for travel during attacks as they can hide from air surveillance much better than vehicles.

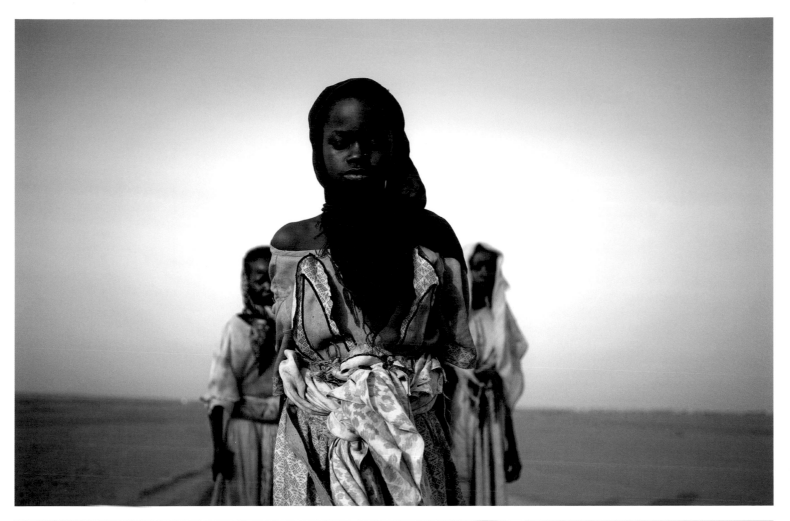

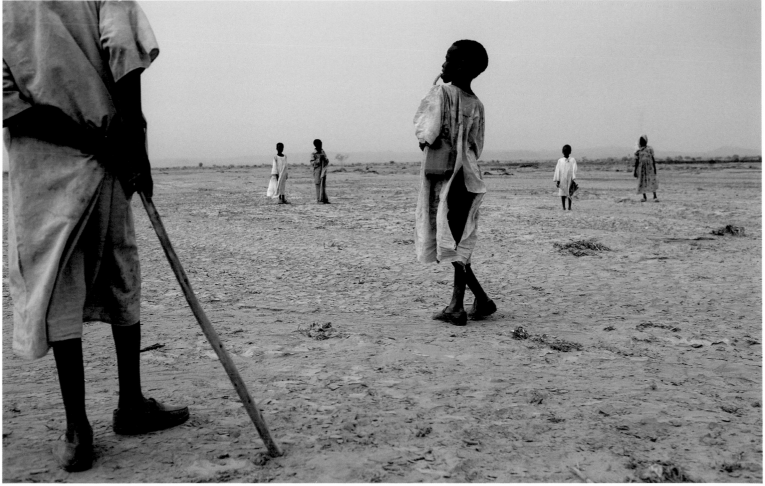

Above. Ron Haviv. Young girls leave a camp for internally displaced people in search of firewood, essential for cooking, June 2005. The work can take all day, leading them past government checkpoints and making them vulnerable to attacks. Girls as young as eight have been raped and killed trying to collect firewood.

Below. Ron Haviv. Young boys and girls herd sheep in territory controlled by the Sudan Liberation Army in North Darfur, June 2005.
Overleaf. Ron Haviv. A boy watches a UN World Food Programme helicopter leave Fina, an isolated town in South Darfur, June 2005.

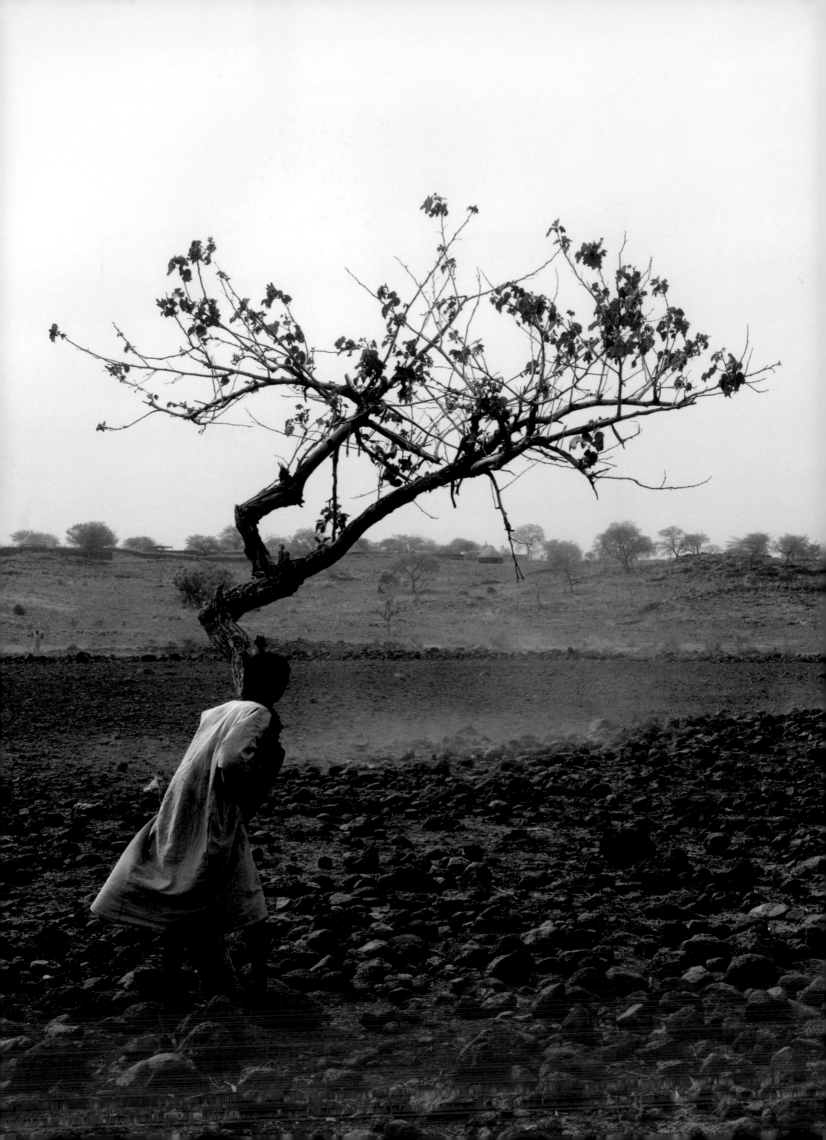

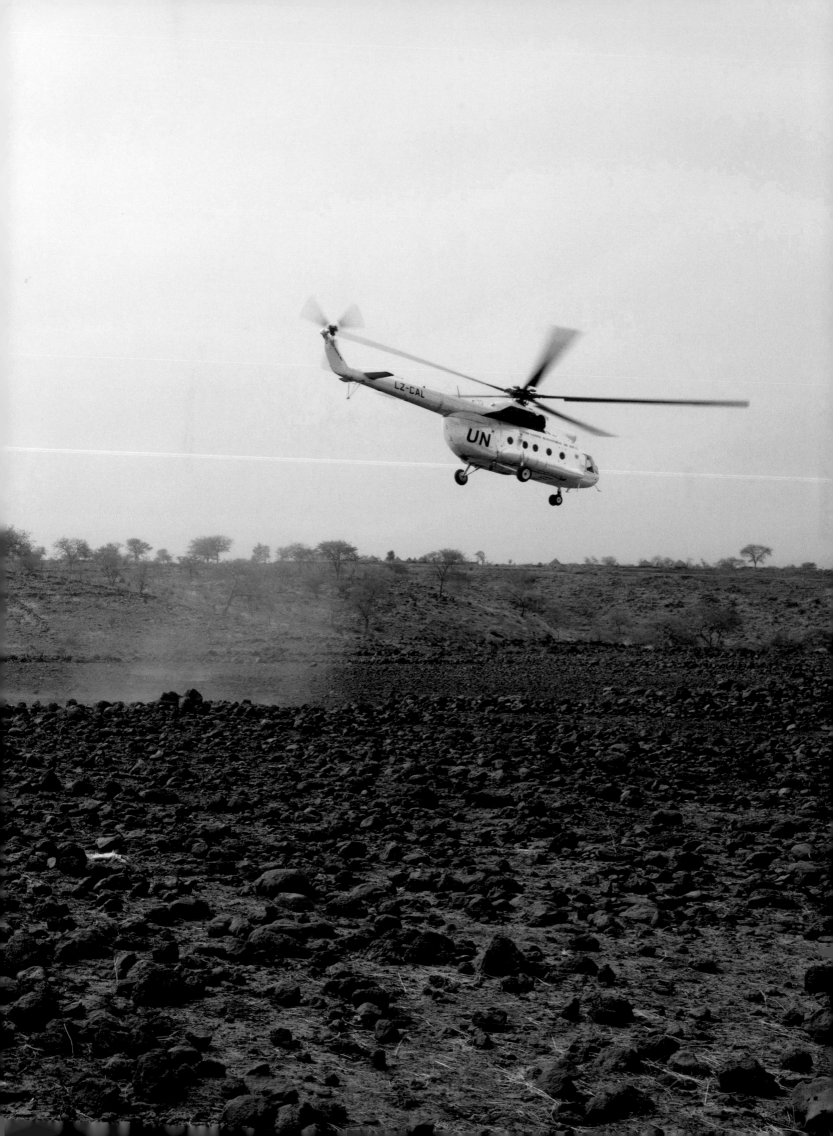

Above. Ron Haviv. Sudan Liberation Army soldiers in Tabit, about 45 kilometres (28 miles) south of El Fasher, capital of North Darfur, June 2005. Water for this area, which has a population of over 13,000, is supplied by only two handpumps.

Below. Ron Haviv. A child shields himself from a sudden gust of wind and sand at a camp for internally displaced people (IDP) in Selia, West Darfur, June 2005.

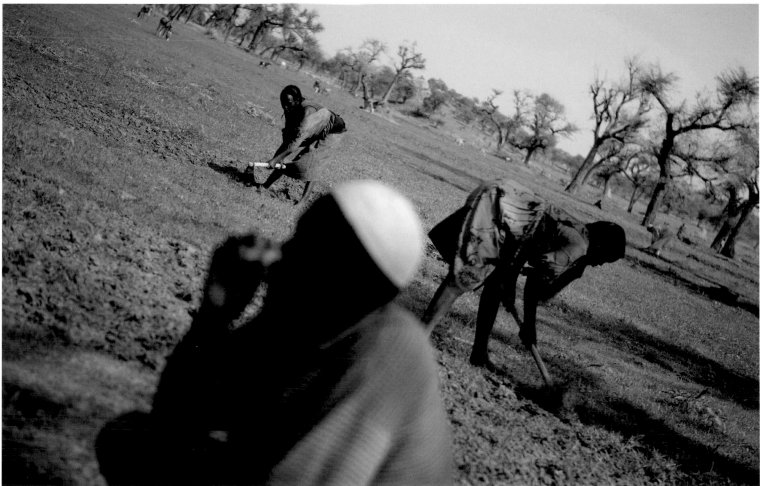

Above. Ron Haviv. Abu Shouk IDP camp, El Fasher, North Darfur, June 2005. More than 70,000 IDPs live at the camp, with new arrivals each week.

Below. Ron Haviv. Morni camp residents in West Darfur planting crops, June 2005. If they share the harvest with the Janjaweed, they are allowed to continue farming. **Overleaf. Gary Knight.** Women returning from Kutum market to Fata Borno IDP camp; African Union soldiers protect them from Janjaweed attack, January 2007.

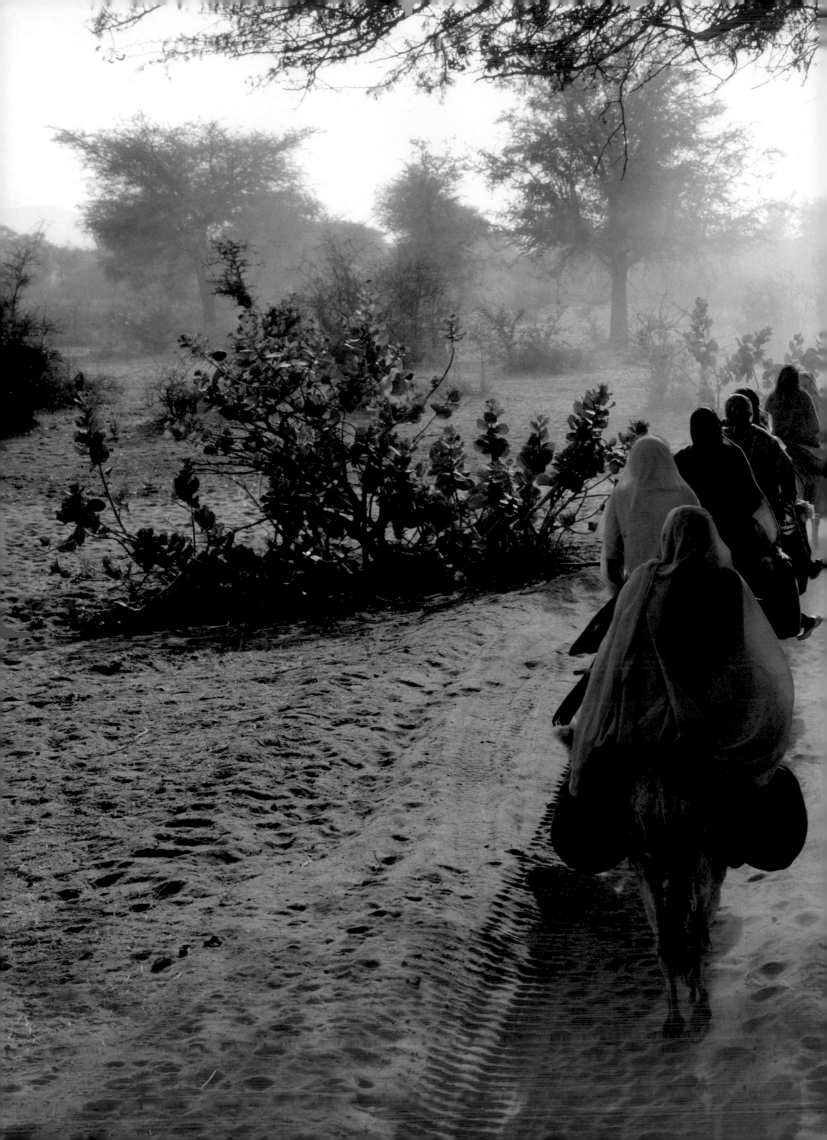

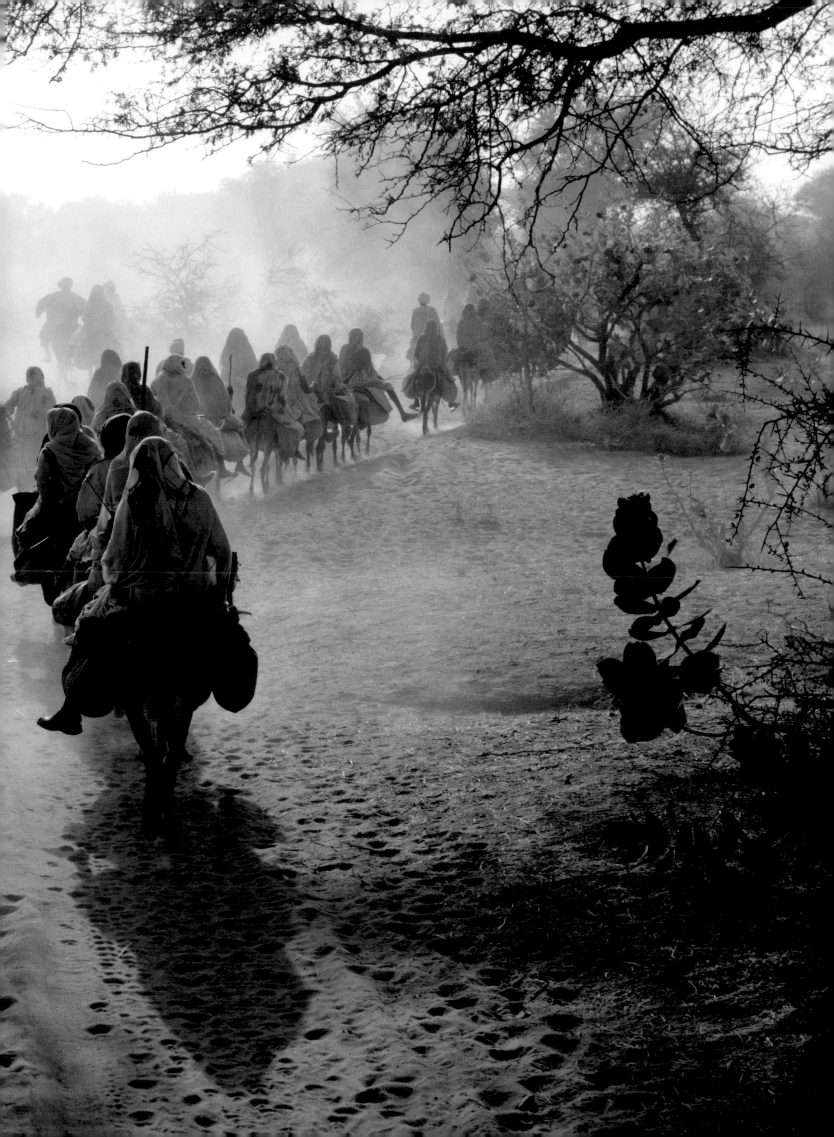

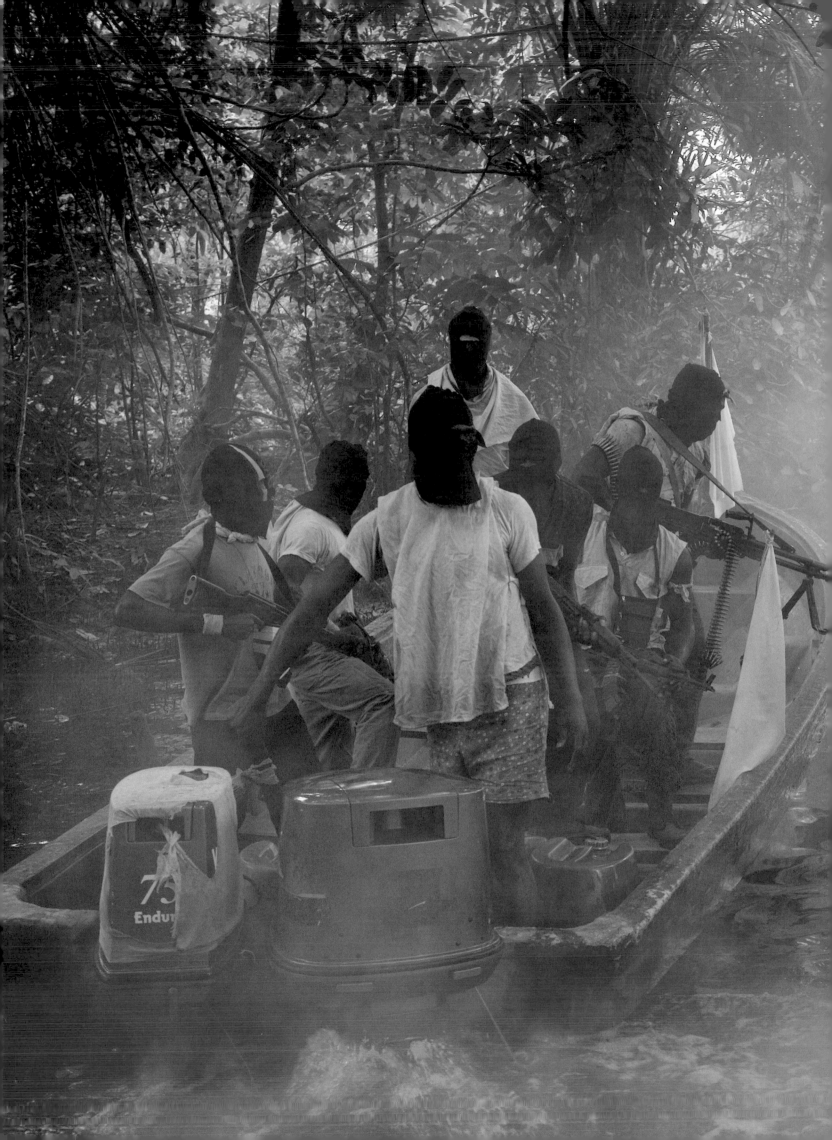

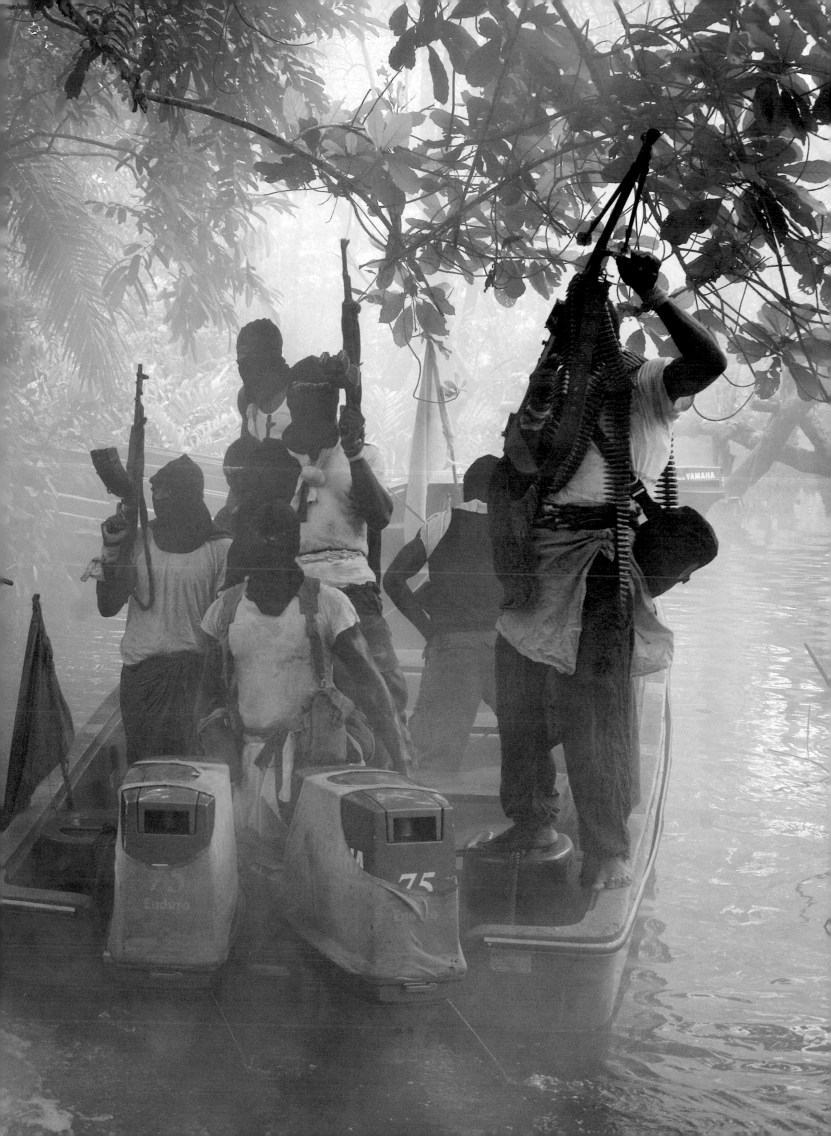

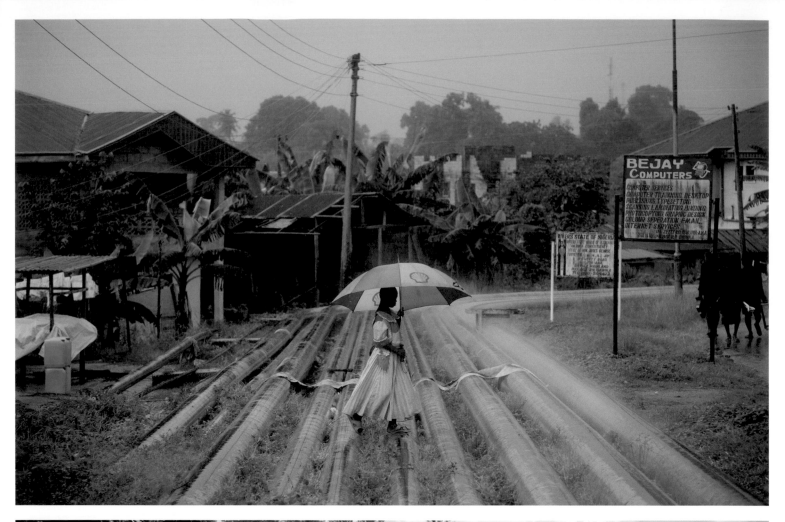

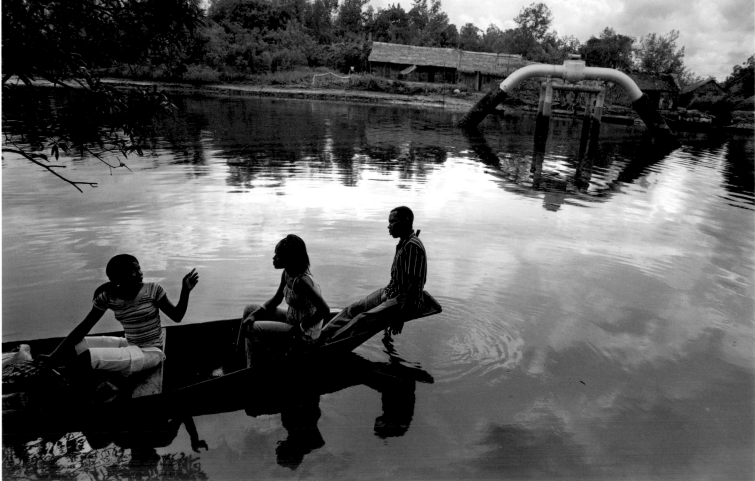

Previous page. Militants of the Movement for the Emancipation of the Niger Delta (MEND) accompany a Shell worker, recently released from hostage, to freedom, 2006. Nigerian military boats later ambushed the group and killed all nine MEND members and the Shell worker.

Above. A young woman uses the oil pipes as a walkway in the port town of Okrika, the Niger Delta, 2006.
Below. A Shell pipeline runs through the harbour of this Nembe fishing village in Bayelsa State, 2006, where the water is polluted and fish stocks are depleted.

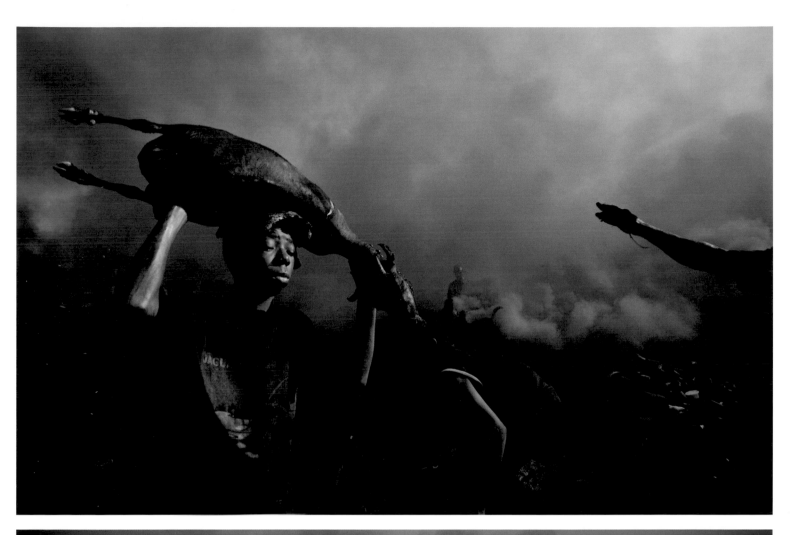

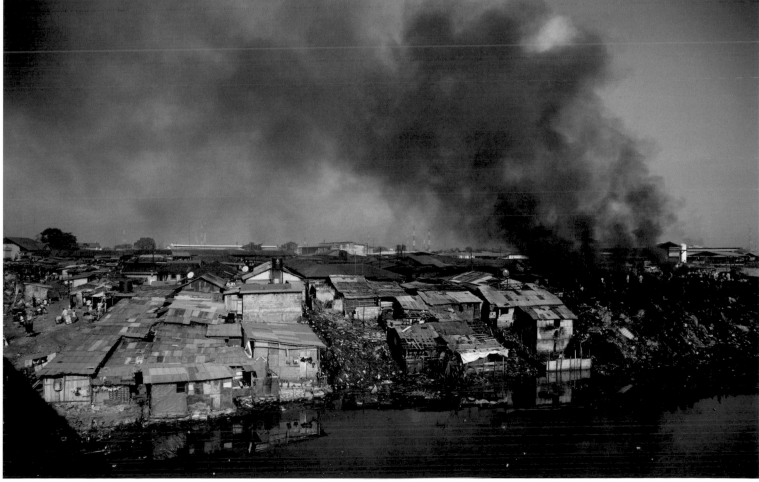

Above. A boy carries a freshly killed goat through the black smoke of burning tyres, used as fuel at the Trans Amadi Slaughterhouse, Port Harcourt, 2006.

Below. The Trans Amadi Slaughterhouse, Port Harcourt's main abattoir, displays deplorable, unhygienic conditions, seen here in 2006. The animals are killed outside, their blood spilled into the river below.

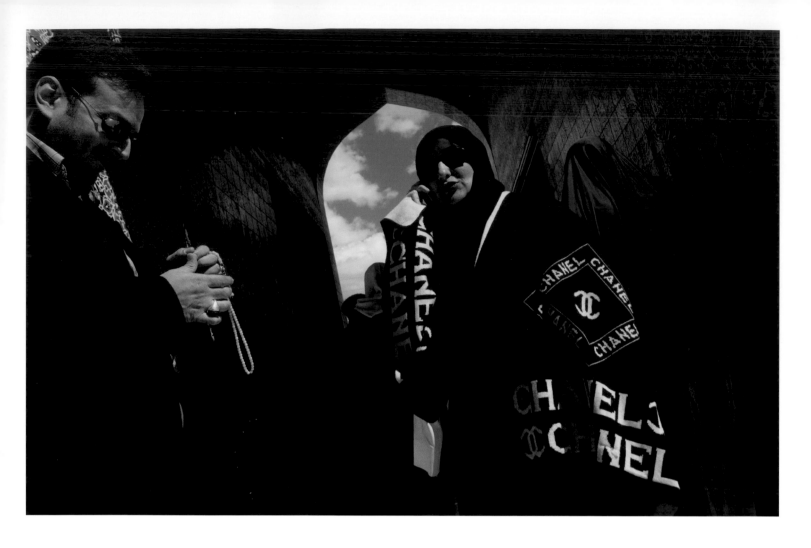

2004–2008
MODEST: WOMEN IN THE MIDDLE EAST
ALEXANDRA BOULAT

Alexandra Boulat visited the Middle East – including Afghanistan, Iran, Syria and Gaza – over several years. She discovered that in order to understand women in this region, she had to set aside western cultural and social values, especially those relating to women's rights and freedom. Women of the Middle East, against a background of political and economic struggle, are forced to face issues such as Islam, fundamentalism, war, domestic violence and lack of education. Few women are inclined to embrace western influences. In each country, they are condemned by laws or moral codes if they try to escape traditional responsibilities, where family and honour are held to be the first and only rule. Each woman who agreed to be photographed has her own story to tell: from mother to pilgrim, to teenager, to policewoman, Boulat's images reveal their attitudes, their rituals, their frustrations and their joys.

A Kuwaiti woman, wearing a Chanel scarf over her chador, with her husband at the shrine of Zaynab, granddaughter of the prophet Muhammad, Sayida Damascus, Syria, March 2006.

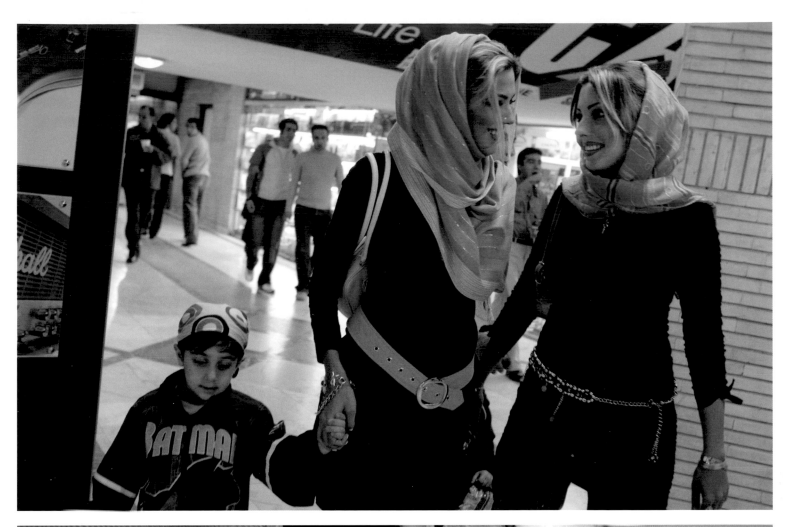

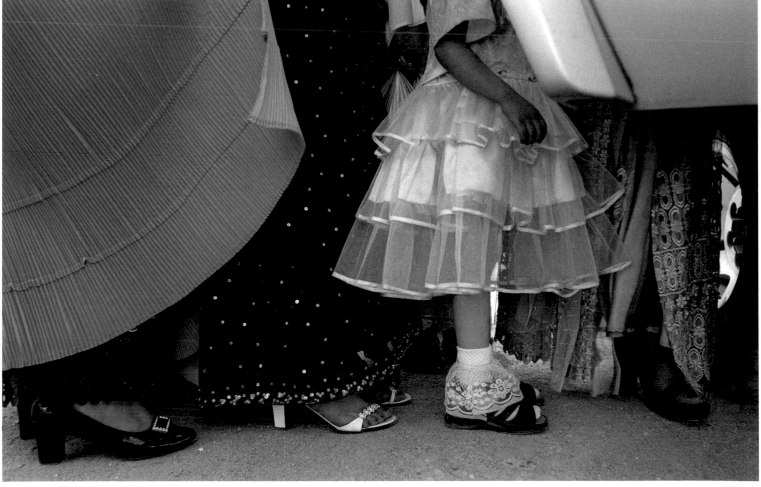

Above. Women in a shopping mall in northern Tehran, Iran, October 2004.

Below. Heading to a wedding party in Kabul, women of all ages wear a variety of fashion styles, from traditional burka to pink tutu, July 2008. **Overleaf.** Women praying in Pakistan.

Above. A female Hamas supporter holds up a copy of the Koran during a campaign rally of Hamas election candidates for the Palestinian Legislative Council in Gaza, January 2006.

Below. A Palestinian teenager at an exam at the Islamic University of Gaza, May 2006.

Above. Shafiqa, 60, mother of 15 children, arrives in Kabul, Afghanistan, from Mazar-e Sharif for medical treatment, September 2004.

Below. Women police in training at the shooting range, Tehran, Iran, November 2004.

2004
LOST IN TOKYO
JOACHIM LADEFOGED

During April 2004, Joachim Ladefoged visited Tokyo, a city that
is considered an archetype of the modern metropolis and that
offers a case study in extremes and contradictions. When night
falls, electronic billboards cast fluorescent light over the city. Tokyo's
multiplicity of scales, at least to the foreigner's unaccustomed
eye, presents a kaleidoscope of impressions: neon ads flash
incomprehensible messages, street vendors' tiny stands lie at the feet
of majestic fashionable shops, young women's mobile phones
capture images and become toys, just like any other fashionista's
accessories. Amid the restlessness, as though protected by the
never-ending reminder of human presence within the city, the ones
who are tired of it all take a break by managing to cuddle in
deserted stairways and corners. Isolated in a moving crowd, the
tourist's perceptions are blurred as he alternately endures and
participates in the city's pulse.

Coffee shop, Shibuya district, Tokyo.

Above. Train station in the shopping district of Harajuku, Tokyo.

Below. Red-light district, Kabukicho, Tokyo.
Overleaf. Subway tunnel restaurant, Shinjuku district, Tokyo.

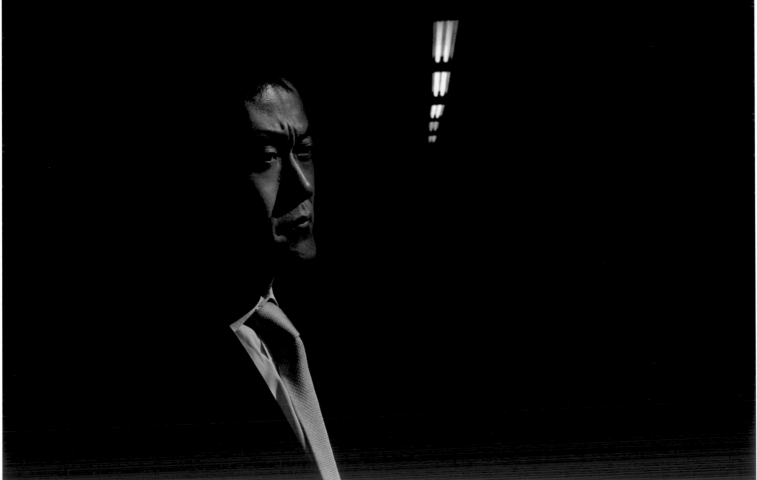

Above. Camera phones, Shibuya district, Tokyo.

Below. Businessman, Shinjuku district, Tokyo.

Above. Shopping street, Harajuku, Tokyo.　　　　　　　　　**Below.** Red-light district, Kabukicho, Tokyo.

III. LANDSCAPES IN TURMOIL

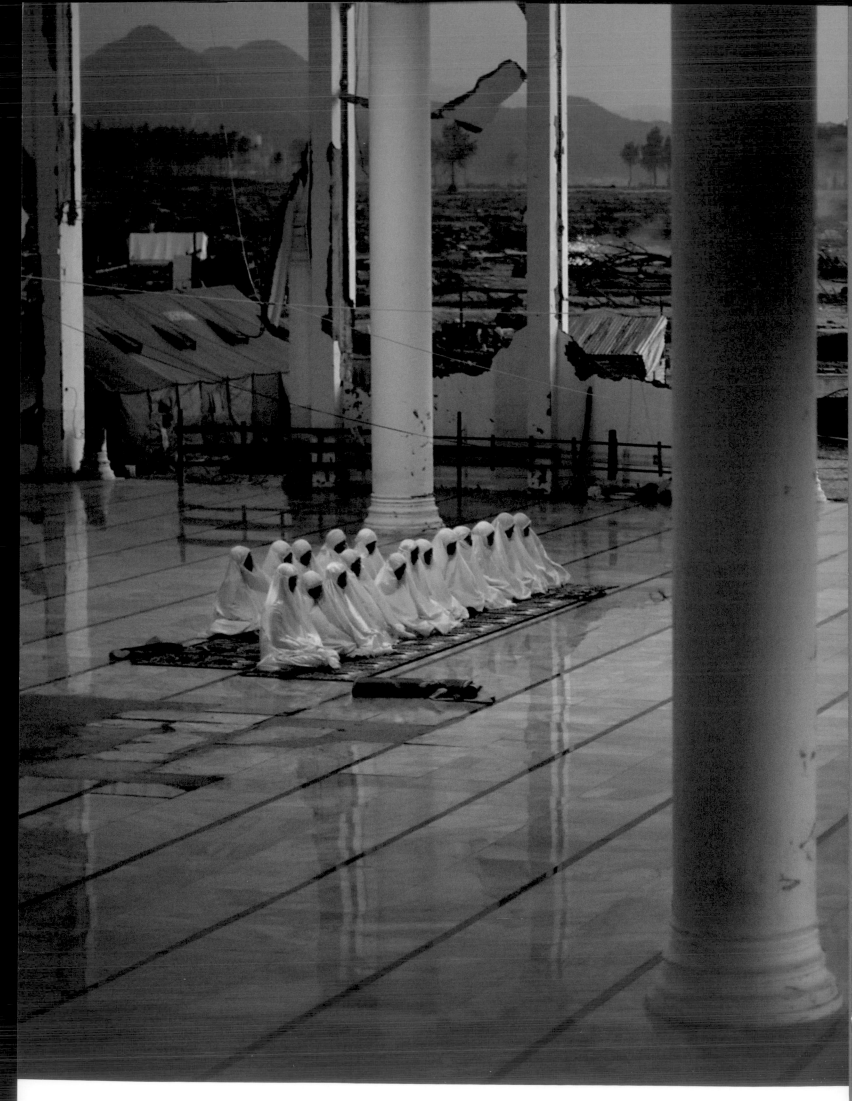

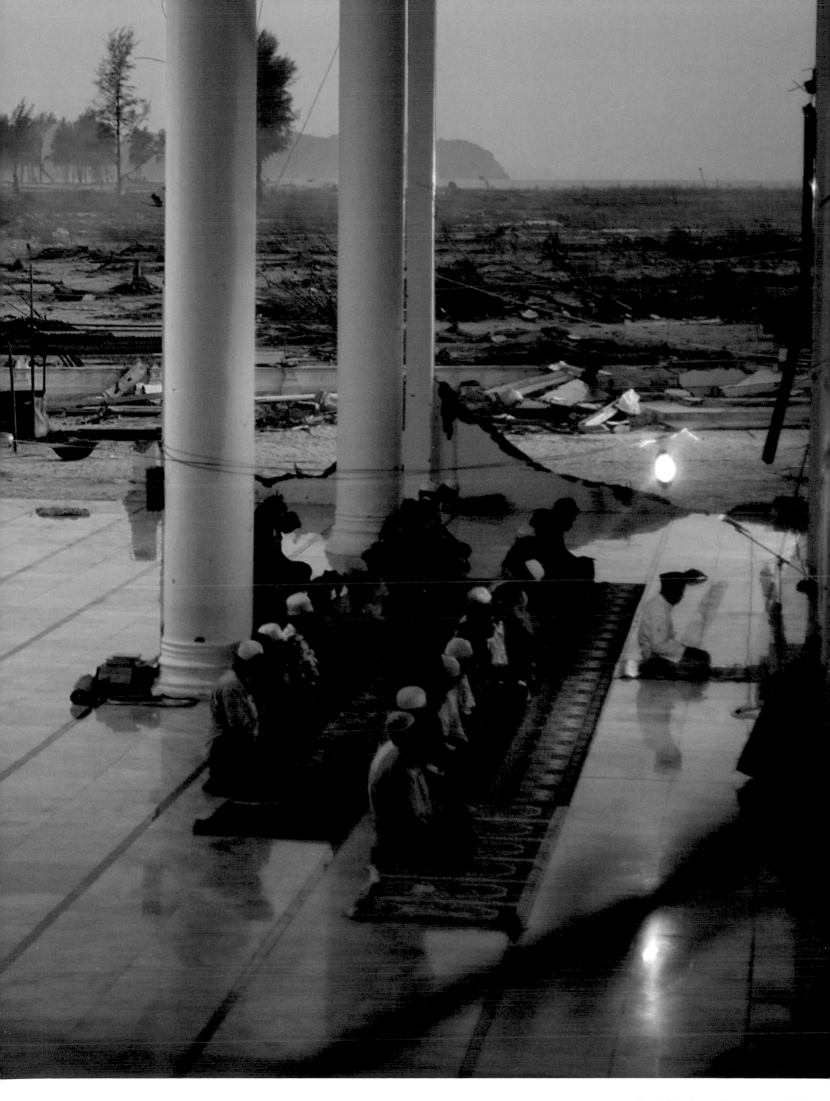

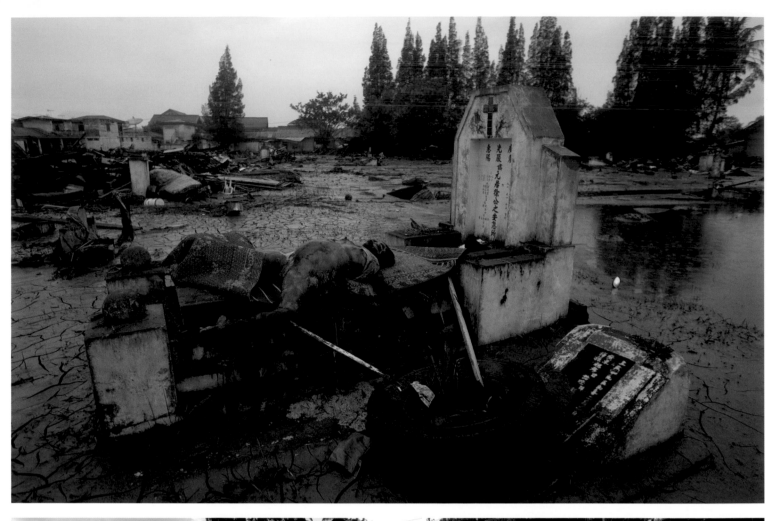

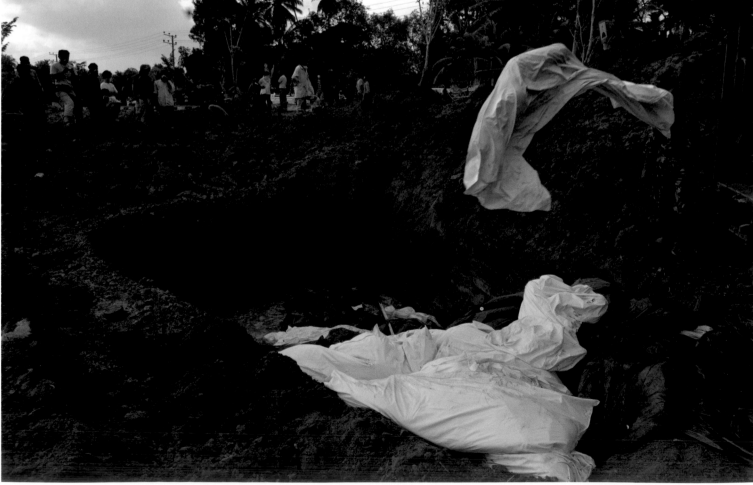

Above. John Stanmeyer. The body of a woman lying on a tomb at the cemetery in Banda Aceh, northern Sumatra, Indonesia. Much of northern Sumatra was completely destroyed by the tsunami.

Below. John Stanmeyer. Bodies are tossed into a mass grave in Banda Aceh, which suffered devastation when a succession of three tsunamis followed the earthquake. Over 100,000 people were killed in Aceh Province alone.

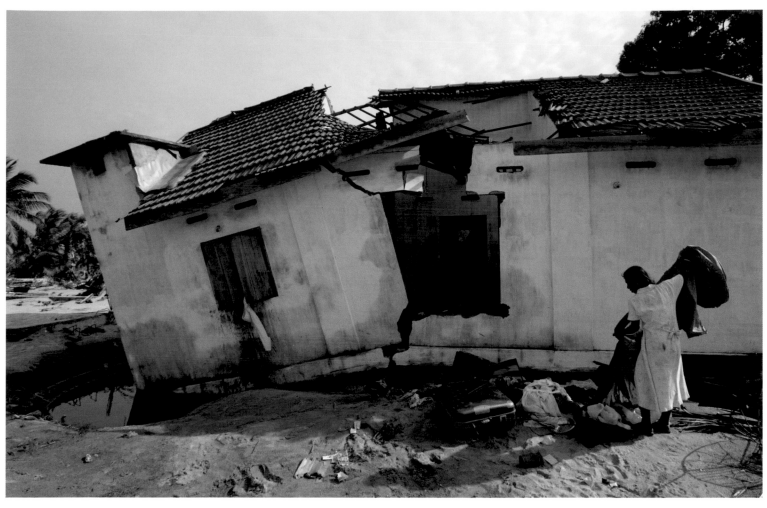

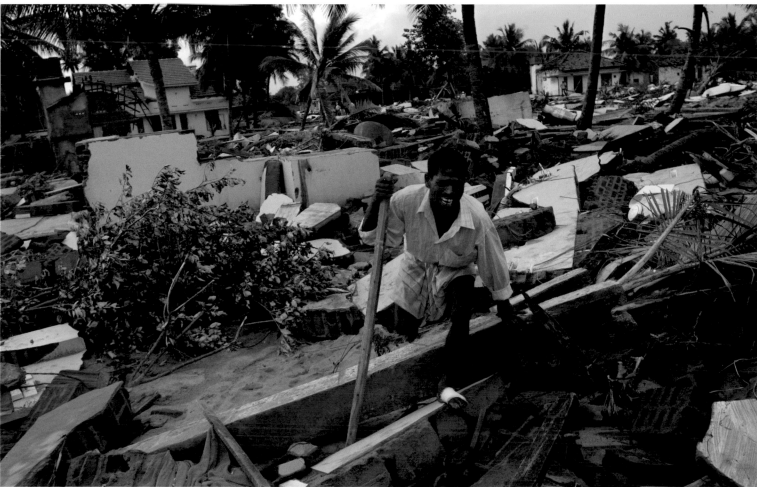

Above. John Stanmeyer. A woman salvages a few possessions from her destroyed home after the tsunami struck the city of Batticaloa on Sri Lanka's east coast. Thousands were killed in the island's second largest city.

Below. John Stanmeyer. An injured man returns to his wrecked home in the town of Kalmunai, south of Batticaloa, on the east coast of Sri Lanka. The tsunami claimed the lives of every member of his family.

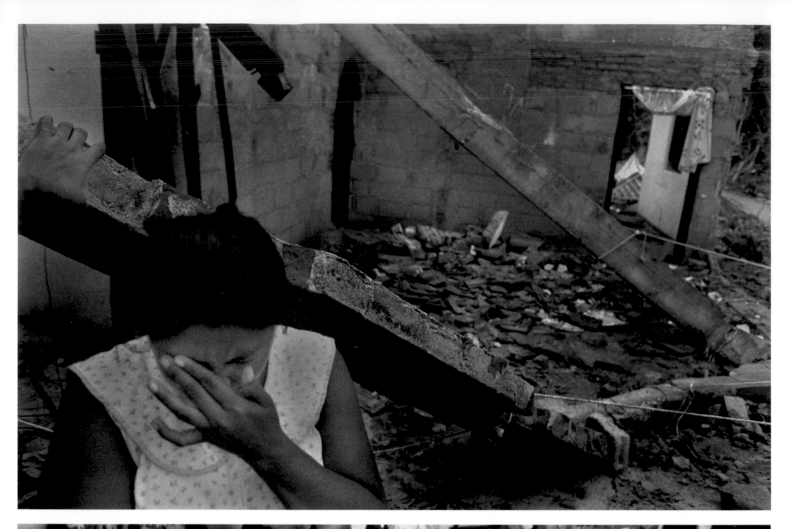

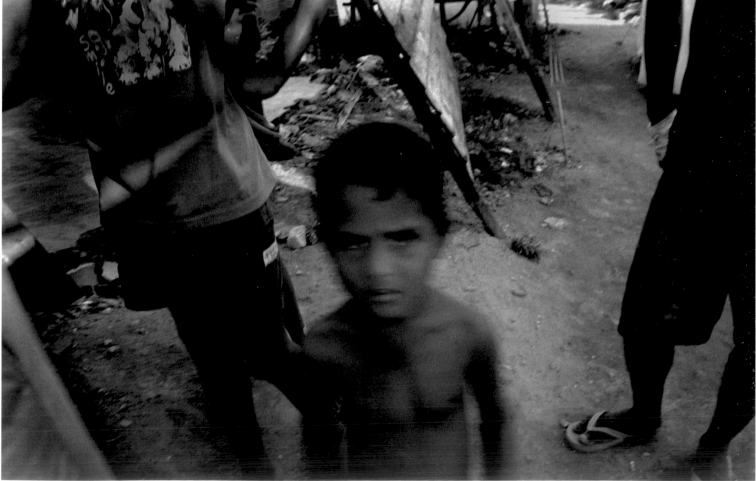

Above, below and opposite. Antonin Kratochvil. The destroyed fishing village and beach resort of Weligama on Sri Lanka's south coast. Tsunami survivors lost everything and have no means to rebuild their lives, but they refuse to leave for fear that the government won't allow them to return to their shoreline homes.

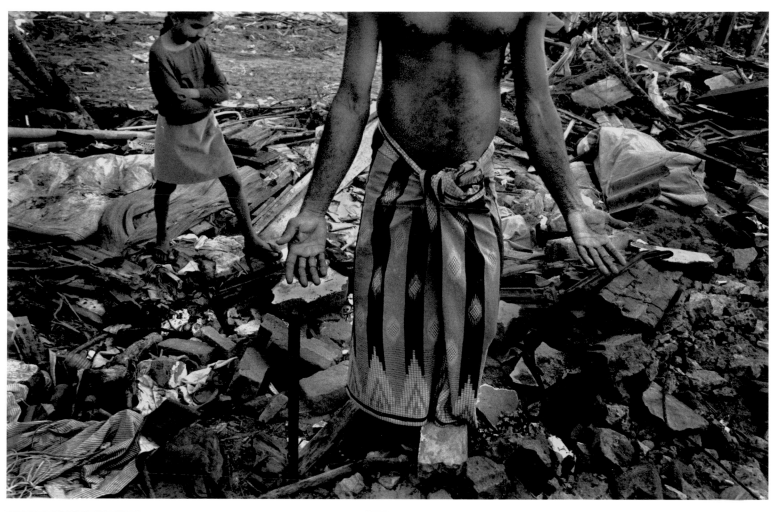

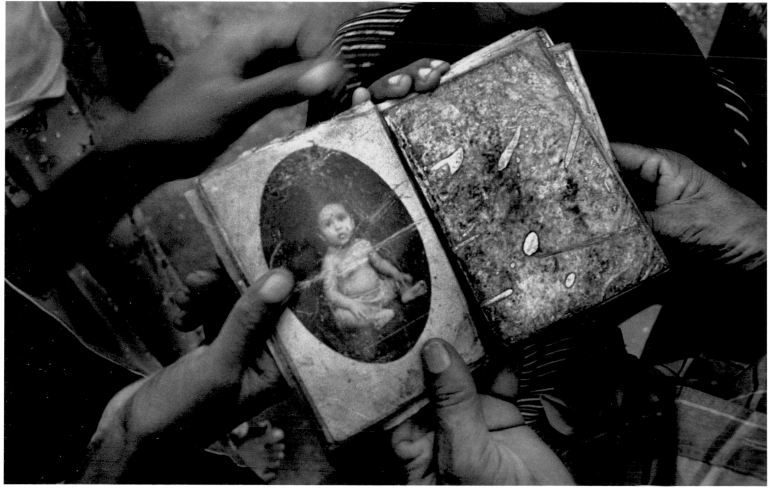

Above. Drunken men in Ilineci, a 'ghost' village near Prypiat.

Below. At the edge of the exclusion zone around Chernobyl.

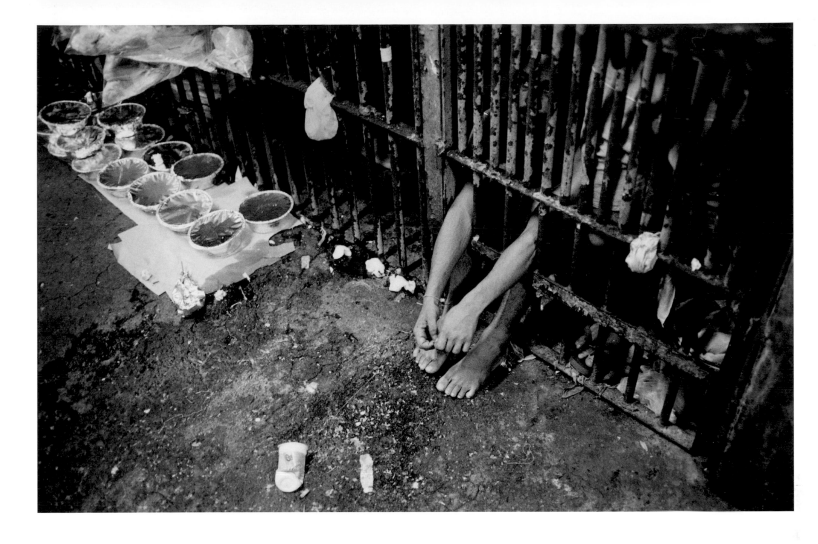

2005
CELL BLOCK RIO
GARY KNIGHT

Gary Knight was introduced to the governor of Rio de Janeiro's Polinter Prison by a fellow photographer at a local newspaper and given the rare opportunity to document its shocking conditions. The governor herself was appalled and, wanting the situation to be exposed, was apparently more comfortable with a foreign photographer doing the reporting. Prisoners are crowded into cells, four men to one square metre, in temperatures soaring up to 50 °C. Many of the prisoners are awaiting trial, but the longest-serving has been locked in the same cell for five years. Imprisonment is for crimes as varied as non-payment of alimony and murder. The prisoners are from the poorest and most vulnerable sections of society, have poor legal representation and are disenfranchised from political representation as they have no vote. It seems that they, like many prisoners the world over, are completely ignored by those who have the power to institute reforms.

Above. One of 98 prisoners crammed into a cell designed for 16 inmates and measuring 25 square metres.
Overleaf. The longest-serving prisoner has been incarcerated in this cell for five years. The old-timers sleep in hammocks up high, the newcomers on the floor.

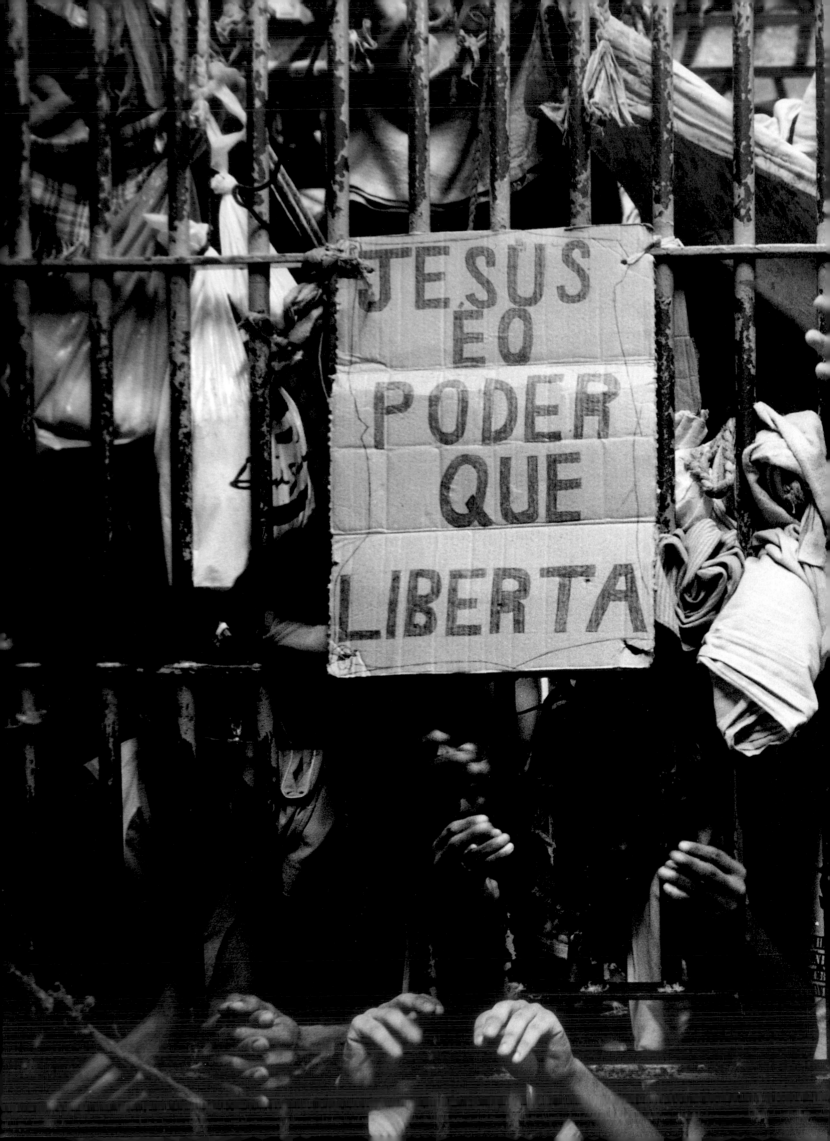

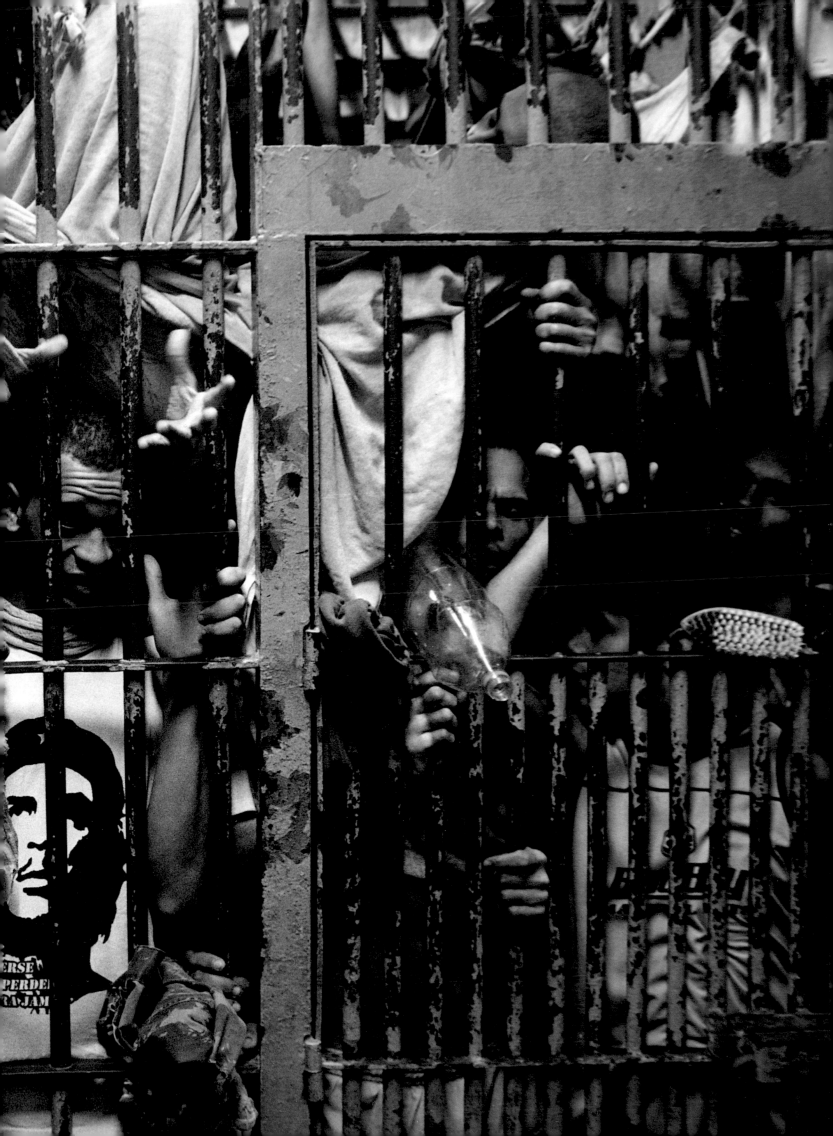

2005
NORTH KOREA: THE HERMIT NATION
CHRISTOPHER MORRIS

To visit North Korea is to enter one of the world's last closed societies. The tiny communist state and aspiring nuclear power is effectively shut off and visitors are limited to the (privileged) few. In October 2005, Christopher Morris was granted a rare visit and found its capital, Pyongyang, orderly and its citizens patriotic. His guided tour, along with a group of other western journalists, took place during a period of increasing isolation. The North Korean government had taken small steps towards openness and reform, encouraging hopes of a rapprochement with the West. But in 2005, Supreme Leader Kim Jong-il returned to previous, more repressive, communist systems, maybe fearing that private trade and greater contact with the outside world would undermine his political control. In addition, the regime seemed to be pressuring foreign aid workers to leave. The West was worried that the possibility of persuading North Korea to renounce its nuclear weapons programme was becoming increasingly distant. Today, tensions over its nuclear ambitions have worsened and further damaged ties with South Korea.

A huge photograph of Kim Jong-il, the Supreme Leader of North Korea, is displayed in the capital, Pyongyang.

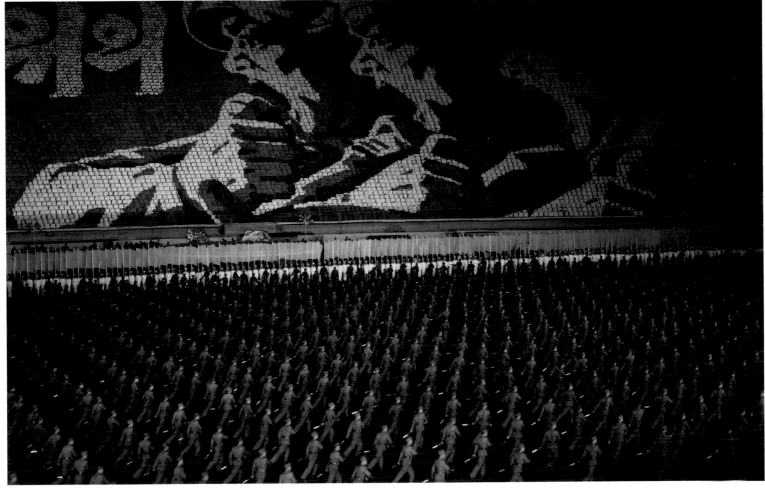

Above. North Korean soldiers attend an exhibition of purple 'Kimilsungia' orchids and red 'Kimjongilia' begonias in Pyongyang. The hybrids were specially cultivated and named in honour of Kim Il-sung, the late leader, and his son and current ruler, Kim Jong-il.

Below. North Koreans perform in the country's famed Arirang Mass Games at the May Day stadium in central Pyongyang. This festival was held to mark the 60th anniversary of the founding of the ruling Korean Workers' Party.

Above. Daily life on Changwang Street in Pyongyang. In the middle ground can be seen a female traffic warden

Left. Government drivers wait outside the Koryo Hotel on Changwang Street, Pyongyang.
Right. A street scene outside an exhibition of 'Kimilsungia' and 'Kimjongilia' flowers in Pyongyang.

Above. A government minder keeps a watchful eye on a party of western visitors at the USS *Pueblo* in Pyongyang. The warship was captured while on an intelligence-gathering mission in North Korean waters in January 1968.
Left. Fishing at a lake on the outskirts of Pyongyang.

Right. Students studying English at the elite Kumsung Educational Institute in Pyongyang. The students use material downloaded by the country's main computer research centre, but they have no direct internet access.
Overleaf. Commuters travel on an underground train in Pyongyang.

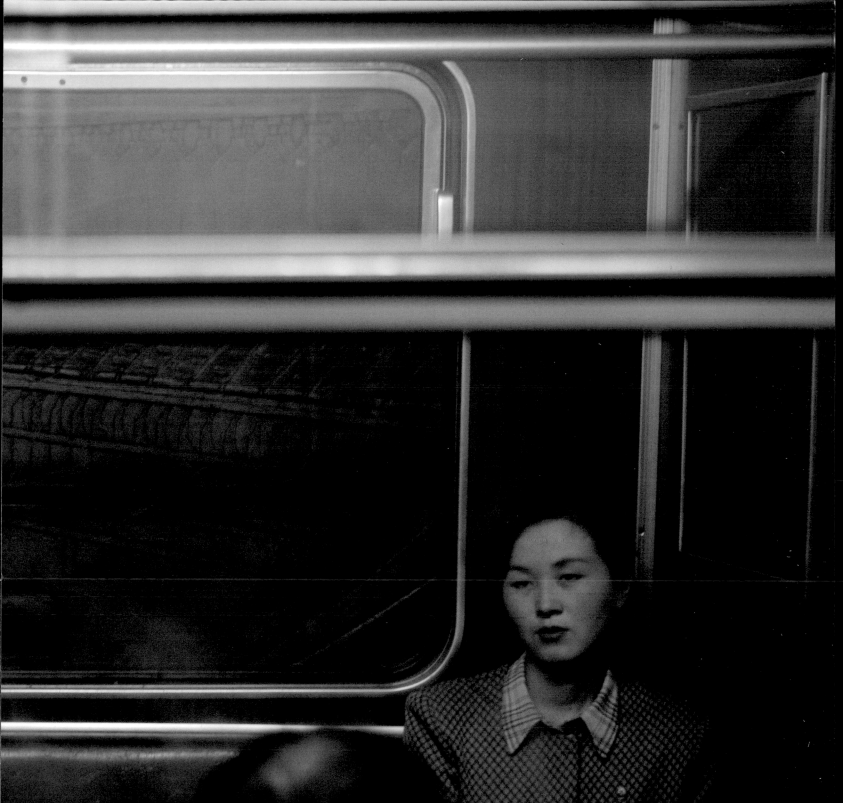

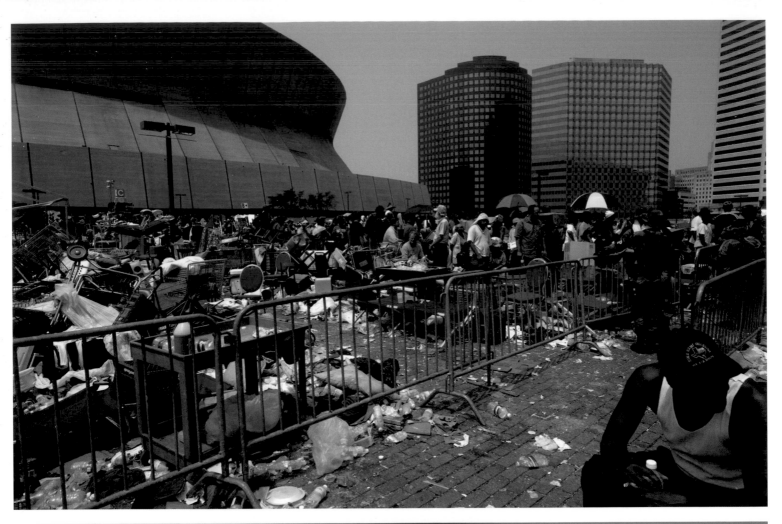

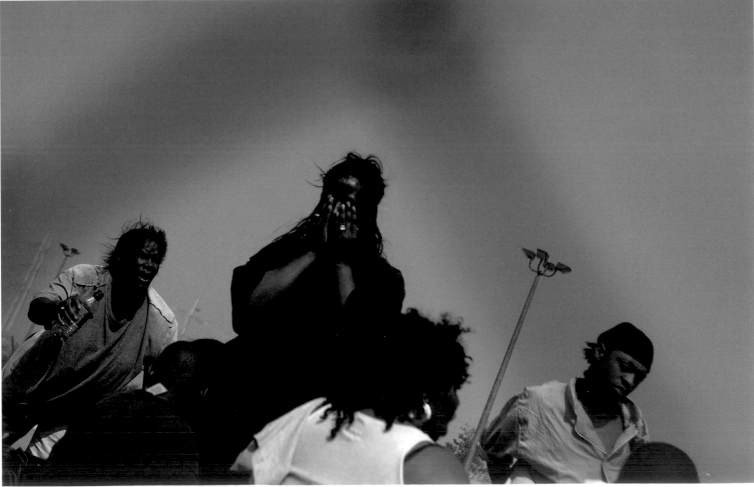

Above. Ron Haviv. Following Hurricane Katrina, people and their belongings continue to be evacuated to the Superdome, New Orleans, 3 September 2005. The number of evacuees rose to around 20,000. With no water and no power, sanitary conditions in the emergency shelter became unbearable.

Below. Ron Haviv. Survivors await airlift by helicopter from the convention centre where they had taken refuge following Hurricane Katrina, New Orleans, 3 September 2005.

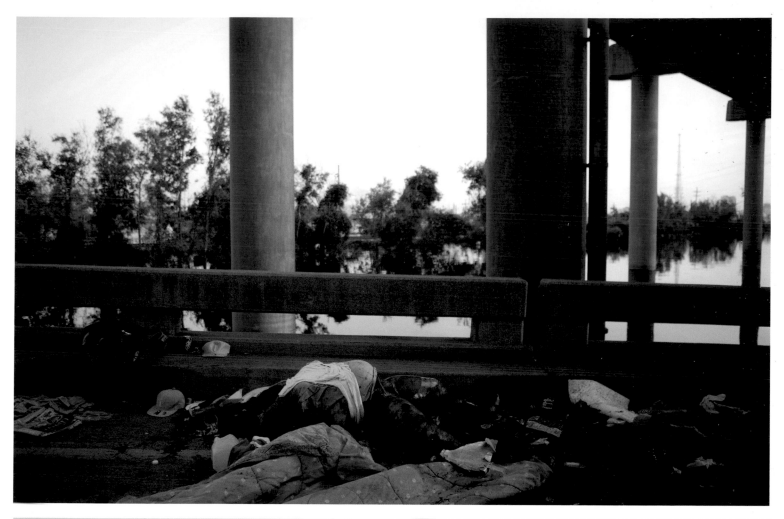

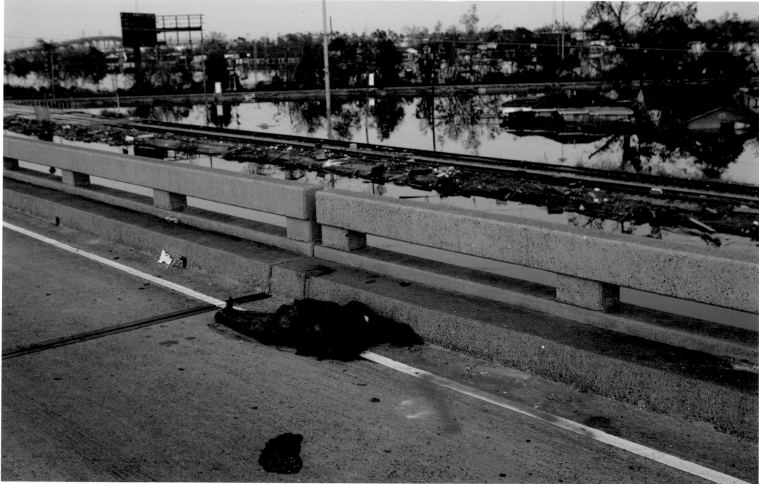

Above and below. Christopher Morris. Victims of Hurricane Katrina lie abandoned on a New Orleans highway, 8 September 2005.

Overleaf. Ron Haviv. A civilian volunteer who rescued hundreds of people in the aftermath of Hurricane Katrina, walks through a flooded neighbourhood at the end of his day, New Orleans, 6 September 2005.

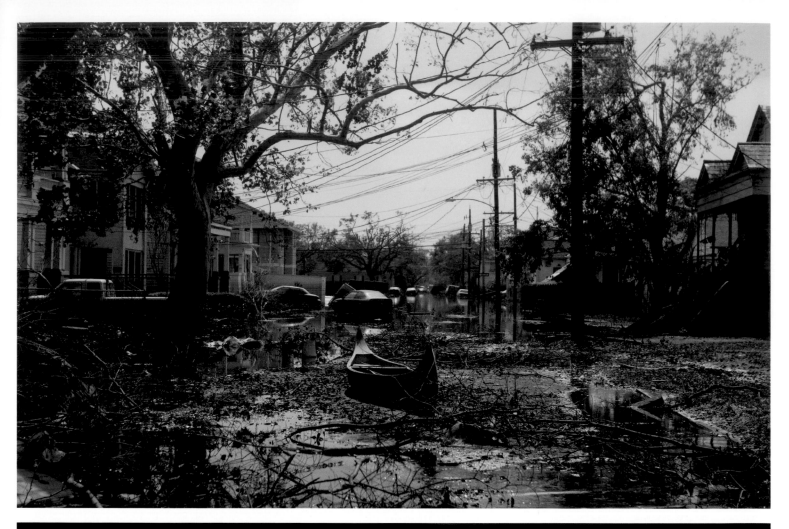

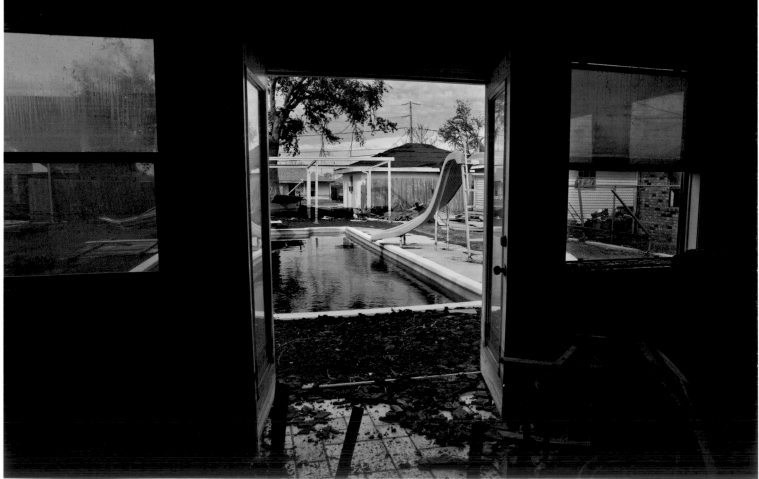

Above. Christopher Morris. Extensive damage caused by Hurricane Katrina in Slidell, northeast of New Orleans, 16 September 2005.

Below. Ed Kashi. Destruction in Buras, south of New Orleans, where Hurricane Katrina first hit the state of Louisiana, 16 December 2005.

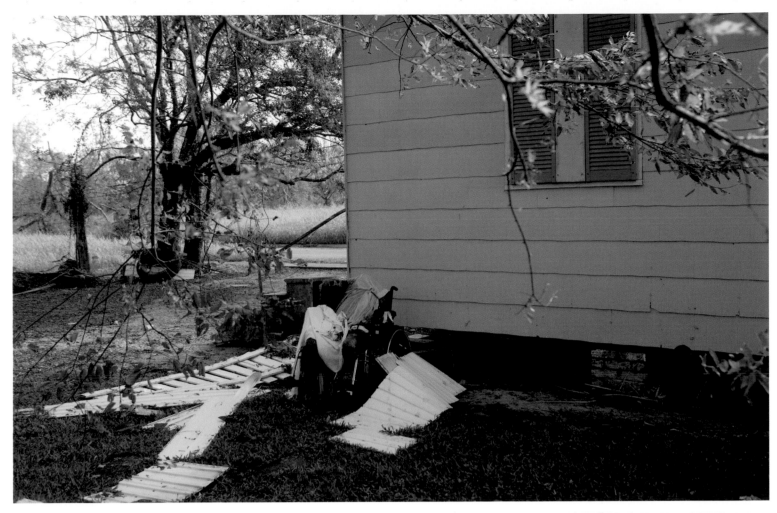

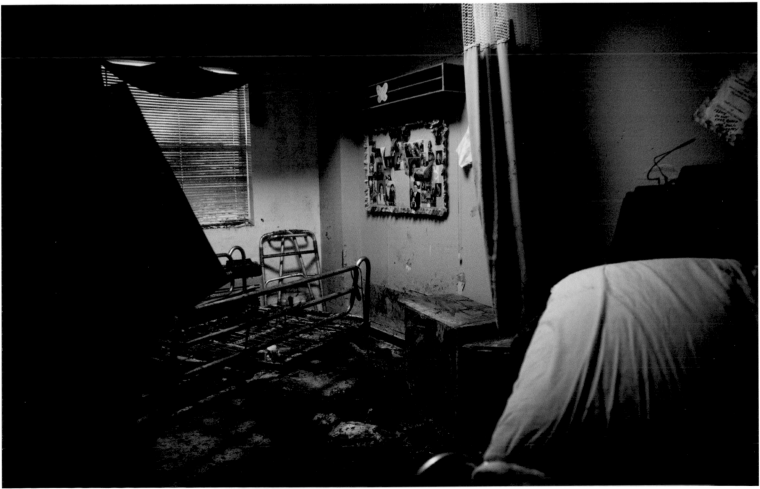

Above. Christopher Morris. The remains of an unidentified victim of Hurricane Katrina in St Bernard Parish, southeast New Orleans, 11 September 2005.

Below. Christopher Morris. Residents from St Rita's Nursing Home, named after the patron saint of impossible causes, were not evacuated; only 24 were later rescued while 35 drowned in a wall of mud and water, St Bernard Parish, 17 September 2005.

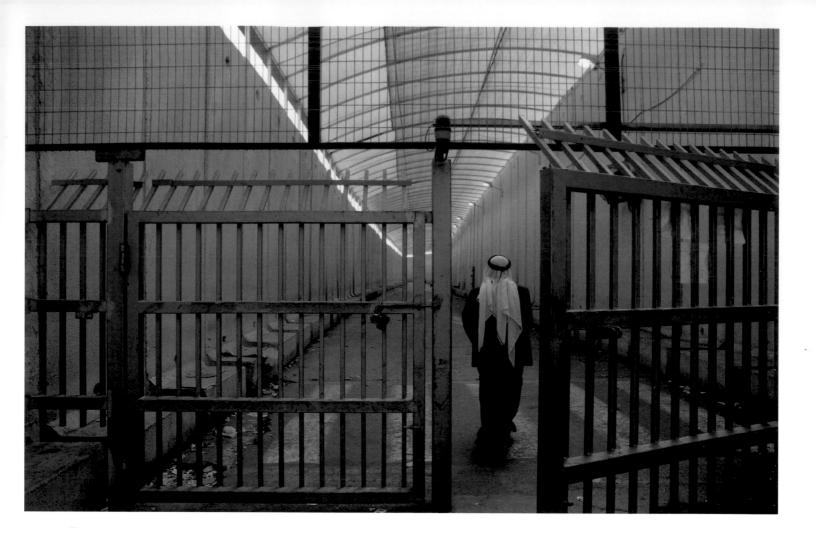

2006
GAZA'S STRUGGLE
ALEXANDRA BOULAT

Following Israel's unilateral withdrawal from Gaza in 2005, Palestinians living inside the densely populated territory were hopeful that an end to years of misery and suffering may finally be at hand. But the dismantling of Jewish settlements proved a false dawn for the roughly 1.5 million Palestinians – more than half of whom were refugees – crammed into the narrow strip of Mediterranean coast between Israel and Egypt. After Hamas won the 2006 elections for the Palestinian Legislative Council, militants stepped up their rocket attacks on Israel, who still controlled Gaza's borders. Israel responded with air strikes which often killed bystanders. Western countries classified Hamas as a terrorist organisation so their sympathy for Gaza's civilians was muted. Although there were improvements in law and order under Hamas, the territory witnessed almost daily kidnappings and frequent clashes between armed factions of Hamas and its main political rival, Fatah. Alexandra Boulat photographed the struggle in Gaza and captured a population trapped in a seemingly endless cycle of conflict and pain.

A Palestinian man returns to Gaza via the checkpoint at Erez, on the border between Israel and Gaza, May 2006. Israel's controversial security wall looms large.

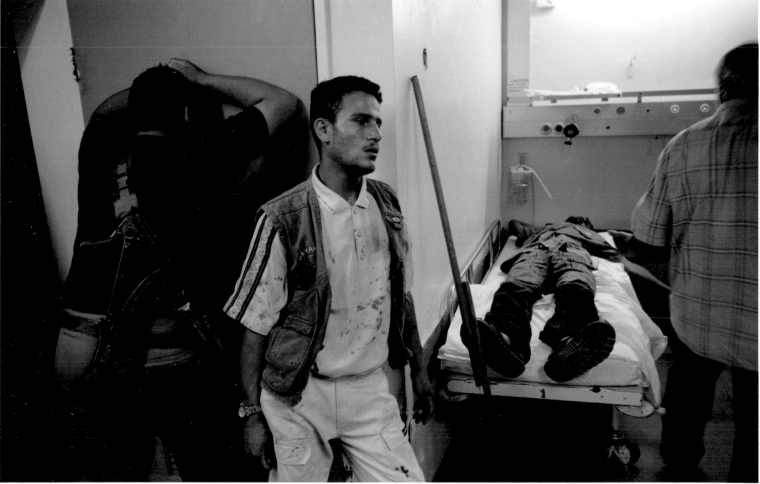

Above. A Palestinian crawls inside an 800-metre-long tunnel at Rafiah, on the Gaza–Egypt border, February 2007. The tunnels are used to smuggle goods, weapons and militants from Egypt into Gaza. Israel claims large quantities of weapons have passed through the border since Israel's unilateral withdrawal from Gaza in 2005.

Below. Fighters mourn the deaths of family members at Al-Shifa Hospital, Gaza City, July 2006. Three members of one family were killed in an attack on their home in Karni, east of the city. The Israeli 'Summer Rain' operation aimed to free a captured Israeli soldier and halt Palestinian rocket fire.

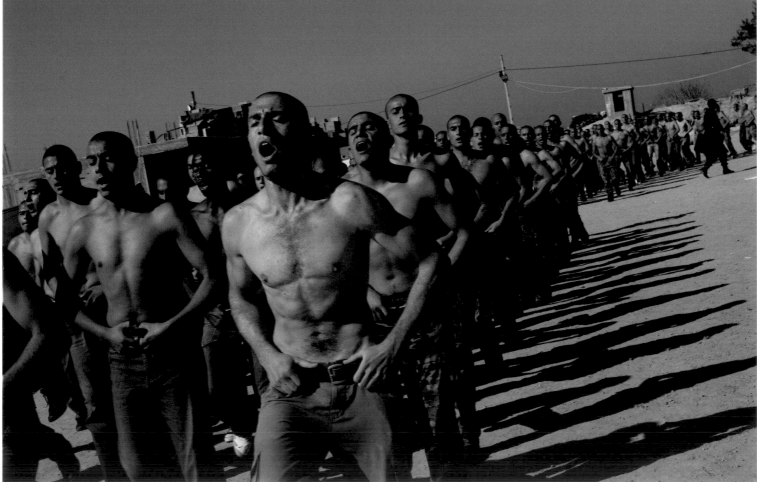

Above. Hamas supporters at a rally for the Palestinian Legislative Council election in Gaza, January 2006. Hamas swept to victory over the ruling Fatah party.

Below. New recruits for the Palestinian Presidential Guard training in Gaza, January 2007. The United States publicly committed $80 million to help train and equip President Mahmoud Abbas's security force, along with up to $42 million to promote alternatives to Hamas.

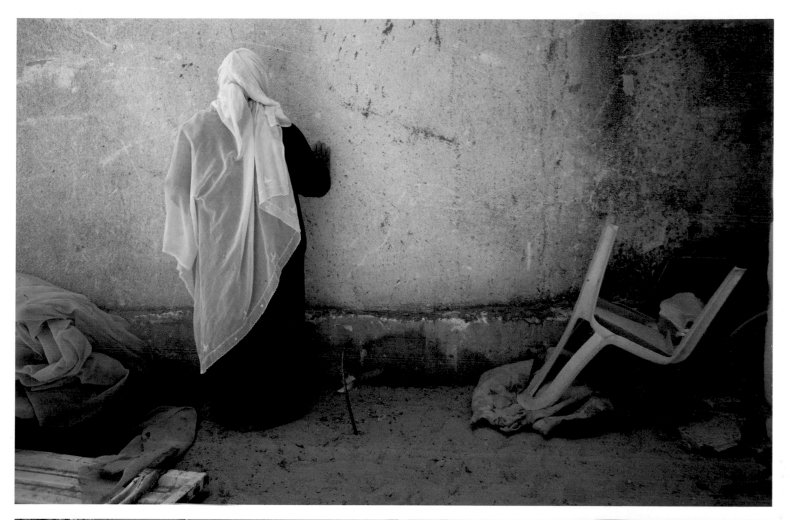

Above. A woman attends the funeral of seven members of one family, killed by an Israeli air strike on a beach in the northern Gaza Strip, June 2006.

Below. A Palestinian house occupied by Israeli special troops during an incursion in Gaza, near the Karni border crossing, September 2006.
Overleaf. Children look for a new classroom, Beit Hanun, Gaza, November 2006. The Israeli military operation, 'Autumn Clouds', wrecked the town and killed 65.

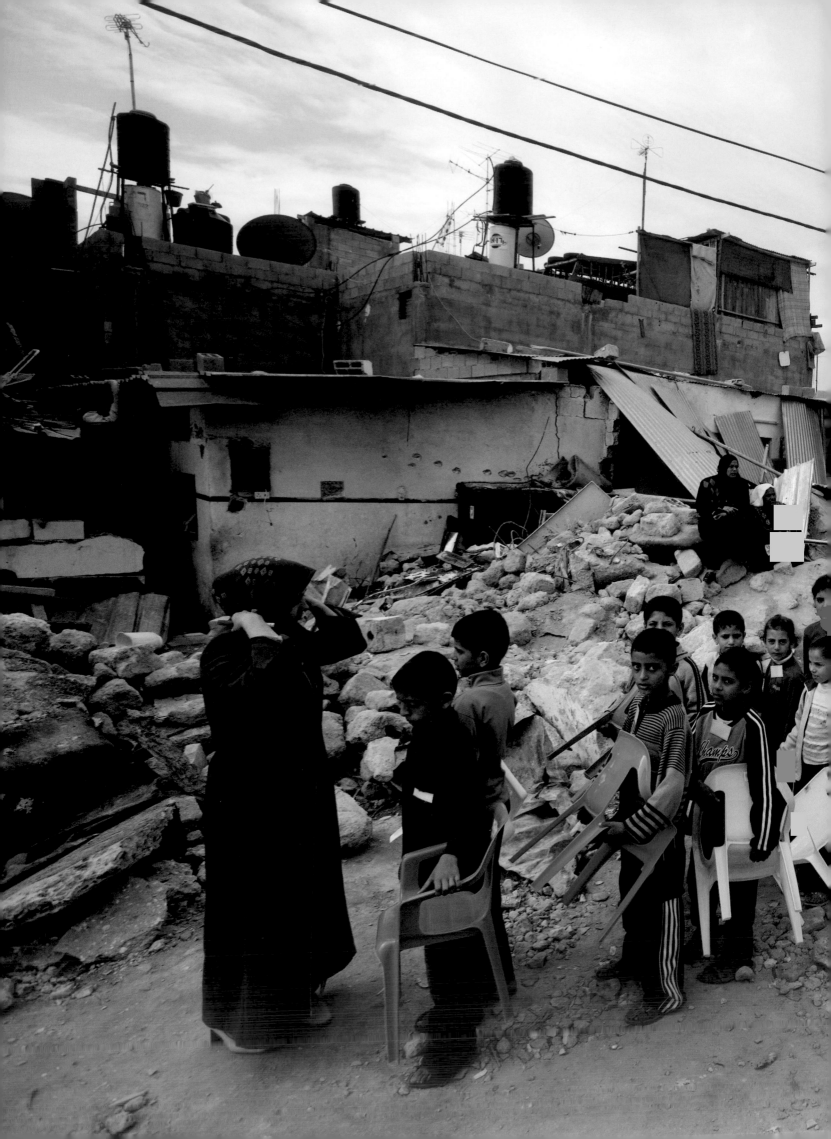

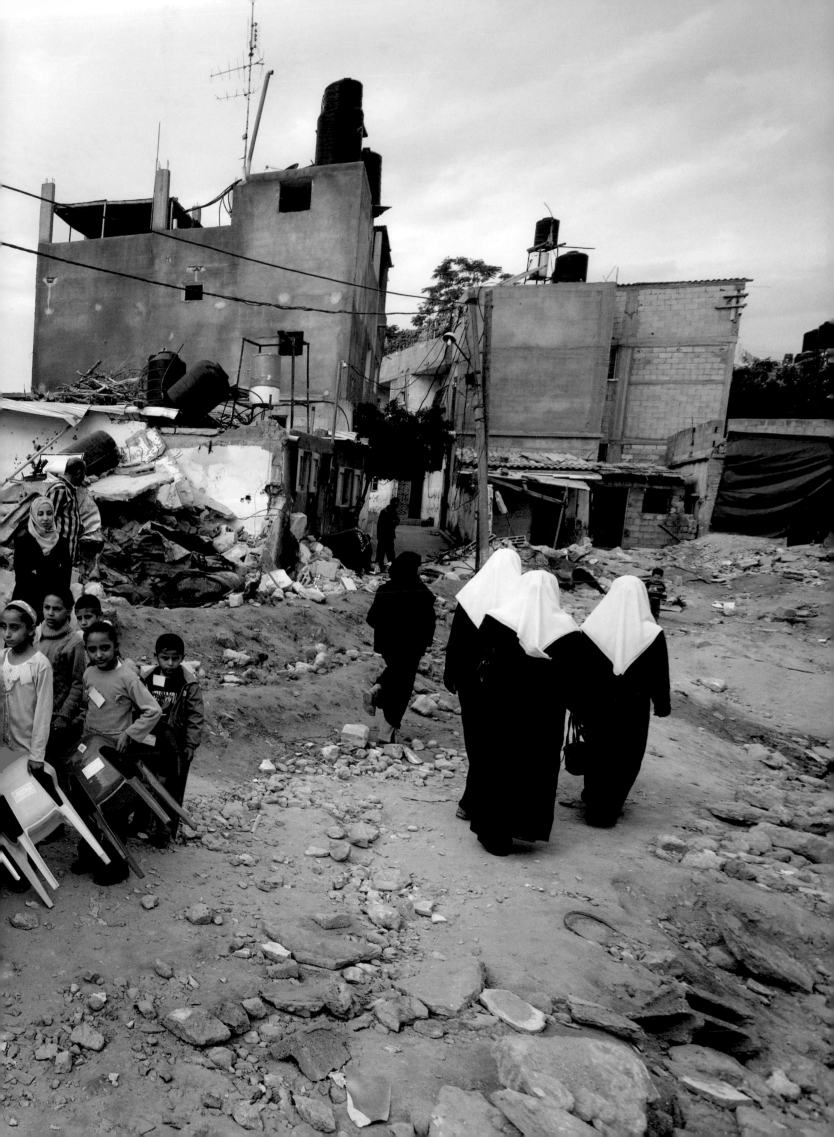

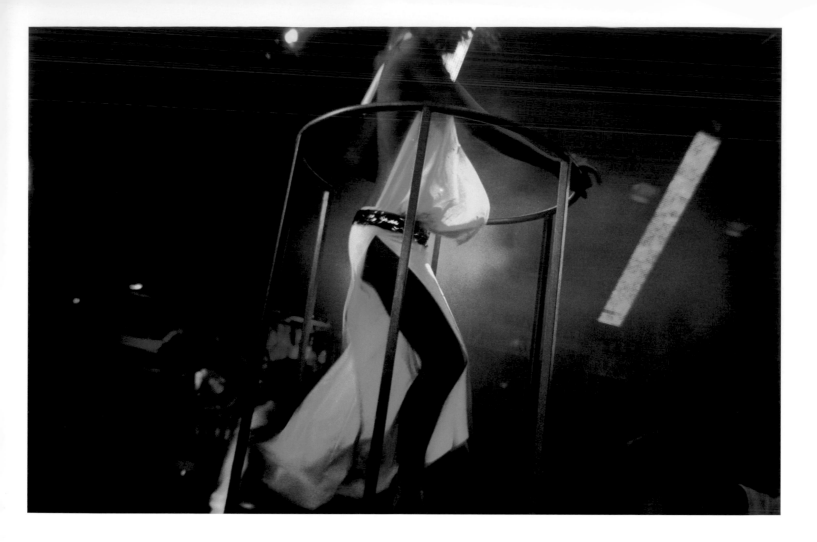

2006
MOSCOW NIGHTS
ANTONIN KRATOCHVIL

In the early 1990s, when the Iron Curtain fell, there were no real, commercial nightclubs in Russia's capital. Today, the Moscow scene makes that of every other western city look tame. The end of the Soviet Union saw free-market capitalism and the power of the oligarchs rise as ever-escalating wealth was concentrated in the Russian capital. The total income of Russia's top 10 per cent grew by half and the richest three dozen had a net worth of nearly a quarter of the country's GDP. In a country where the last century has seen a monarchy, two revolutions, two world wars, communism, capitalism and now economic collapse, the only thing more important than making money is spending it; this might be your last chance. The hugely wealthy elite – including oil tycoons, Kremlin power brokers and top athletes – flaunted their hedonistic lifestyle, partying hard and into the early hours. Thinking nothing of paying $10,000 for a well-placed table, the men indulge a boundless appetite for unbelievably beautiful women. In 2006, at the height of this excess, Antonin Kratochvil infiltrated the Moscow hot spots to investigate.

A dancer performs at a Moscow nightclub. Such places attract Moscow's golden youth, the new rich and the mob.

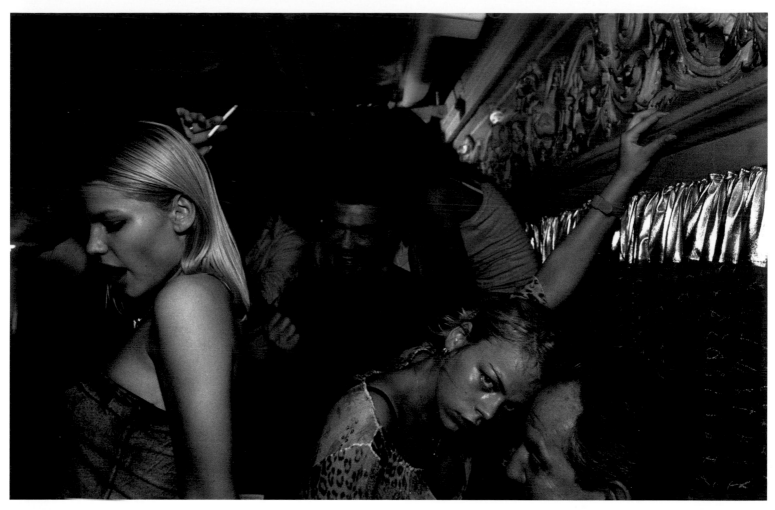

Above. Clubbers in one of Moscow's hot spots.
Left. A performer on stage at a Moscow club.

Right. Exotic dancers, backstage, prepare to perform.
Overleaf. Exotic dancers on their way to the stage.

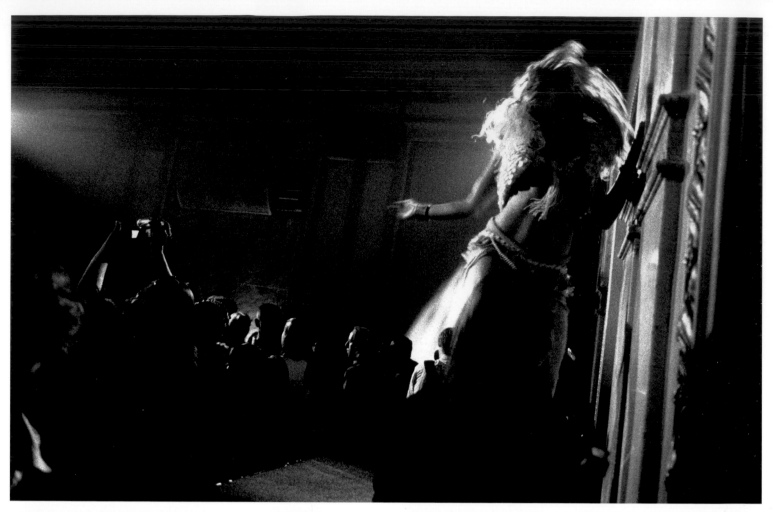

Above. A dancer performs on stage.

Left and right. Patrons at a Moscow club.

Above. A performer in a bedroom on the *Maxim Gorky*, once Stalin's private yacht, on the Moskva River.

Left. Soldiers guard a private party on the *Maxim Gorky*.
Right. Women embracing on board the *Maxim Gorky*.

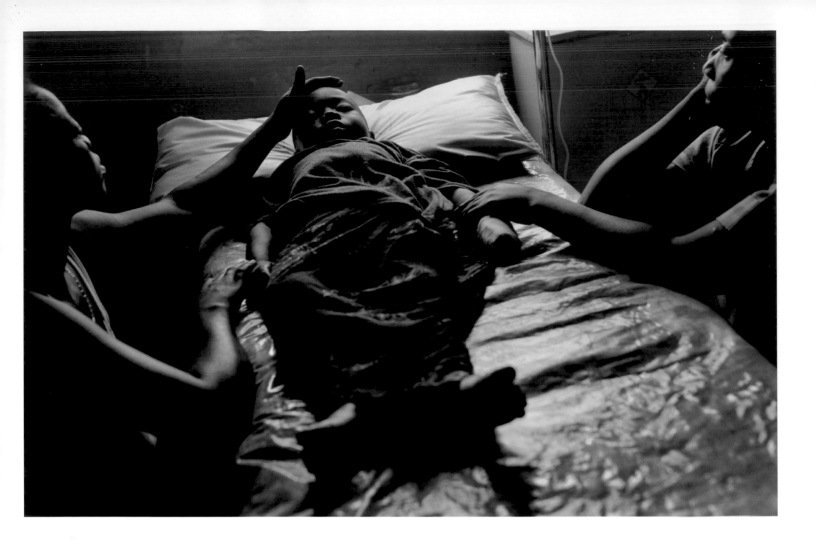

2006
MALARIA
JOHN STANMEYER

Malaria remains one of the leading causes of death and illness
worldwide. It is endemic in 107 countries and infects up to 500
million people annually. In Africa alone, nearly 3,000 people,
mostly children under five, die from malaria each day. According
to the World Health Organization, these figures have worsened
over the past 10 years. Drug-resistant strains of the disease, lack
of basic health care, war, poverty and insufficient funding for
research and prevention have thwarted improvements. During
2006, John Stanmeyer travelled to five countries on three continents
to document not only the harsh realities of one of our world's
biggest killers, but to delve into the issues surrounding the spread
of malaria: urban environments, human encroachment into the
Amazon, which is causing staggering increases in malaria cases,
education and prevention – and solutions to help put an end to
this plague that kills over 1 million people each year.

Edwin Malesu, four, is afflicted with cerebral malaria. His mother Maybel Kazhina
and grandmother Estridah Chimbimbi are by his side at the Kalene Mission Hospital
in Kalene Hill, northwest Zambia. This is the second time that Edwin has contracted
malaria but the previous bout was not so severe.

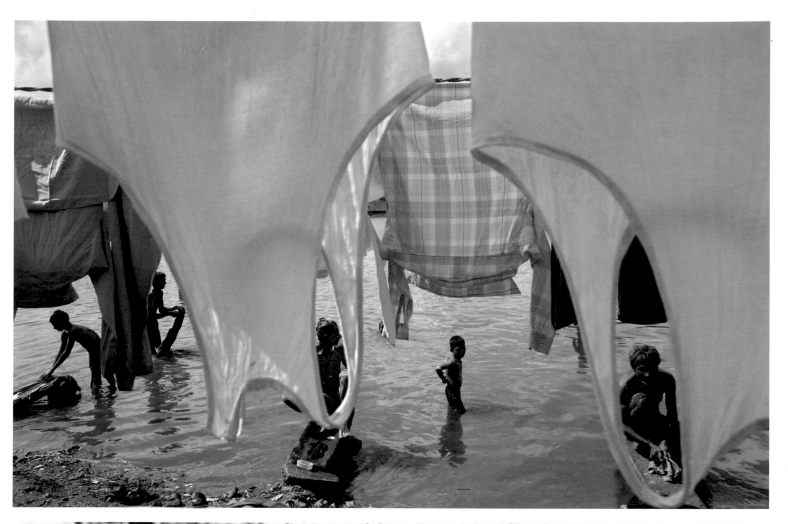

Above. Laundry labourers at Chappan Lake, in the Tiljala district of India's Kolkata, wash clothing and sheets for businesses around the city. According to the municipal health department, this is a known hotspot for malaria, the stagnant water providing an optimum breeding environment for mosquitoes.

Below. 'Malaria Is Not Acceptable' performed by a theatre group in Lugoba, a remote village 110 kilometres (70 miles) northeast of Dar es Salaam, Tanzania. Sponsored by Population Services International, the campaign shows through street theatre how malaria is preventable with simple precautions such as mosquito netting.

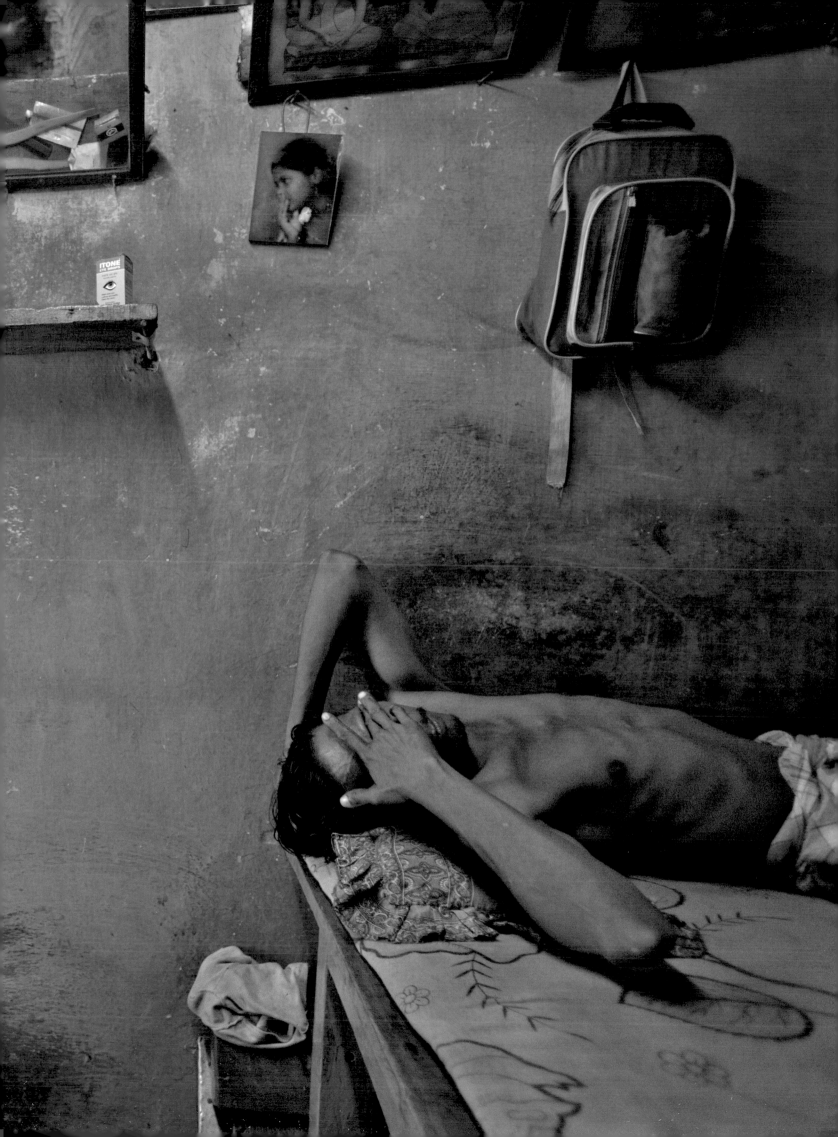

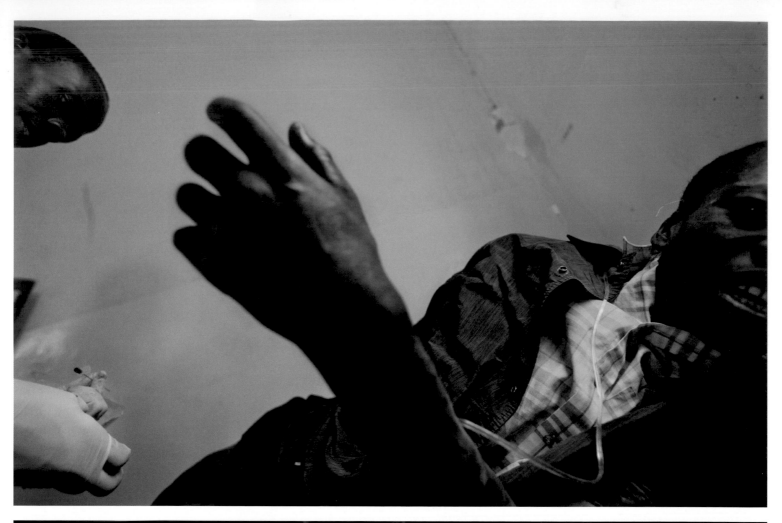

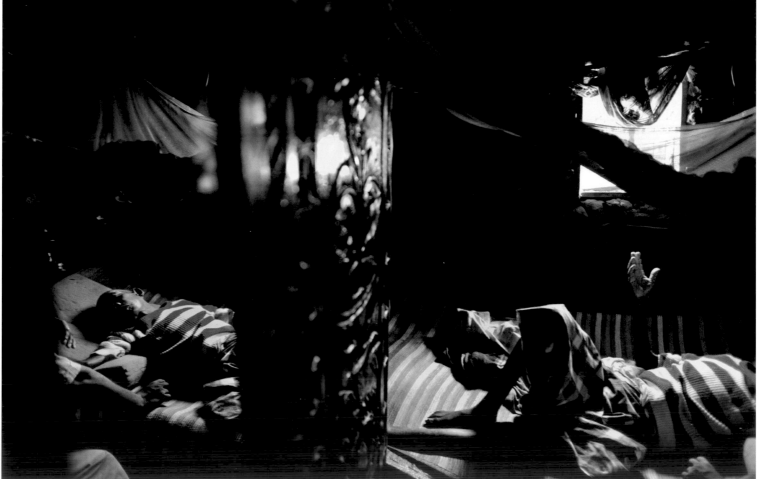

Previous page. In Jugipara Bylane, located within the maze-like area of Rajabazar in Kolkata, Kashi Songkar, 27, is confined to bed with malaria in his home that he shares with six relatives. This is the first time he has contracted the disease but his wife, Usha Songkar, 20, has been struck twice.

Above. Gideon Gori, 20, admitted to the Kisii District Hospital in Nyanza province, Kenya, with severe malaria spreading to his brain, causing dementia or psychosis. Below. Omar Mwinyimkuu, sick with tuberculosis, lies beneath a mosquito net to help prevent malaria, at his home in Bagamoyo, Tanzania.

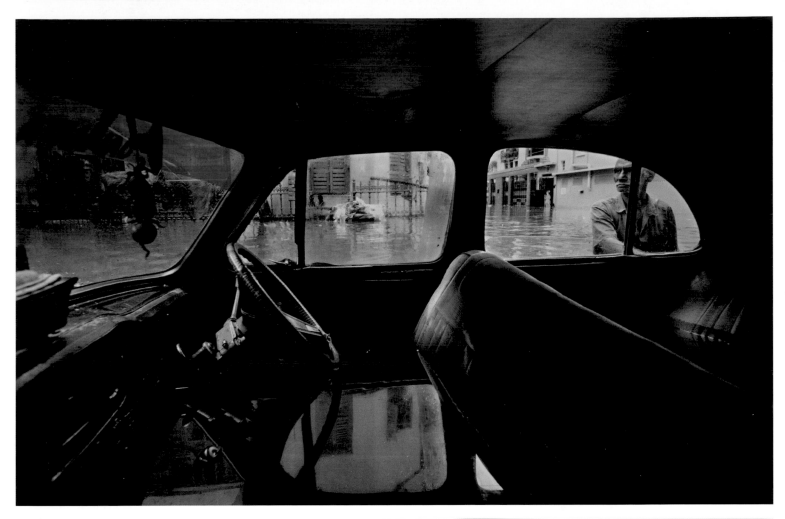

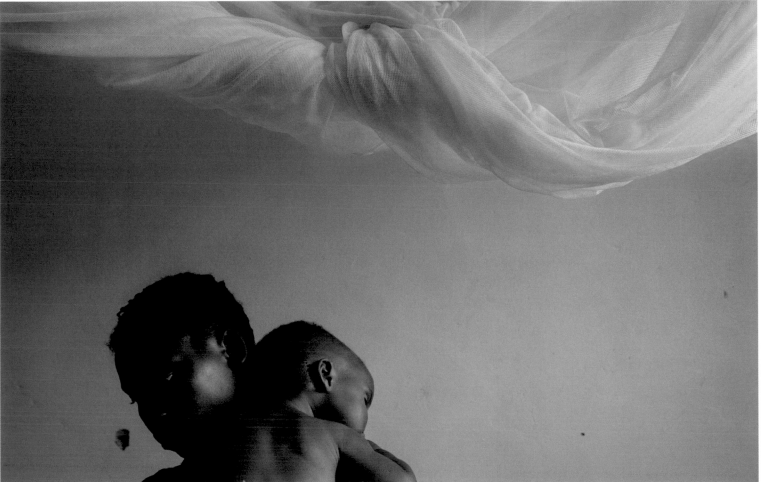

Above. A taxi marooned in the flooded Heysham Road in the Bhawanipur district of south central Kolkata, India. This area is often plagued by malaria. Clogged drains filled with rubbish cause severe urban flooding; the stagnant water left lingering in this taxi will become a perfect breeding ground for mosquitoes.

Below. Vunel Kasachi with her 10-month-old son Nicholas, who contracted malaria and is being treated at the Kalene Mission Hospital in Kalene Hill, northwest Zambia.

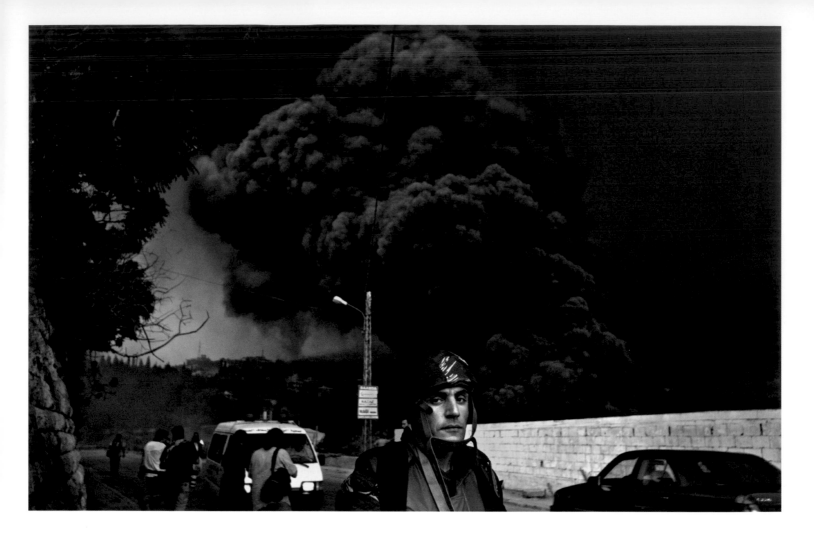

2006
LEBANON IN CRISIS
STEPHANIE SINCLAIR

In July 2006, Hezbollah, the militant group based in south Lebanon, killed eight Israeli soldiers near the border with Israel and seized two more. In retaliation, Israel launched attacks on the country. For 34 days, many Lebanese people were entangled once again as innocent victims in a conflict. Hostilities ended with a ceasefire brokered by the United Nations. Over 1,000 people, mostly Lebanese civilians, were killed. Over 1 million Lebanese civilians and 300,000 to 400,000 Israelis were temporarily displaced. The economies of both countries suffered, but Israel's bombing campaign caused long-term damage to Lebanon's infrastructure – roads, bridges, electricity and water plants. While it remains debatable whether there was a victor in the 2006 Lebanon War, it is clear that, yet again, the civilian population caught in the middle were the veritable losers.

A Lebanese Army soldier guards the scene of an Israeli air strike on the eastern outskirts of Beirut, Lebanon's capital. Later that night several members of the army were killed in a subsequent air attack in the same area.

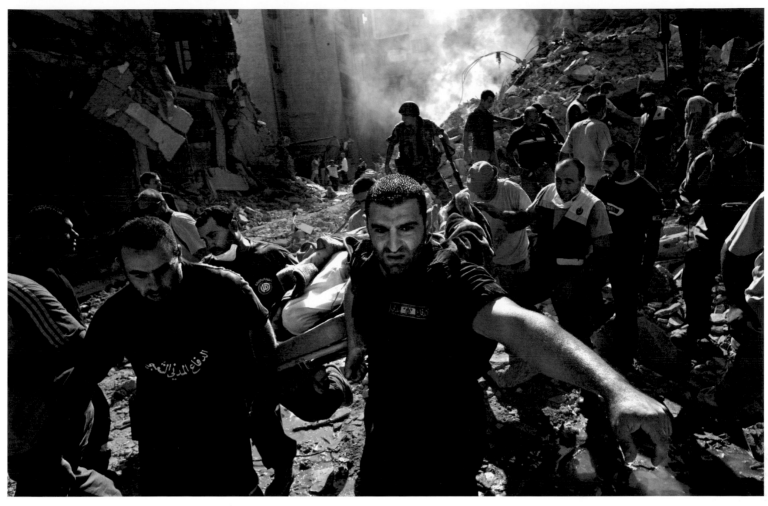

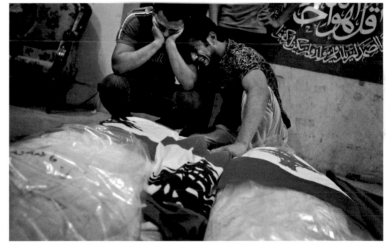

Above. Lebanese civil defence workers remove bodies in Beirut's residential neighbourhood of Chiyah, after an Israeli air strike killed more than two dozen people and wounded scores more.

Left. A Raad 1 missile, said to be owned by Hezbollah, is drawn in the dust formed by the incessant Israeli bombing in the southern city of Soûr (Tyre).
Right. Families mourn those killed when a Beirut apartment building was bombed by Israeli planes. During the burial, the Israeli army continued shelling the area.

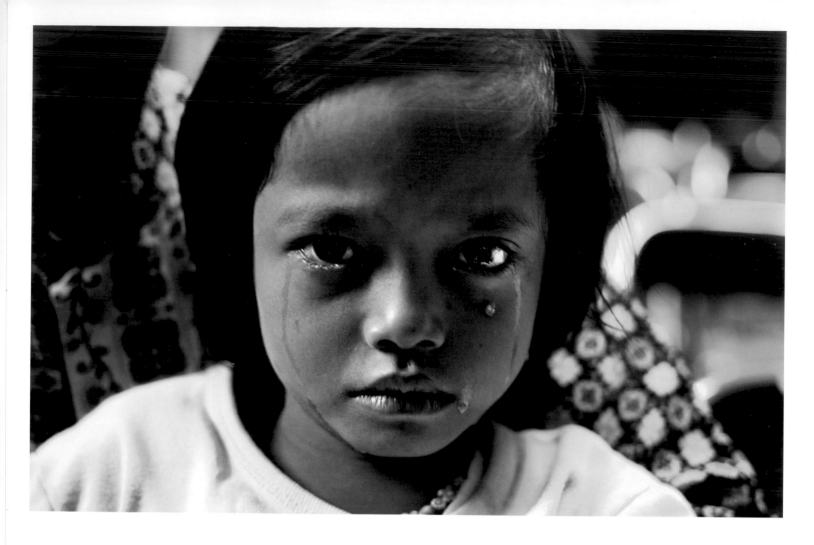

2006
A CUTTING TRADITION
STEPHANIE SINCLAIR

Each spring, in Bandung, Indonesia, mothers take their daughters to a circumcision event where they are handed over to a small group of women who, swiftly and yet with apparent affection, perform the procedure. Organized by an Islamic educational and social services organization, circumcisions take place in a prayer centre or a school classroom. The procedure takes several minutes. Afterwards, the girl's genital area is swabbed with antiseptic. After dressing, she returns to a waiting area, where she's given a small, celebratory gift and a cup of milk. She has now joined a quiet majority in Indonesia, where, according to a 2003 study by the Population Council, 96 per cent of families surveyed reported that their daughters had undergone some form of circumcision by the time they reached 14. These photographs were taken in April 2006 at the Assalaam Foundation's annual mass circumcision, which is free and open to the public, and held during the lunar month marking the birth of the Prophet Mohammed.

A young girl in tears, having just been circumcised. The practice is performed both as a societal custom and as what some Indonesian Muslims see as a religious duty.

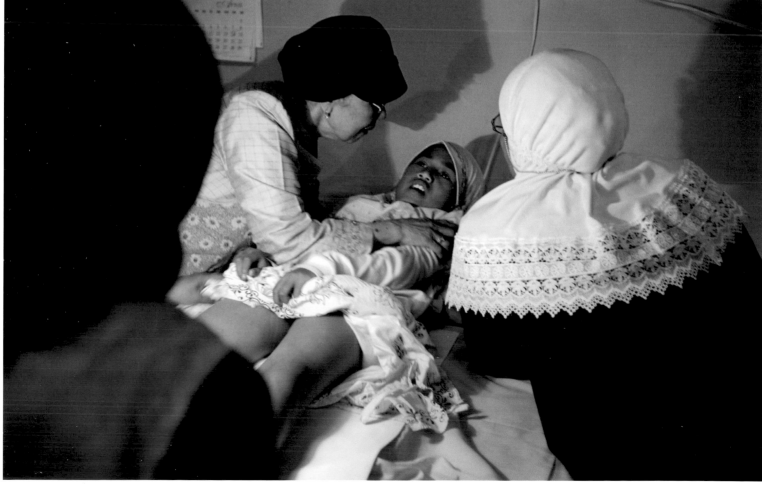

Above. Female circumcisers and their attendants in a primary school classroom, where they are waiting for their next circumcision patients.

Below. Attendants try to pacify a young girl before her circumcision. **Overleaf.** A young girl cries out as she is circumcised. Meanwhile, other circumcisions are being carried out in the same classroom.

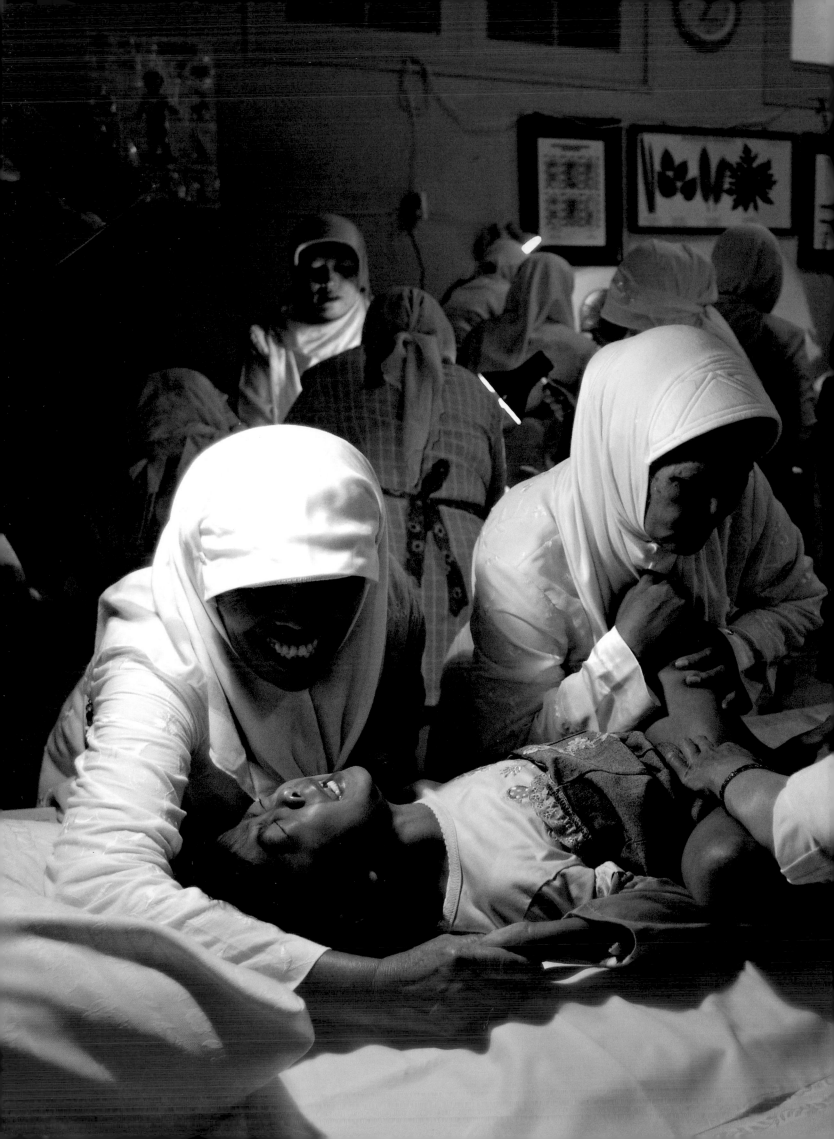

2007
INDIAN HIGHWAYS
ED KASHI

India is the world's largest democratic nation and, second only to China in the world's most populous countries, it has an estimated 1.2 billion inhabitants. While approximately 70 per cent of people live rurally, the rest have migrated over the past few decades to over 200 towns and cities across the country; its urban population has risen by 32 per cent. This rapid metropolitan increase is a potent sign of India's economic progress and the 5,847-kilometre (3,633-mile) Golden Quadrilateral (GQ) highway, which links the four major municipal centres of Delhi, Mumbai, Chennai and Kolkata, is accelerating the young nation's growth. Until now, India's dilapidated system of roads has impeded the country's pursuit of modernization. However, the technologically advanced GQ highway has been met with some concerns as it challenges age-old traditions and tests the nation's founding principles of idealism and austerity as clashes over land use and enterprise zones persist. Ed Kashi's images provide a visual exploration of India's turbulent journey from Gandhi's vision of spiritual, bucolic tranquility to a dominant global marketplace.

Daily life bustles around construction of an elevated section of the Golden Quadrilateral highway in Bangalore. The Golden Quadrilateral is one of India's most ambitious infrastructure projects. Construction began in 2000 and has yet to be fully completed.

Above. Children play in a suburban street by their homes in Palm Meadows, an exclusive, gated community in Bangalore. The community consists of 550 houses, each selling for an average of $1.5 million. Developments like these are increasing as the nation's economy grows and new consumers want elite products.

Below. A transgender sex worker, or *hijra*, engages in paid sex with a client at the hamam in Madanayakana Halli. Hamams have employed eunuchs and transgender sex workers for centuries, unthreatened by modernization. Today, the main clients are the 5,000 truck drivers who come each day via the GQ highway.

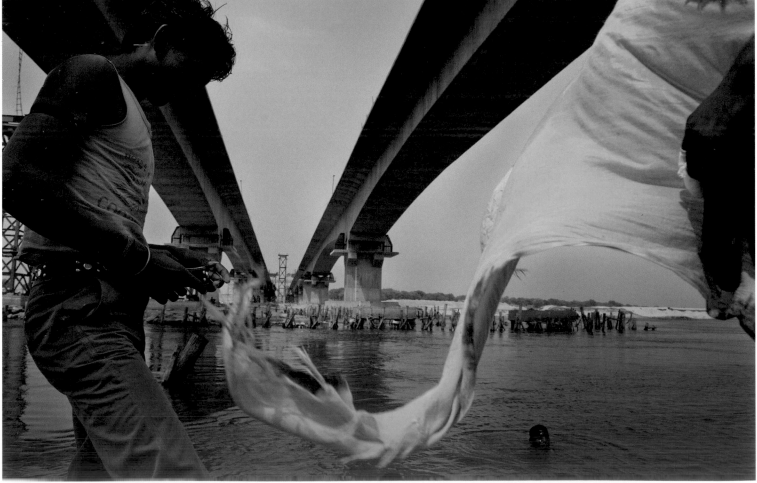

Above. A Hindu priest performs pujas (blessings) at the Prasanna Ganapathy Temple, in central Bangalore. Historically, priests bestowed these prayers on the maharajas' elephants and camels. Today, the priests sanctify new cars, auto rickshaws and motorbikes to ensure their divine protection and prosperity.

Below. Tradition and modernization coexist as local youths swim in the Ganges River, regarded as sacred in Hinduism, under the GQ highway's bridge in Muratganj, Uttar Pradesh.

Above. A trucker's helper surveys the damage to their overturned vehicle carrying a load of straw bales on the GQ highway outside Kishangarh, Rajasthan.
Below. Ramgarh Takri, a slum housing a mainly Muslim community, overlooks the newly constructed GQ highway in Mumbai.

Overleaf. The wrapped body of a deceased driver's assistant, 15, lies in an underpass of the GQ highway in Kanpur, Uttar Pradesh. The young boy had run away from his home just a few days before and was killed when his driver, drunk at the wheel, crashed into a parked truck.

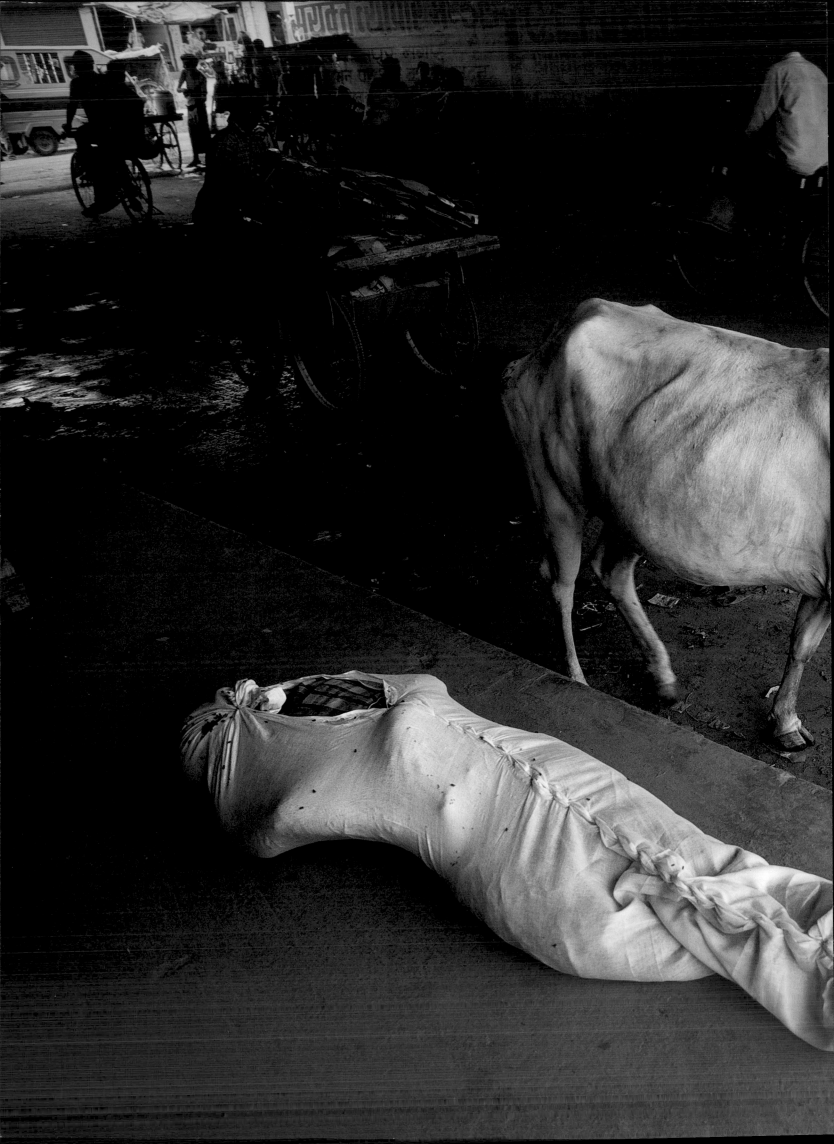

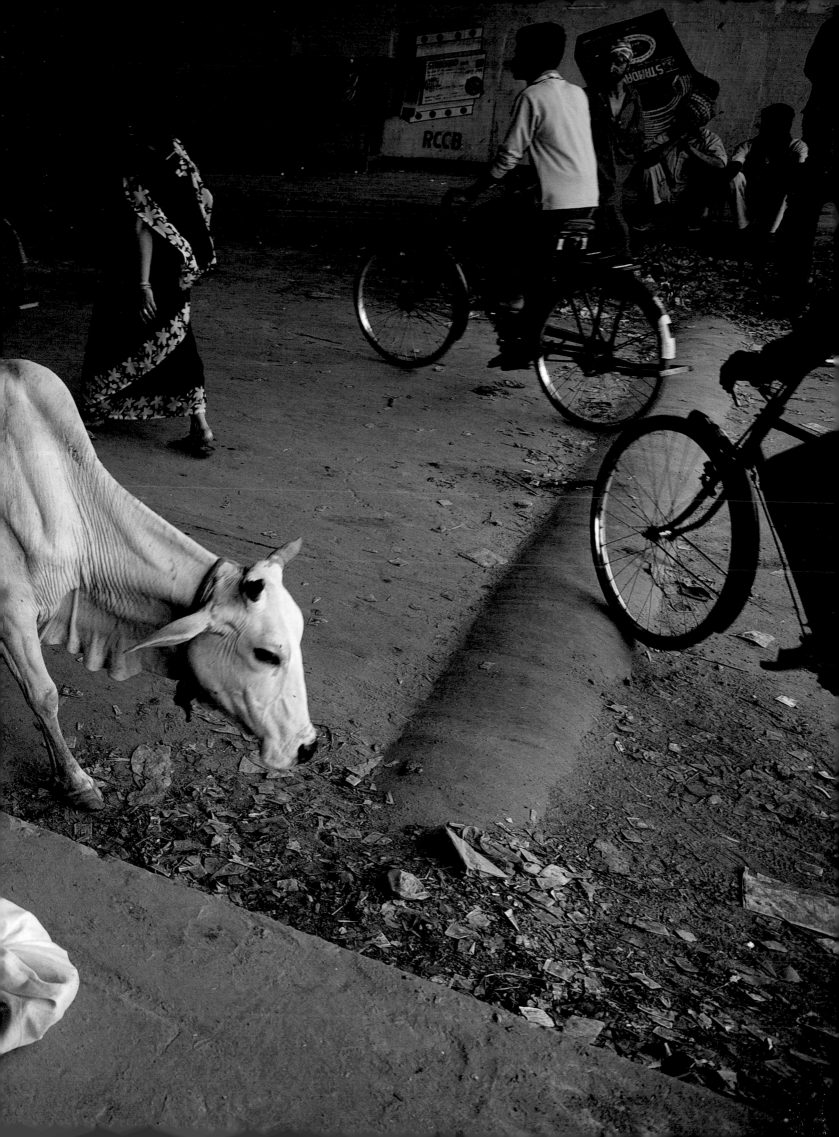

IV. CHANGING OF THE GUARD

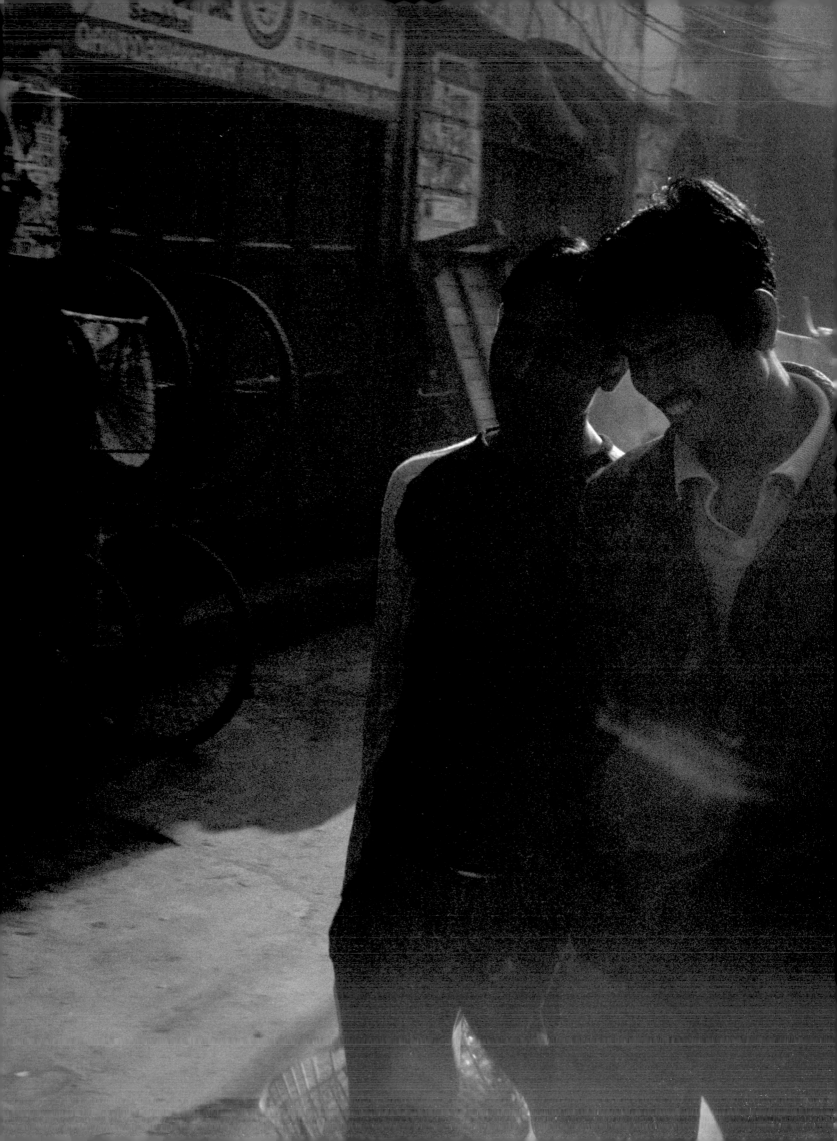

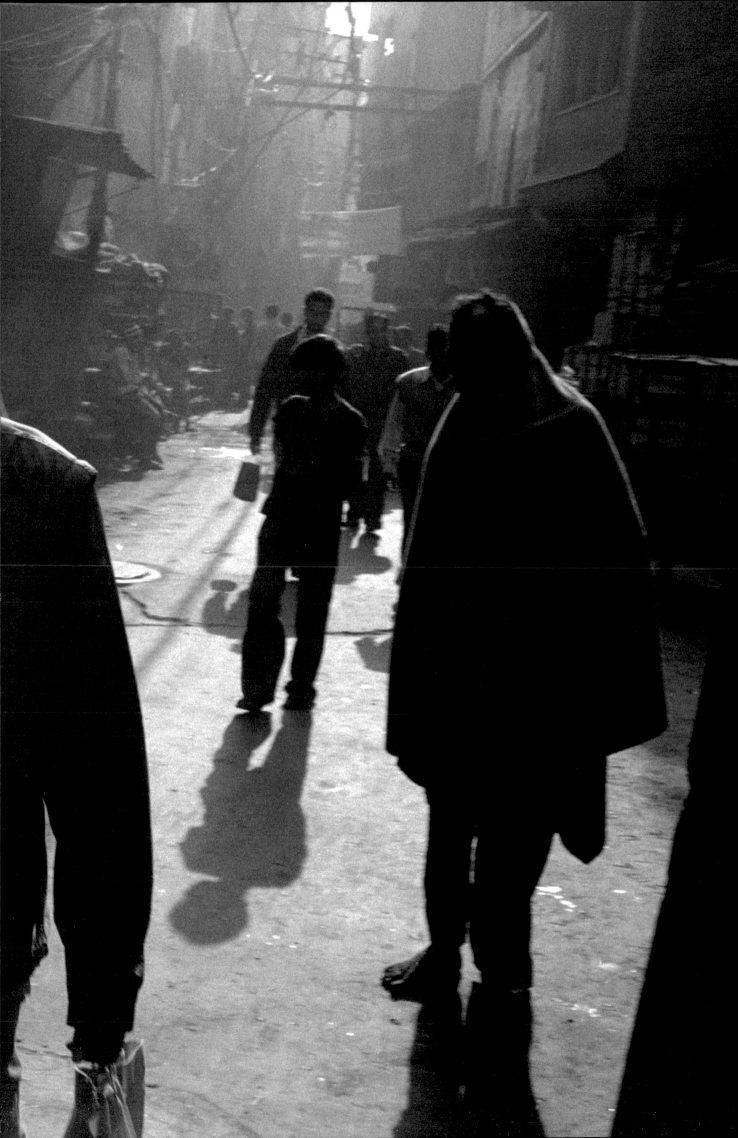

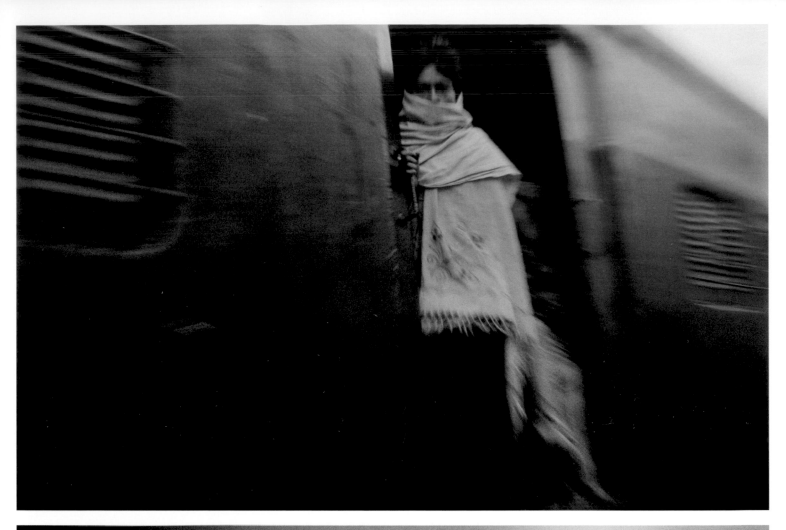

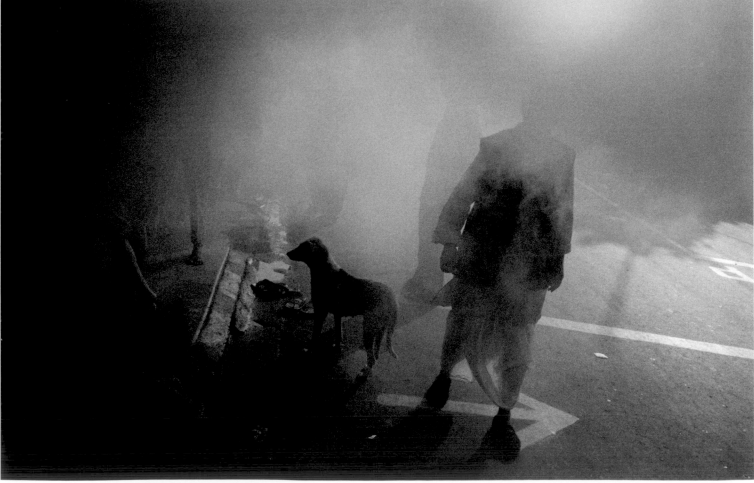

Above. A labourer commutes to Delhi from an outlying rural area, January 2009. **Below.** A man seen through a cloud of incense smoke, Delhi, January 2009.

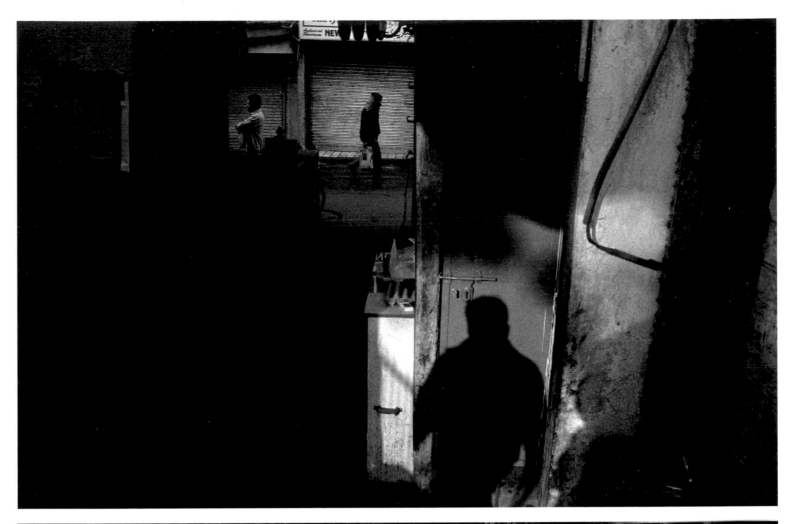

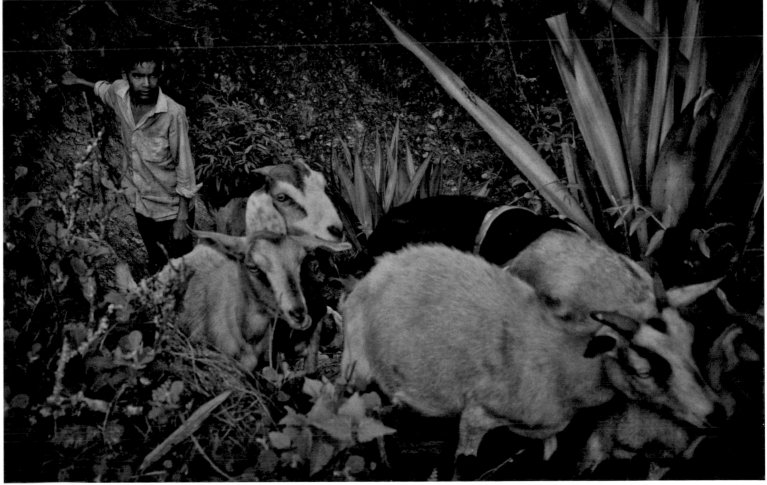

Above. Daily life in a Delhi street, March 2009.

Below. Herding goats in Chaurmauni Settlement, Nepal, May 2007.

Above. Remnants of a meal on a table in an old train station in Kansas City, Missouri.

Below. Morning in Pine Ridge, South Dakota. Lakota Indians have just been released from 'the drunk tank' – the police holding cell.

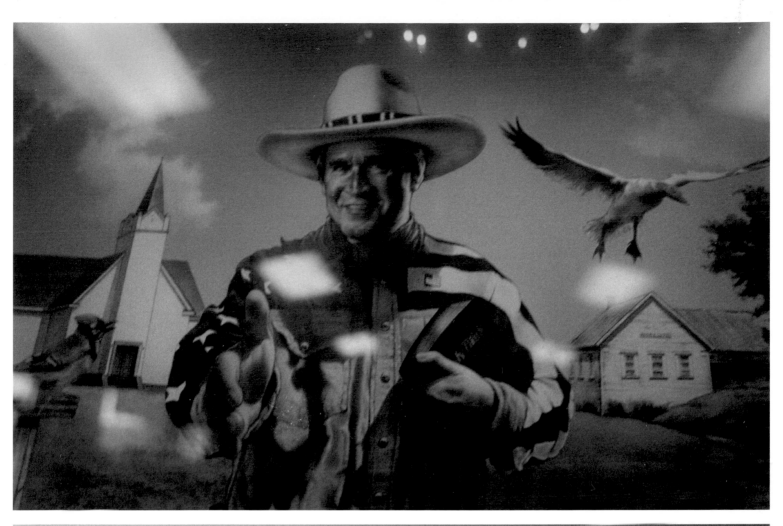

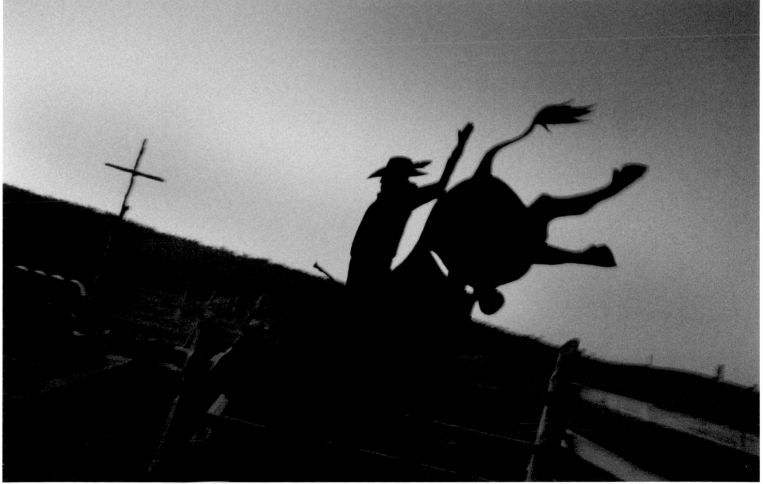

Above. A painting of George W. Bush in a diner, Crawford, Texas.

Below. A bull riders' cemetery, Arizona.

Above. A three-kilometre (two-mile) long freight train, Wyoming. Below. Coach travellers, Las Vegas, Nevada.

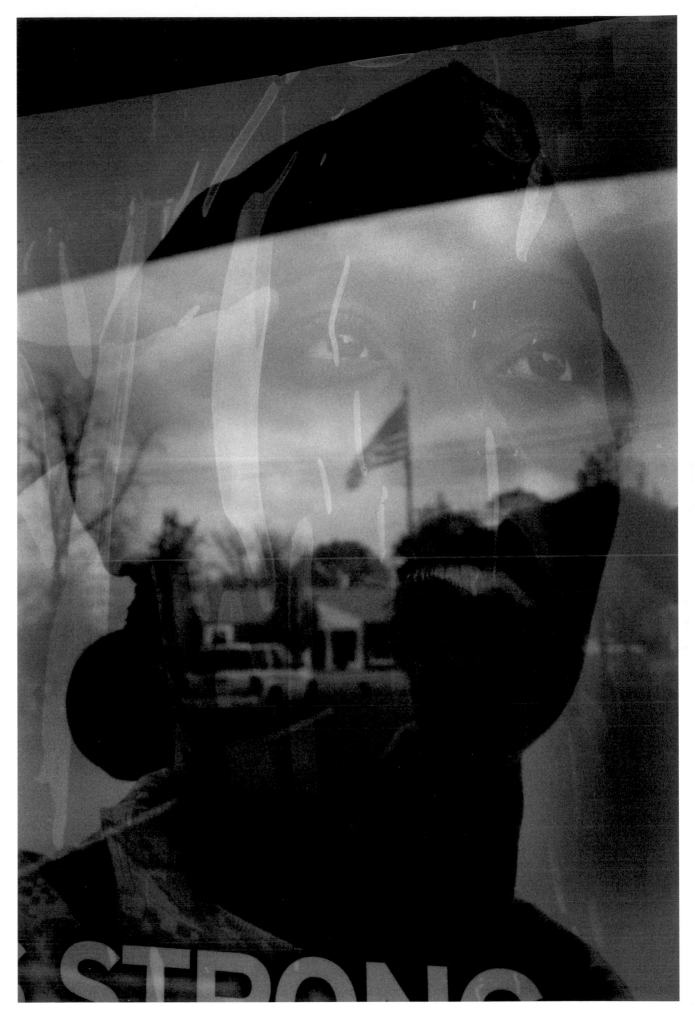

A poster displayed at a US Army recruiting centre in St Louis, Missouri.

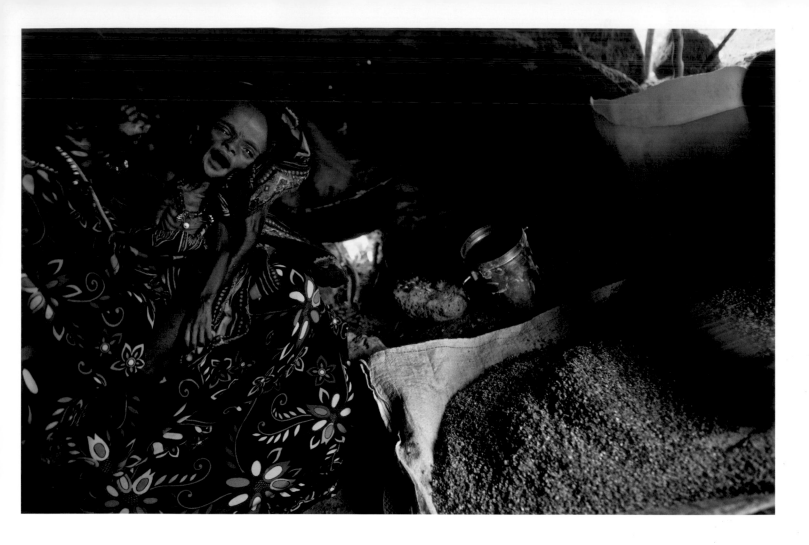

2008
FOOD CRISIS
JOHN STANMEYER

In 2008, riots broke out globally because of rising food costs, and Egyptians are still queuing up every morning for government-subsidized bread. Flooding in North America caused commodities to spike, resulting in basic food items becoming too expensive across the globe, while changing weather patterns in the Indian Ocean spread drought through the Horn of Africa, spawning a famine in Ethiopia. Families in Bangladesh and the Philippines fed themselves with little or no money – and still today, nearly 1 billion people live on $1 per day. These factors are delicately linked, intertwined on a global scale, affecting our world food supply. With a projected global population of 9 billion by 2050, producing enough food is critical as we move towards an end of plenty. In 2008, John Stanmeyer visited nearly every continent to chronicle the causes and effects of rising food prices. With a rigorous documentary approach, Stanmeyer exposes a subject never before so acutely studied, researched and photographed; this work delves into the myriad of layers that affect how we feed ourselves.

Momina Mohammed, 34, tries to nurse her son, Ali, who is acutely malnourished, in an Eritrean refugee camp in Suola, Ethiopia, near to Eritrea. Momina, who hasn't eaten properly for months, can no longer produce breast milk. Droughts have caused thousands to lose their animals and rising food costs prohibit buying food.

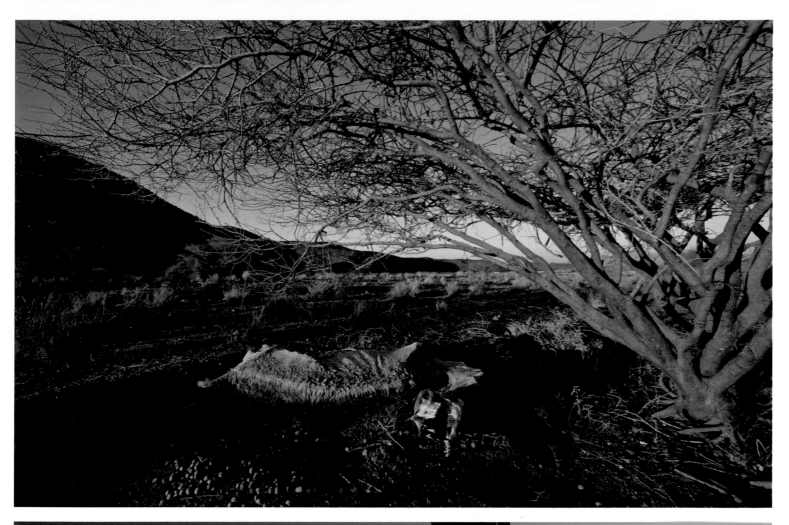

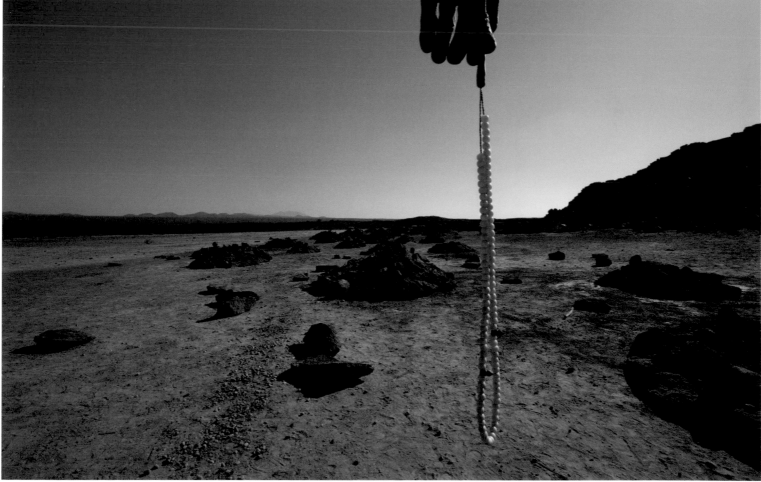

Above. Remains of a camel that died of starvation in Mabaalea village, a remote encampment located in the Teru district of northern Ethiopia's Afar region.

Below. A man visits the grave of his son, who starved to death in the Suola refugee camp, northeastern Ethiopia, near to Eritrea, where more than 10 Afari refugees had perished in the previous three weeks. Over 4,000 Eritreans recently fled across the border when the Eritrean military began abducting young Afari males.

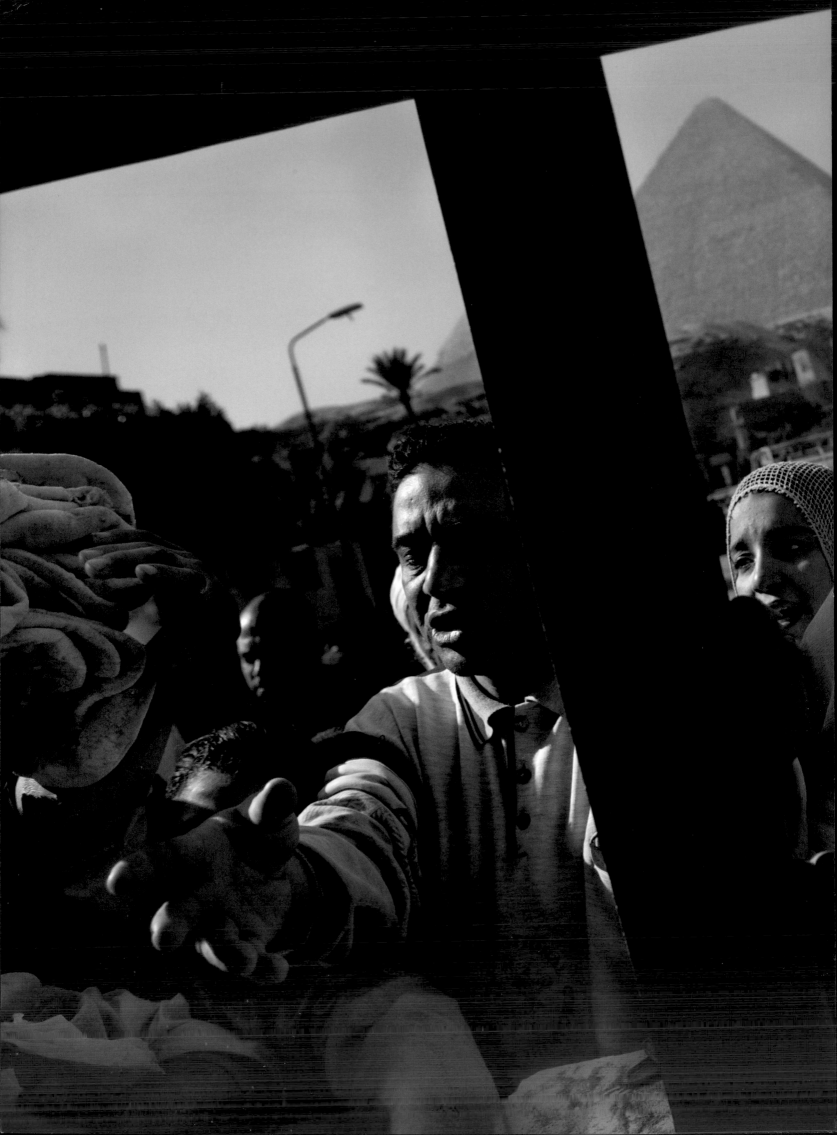

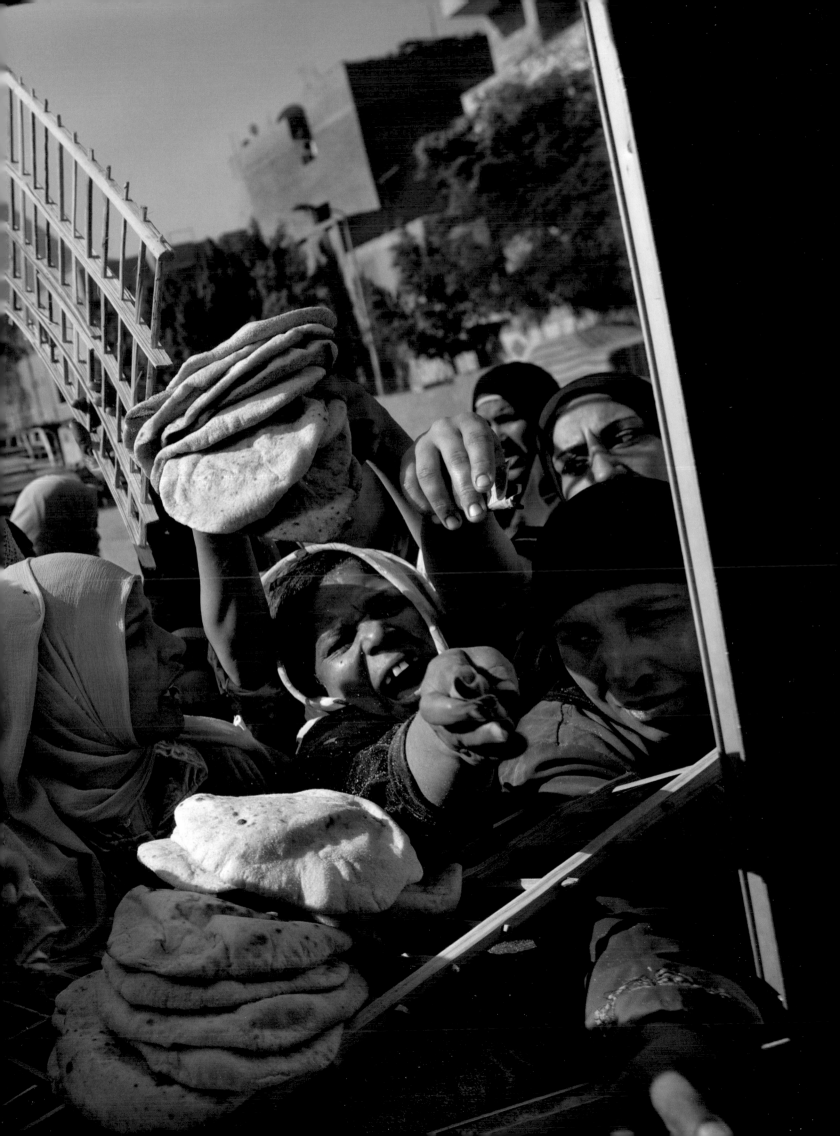

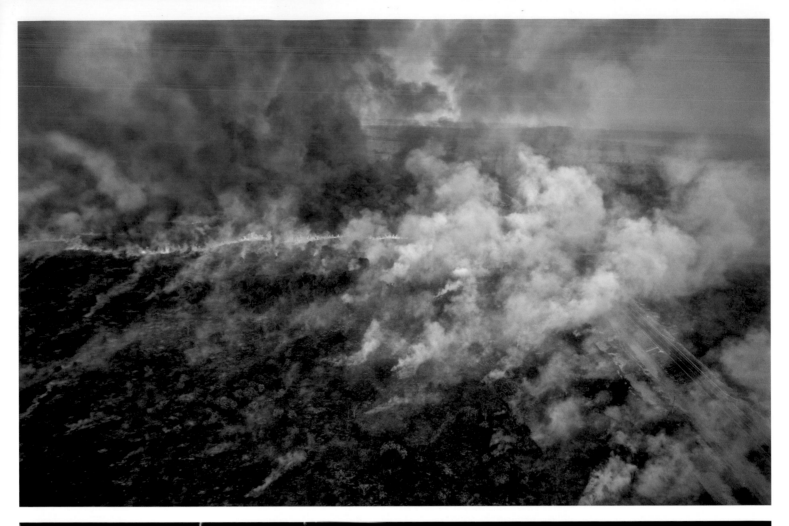

Previous page. Women and men jostle to collect bread from a distribution centre in Nazlet el Samann in Giza, Egypt. Forty-five per cent of Egypt's population lives in poverty, which forced President Hosni Mubarak's government to subsidize bread for decades. In 2008, riots erupted over the rise in food costs.

Above. Deforestation in the upper Mato Grosso state, Brazil, where farmers are burning rainforests to make way for more farmland to raise cattle and soybeans. **Below.** Pork on sale at a market in Guangzhou. China's meat consumption is rapidly rising. Soybeans are imported from the USA, Brazil and Argentina for animal feed.

Above. In the Philippines, women select viable grains of rice for store at the International Rice Research Institute to ensure that all hybrids are available in case of crop failure anywhere in the world.

Below. A woman picks up every leftover grain of rice from a harvested field in Kurigram, northern Bangladesh. Millions of Bangladeshi are forced to survive on less than $1 per day.

2008
SOMALIA
FRANCO PAGETTI

Since the overthrow of Siyad Barre in 1991, Somalia has been in perpetual crisis: with no effective central government, a series of civil wars, recurring drought and clan-based fighting, it is also a humanitarian disaster. In 2004, after several failed international peace processes, a UN-backed transitional government was established, but it has failed to assert authority or to ameliorate the decades of underdevelopment. By 2008, when Franco Pagetti took these photographs, the country had experienced some of the deadliest violence in its history. Two years earlier, Ethiopian forces led an armed intervention to oust the Islamist movement in power across much of the south, including the capital, Mogadishu. Though the government regained nominal control, the Islamists regrouped, growing into an insurgency against which an African Union peacekeeping force has fought a losing battle. Pirates meanwhile swaggered onto the northern coast, taking hostages and demanding ransoms in the millions. A staggering 600,000 Somalis fled Mogadishu in 2007; for those left behind, life in this collapsed state is nasty, brutish and short.

Somalis walk among the remains of destroyed ancient structures in the Hamar Weyne district of Mogadishu. This is one of the most dangerous areas of the city.

Above. Women walk past the skeletal remnants of bullet-ridden buildings in Mogadishu's Shangani neighbourhood, once one of the city's wealthiest areas.

Below. Somalis shop at an open-air market in the shadows of decaying buildings in the Hamar Weyne district of Mogadishu.
Overleaf. Fishing boats at Mogadishu's beach. Sometimes the boats are used to illegally transport refugees to Yemen.

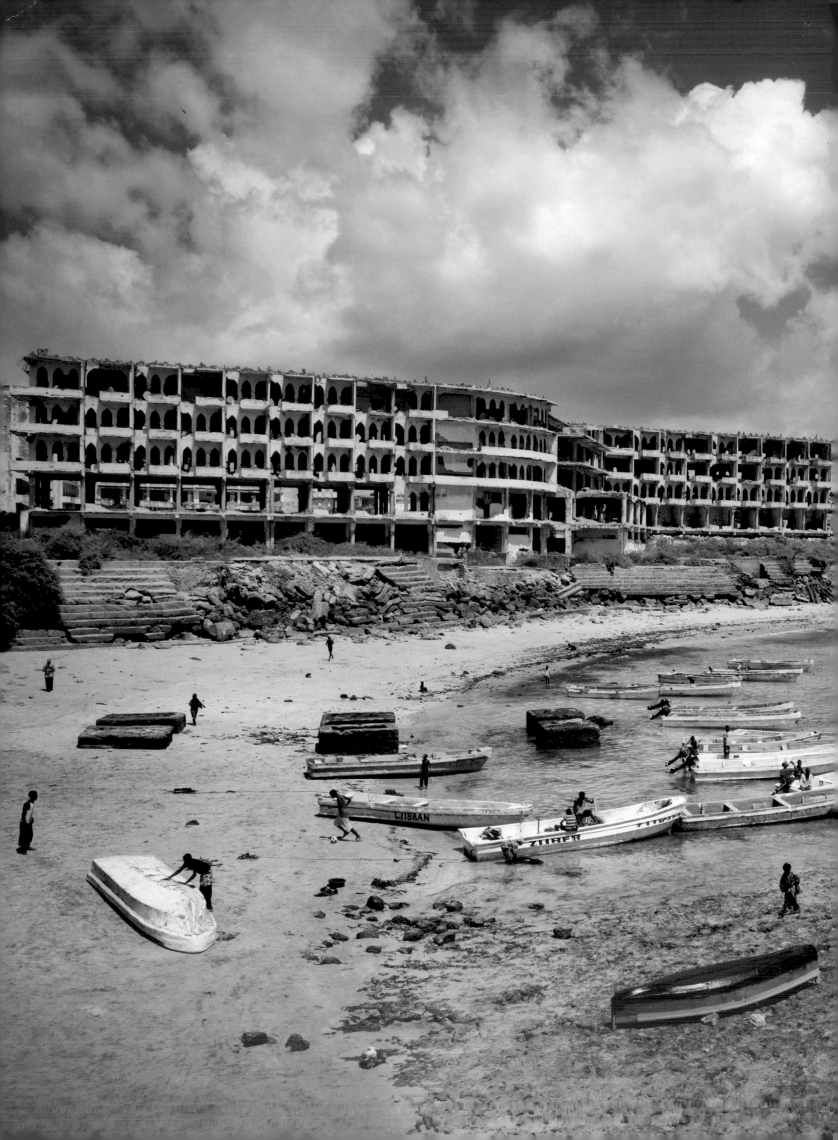

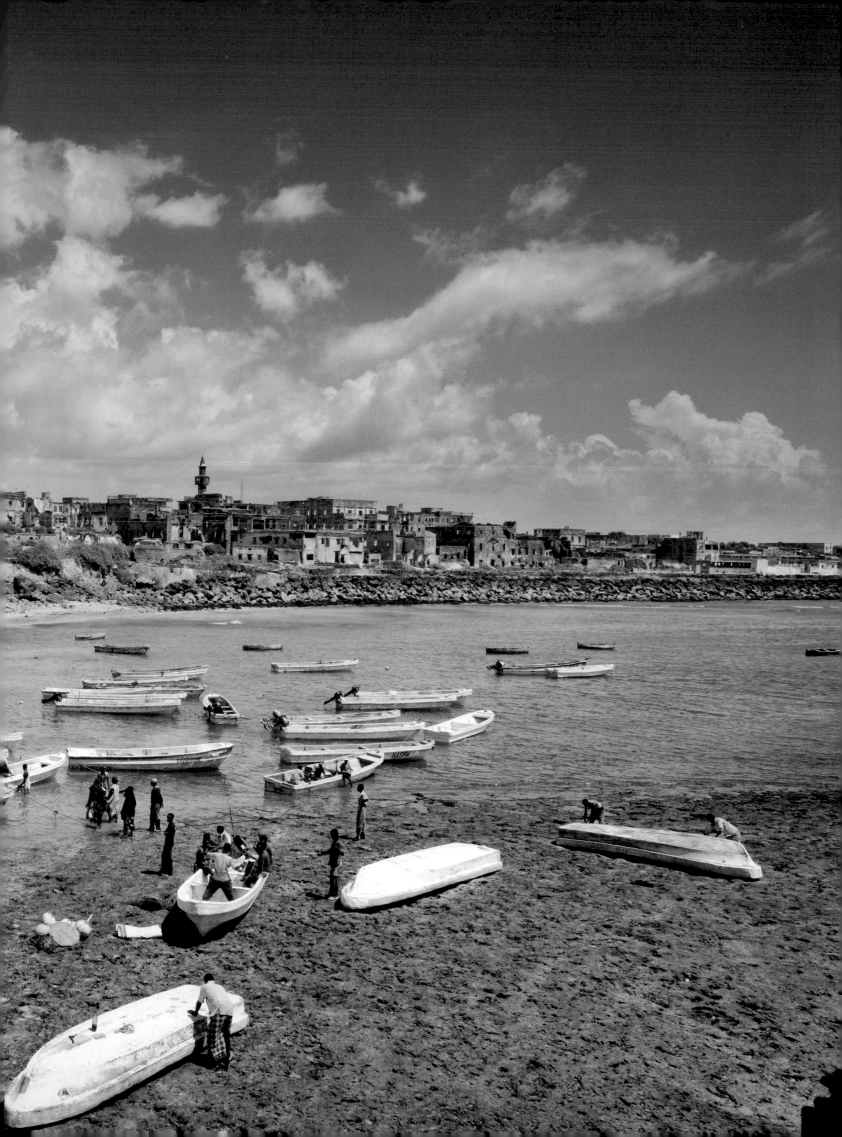

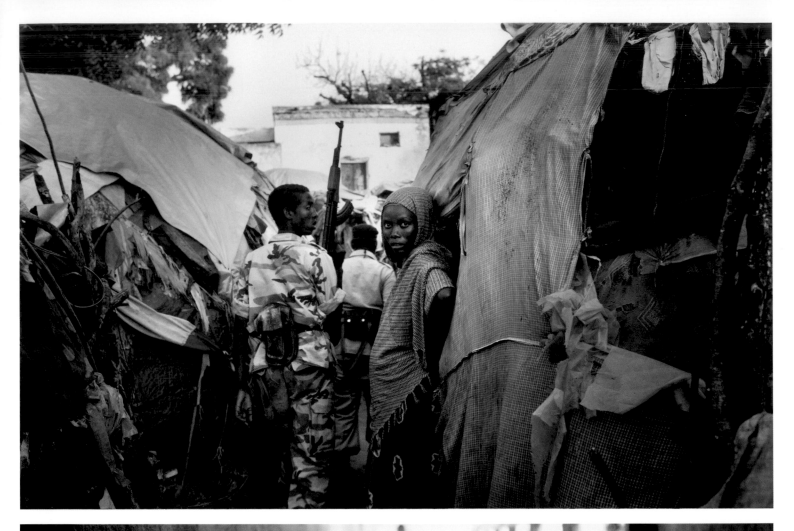

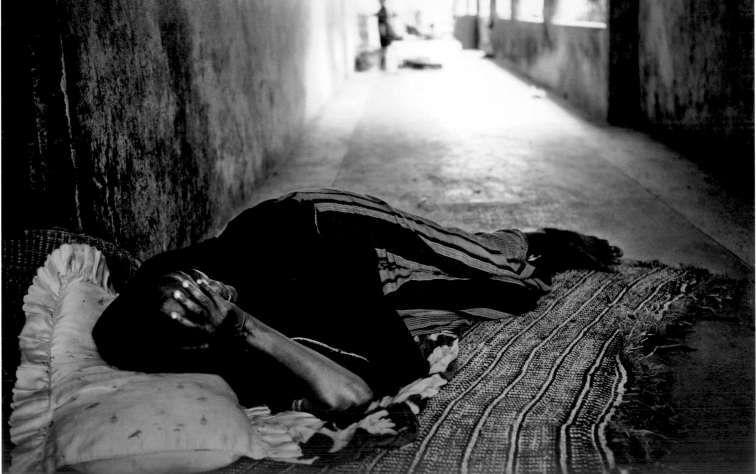

ABOVE. Soldiers patrol the Al Hijra refugee camp, Shangani district, Mogadishu. Some of the IDPs (internally displaced persons) have been living here since 1995.

BELOW. A woman rests in one of the biggest refugee camps, formerly a polytechnic school, in the heart of Mogadishu's Banadir district.

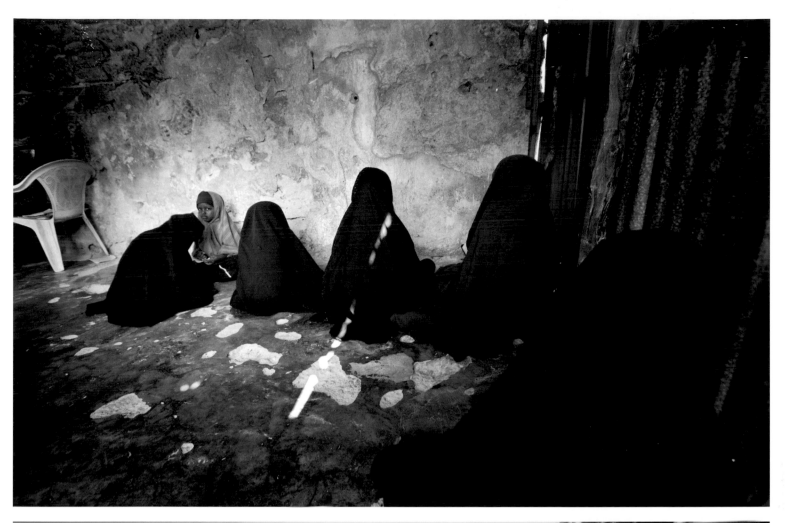

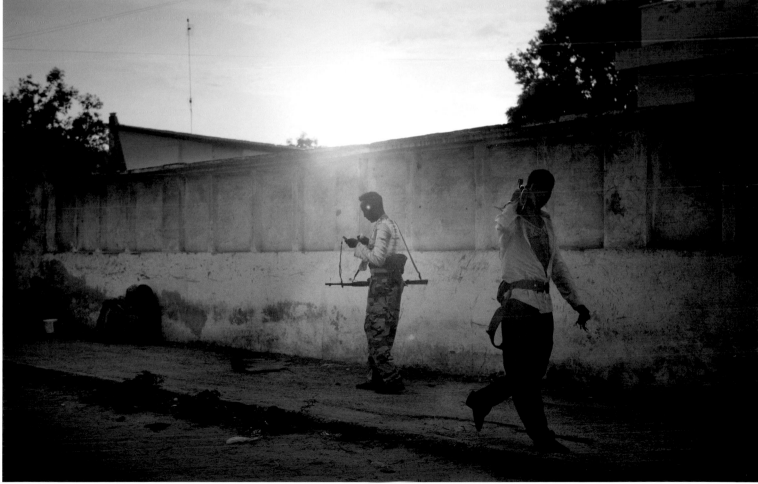

Above. Girls study at a *madrasah* (school for Islamic study) in the Al Hijra refugee camp in the Shangani district, Mogadishu.

Below. Soldiers of the Transitional Federal Government (TFG) patrol a controlled government area along the KM4 road in the Benadir region of Mogadishu.

2008
IRAQ SURVIVORS
FRANCO PAGETTI

Franco Pagetti has documented the war in Iraq since the US invasion in 2003. The invasion broke the community into sectarian halves: Sunni and Shi'ite, who had lived alongside each other for 1,400 years – albeit not in perfect harmony – became mortal enemies, resulting in neighbourhood violence, murder and reprisals.
In this series of black and white portraits, mostly taken in 2008, Pagetti captures the faces of ordinary people who live and work in Baghdad, trapped amid the violence and suicide bombings that have become an almost weekly occurrence in the capital. They are the lucky ones – the survivors.

286. From left to right, Ali Abdul Hussein, Mohammed Abdul Redha and Ahmed Khalaf. They are Shi'ites who work in the local office of political leader Moqtada al-Sadr. After a Sunni mosque was attacked, they helped to secure it.

287. Aya Abbas Hussain, 9, (left) and Banee Adel Abdullah, 8 (right). Both walk to their school in Hayy Al-Jami'a, despite the threat of car bombs.

288. **Above left.** Nazar Khadim Harib, 31, is a butcher in Al-Jadriya.

288. **Above right.** Andalus Abdal-Rahim Hammadi with his wife, Shada, his son, Ibrahim, and his daughter, Sajda. Hammadi is a former private taxi driver from Al-Doura.

288. **Below left.** Firas Hadi Zibala, 31, is a baker in Hayy Al-Jami'a in the Mansour district of Baghdad.

288. **Below right.** Abdul Rihman Tarik Jasim, 20, sells cigarettes near Baghdad University in Al-Jadriya.

289. **Above left.** Ibrahim Mohammed Ali, 50, sells CDs and other ephemera in Al-Jadriya, near the Baghdad University campus.

289. **Above right.** Abbas Anwar, 22, sells paraffin on the black market, waiting for customers on a Karrada street.

289. **Below left.** A man, who wishes to remain anonymous, sells vegetables and fruit in Karrada.

289. **Below right.** Ammar Samir, 23, is a fisherman who lives in Karrada with his wife and their two-year-old daughter.

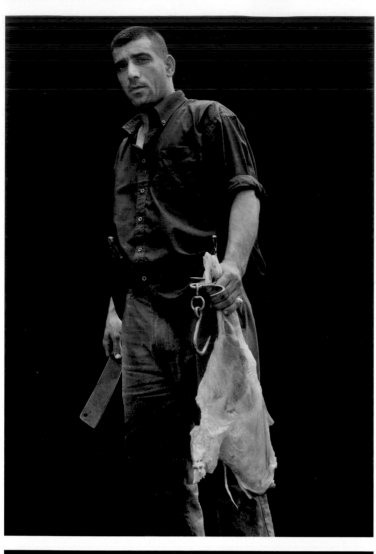
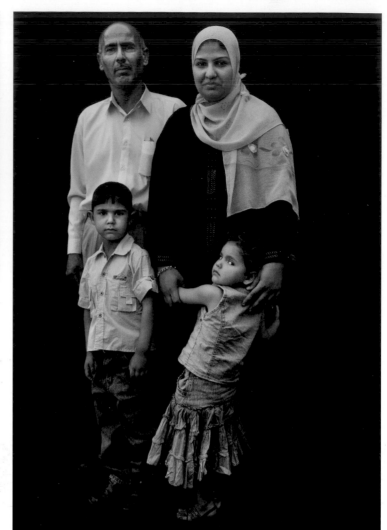

2008
CARTIER INTERNATIONAL POLO DAY
CHRISTOPHER MORRIS

Held each July, the Cartier International Polo Day sparkles as the crown jewel of the British social season. Drawing crowds of more than 30,000, it is the calendar's most glamorous and prestigious event. In 2008, Christopher Morris uniquely documented the full spectrum of glamour and prestige that filled the fields at the Guards Polo Club situated in Windsor Great Park. Among the multitude of attendees enjoying the summer sunshine, and caught on camera by Morris during the course of the day, were Prince Charles, burlesque performer Dita Von Teese and Harry Potter star Emma Watson. Alongside the privileged guests, members of the paying public took in some of the most ferocious and exciting polo in the world, although all in all there was probably more mutual people and fashion-watching than attention on the sport itself.

Above and following pages. The Cartier International Polo Day at the Guards Polo Club in Windsor, England, Jul, 2008.

2008
SOUTH OSSETIA WAR
VII

On 7 August 2008, Georgian forces followed exchanges of heavy fire with separatists in South Ossetia, a de facto independent province of the former Soviet republic of Georgia, by launching a large-scale military offensive on Tskhinvali, South Ossetia's capital, attempting to retake the enclave by force. Russia, which had been increasing its ties with the breakaway Ossetians since the spring, responded by sending aircraft and armoured units into South Ossetia and targeting vital military and logistical locations inside Georgia proper. Russian and Ossetian troops battled Georgian forces throughout South Ossetia for several days, killing hundreds and displacing thousands. Ron Haviv and Marcus Bleasdale's photographs document the Russian advance into Georgia and its aftermath.

Ron Haviv. A Russian helicopter flies over a road leading to a major Georgian city, an area that Russian forces controlled at the time.

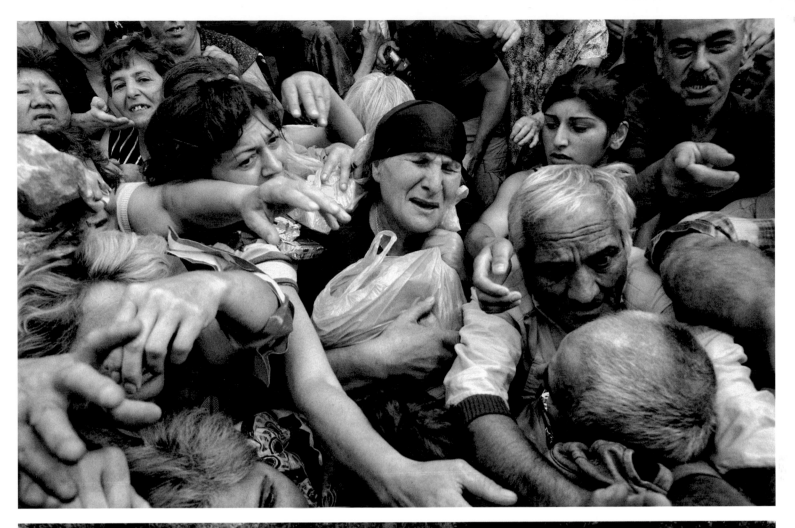

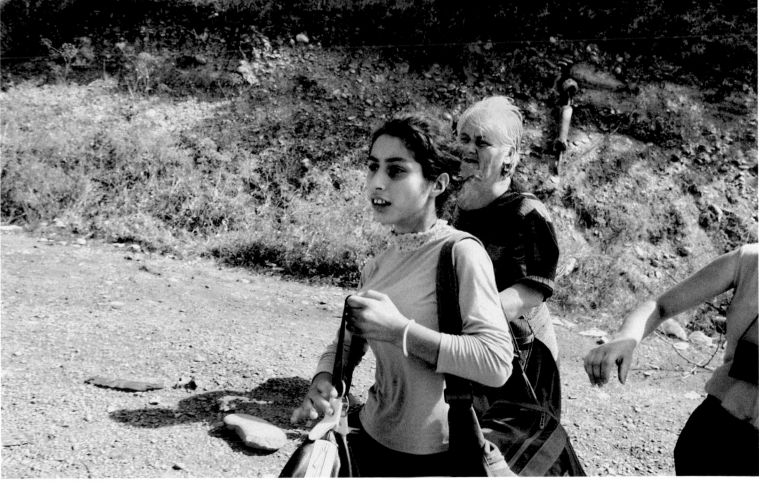

Above. Ron Haviv. Georgians jostling for food aid, which was in short supply during the conflict.

Below. Ron Haviv. Georgian families flee their homes as Russian troops move deeper into Georgian territory.
Overleaf. Ron Haviv. Georgian military bury soldiers killed in the conflict.

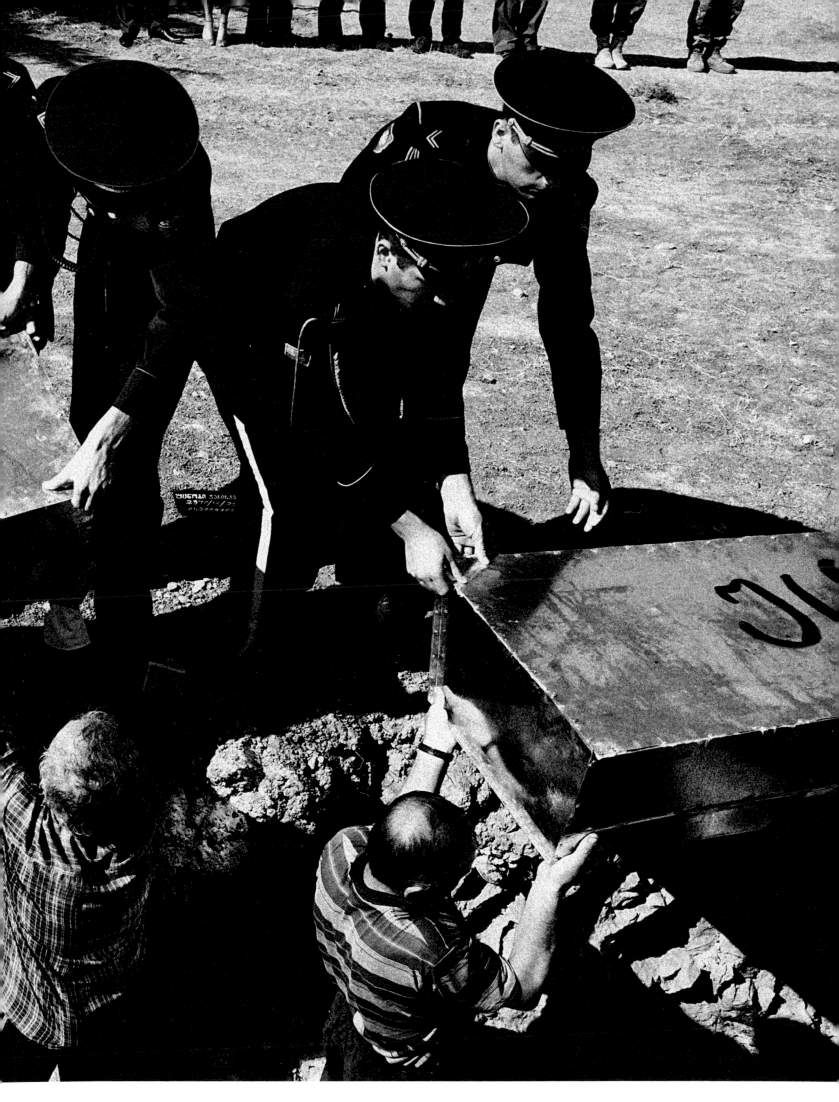

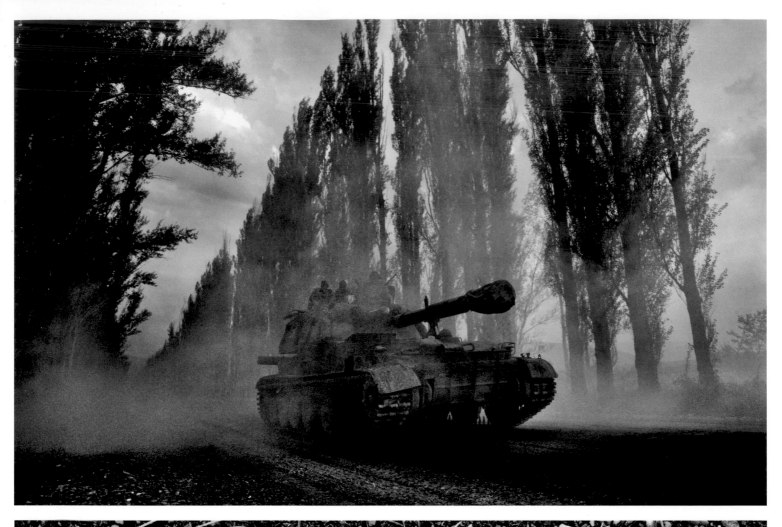

Above. Marcus Bleasdale. Russian tanks pull out of the central Georgian town of Gori after a war that had lasted a week.

Below. Marcus Bleasdale. As Russian troops advanced into Georgia, Georgian soldiers shed their uniforms and fled.

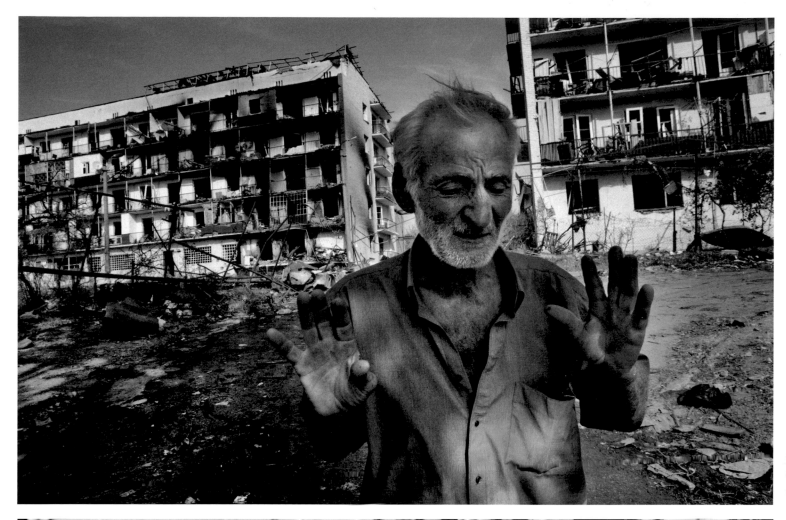

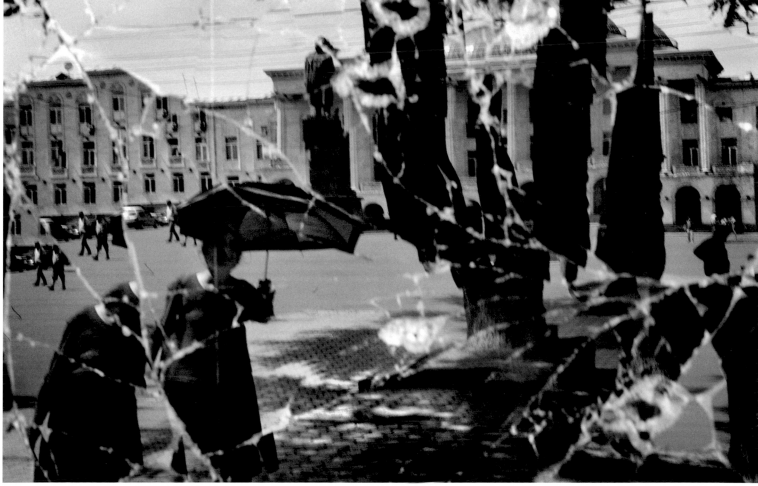

Above. Marcus Bleasdale. A man from the Georgian town of Gori is made homeless by the Russian air strike during their advance into Georgia. Although the Russian assault was ostensibly on military targets, many residential buildings were hit.

Below. Marcus Bleasdale. Citizens in Gori's Stalin Square walk past a building destroyed by Russian cluster bombs.

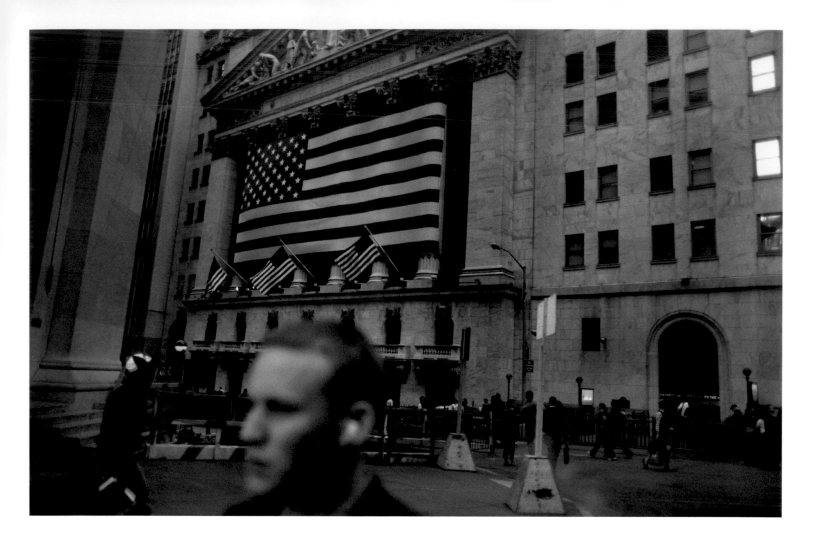

2008–2009
GLOBAL FINANCIAL CRISIS
VII

In September 2008, Wall Street faced its biggest crisis since the
Great Depression. The collapse of Lehman Brothers and the Bank
of America's emergency purchase of Merrill Lynch were followed by
bankruptcies, massive job losses and fear of an economic depression.
Investment banks, which once ruled high-end speculative finance,
crumbled as hundreds of billions in mortgage-related investments
went bad. The US government seized the nation's largest insurance
company and largest savings and loan company. In October 2008,
a collapse was headed off by the US Congress's bailout plan and
actions by the Federal Reserve to pump money into the system.
Although financial meltdown was avoided in the United States, the
crisis spread around the globe, forcing countries in Europe to seek
emergency aid from the International Monetary Fund. The turmoil
in Wall Street was mirrored by pandemonium in the City of London,
Europe's financial capital.

Antonin Kratochvil. People walk past the New York Stock Exchange on Wall Street,
September 2008.

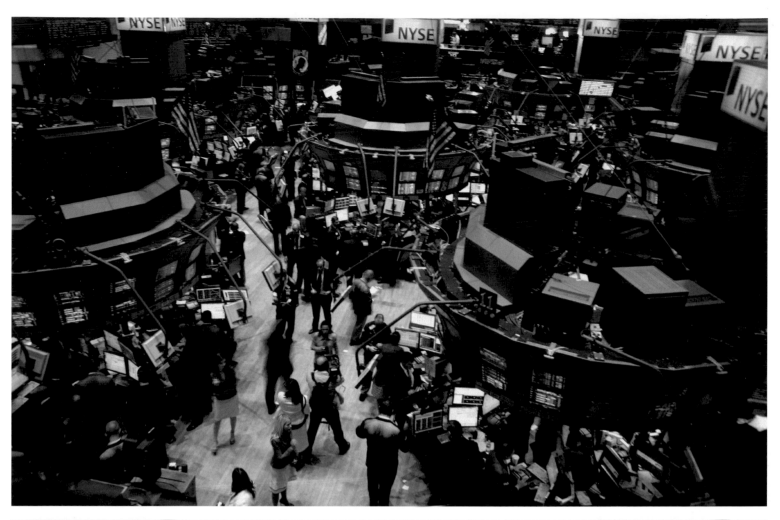

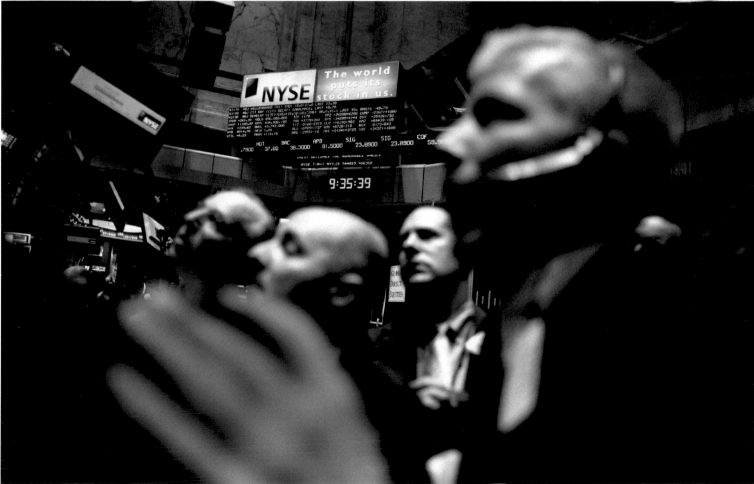

Above. Antonin Kratochvil. On the trading floor of the New York Stock Exchange, September 2008.

Below. Antonin Kratochvil. Traders in the New York Stock Exchange clamour to close their deals, September 2008.

Above. Antonín Kratochvíl. A Jaguar sports car on display at the Motorexpo held at the World Financial Center, New York, September 2008.

Below. Antonín Kratochvíl. A man holds his head in his hands while sitting on the steps of the Federal Hall National Memorial, adjacent to the New York Stock Exchange, Wall Street, New York, September 2008.

Antonin Kratochvil. Workers at Lehman Brothers clear out their offices at the midtown Manhattan building, New York, September 2008.

Above. Marcus Bleasdale. Mobile phones on a broker's desk, London, September 2008.

Below. Marcus Bleasdale. In the City of London, brokers are frantic as banks unwind deals and try to protect themselves from market volatility, September 2008.

Above. Marcus Bleasdale. Banks filing for bankruptcy amid financial turmoil does not stop city brokers having their busiest time in years, London, September 2008.

Below. Marcus Bleasdale. Traders at BGC Partners in London battle through the financial crisis one year after Merrill Lynch collapsed, September 2009.

2008–2009
POLYGAMY IN AMERICA
STEPHANIE SINCLAIR

The Fundamentalist Church of Jesus Christ of Latter-Day Saints
(FLDS) is North America's largest practitioner of plural marriage
and the most secretive Mormon sect in the United States. They
gained international notoriety with the arrest of their leader Warren
S. Jeffs, who in 2006 was wanted by the FBI for avoiding prosecution
relating to his alleged arrangement of unlawful marriages between
adult male followers and underage girls. Stephanie Sinclair spent
over a year with the FLDS to explore how this protective community
continues to survive amid what they consider to be a battle over
faith and the authorities' desire to end their way of living. Residents
are encouraged to keep a low profile as polygamy is against
the law in the United States, and men in this community can have
anywhere between one and 20 or more wives and multitudes
of children. Polygamy is seldom prosecuted in the United States'
Mormon-dominated southwestern states because most Mormons
are descendants of polygamy despite their later widespread
renunciation of the practice.

A highly respected member of the FLDS, Joe Jessop is the patriarch of a family of
five wives, 46 children and – at last count – 239 grandchildren. 'My family came
to Short Creek,' he says, ' ... to obey the law of plural marriage, to build up the
Kingdom of God.'

Above. Daughters of FLDS leader Warren S. Jeffs, Susan Jeffs, 9, and Josephine Jeffs, 15, relax in their room after a day of playing.

Below. Four sons and a son-in-law of Warren S. Jeffs sing a hymn shortly after the arrest of the FLDS leader. Portraits on the mantelpiece are of the former FLDS leader Rulon Jeffs (right) and his son Warren, who replaced Rulon after his death in 2002.

Above. After helping bring in the hay harvest, Amber Barlow, 16, soars on a home-made swing with friends at the 1,600-hectare (4,000 acre) FLDS ranch in Pony Springs, Nevada.

Below. Young FLDS women tarp the harvest on their Pony Springs ranch. 'It's hard work, but I enjoy it,' says Annette Jessop, 19 (far right). 'I'm with friends and away from the rest of the world.' Despite their conservative lifestyle, FLDS women drive, have mobile phones and are computer literate.

Above. Children enjoy the snow at Harker Farms, Utah, a dairy and alfalfa farm run by FLDS members. In keeping with original Mormon teachings, much of the property in Hildale (Utah) and Colorado City (Arizona) is held in a trust for the Church.

Below. FLDS students in Bountiful, British Columbia, take a bus to school. While the Canadian community has its own school, nearly all FLDS children in Hildale (Utah) and Colorado City (Arizona) are homeschooled.

Previous Page. Verda Shapley, 19, reaching for a cable trolley, with her sisters in a Hildale pond, Utah. FLDS members wear modest attire, even while swimming.
Above. Bishop Merril Jessop (centre) heads a receiving line beside the casket of his first, and only legal, wife Foneta, while his other wives line up behind him.

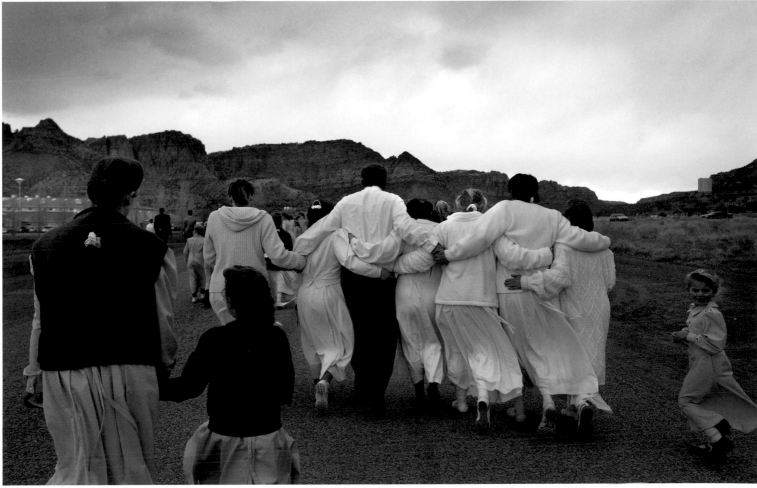

Above. Meagan Jessop, 16, trains her horse to lie down on command at her father Joe S. Jessop's home in Short Creek, Arizona.

Below. An FLDS man leaves Foneta Jessop's funeral service, linking arms with six of his wives, two of them Foneta's daughters. Only men deemed 'godly' are permitted to enter into plural marriage by the church leader; those later judged unworthy can have their wives and children reassigned to other men.

Stephanie Sinclair – Polygamy in America 313

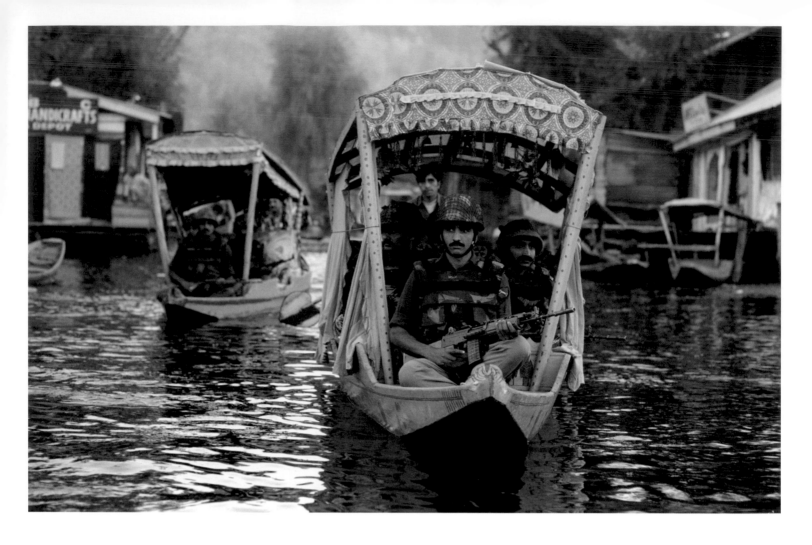

2009
KASHMIR: FAULT LINES
VII

Caught between two nuclear-armed powers, Kashmir struggles
for independence against a brutal occupation by India's 400,000
troops. The territory has been in dispute since 1947, when Muslim-
majority Kashmir was handed over to Hindu-majority India, despite
Muslim-majority Pakistan's objections. The 1948 ceasefire agreed
that one third of the region should be administered by Pakistan
and two thirds by India. In 1989, an armed insurgency – indigenous
resistance groups and Pakistani-backed foreign guerrillas – called for
independence. Kashmir is tormented by violence: each day around
15 Kashmiris are killed by security forces. India claims the insurgents
are terrorists from Afghanistan and Pakistan-administered Kashmir,
encouraged by the Pakistan government. Pakistan calls them 'Kashmiri
freedom fighters' and insists that it provides only diplomatic support.
In May 2009, against a background of continuing killings, two
women were allegedly raped and killed by Indian security forces,
provoking violent protest in Srinagar. The riots led to more killings
and further riots, mirroring this ongoing pattern of unending conflict.

Gary Knight. A disputed region since 1947, the Special Boat Patrol of the Indian
Army cruises Dal Lake, Srinagar, in search of pro-independence insurgents, 2001.

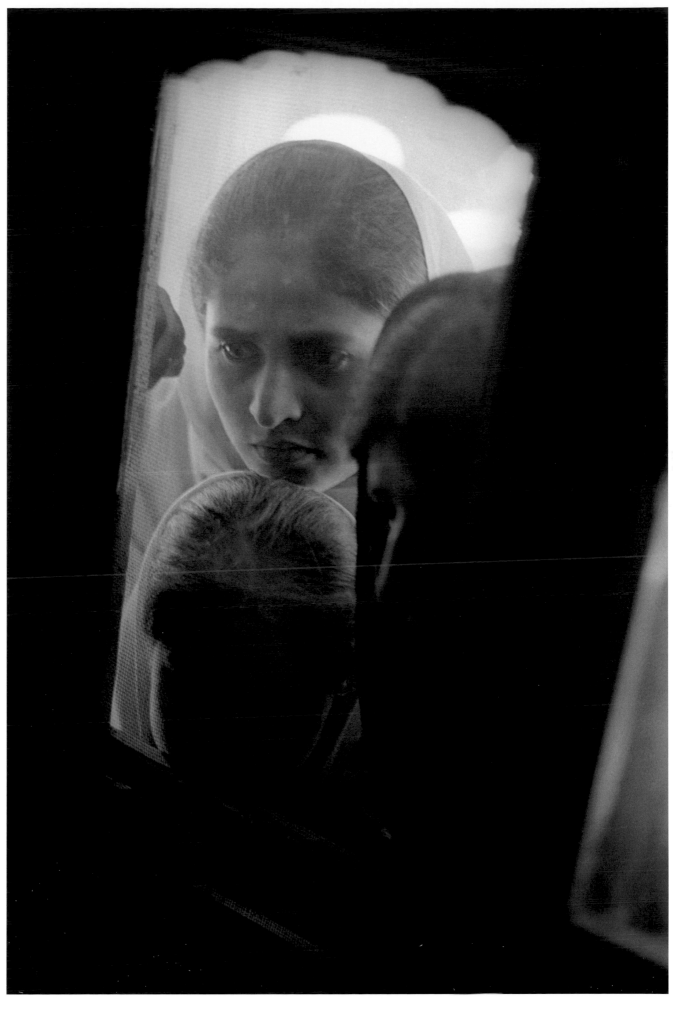

Above. Gary Knight. Young Kashmiri girls look through a window at a bereaved family whose son was killed by Indian security forces in 2001.
Overleaf. Marcus Bleasdale. The burial of a Kashmiri student, allegedly murdered by Indian security forces in Srinagar, 16 July 2009.

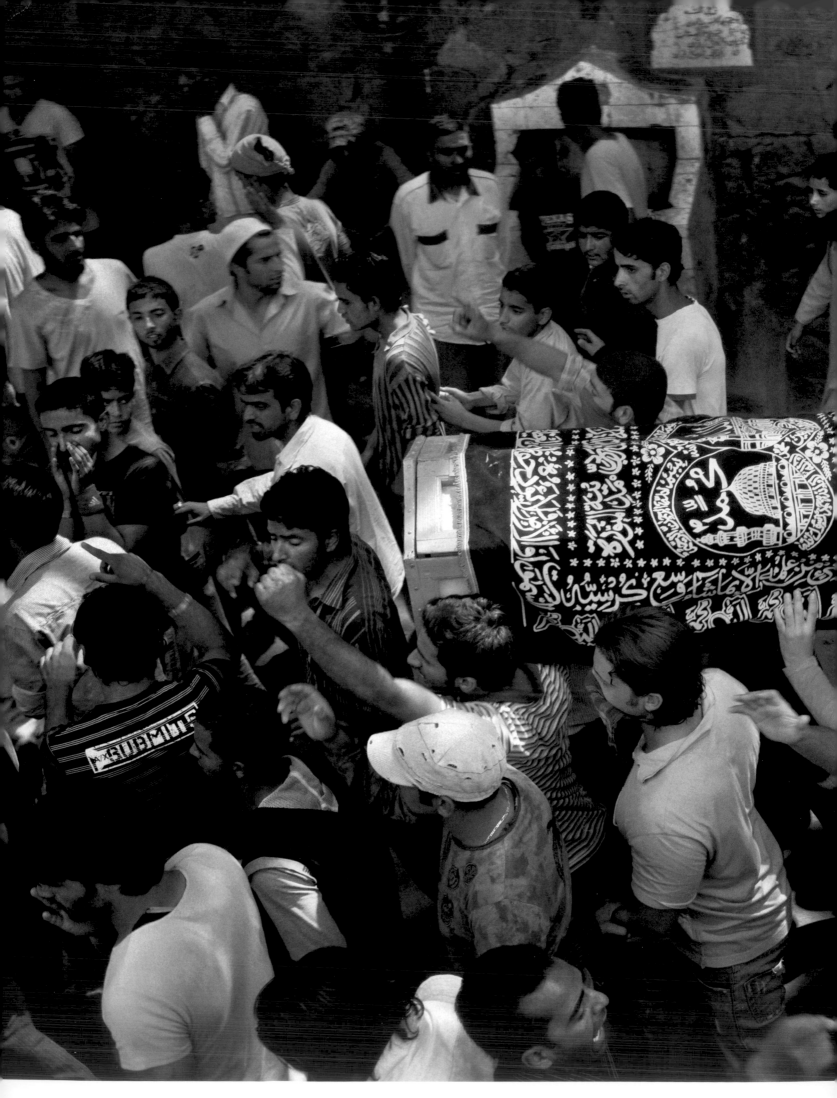

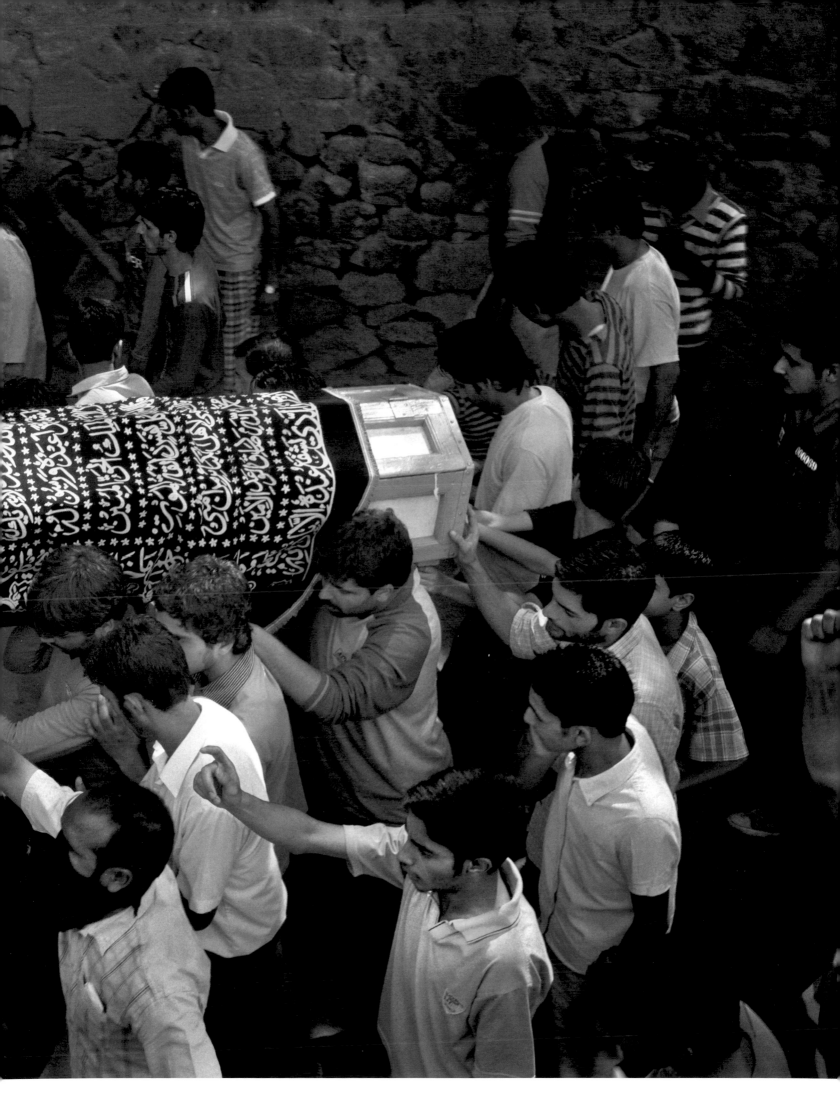

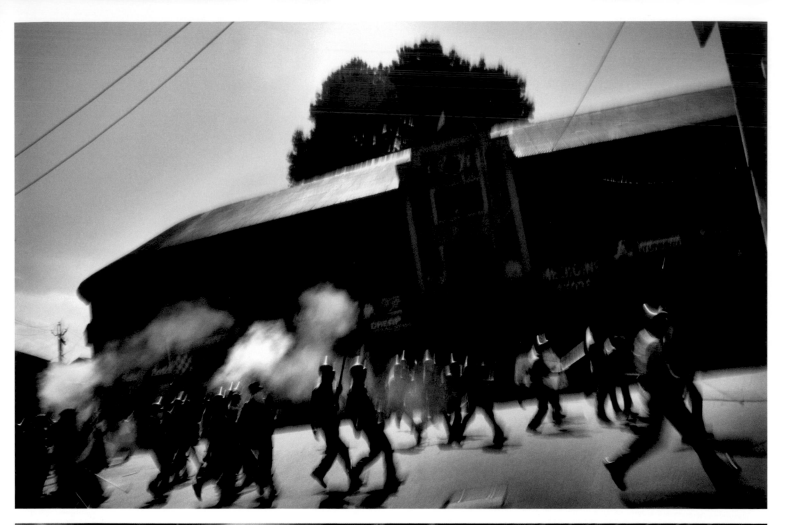

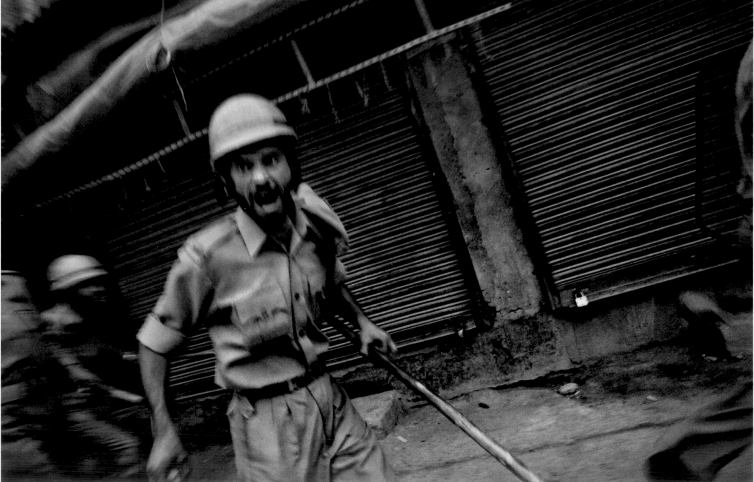

Above. Marcus Bleasdale. Members of India's Central Reserve Police Force (CRPF) advance on protestors throwing stones at the CRPF and the Kashmir police. 16 July 2009. The protest in Srinagar erupted after the bodies of two young women were discovered amid claims that they were raped and murdered by CRPF paramilitaries.

Below. Marcus Bleasdale. Security forces rush towards young men demonstrating in Srinagar, Kashmir's regional capital, 16 July 2009. Three protestors were killed and four injured. The rioting started after two girls were allegedly raped and murdered by members of India's Central Reserve Police Force.

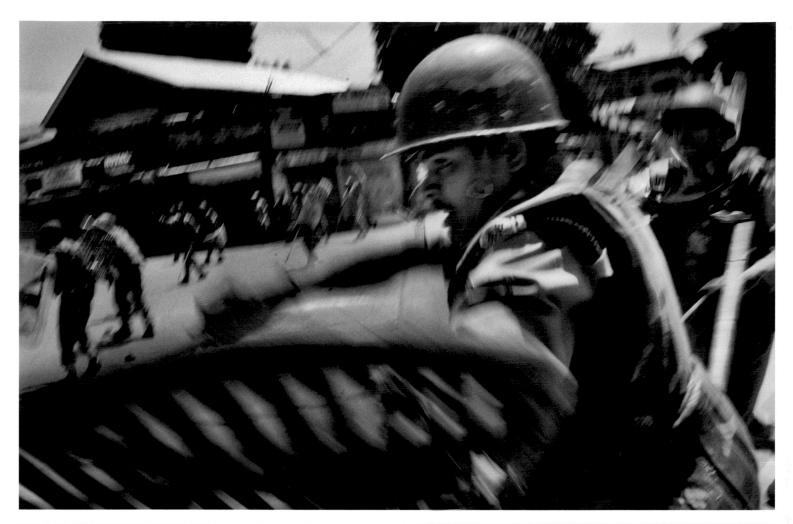

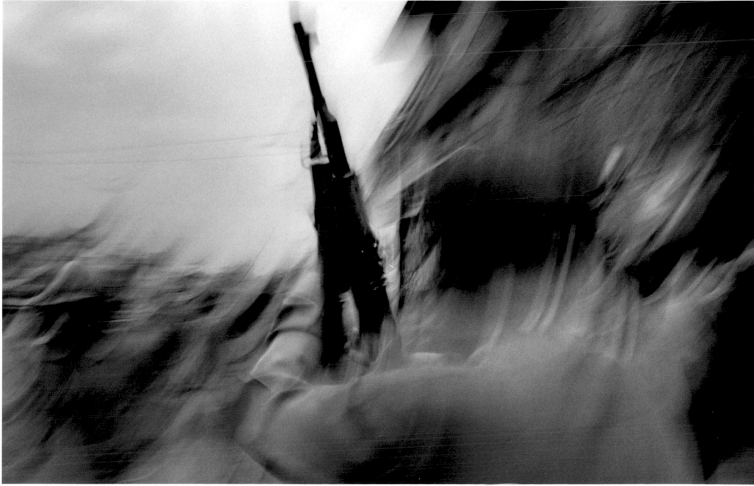

Above. Marcus Bleasdale. In Srinagar, stone-pelting protestors are overcome by the heavily armed Indian Central Reserve Police Force (CRPF), who fire tear gas and charge with batons, 16 July 2009. Pitched battles lasted for many days after more local residents disappeared, presumed kidnapped by the security forces.

Below. Marcus Bleasdale. A member of the Kashmiri police rushes to quell a group of young protestors, 16 July 2009. The rioters are hurling rocks at the security services and had set alight parts of Srinagar in response to the alleged abduction of Kashmiri people by members the Indian Central Reserve Police Force.

2009
CONGOLESE SYMPHONY ORCHESTRA
MARCUS BLEASDALE

In a country destroyed by war and corruption, the mere existence
of an orchestra seems unimaginable. However, in the Democratic
Republic of Congo (DRC), in 1994, a handful of church musicians
began practising the violin, taught themselves to play cello, added
a choir and gave their first concert 10 months later. In June 2009,
Marcus Bleasdale visited the Orchestre Symphonique Kimbanguiste
(OSK), which today consists of 80 instrumentalists and a choir
of 60. With no funding to support them, most of the musicians
bought their own instruments (second-hand from China). Others
rely on Albert Matubanza, who, as well as being a gifted musician,
has taught himself to build string instruments using local wood
and telephone wire for strings. The Kimbanguist Church is the third
largest Christian denomination in the DRC. Armand Diangienda
– the grandson of Simon Kimbangu, the Church's founder – is
the OSK's director. On 28 June 2009, the orchestra gave its first
open-air concert in Kinshasa, playing Orff's *Carmina Burana*, parts
of Handel's *Messiah* and the fourth movement of Beethoven's
Ninth Symphony.

In the backyard of their church in Kinshasa, DRC's capital, flautists of
the Orchestre Symphonique Kimbanguiste practise in preparation for
their Independence Day concert.

Above. A violinist of the Orchestre Symphonique Kimbanguiste rehearses in Kinshasa.
Below. Armand Diangienda conducts a rehearsal of the Orchestre Symphonique Kimbanguiste in Kinshasa.

Overleaf. The congregation of the Kimbanguist Church, Kinshasa, during a 12-hour Sunday service.

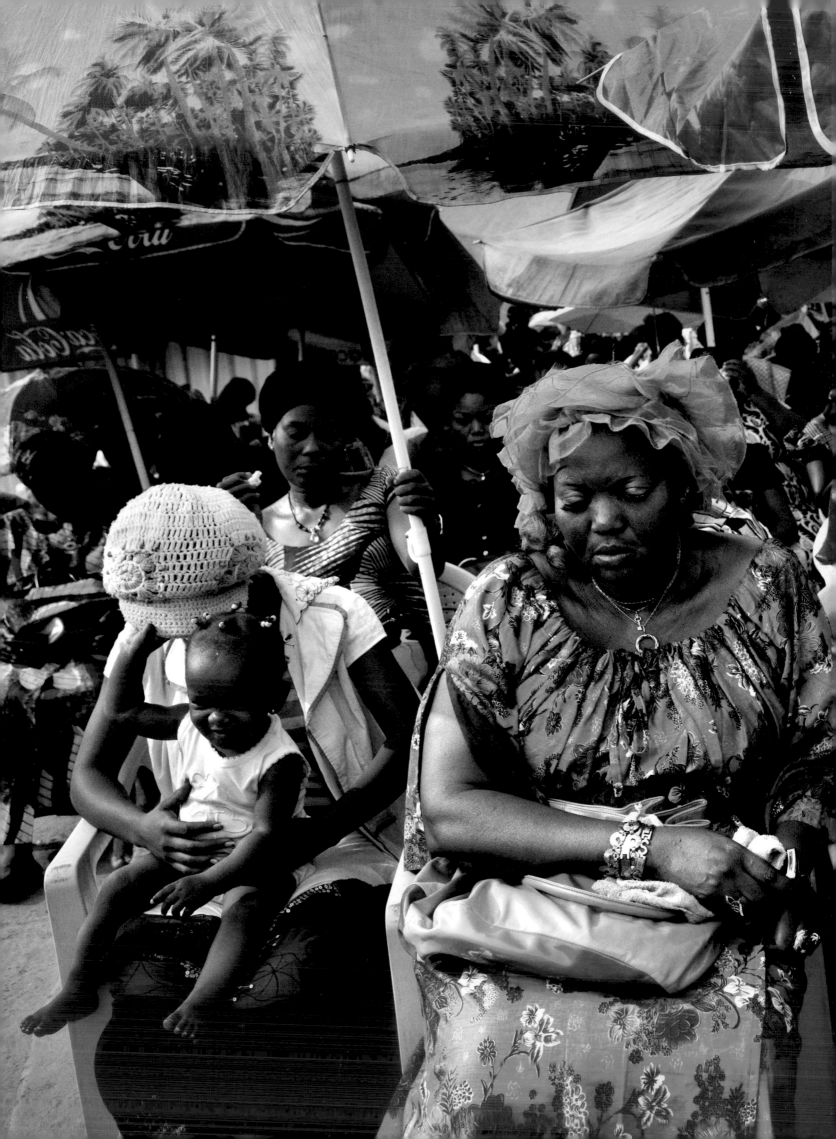

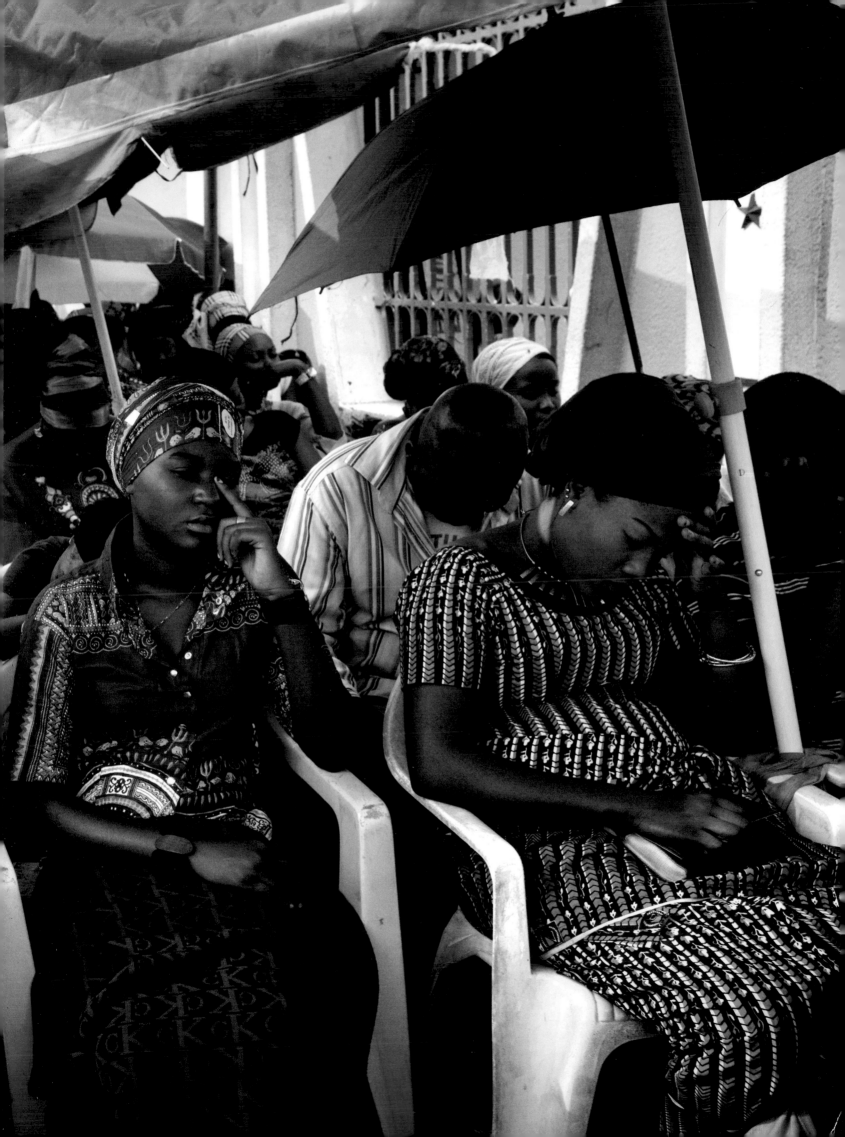

Above. Behind the Kimbanguist church in Kinshasa, OSK trombonists get together at night to practise for the Independence Day concert.

Below. Seated on a pew of the Kimbanguist church in Kinshasa, Nonogolo studies his music for the Independence Day concert.

Above. In the lit-up back garden of the Kimbanguist church in Kinshasa, trumpeters of the Orchestre Symphonique Kimbanguiste practise for their Independence Day concert.

Below. An OSK violinist and flautist, plus other members of the orchestra, rehearse inside the Kimbanguist church in Kinshasa.

Italian actress Margareth Madè, wearing Dolce & Gabbana, at the Metropòl,
Milan, May 2010.

Christian Dior, Haute Couture Autumn 2009 Collection, Maison Christian Dior, avenue Montaigne, Paris.

Above. Valentino, Haute Couture Spring 2010 Collection, quai Malaquais, Paris.

Left. Christian Dior, Haute Couture Spring 2010 Collection, quai Malaquais, Paris.
Right. Christian Dior, Haute Couture Spring 2010 Collection, quai des Orfèvres, Paris.

2009
OBAMA'S BURDEN
CHRISTOPHER MORRIS

On 1 December 2009, President Barack Obama unveiled his
strategy on the war in Afghanistan at a crucial address made at
the prestigious US Military Academy at West Point, New York.
The president outlined plans to increasingly hand over responsibility
to the Afghan authorities over a period of 18 months, while also
ordering 30,000 more US soldiers to Afghanistan, bringing the total
US troop strength to over 100,000. He claimed that world security
was at stake and called for more allied troops in order to defeat
Al Qaeda and prevent the resurgent Taliban from overthrowing
the government. In response, Anders Fogh Rasmussen, NATO's
secretary general, pledged to provide at least 5,000 extra troops,
acknowledging that instability in Afghanistan would increase risks
of insecurity for citizens across the world. Although the Afghan
government and security forces supported the new strategy, they
voiced concern over the announcement of a pull-out date, which
might make the insurgents even more determined in their resolve.

Above. US President Barack Obama delivers his strategy for Afghanistan in the
Eisenhower Hall of the United States Military Academy, West Point, New York.
Overleaf. Cadets of the West Point Military Academy listen to President Obama
presenting his arguments for deploying 30,000 additional US troops in Afghanistan.

Previous page. A family goes about their daily business in Maradich, a village in the Pech Valley. US bases are positioned along the river valley.
Above. Graffiti on the wall of a house in the old part of Kabul.

Below. Hussein, 28, lives in the ancient part of Kabul. He was wounded during the fall of the city in 2001, fighting with the Taliban against the Northern Alliance. A shot in his back rendered him paraplegic.

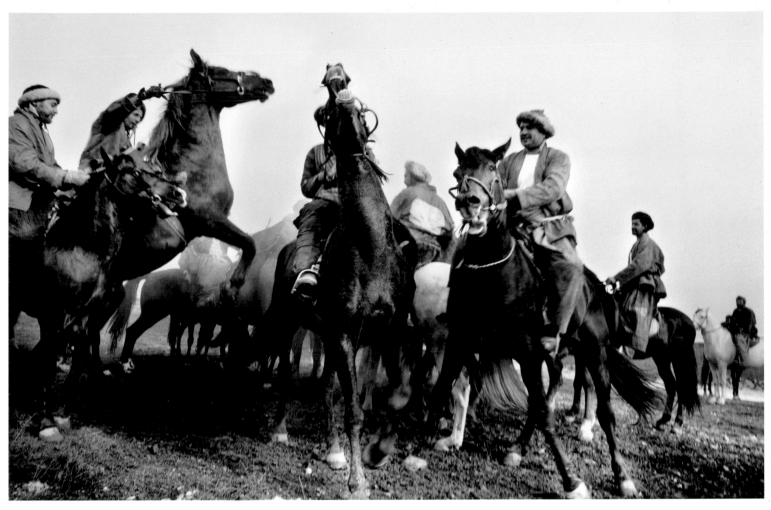

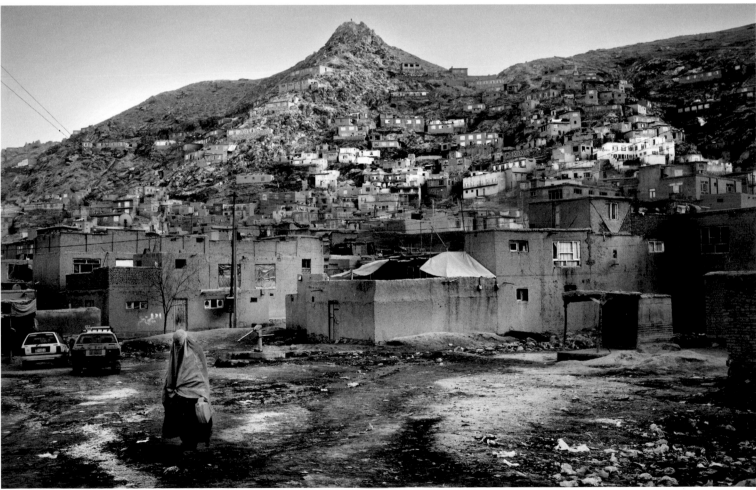

Above. Men on horseback play buzkashi, the Afghan national sport, in Kabul. The aim is to grab an animal carcass from the ground and pitch it across a goal line or into a circle. The game has been played in northern Afghanistan since the days of Genghis Khan, the thirteenth-century Mongol warrior.

Below. A burka-clad woman walks down a muddy street in Kabul.

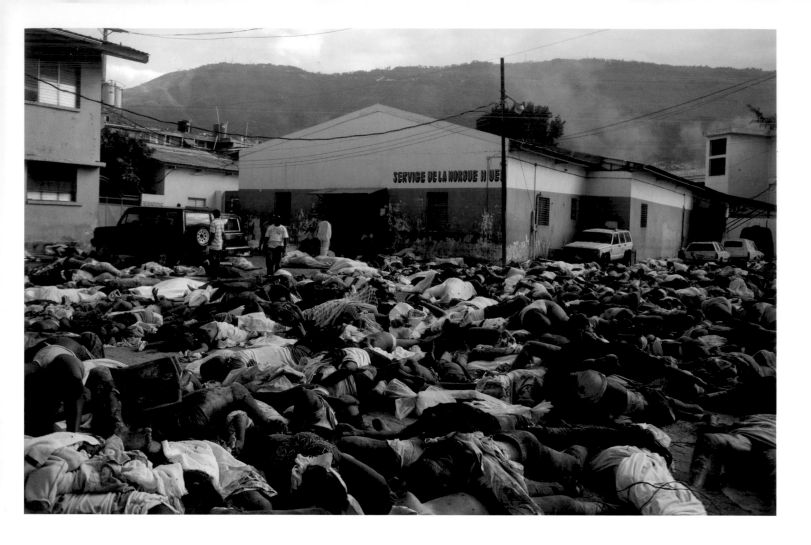

2010
HAITI EARTHQUAKE
RON HAVIV

On 12 January 2010, an earthquake magnitude 7.0 struck the impoverished nation of Haiti. With little resistance from the poor infrastructure, the capital Port-au-Prince and surrounding areas were destroyed. More than 220,000 people were killed and 1.5 million people were made homeless. Emergency aid was hampered by a wrecked airport and obstructed roads. In the capital, shortages of food and medical supplies triggered looting and some violence. Before the earthquake struck, more than 70 per cent of the country's population were living on less that $2 per day; half the people in Port-au-Prince had no toilets and only one third had access to tap water. Now there are 19 million cubic metres of rubble in the capital and 1.5 million people are living in camps. It is estimated that it will take five to 10 years to rebuild Haiti. Ron Haviv arrived in Haiti the day after the earthquake hit to document the aftermath.

Bodies are piled up outside the morgue at the main hospital in Port-au-Prince, Haiti's capital. They were eventually loaded onto trucks and taken to a mass grave on the outskirts of the city.

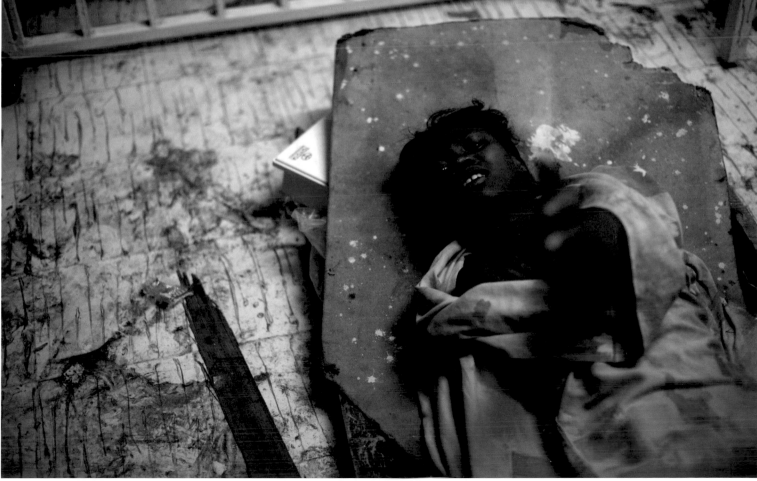

Above. The body of a young girl awaits burial in a makeshift morgue in the grounds of the Port-au-Prince hospital.

Below. A woman asks for help as she lies in front of a temporary medical clinic on a Port-au-Prince street.
Overleaf. Haitians flee for the countryside in search of food and more adequate shelter after the earthquake struck the capital.

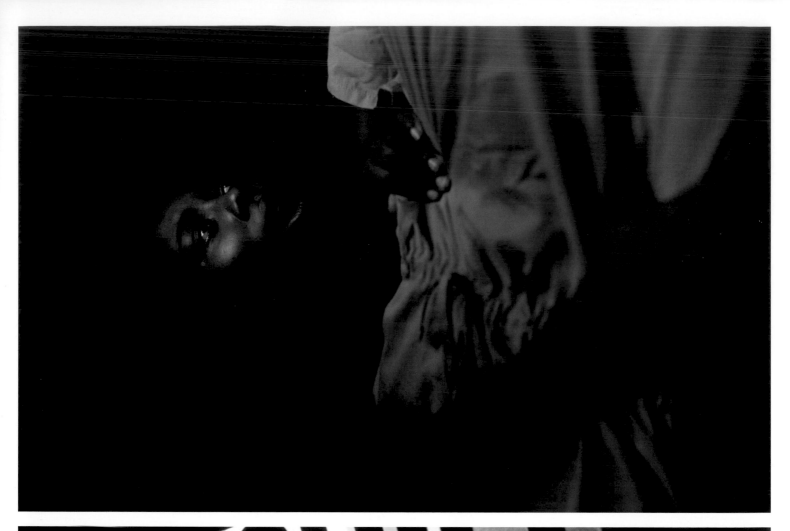

Above. A patient receives stitches at a clinic in Port-au-Prince.

Below. People jostle for food handouts from the Yéle Haiti Foundation in Cité Soleil, an extremely poor and densely populated area of Port-au-Prince.

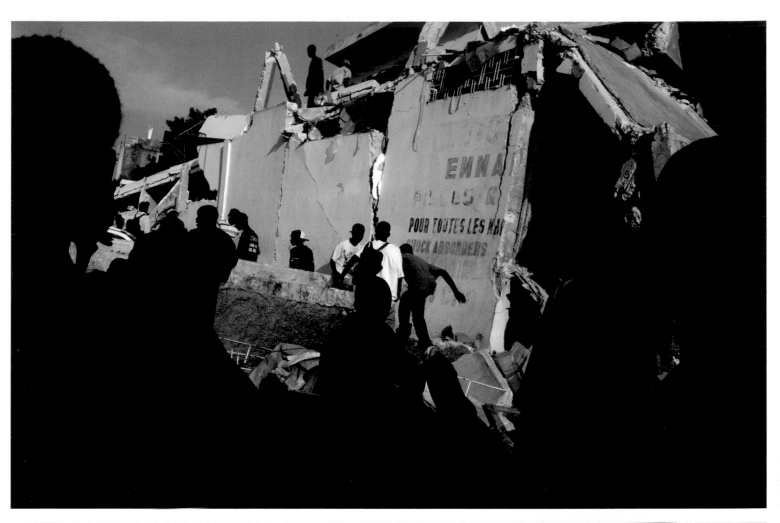

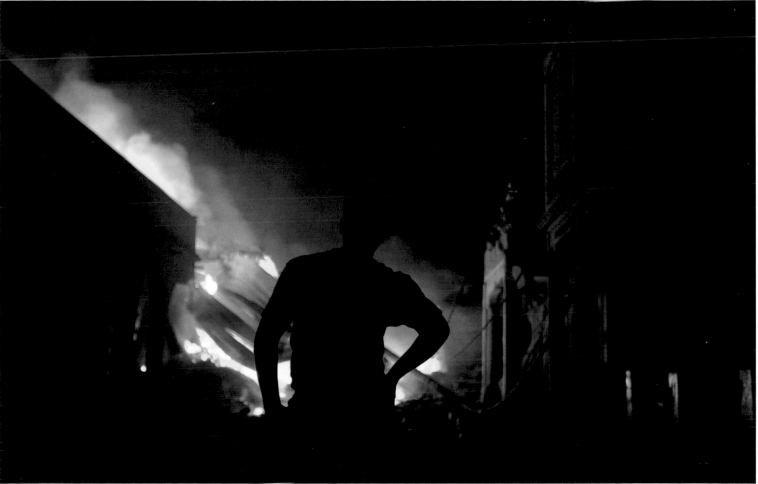

Above. Sporadic looting occurred in the aftermath of the earthquake, much of it perpetrated by people struggling to find basic supplies.

Below. Numerous fires broke out in the downtown area of Port-au-Prince after the earthquake struck.

2010
CHINA: I HAVE NO ENEMIES
MARCUS BLEASDALE

Marcus Bleasdale visited Beijing in October and November 2010 to explore the contradictions of a country that is the world's fastest-growing economy but also an old-style authoritarian state. Thirty years of around 10 per cent growth has lifted millions of Chinese out of poverty. For many, this is a golden era, a period of stability and prosperity, but this is giving people the chance to stop and think. New technologies such as the internet are putting current events within the reach of China's once information-starved masses. People are beginning to demand more – from protection against the state tearing down their homes, to an end to government corruption, which makes daily life so difficult for ordinary citizens. Liu Xiaobo, imprisoned human rights activist and winner of the 2010 Nobel Peace Prize, declared: 'I Have No Enemies.' It was his appeal to the Chinese government for a peaceful transition towards freedom and justice for its people.

Chinese military march across Tiananmen Square after removing a seemingly passive group of people. The huge red banners proclaim: 'comprehensively push the building of a socialist economy, political construction, cultural construction, social construction, ecological construction and party construction ...'

Above. A man cycles past the remains of his old home, overshadowed by the China Unicom building. Painted on the wall is 'DEMOLISH – This wall is unsafe. Do not come close.' New apartment blocks will be built for wealthy Chinese, while the original residents are moved to out-of-town complexes.

Below. A man has his hair cut in a *hutong* – one of hundreds of alleys that make up Beijing's old city. Fifteen years ago Beijing had thousands of *hutongs*, but most have been levelled to make way for giant property developments backed by wealthy entrepreneurs and Communist Party officials.

Previous page. An enormous LED screen at The Place, a high-class shopping mall in Beijing's central business district, displays the national flag.

Above. A little boy and his dream car outside the BMW Lifestyle shop. Some years ago children played with home-made cars, but many now have toy sports cars. **Below.** The Lamborghini garage in the centre of Beijing. Increasing wealth has led to an explosion in the sale of high-end performance cars

Above. Young people using the internet in a bar in a suburb of Baoding, Hebei province. The internet both satisfies and creates a huge desire for information in China. Although it can be a force for change, the government also uses it to monitor social activity.

Below. High-rise buildings, financed by foreign investment, tower over a street in Beijing.

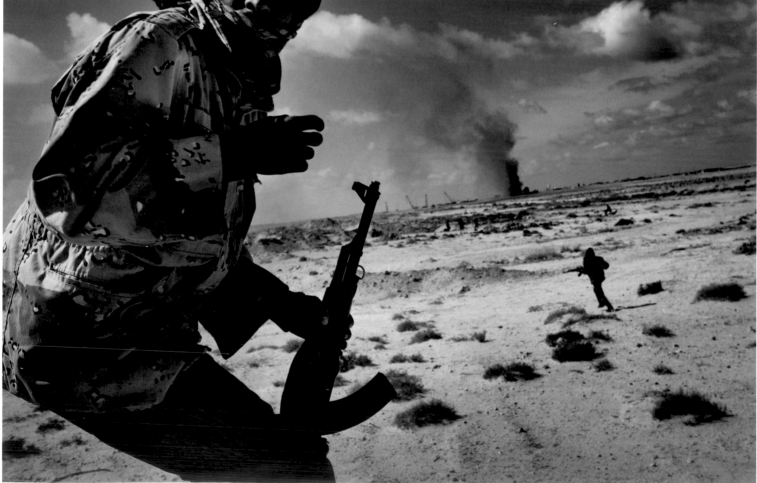

Above. Franco Pagetti. An underground jail found by opposition supporters at a palace compound in Muammar Gaddafi's military headquarters at Al-Katiba, Benghazi, Libya, 24 February 2011.

Below. Franco Pagetti. Rebel fighters seen on the outskirts of Bin Jawwad, near Ras Lanuf, Libya, 6 March 2011. Heavy fighting went on throughout the day, as Muammar Gaddafi's troops hit the opposition with air strikes, artillery and sniper fire. The day before opposition troops had taken Ras Lanuf from loyalist troops.

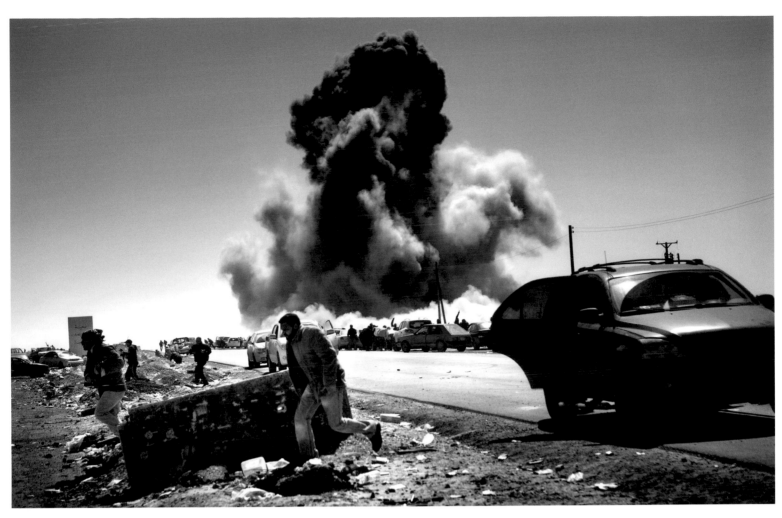

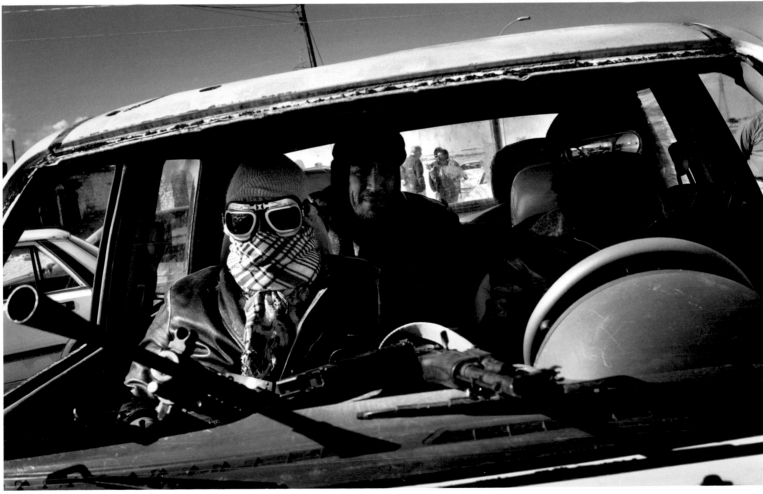

Above. Franco Pagetti. A government airstrike on the frontline in Ras Lanuf, Libya, 7 March 2011. Government troops loyal to Libyan leader Muammar Gaddafi drove opposition forces out of the strategic oil town, forcing a frantic rebel retreat through the desert.

Below. Franco Pagetti. Libyan rebels on the outskirts of Ajdabiya, eastern Libya, 20 March 2011.

CONTEXT OF EVENTS

1989

After 28 years as a symbol of repression, the Berlin Wall is pulled down

Student protests in Prague prompt the Velvet Revolution and the overthrow of the Czech Communist government

Bloody demonstrations end the dictatorship of Nicolae Ceausescu in Romania

The Dalai Lama is awarded the Nobel Peace Prize

The first full episode of *The Simpsons*, a satirical parody of a working-class American family, airs in the United States

George H. W. Bush and Mikhail Gorbachev declare an end to the Cold War at the Malta summit

1990

Tim Berners-Lee develops the World Wide Web at CERN in Switzerland

South Africa frees Nelson Mandela after 27 years of confinement

Widespread riots against the proposed poll tax in Britain contribute to the resignation of the country's first female prime minister Margaret Thatcher

The USA launches the Hubble Space Telescope at a cost of $1.5 billion

East and West Germany are united while Latvia and Azerbaijan seek their independence

Iraqi troops invade Kuwait and seize petroleum reserves

The World Health Organization declassifies homosexuality as a disease

The first free elections in Yugoslavia return nationalist parties as the victors across the federation

1991

The USA leads a UN-authorized military alliance against Iraq in the Gulf War

The USA indicts two Libyans accused of the 1988 bombing of Pan Am Flight 103 over Lockerbie, Scotland

President Gorbachev resigns amid the break-up of the Soviet Union

Somalian Dictator Siyad Barre flees the presidential palace amid civil war

After 36 years of alliance, The Warsaw Pact is officially dissolved in Prague

Hezbollah militants finally release their American hostages; some of the prisoners were held in Lebanon for over five years

Croatia, Slovenia and Macedonia secede from Yugoslavia; fierce fighting breaks out in Croatia between Serbs and Croats

Poland, Hungary and Czechoslovakia sign the Visegrad Agreement promoting free-market policies

1992

The Yugoslav Federation breaks apart; war breaks out in Bosnia as the Serbian population seek independence

Russian Parliament approves the START treaty, a nuclear arms reduction agreement with the USA

US forces leave the Philippines, ending nearly a century of American military presence in the region

The UN approves US-led forces to protect food aid in Somalia

A moratorium on northern cod fishing is imposed by the Canadian government after decades of overfishing

The Maastricht treaties advance political and economic union in Europe

After over a decade, El Salvador's civil war comes to an end

1993

In response to the US involvement in Israel, terrorists detonate a bomb beneath the North Tower of the World Trade Center in New York, killing seven

In the infamous Black Hawk Down gun battle, 18 US Army Rangers are killed in Mogadishu, Somalia

With the Maastricht Treaty, Europe's single economic market begins, creating the modern-day European Union

Srebrenica in Bosnia is designated a 'safe haven' by the UN

An IRA bomb rips through the City of London causing £350 million of damage

Yasser Arafat and Yitzhak Rabin agree to sign the Oslo Accords between Israel and Palestine

Bill Clinton becomes president of the USA

1994

Rwandan genocide of Tutsis by Hutus begins; it is estimated that 800,000 are slaughtered in about 100 days

South Africa holds its first interracial national election with ANC candidate Nelson Mandela elected president

After 25 years, the IRA declares a complete ceasefire in Northern Ireland

Russia attacks the secessionist Republic of Chechnya

Yasser Arafat returns to the Gaza Strip

after nearly three decades in exile

Edvard Munch's *The Scream* (1893) is stolen in Oslo

Israel and Jordan resume peaceful relations for the first time since 1948

Israelis and Palestinians sign accord for Palestinian self-rule

Haitian president Jean-Bertrand Aristide returns to power after US intervention

The USA is forced to bail out Mexico after financial meltdown

US President Bill Clinton orders the Bosnian arms embargo ended

1995

A mortar bombing of a Sarajevo marketplace triggers NATO military intervention in Bosnia; a ceasefire paves the way for the Dayton Agreement, ending the Bosnian War

Aum Shinrikyo cult members release nerve gas on the Tokyo subway

Iraq admits the existence of its biological weapons programme

More than 8,000 Bosnian men and boys are slaughtered at Srebrenica

New, advanced treatments for HIV/AIDS become available – but there is still no definitive cure

France explodes nuclear device in Pacific sparking international protests

The Nuclear Non-Proliferation Treaty is extended indefinitely by 170 countries

Former American football star O. J. Simpson is found not guilty of murder

Nigeria hangs writer Ken Saro-Wiwa and eight other minority rights advocates

1996

Bosnian-Serb president Radovan Karadzic becomes a fugitive following an arrest warrant for war crimes

Peace talks at the Kremlin result in Chechen ceasefire

Taliban Muslim fundamentalists capture Afghan capital of Kabul

Ethnic violence breaks out in Zairian refugee camps; thousands of refugees from Rwanda and Burundi are subsequently forced to flee

Kofi Annan is named UN secretary-general

Lebanese civilians are killed by Israeli shells in the village of Qana, provoking reprisals in Egypt

China agrees to world ban on atomic testing

The 36-year civil war in Guatemala comes to an end

1997

Israel gives up large part of West Bank city of Hebron in a new agreement

A state of anarchy erupts in Albania as almost a third of the population loses their savings because of collapsed pyramid schemes

Clearly visible in the night sky, Hale-Bopp comet is the closest it will be to Earth until the year 4397

A deadly fire kills 300 pilgrims outside the holy Muslim city of Mecca

Cambodia's Khmer Rouge hold the trial of long-standing leader Pol Pot, sentenced to house arrest for life

Mother Teresa dies aged 87; tens of thousands line the funeral route in Kolkata, India

US serial killer Andrew Cunanan murders fashion designer Gianni Versace

Two billion people watch the televised funeral of Diana, Princess of Wales

A computer, Deep Blue, beats World Chess Champion Garry Kasparov

The first colour photograph appears on the front page of *The New York Times*

Thousands of civilians are massacred during the ongoing Algerian civil war

The British hand back the colony of Hong Kong to China after 156 years

1998

President Clinton is embroiled in a White House sex scandal with intern Monica Lewinsky, leading to his impeachment

Following riots sparked by financial crisis, Indonesian dictator Suharto steps down after 32 years in power

Saddam Hussein accepts UN weapons inspectors into Iraq but the regime's noncooperation leads to US air strikes

The Good Friday Agreement, a landmark peace accord, is endorsed in Belfast, Northern Ireland

US embassies in Kenya and Tanzania are bombed by a group linked to Osama bin Laden's Al Qaeda terrorist network

Hindu nationalist Atal Bihari Vajpayee becomes India's tenth prime minister

1999

Eleven weeks of NATO air strikes against Serbian targets leads to an agreement to withdraw troops from Kosovo

Two students go on a shooting spree in Columbine High School in the United States, killing 15 including themselves

In a referendum, the people of East Timor vote for independence from Indonesia

World population exceeds 6 billion

Military coup led by General Pervez Musharraf overthrows incumbent Pakistani government

World Trade Organization conference disrupted by violent protests in Seattle

Russia sends ground troops to Chechnya as conflict with Islamic militants intensifies

Australians vote to retain the British Queen as their head of state

The Kingdom of Bhutan legally permits television for the first time

More than 17,000 people die in a magnitude 7.4 earthquake in Turkey

2000

Ehud Barak, Yasser Arafat and Bill Clinton attempt to bring peace to the Middle East at Camp David, Maryland, USA

The United Nations Millennium Development Goals are adopted in New York, launching a global commitment to reduce extreme poverty by 2015

Violence erupts as the second Palestinian intifada against Israel begins

The first white farmer is killed in a wave of land confrontations in Zimbabwe

Despite a dispute over votes, George W. Bush is confirmed as the 43rd President of the United States

Pope John Paul II conducts a pilgrimage to Jerusalem in which he prays for forgiveness of the sins of those involved in the Holocaust

The 'dotcom' bubble bursts as technology stock markets in the United States plunge

Al Qaeda suicide bombers attack the USS *Cole* in Aden, Yemen

The Chernobyl nuclear power plant is permanently shut down

Serbian dictator Slobodan Milosevic is deposed and handed over to The Hague

Construction begins on India's Golden Quadrilateral highway

2001

Having stood for centuries, the Bamiyan Buddhas are destroyed by the Taliban government in Afghanistan

The foot-and-mouth livestock disease decimates the UK farming industry

Democratic Republic of Congo president Laurent Kabila is killed by one of his bodyguards amid a civil war involving five of its neighbouring countries

Under the auspices of Osama bin Laden and his Al Qaeda network, two hijacked passenger planes are flown into the World Trade Center in New York City and a third into the Pentagon in Washington, DC

Enron, the multinational Texan energy company, files for bankruptcy

US troops invade Afghanistan in the hunt for Osama bin Laden

Letters containing anthrax are sent to Capitol Hill, Washington, DC

Riots erupt in Argentina as confidence in the economy collapses

The King and Queen of Nepal are shot dead by the heir to the throne

2002

A single currency, the euro, is introduced across participating nations in Europe

Master couturier Yves Saint Laurent holds his last show, Paris, France

A permanent detention facility, Camp Delta, is established at Guantanamo Bay in Cuba, to hold suspected Al Qaeda terrorists

East Timor achieves independence from Indonesia and becomes the world's youngest democracy

Theatre-goers are held hostage by Chechen rebels in Moscow, Russia

The International Criminal Court in The Hague comes into force, able to prosecute individuals for crimes against humanity, war crimes and genocide

George W. Bush condemns Iraq, Iran and North Korea as an 'axis of evil' in his State of the Union address

The Bali bombings claim the lives of 202 tourists and locals in Indonesia

A British government dossier claims that Iraq owns weapons of mass destruction; it is later discredited

2003

A coalition led by US forces invades Iraq to topple Saddam Hussein's regime

UN-backed West African forces, assisted by US troops, intervene to bring an end to the Liberian Civil War

Saddam Hussein is captured by US troops in an underground hideout near his home town of Tikrit, Iraq

The newly discovered illness SARS causes worldwide panic

The US space shuttle *Columbia* breaks up upon reentry to the Earth's atmosphere; there were no survivors

CONTEXT OF EVENTS

2004

Amid economic and social hardship, Haiti descends into rioting and rebel control

Islamic extremists bomb Madrid's train system, killing 190 and injuring 1,800

Atrocities committed by US troops on Iraqi prisoners in Abu Ghraib are exposed

The first death from human-to-human transmission of avian flu (H5N1) occurs in Thailand

An earthquake measuring 9.3 strikes off the coast of Sumatra causing a catastrophic tsunami hitting coastal communities across Southeast Asia, India and Sri Lanka

The UN High-Level Threat Panel identifies poverty, infectious disease and environmental degradation as the main threats to mankind

Chechen terrorists hold children and adults hostage in a school in Beslan

2005

8.5 million people vote in Iraq's first democratic election

Pope John Paul II dies in the Vatican City and is replaced by the German-born Cardinal Joseph Ratzinger, now Pope Benedict XVI

London wins the 2012 Olympic bid – only to be rocked by multiple terrorist bombings the next day

One of the strongest Atlantic hurricanes recorded, Katrina lays waste to the Gulf Coast of the United States

Separatist violence between Buddhists, Malay and Muslims spikes in the tumultuous region of southern Thailand

Over 80,000 die in the massive earthquake and numerous aftershocks that struck the Kashmiri region of northern India and Pakistan

Egyptian president Hosni Mubarak wins re-election after 24 years in power

Syria finally withdraws from Lebanon after nearly 30 years of military domination

North Korea officially announces that it possesses nuclear weapons

Controversy explodes after a Danish newspaper prints a cartoon depicting the Prophet Mohammed

2006

War erupts in Somalia as Ethiopia and the transitional government join forces to battle the Islamic Courts Union

Saddam Hussein is executed in Baghdad

Serbia and Montenegro dissolves as

Montenegro votes for independence

Hamas elected to Palestinian Legislative Council ahead of the ruling Fatah party

Lebanese militant group Hezbollah kill eight Israeli soldiers; Israel launches attacks on Lebanon

Osama bin Laden's number two, Abu Musab Al-Zarqawi, is killed by a US air strike

Massive student protests electrify Greece

Former Russian spy Alexander Litvinenko is poisoned by polonium in London, straining UK-Russia relations

2007

President George W. Bush commits to sending 20,000 more US troops to Iraq in an attempt to turn the tide of the growing insurgency

Pakistan's former prime minister Benazir Bhutto is assassinated in a suicide attack

The government of Nepal announces the dissolution of its 240 year-old monarchy

After ten years in power, the UK Labour Party's longest-serving prime minister, Tony Blair, steps down

Contested election results lead to widespread instability across Kenya

An international panel publishes a major report warning of the dangers of global climate change

2008

The Kosovar Albanian parliament declares independence

Russia and Georgia go to war over the disputed region of South Ossetia

Lehman Brothers is forced to declare bankruptcy and becomes one of the first high-profile victims of the global financial crisis

Senator for Illinois Barack Obama is elected the first African-American president of the United States

Global food riots break out due to rising food costs as commodities spike

Malaria causes nearly 1 million deaths, mostly among African children

A series of coordinated terrorist attacks strike the heart of Mumbai, India

A massive earthquake hits the Sichuan region of China, killing almost 70,000

The Olympics are hosted in Beijing, China

2009

Austrian Josef Fritzl is found guilty of holding his daughter captive for 24 years

Global panic erupts with the spread of swine flu

Riots break out in Kashmir after Indian security forces are accused of abduction and murder

Barack Obama announces his plans for the future of US military involvement in Afghanistan and he also makes a historic speech to the Muslim world in Cairo, Egypt

Former South African president Thabo Mbeki leads an investigation into an African solution to the Darfur crisis

A special tribunal in The Hague begins its investigation into the 2005 assassination of the former prime minister of Lebanon Rafik Hariri

2010

A magnitude 7.0 earthquake strikes the impoverished nation of Haiti

Much of the Polish political elite, including President Lech Kaczynski, are killed in a plane crash over Russia

Global air travel is massively disrupted by clouds of volcanic ash, spewed from the Eyjafjallajokull volcano, Iceland

South Africa becomes the first African nation to hold the FIFA World Cup

Wikileaks causes international controversy with the online release of thousands of confidential US diplomatic documents

The Nobel Peace Prize is awarded to Liu Xiaobo, risking diplomatic relations with China, where he is under house arrest for 'inciting subversion of state power'

2011

South Sudan wins independence following a historic referendum

Arizona senator Gabrielle Giffords is critically injured by a lone gunman, provoking political controversy over the growing strength of the anti-tax tea party movement in the USA

Protests in Tunisia spark waves of revolution in Arabic and North African states, most notably in Egypt and Libya

One of the strongest earthquakes ever recorded causes a devastating tsunami off the east coast of Japan

Violence erupts in Cote d'Ivoire as the former president refuses to step down after losing the 2010 election

Osama bin Laden is killed by US forces during a targeted raid on a private compound in Abbottabad, Pakistan

INDEX

INDEX

INDEX

ACKNOWLEDGEMENTS

The publishers would like to thank all the photographers at VII for their unwavering commitment to capturing the world as they see it, in all its astonishing and heartbreaking detail. And to all those who worked behind the scenes on this book, in particular Nick Papadopoulos at VII for his consistent enthusiasm and diplomacy, Tom Wright for his invaluable editorial assistance, Daniel Baer for his critical eye during the picture editing process, and Victoria Clarke for her determination and drive to see the project through.

VII would like to thank all our supporters, too numerous to mention, for their wonderful friendship, help and support since VII's launch in 2001. The photographers offer particular respect and appreciation for the help of the magnificent staff, NGOs, corporations, media organizations, hundreds of local journalists, translators, fixers and others as we have entered fleetingly the lives of thousands of extraordinary people over the last decade. What we see in this book is the work of a handful of photographers, but we know that without all of these people/organizations there would be no photographs. VII also thanks Canon USA for their generous production support, and the editorial team at Phaidon Press for their commitment, editing and faith in the book. Special thanks are due to the staff of VII whose dedication, intelligence and sheer hard work has sustained VII for its first decade of existence.

Part of 'A Fire in the Lens', © David Friend, was previously published in *Watching the World Change: The Stories Behind the Images of 9/11* (Farrar, Straus & Giroux, 2006).

Chapter introductions by Anna Rader.

Story texts by the VII photographers, with the exception of 'The Rape of a Nation' by Jan Egeland and 'Moscow Nights' by Brett Forrest.

The photographers of VII dedicate this book to the memory of Alexandra Boulat (1962–2007).

Cover photographs: **Marcus Bleasdale.** Chinese military march across Tiananmen Square, Beijing, China, 2010. **Alexandra Boulat.** Women's day at the Hazrat Ali shrine, Mazar-e Sharif, Afghanistan, 2004. **Ron Haviv.** Young girls leave a camp for internally displaced people in search of firewood, Darfur, 2005. **Ed Kashi.** A trucker's helper surveys their overturned vehicle, Rajasthan, India, 2007. **Gary Knight.** Friends share a laugh in the streets of Delhi, India, 2009. **Antonin Kratochvil.** Residents flee Basra as humanitarian conditions worsen, Iraq, 2003. **Joachim Ladefoged.** A young Kosovo Albanian dives into an artificial lake outside Gnjilane, Kosovo, 1999. **Christopher Morris.** A Chechen fighter flees the presidential palace, Grozny, 1995. **Franco Pagetti.** US soldiers arrest a group of suspected Mahdi Army members in Baghdad, Iraq, 2007. **Stephanie Sinclair.** Amber Barlow, 16, at the FLDS ranch in Pony Springs, Nevada, 2009. **John Stanmeyer.** Children sleep on the floor at the Edhi Village centre for the mentally ill, Pakistan, 2003.

Phaidon Press Limited
Regent's Wharf
All Saints Street
London N1 9PA

Phaidon Press Inc.
180 Varick Street
New York, NY 10014

First published 2012
© 2012 Phaidon Press Limited

ISBN 978 0 7148 4840 2

A CIP catalogue record for this book is available from the British Library.

Designed by Studio Baer

Printed in Italy